Sight *Sound* *Motion*

Sight Sound Motion

Applied Media Aesthetics *Herbert Zettl*

Wadsworth Publishing Company, Inc., *Belmont, California*

ISBN-0-534-00238-2
L.C. Catalog Card No. 72-96125
4 5 6 7 8 9 10 — 82 81 80 79 78

Special credits: The reproduction, on page 56,
of Sunday Afternoon on the Island of Grande
Jatte by Georges Seurat is by courtesy of The
Art Institute of Chicago. All other chapter opening
photographs are by courtesy of Steve Renick, as
are the following photographs: 1·3, 1·5abcd, 1·6,
2·1b, 2·9, 2·22b, 3·17ab, 5·9abc, 6·4cd, 6·14,
6·26abcd, 6·27, 6·71a, 6·78ab, 7·18, 7·27, 7·31,
7·33, 8·5, 9·27, 10·7, 10·9, 11·7a, 13·7abc, 13·41a,
13·42ab, 13·43b, 13·44, 15·24b, 15·25ab, 15·26b.

Preface

There comes a point in the development of every sensitive person when he is no longer satisfied with *feeling,* when he wants to know *why* he feels in a particular way. This degree of aesthetic awareness is important for the media communicator, especially in television and film. He must be able not only to identify significant experiences but also to transmit them to others in a clarified and intensified way. It is also important for the viewer, because he will be able to experience television and film communication on several intellectual and emotional levels and to grow less and less susceptible to irresponsible persuasion. We all should attain a degree of emotional literacy and sophistication in media aesthetics that allows us to judge a television program or film with sureness and confidence. The purpose of this book is to help us in this task.

A thorough understanding of aesthetic principles, and their prudent use, is no longer a matter of choice; it has become an essential prerequisite for the responsible communicator. In the midst of the extreme pollution of our senses and widespread perceptual insensitivity, if not illiteracy, aesthetics may well emerge as one of the most important and effective means for personal and social stability, if not survival.

Specifically, this book describes the basic aesthetic elements and principles of sight, motion, and sound in film and television and suggests how they might be used for optimally effective communication.

To keep the book manageable for the reader without artificially stripping the subject of its immense complexity, the material has been divided into five principal, interconnected aesthetic fields: (1) light and color, (2) space: area, (3) space: volume, (4) time-motion, and (5) sound.

Wherever possible, the aesthetic elements of television and film have been translated into vectors—forces that push or pull in certain directions or simply exert energy. As vectors, the various aesthetic elements and principles yield readily to the unique aesthetic requirements of the *moving image* in television and film.

Since we deal to a large extent with visual images, many pictures have been included as the primary learning material. Often, the captions are intended to illustrate the pictures rather than vice versa.

Other material in reduced type often contains information that falls outside the periphery of the various aesthetic fields but that is nevertheless important to the topic under discussion—for example, brief biographical data.

In describing the principal aesthetic fields, information has been used that evolved from rigorous empirical research, as well as ideas and insights that are admittedly speculative at this point. For this is the way theory is generally built: by observing and empirically testing the properties and behavior of some elements, while at the same time daring the intuitive leap that might suggest a structural relationship or a communication potential.

In this book, the reader is given basic aesthetic building blocks, complete with some blueprints for their use. It is left up to him to build his dream house—to use television and film the way he sees fit.

Yet, even if the dream house never gets built, this book would have purpose. Simply, if someone can be shaken loose from his perceptual complacency and made to see, feel, listen, and move about with heightened awareness and joy; if someone can be helped to find his way through the chaos of his daily experiences and to recognize and benefit from the significant ones; if someone can be helped to feel compassion for his fellowman and to share his experiences with him in a clarified way; if someone can be helped to reach even a minimal degree of emotional literacy that contributes ultimately to self-awareness, self-respect, and love—then this book has proved its worth.

I should like to thank Peter Dart, Roger Englander, and Martin Rabkin for their insightful and knowledgeable comments and suggestions for the final preparation of the manuscript.

I am especially indebted to Rebecca Hayden, Communications Editor, and Steve Renick, Art Director, Wadsworth Publishing Company, for their sensitive guidance and generous contributions throughout the making of this book. From the very outset, they established a high professional standard and made me adhere to it. Like me, they lived the project from beginning to end.

Also, many thanks to the following people for their help. Tom Ballin, E. A. Bentz, Stuart Cooney, Darryl Compton, Gordon Gray, Jerry Higgins, Stuart Hyde, Colby Lewis, Nikos Metallinos, Quinn Millar, Grace O'Connell, Olga Stacevich, Dan Whiteman, Dave Wiseman, the many students, colleagues, and friends who appear in the photographs, and, of course, my family.

Herbert Zettl

*California State University,
San Francisco*

Contents

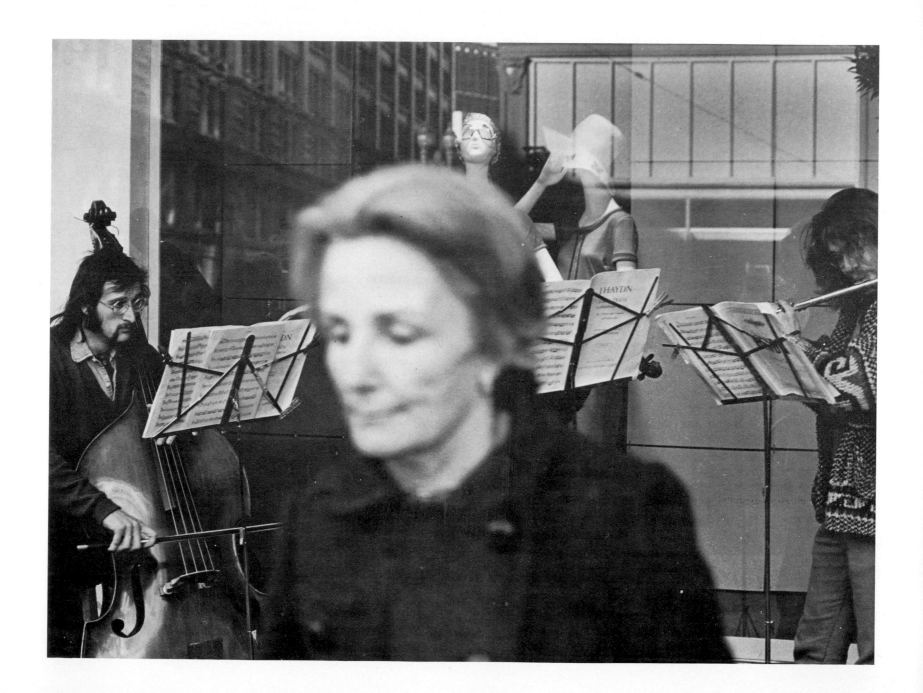

1[1]

Aesthetics: Life and Media

Whether consciously or not, we make many aesthetic choices every day. When we decide what to wear, how to arrange the items on a desk or dinner table, even when judging speed and distance while driving, we engage in basic perceptual, basic aesthetic, activities.

When we design a layout for a poster, a set for a television drama, or when we look through a camera viewfinder to frame a particular shot, we once again make precise perceptual judgments, except that now we are very much aware of aesthetic decision making. This kind of decision making, as any other, requires that we know what choices are available, that we have some guidelines, some principles, that help us to make the most effective decisions. To be an artist in any medium presupposes that we can go beyond the everyday perceptual reflexes, that we approach creative problems with an educated perception and a certain degree of emotional literacy. When working with a specific medium, such as television or film, we must become sensitive, not only to our general environment but also to the aesthetic requirements and potentials of the medium. It is not enough to have a significant vision. We must also learn to give to significant vision significant form so that it can be shared with our fellowman.[1] If not communicated, a significant vision remains an insignificant dream. After all, sharing one's significant vision with his neighbor is a fundamental responsibility of man. For a professional communicator and artist, such sharing is his duty.

To aid you to give to significant vision significant form in television and film, to recognize the aesthetic requirements and potentials of the media, and to use them for effective communication that goes beyond the mere distribution of information is the purpose of this book.

We no longer limit aesthetics to the traditional philosophical concept that deals solely with the understanding and appreciation of beauty and with man's ability to judge beauty with some degree of consistency. Nor do we consider aesthetics to mean merely the theory of art. Rather, we have taken the original meaning of the Greek verb *aisthanomai* ("I perceive") and *aisthetike* ("sense perception") as the basis for our examination of the specific television and film image elements: light, space, time-motion, and sound.

Aesthetics, then, means for us a study of certain sense perceptions and how these perceptions can be most effectively clarified, intensified, and interpreted through a medium, such as television or film, for a specific recipient. Since all media elements interconnect and are ultimately shaped by our perceptual sensitivities, we call the operational field within which we conduct our examination *contextualistic aesthetics,* or simply *contextualism.*[2]

Contextualistic Aesthetics

Contextualistic aesthetics stresses an essential, intimate, purposeful relationship between art and life. This concept is quite contrary to the more traditional point of view of the isolationists, who make it a point to isolate art from the ordinary experiences of life. The isolationist insists that valid aesthetic experiences can happen only when one is confronted by a magnificent work of the "pure arts," such as a great musical composition, painting, poem, drama, or sculpture. "Life is one thing and poetry is another thing," exclaims Ortega y Gasset, summing up the isolationist's point of view briefly and succinctly.

José Ortega y Gasset, Spanish essayist and philosopher (1883–1955).

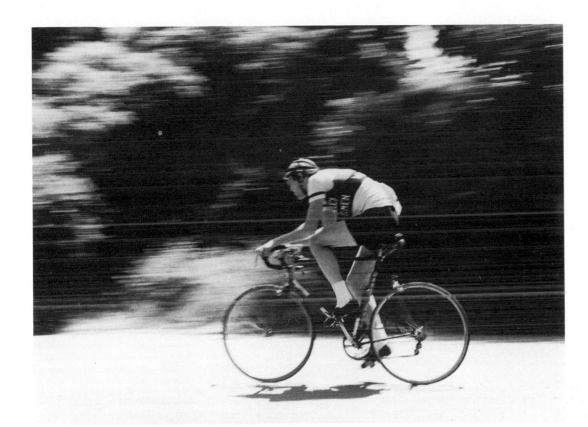

1·1 *Within the contextualistic framework, aesthetic experience can be drawn from all aspects of life. We can speak of the "art" of cooking or bicycling as legitimately as of the art of photography and dance.*

But, you may ask, how does the contextualist distinguish between art and non-art, especially since he sees art even in the ordinary experiences of life? Is not every aspect of life, every experience we have, art for the contextualist? No. The ordinary daily routine experience may be full of wonder sometimes when closely examined, but it is not art. Not yet, in any case. But it has the potential of becoming art—of serving as the raw material for the act of aesthetic communication that we generally call art.

What, then, is the deciding factor that elevates the ordinary life experience into the realm of art?

This factor is the artist, or group of artists, who perceive, order, clarify, intensify, and interpret a certain aspect of the human condition for themselves and, later, for someone else (Fig. 1·2).

The philosopher Irwin Edman (1896–1954), one of the foremost representatives of contextualistic aesthetics, states clearly and simply the contextualist's basic aesthetic concept:

So far from having to do merely with statues, pictures, symphonies, art is the name for that whole process of intelligence by which life, understanding its own conditions, turns them into the most interesting or exquisite account.[3]

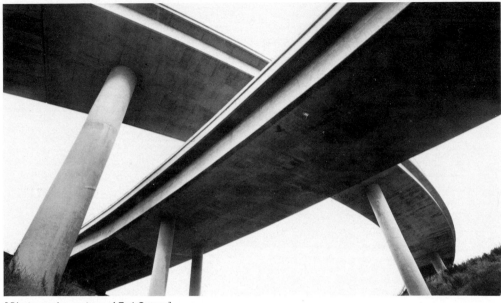

1·2

[Photograph courtesy of Ted Organ.]

This process presupposes that life is given "line and composition" and that the experience is clarified, intensified, and interpreted. "To effect such an intensification and clarification of experience," Edman says, "is the province of art."[4]

Besides the close relationship between art and life and the clarification and intensification of experience, these major factors help to define contextualism: order and experience complexity; context; responsibility; and, in our case, the media of television and film.

Let us briefly discuss each of these points. The first two factors are repeated for clarity's sake.

Relationship between Art and Life All human activities have an aesthetic potential. Aesthetic experiences can be drawn from *all* facets of life.

Art as Clarified and Intensified Experience Aesthetic experience is ordered, clarified, intensified, and interpreted experience. Operationally, this means that we must learn how to observe life, to select those aspects of it that seem especially significant, to clarify and to intensify with a particular medium, such as television or film. We must interpret these experiences in such a way that other people can participate deeply in our communication, thus being able to become more aware of themselves and their surroundings.

Order and Experience Complexity Human experiences are incredibly complex and, to a certain extent, unique. Whenever we begin to work with such experiences, we must have the courage and the ability to cope with their complexities.

1·3 Complexity without order produces confusion.

1·4 Order without complexity produces boredom.

Stripping life artificially of its complex nature is not an intensification but a dilution of experience. Yet, in order to intensify complex experience, we must give to the experience form and shape. Merely to repeat the ordinary experience of life—even with all its random complexity—is not the province of art. We must look at the event, search for its essential qualities, select and emphasize its most important elements, and give it a new structure that will help our fellowman to perceive its significance and to feel its depth. Order and complexity are, therefore, not opposites, but essential companions.[5]

Context Each one of us is a unique person. Each has his very own perceptual set-up and behavioral patterns. Even when witnessing the same event from the same location, each one of us tends to perceive the event from his own point of view, within his own perceptual context. This point of view depends on his previous experiences, his present perceptual sensitivities and predisposition, and his expectations.

We all perceive our environment selectively. We tend to notice only those events, or parts of an event, that are congruent with our previous experience and expectations. We tend to seek information that agrees with our expectations and prejudices and to shut out almost everything else that might interfere with our habitual perception pattern. Art is one effective means to combat this reinforcing of prejudices by selective perception. Art helps, if not forces, us to see things in a new way. Depending on where we place a camera and what field of view we choose to select, we can show

1·5 *Each one of us "sees" the event from his own point of view, depending on his experiential context.*

the same event from various points of view, within different contexts. Each time, we guide the viewer to see new things, to see the event from a different perspective, to break out of his perceptual pattern. We help him educate his perception.

But if each one of us has his own way of looking at things and interpreting them according to his own experience, how can we ever expect to communicate to a group of people, to thousands and millions, with the same message? Would we not have to encode, formulate, our message for each

individual? Fortunately not. First, some symbols and certain experiences are universal. The representation of a mother and child will be similarly perceived by most people, regardless of their cultural backgrounds or individual tastes. Two people in love are also a fairly universal event.[6]

Other, less universal, experiences such as a day in school, going to the movies, visiting a museum, asking someone for directions, all happen within a context that is common to many people, at least in our immediate cultural environment.

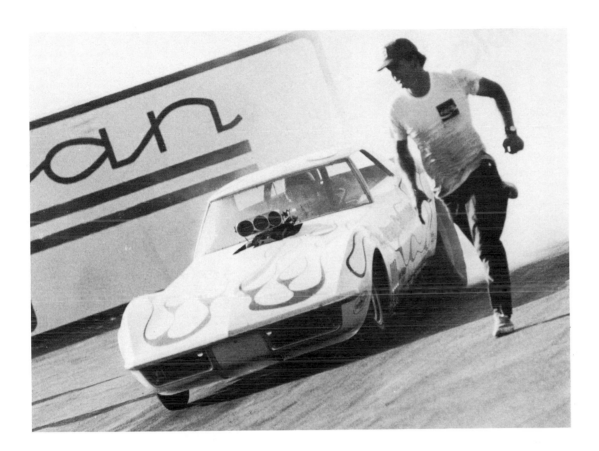

1·6 The tilted street makes the car seem to go faster. The whole event appears less stabile. It communicates more energy than if the street were parallel to the horizontal borders of the screen.

Thus, a television show or film in which such scenes are depicted can be successfully mass-communicated.

But, more importantly, most people react to certain aesthetic variables, such as color, sounds, distance, time, motion, and rhythm, in similar ways. In fact, we can find sufficient consistency in perception patterns to predict with reasonable accuracy how people will respond to specific aesthetic stimuli. The next time you invite a friend to visit, move some of your pictures a little so that they hang slightly crooked. Then watch your friend. Most likely, he will soon get up and adjust the pictures so that they hang straight again. His action is a predictable response to a strong aesthetic stimulus. We apply a similar technique when we cant the camera to make the photographed event appear more labile.

We all feel less comfortable in a pitch-dark room than when the lights are on. A red ball looks more appealing than a gray one. Some of the perception patterns in us are so forceful that our

1·7 *As in the Japanese film* Rashomon, *where one event is seen and described from several different points of view, some paintings, too, permit a variation of viewpoints. In this Picasso painting, we see the girl from straight on, we see her profile, and her reflection representing her other self. We can perceive several layers of her existence.* [Pablo Picasso, Girl Before a Mirror *(1932). Oil on canvas, 64″ × 51¹/₄″. Collection The Museum of Modern Art, New York. Gift of Mrs. Simon Guggenheim.*]

Pablo Picasso (1881–1973), Spanish painter and sculptor.

response to aesthetic stimuli is almost totally predictable. Take a look at some well-known optical illusions (Figs. 1·8, 1·9, and 1·10).

There are, of course, subtle aesthetic variables that we can use to produce a specific aesthetic response in the recipient, even if he is not consciously aware of these variables. In short, we can manipulate a person's perception, and ultimately his behavior, by a precise, calculated application of aesthetic variables and variable complexes. In the following chapters, we will discuss some of these variables—such as light, motion, sound— as well as variable combinations and their most common aesthetic effects.

Responsibility Whenever we engage in an act of manipulation, we must assume great responsibility. This is especially essential when we manipulate someone's feelings, his emotions, and ultimately his behavior. Most often, the recipient of our aesthetically clarified and intensified messages is not even aware of being, at least partially, manipulated.

1·8 You know that the two center circles are of the same size and that the two horizontal lines are of equal length. But, if you are honest with yourself, the center circle (a) seems larger than (b), and line (c) seems longer than (d).

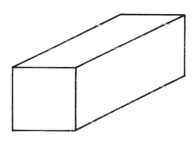

1·9 This box seems to spread at the right end, though if you measure the box, the front and back ends have equal dimensions.

1·10 Most likely, you will not see houses that get progressively smaller but rather houses that stand at different distances from you.

There is relatively little difference between the anesthetized patient on the operating table and the aesthetically unaware television or film viewer. Both persons can do very little about what is happening to them. All they can do is to *trust* us, to trust our skills, our good judgment, and, above all, our good intentions. Obviously, the surgeon who cuts into human beings with his scalpel, and we, who cut into human beings with highly charged, keenly calculated aesthetic energy, have an equally grave responsibility toward them. That is why con-

textualism stresses the close relationship between aesthetics and ethics, between technical skill and moral purpose.

For a mass-communicator, who daily influences millions of unsuspecting people, acceptance of such responsibility is a major job prerequisite. Skill alone is not enough. First and foremost, he must bring to his job a genuine concern for his fellow human beings. He must want to make his fellowmen more aware of themselves and their surroundings. He must love them.

1·11 *A widely prevailing misconception is that television and film are mere distribution devices for ready-made messages.*

1·12 *Rather, you should consider the medium an essential and integral part of the total communication process. The medium not only distributes the message but helps to shape it.*

But as consumers of mass communication, we cannot escape similar responsibilities. If we want to guard against irresponsible persuasion and to take an active part in making mass communication more beneficial to our fellowmen, we—even as consumers of mass communication—must learn as much as we can about the methods and techniques of mass communication.

For example, by understanding the basic principles of media aesthetics, by knowing how pictures and sound can be distorted and manipulated, we are less susceptible to blind persuasion. We will be able to look at the real value of a message, and, if necessary, remain largely objective in our decision making. In effect, we will be able to preserve freedom of choice.

Once media aesthetics become the common province of both communication originator and recipient, the prudent use of the media will become less of a problem for either party. Both will find it easier to be honest and to treat the other with the respect and dignity worthy of concerned human beings.

Media Media do not usually enter into the discussion of conventional contextualism. They are usually taken for granted, representing merely the "medium" through which clarified and intensified experience is transmitted. In mass communication, however, the media themselves take up an important place, not only in the distribution of the message but also in the shaping of the message. The media, such as television and film, are not neutral machines that represent merely a cheap, efficient, and accessible distribution device for ready-made messages. On the contrary, the media have a great influence on the *shaping* of the message, the way the original event is clarified and intensified. Television and film speak their very own aesthetic language; they have their very own aesthetic requirements and potentials. They are an integral part of the total communication process, not just the channel by which the communication is sent.

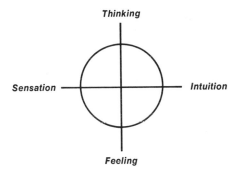

1·13 *Jungian circle.*

Media Aesthetics: Method

The theory is clear. You will become sensitive to your environment. You will be able to observe life and to recognize the intellectual, emotional, physical and spiritual, and aesthetic needs of your fellowmen. You want to help them to fulfill their needs, to become totally sensitive, responsible, self-fulfilled, loving people. You have media available (such as television and film) that can make this task possible. You want to help people to become more essentially human. You want your neighbors, millions of them, to become intellectually, and especially emotionally, more literate than they presently are. You want to carry out this task with optimum effectiveness.

One approach to this difficult assignment is to learn as much as you can about media aesthetics; you must educate your own perceptions in the context of media such as television and film. You must become emotionally literate. Only then can you hope to perceive the complexities, peculiarities, and subtleties of life. Only then can you expect to clarify and intensify them into an aesthetic experience. You must become sensitive to your sur-

roundings first, before you can expect to make other people sensitive to theirs.

Moholy-Nagy (1895–1946), one of the leading figures of the Bauhaus, pleaded for a systematic education of our senses almost half a century ago:

[We ought to] add to our intellectual literacy an emotional literacy, an education of the senses, the ability to articulate feeling through the means of expression. Without the balanced performance of intellect and feeling, man becomes crippled, one-sided.[7]

Moholy-Nagy advocated the interrelatedness of all human activities, art, science, and technology, very much in line with the psychologist Carl Gustav Jung (1875–1961), who saw as the ideal state of man a harmonious interaction of thinking, feeling (happy-sad, good-bad), sensation (hot-cold), and intuition.

A thorough understanding of media aesthetics should help you to come as close to the center of the Jungian circle as possible and to help others do likewise. To do this, you must educate your perception. You must develop a facility to *know what you feel.*[8]

Being able to talk about aesthetic concepts and variables is extremely important in a committee art, such as television and film, in which you must discuss your aesthetic objectives with the members of a production team.

The specific method used here to help you learn about media aesthetics is similar to that employed by the Bauhaus. Rather than examining medium content, that is, engaging in an analysis of television programs or films, we will isolate and discuss the fundamental aesthetic elements of television and film: light, space, time-motion, and sound. Once you know the aesthetic characteristics and potentials of these fundamental image elements, you can combine these elements according to the medium requirements and potentials

The Bauhaus (literally translated "building house" or, more appropriately, "house for building") was founded by the well-known architect and artist Walter Gropius in Weimar, Germany, in 1919. Members of the Bauhaus included such eminent artists as Wassily Kandinsky, Paul Klee, Johannes Itten, Oskar Schlemmer, and László Moholy-Nagy. The Bauhaus developed a unique style for everyday objects, such as furniture, dishes, and tools, by following to its limits the basic credo: "Form follows function." Its approach to educational theories was a thorough examination of such basic elements as light, space, movement, texture, and the like. As you will discover, we use a similar approach to media aesthetics. The Bauhaus was forced to close in 1933 as part of Hitler's drive to rid German culture of all "degenerate art." Later, Moholy-Nagy transferred the Bauhaus to Chicago, where it became the School of Design and, later, the Institute of Design. But it never reached the prominence of its forerunner, the Bauhaus.

1·14 *Deductive approach.* **1·15** *Inductive approach.*

a

a

b

b

c

c

d

d

Wassily Kandinsky (1866–1944), Russian painter and theorist who later joined the faculty of the Bauhaus, advocated an approach to abstract painting that has given direction to our method of media aesthetics. Rather than approaching an abstract painting deductively, Kandinsky worked inductively. For example, instead of reducing a still life from its photographic realism down to its essential formal elements, such as roundness, redness, and the like, he built up a structure with the basic elements of his medium, painting: points, lines, planes, colors.[9]

The final outcomes may look quite similar. But in the deductive approach, the event is reduced to its essential elements (Fig. 1·14). In the inductive approach, the event is built with the aesthetic elements unique to the medium used (Fig. 1·15). The new combinations of the image elements provide the recipient with a totally new insight into the original event, the still life, which acted as the basic communication stimulus and experience.

of television and film into patterns that clarify and intensify, and effectively communicate, significant experience.

Ideally, you should be able to develop a language unique to the medium of your choice—a language that will enable you to speak with optimum clarity and impact, and with a personal style.

Summary

In this chapter, we covered the general background of aesthetics, the general framework of contextualism, and method in media aesthetics.

The general purpose of this book is to help ourselves to give to significant vision significant form in television and film, to recognize the aesthetic requirements and potentials of the two media, and to use them for effective communication that goes beyond the mere distribution of information. Specifically, we use media aesthetics as a study of certain sense perceptions and how these perceptions can be most effectively clarified,

intensified, and interpreted with media, such as television and film, for a specific recipient. The operational field within which we conduct our examination of media aesthetics is a modified *contextualism.*

Contextualism is the name for an aesthetic attitude that is characterized by the following factors: (1) All art happens within the context of life; there is an essential relationship between art and life. (2) Art is basically clarified and intensified experience, whatever the realm in which the experience may lie. (3) Aesthetic experience is highly complex. Even within the clarified and intensified experience there operate a multitude of interconnected perceptual factors, but there are enough perceptual constancies so that principles and critical standards can be developed. (4) Dealing with people on all levels must be done with a sense of responsibility. The responsibility is greater, however, if we deliberately influence people's perceptual and emotional qualities. (5) The medium with which the clarification and intensification of experience is attempted must be considered an integral part of the aesthetic process; therefore, the characteristics and potentials of media must be studied and understood.

Just as Wassily Kandinsky established a new aesthetic of painting by working inductively with the basic elements of point, line, plane, texture, color, and the like, we will establish media aesthetics by examining the basic aesthetic media factors of light, space, time-motion, and sound. It is hoped that the examination of the various factors will lead you to build a medium vocabulary; that the various combinations of these factors will suggest a medium language; and that we can then use that language to add to the education for intellectual literacy the very much needed education for emotional literacy—thus helping man to become more human.

Notes

[1] The concepts of significant vision, significant form, and significant function were developed by Dr. Stuart Hyde, Chairman, Department of Broadcast Communication Arts, California State University, San Francisco, and provide the basis for his course History and Analysis of the Public Arts.

[2] The term "contextualism" was coined by Stephen C. Pepper, one-time chairman of the art department, University of California at Berkeley. See his *Aesthetic Quality: A Contextualistic Theory of Beauty* (New York: Charles Scribner's Sons, 1938), and *The Basis of Criticism in the Arts* (Cambridge, Mass.: Harvard University Press, 1945). See also Lewis Edwin Hahn, *A Contextualistic Theory of Perception,* University of California Publications in Philosophy, vol. 22 (Berkeley: University of California Press, 1942).

[3] Irwin Edman, *Arts and the Man* (New York: W.W. Norton & Company, Inc., 1956), p. 12.

[4] *Ibid.*

[5] Rudolf Arnheim, *Toward a Psychology of Art* (Berkeley: University of California Press, 1966).

[6] Compare: Edward Steichen, *The Family of Man* (New York: The Museum of Modern Art, 1955).

[7] László Moholy-Nagy, *Vision in Motion* (Chicago: Paul Theobald & Company, 1947), p. 5.

[8] Ernest Lindgren, *The Art of the Film,* 2nd ed. (New York: The Macmillan Company, 1963), p. 263.

[9] Wassily Kandinsky, *Point and Line to Plane,* trans. Howard Dearstyne and Hilla Rebay (New York: Solomon R. Guggenheim Foundation, 1947).

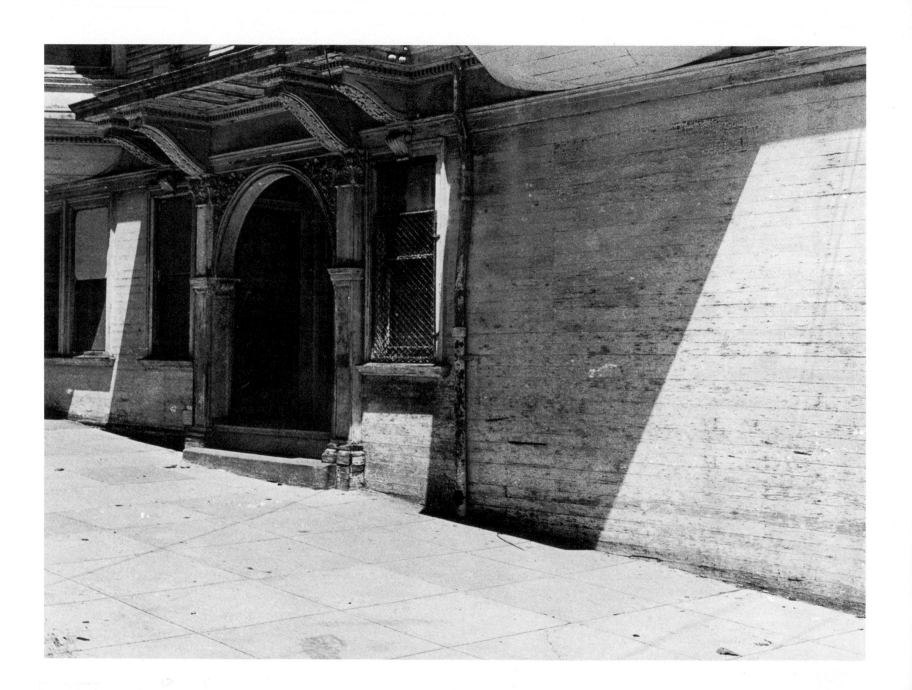

2 15

The First Aesthetic Field: Light

2·1

Light is essential for life. It is necessary for most things to grow. It facilitates visual perception and orients us in space and time. Light is the signal that our eyes receive and our brain translates into perceptions. When we look at our surroundings, we receive a great multitude and variety of light reflections. Each reflection has a certain degree of light intensity and complexity. The intensity variations appear to us as light or dark areas, as light and shadow, and the complexity as color.

Of course, we perceive light reflections as actual things. Most likely, we do not say, "I see the light variations that are reflected off these various surfaces." Rather, we say, "This is an automobile." Often we conceive light to be the property of the objects themselves.[1] We speak of light and dark hair, a red ball, a green frog, a bright sky.

Since we receive with our eyes actually nothing but light variations, we are able to influence someone's visual perception by a deliberate manipu-

The Nature of Light

Light is a form of radiant energy. Light consists of separate bits of energy (energy particles), which behave commonly as electromagnetic waves. Light makes up a part of the total electromagnetic spectrum, which includes such other electric and magnetic energy waves as heat, radio waves, X rays, and alternating current.

The so-called white sunlight consists of a combination of light waves, which are visible as various colors. When white sunlight is bent by a prism, it separates into a spectrum of clearly discernible hues: violet, blue, green, yellow, orange, and red. (See Fig. 4·1, page 58).

Since we can see the colors, that is, the various electromagnetic waves, light is defined by the physicist as *visible radiant energy.*

Actually, light is invisible. We can see it only at its source or when reflected (Fig. 2·1).

If there were no reflecting atmosphere, the sky would appear always dark, and we could see the stars even during the day. On the moon astronauts see, even in sunlight, a black sky. If our surroundings did not reflect light, we would live in total darkness, much as if there were no light at all. The reflecting aspect of light becomes very important as soon as we begin to modulate and articulate light for a specific purpose. The nature of the reflecting surface, the angle of reflection, the degree of light diffusion and absorption, all play an extremely important part in creative lighting.

lation of light. In the photographic media, we do this with lighting.

Before you attempt to manipulate light and to use it creatively, you should familiarize yourself briefly with (1) the nature of light, (2) external and internal light, and (3) lighting purpose and functions.

External and Internal Light

Film and television are pure light shows. In contrast to the theater, for example, where light is used simply to make things visible on stage and to set a mood, the final screen images on film and television consist of light. The *materia* of theater, the stuff that makes theater, is people and objects in the real space of the stage. The *materia* of film and television, however, is light. The control of light, therefore, is paramount to the aesthetics of television and film. Both film and television operate with external and internal light.

External light is the light that is captured by the lens. It may be the light used in the studio or sunlight in outdoor scenes. External light is reflected off objects. External lighting is obtained by the manipulation of external light sources, most commonly lighting instruments (Fig. 2·2).

Internal light is the energy used to make the images visible on the motion picture or television screen. In film, internal light is produced by the projection bulb, the basic energy source for the screen images. In television, internal light is the electron beam (Fig. 2·3).

The internal light in film is manipulated by a variety of filters, the actual film. Since the filters, or film frames, can vary considerably from one to the next, the internal energy source, the projection bulb, should remain as constant as possible.[2]

The internal light in television, the electron beam, is in constant flux. The scanning beam that hits the phosphorous television screen constantly changes its intensity and location, thereby providing for dark and light, as well as various color areas on the screen. Since the beam is not only flexible in terms of intensity and direction but also control-

lable, we can use this internal light as an additional lighting device. (Internal lighting will be discussed more thoroughly in Chapter 3.)

Lighting Purpose and Functions

The basic purpose of lighting is the manipulation and articulation of the perception of our environment. Lighting helps us, or makes us, see and feel in a specific way. Lighting helps to clarify and intensify our environment; it provides a context for our experiences.

A more specific purpose of lighting is to *articulate our outer, space-time environment,* as well as our *inner, emotional environment.* This specific lighting purpose suggests the various functions of lighting.

There are two basic lighting orientations: *outer*—an orientation in our space-time environment, and *inner*—an orientation in our emotional environment.

Outer Orientation Functions These functions are (1) space, (2) tactile, and (3) time orientations.

Space Orientation Lighting orients us in space. It can show us *what* an object *looks like,* whether it is round or flat, whether it has rough surfaces or hard edges. It can show us *where* the object is in relation to other things. Effective lighting should give us as much information about the form and dimensions of an object and its relation to its environment as possible. In order to achieve this spatial orientation function, we must carefully control the interplay between light and shadow. Thereby the *control of the shadow* often turns out to be more important than the control of the light areas.

2·2

2·3

Scoop Scoop

Camera

Shadows Define Space

2·4 *When lighted flat with a highly diffused light source, such as a scoop, for example, the absence of shadows reveals nothing more than the basic contour of the objects. Both appear as round disks.*

Spotlight

Camera

2·5 *But as soon as we use a more directional light source, such as an ellipsoidal or Fresnel spotlight, and place it somewhat to the side of the object in order to produce shadows, we have no trouble identifying additional spatial characteristics of each object. The object on the left has a bright area that gradually turns into a dark shadow area; it appears as a sphere. The object on the right, however, remains evenly lighted. It has no shadows. It is a disk.*

Ordinarily, we are not aware of shadows; we take them for granted. We accept readily the harsh and distinct shadows on a sunny day, the soft shadows on an overcast day, the virtual absence of shadows under fluorescent lights. Only occasionally do we become more conscious of shadows. We seek the shade when the sun gets too hot for us during the outdoor picnic, or we shift the reading lamp so that the shadow of our head or hand does not fall directly on the page. Or, we might

chuckle when our shadow shows us an especially distorted image of ourselves.

As soon as we engage in the clarification and intensification of our experiences, however, we not only must become aware of shadows but also must learn to control them very carefully.

It is not the light that reveals the shape of the object, but the shadow. *Lighting for shadows,* then, is the important space-orientation factor. Take a look at Figure 2·6. You will notice a shadow

a

b

c

d

e

2·6 *Without any shadows, we can make out the basic contour of the object, but the true spatial nature of the object and its relation to its environment remain ambiguous (a). The gradual change from light to dark, that is, the shadow on the left, emphasizes the round, three-dimensional nature of the cone (b). The additional shadow on the top of the cone reveals a new spatial condition of the cone: it is hollow (c). The shadow that falls on another surface tells us now where the cone is in relation to the horizontal surface (such as a table); the cone floats above it (d). Now the shadow shows us clearly that the cone rests on the horizontal surface. The initial spatial ambiguity has been drastically reduced by shadows (e).*

that is attached to the cone and another type of shadow that is thrown onto the surface. Obviously, the former type of shadow is called the *attached shadow,* the latter the *cast shadow.*[3]

Sometimes the placement of the attached shadow can influence our perception of whether a surface is protruding or receding (Fig. 2·8). If, therefore, you have trouble correctly identifying

Attached and Cast Shadows

2·7 *The attached shadow is on the object itself; it is always attached to the object. The attached shadow helps to reveal the basic form and dimensions of an object. It simply helps to show what the object looks like.*

2·8 *In this ornament, the attached shadow is at the top of the circles. Since we quite naturally expect that the light is coming from above, we see this ornament first to indent, then to protrude, then to indent and protrude again. By turning the picture upside down, however, we may experience exactly the opposite: a protrusion first, then an indentation, another protrusion, and another indentation.*

indentations and protrusions, light fairly steeply from above, so that the attached shadows are where we ordinarily expect them to be. This type of space articulation through attached shadows is especially important for the scene painter who must frequently paint in, rather than light for, attached and cast shadows.

2·10 The cast shadow is not necessarily attached to the object; it is usually thrown on another object or upon another part of the same object. Cast shadows primarily help us to see where the object is relative to its surroundings.

2·9 Depending on the angle of the light source, the cast shadow may reveal the basic shape of the object that caused it, however much distorted.

2·11 The cast shadow can be, and frequently is, observed as being independent of the object that caused it. Notice that the cast shadow of the person seems still object-dependent. But the shadows around him are independent of the object; we are not necessarily aware of what caused them.

The differentiation between attached and cast shadows was first made by Leonardo da Vinci (1452–1519), an Italian who is considered the most gifted genius of the Renaissance, equally versed as a painter, architect, designer, and inventor.

2·12 *Cast shadows also reveal whether the object rests on another surface or whether it is away from it. Notice how the cast shadow gradually changes its contour and becomes independent of the object. Notice also how the edges of the cast shadow become blurred and the density of the shadow becomes lighter.*

Although generally we are not aware of it, we make continual spatial judgments by "taking in" the general shape of the cast shadow, its density, and its direction. An intense study of cast shadows can be extremely revealing as to the position, size, and shape of an object, even if the object itself remains largely invisible. Air surveillance, for example, relies heavily on the precise interpretation of cast shadows.

2·13 *In some cases, cast shadows are created to break up large, monotone surfaces and to make an area visually more interesting.*

2·14 *Sometimes, they are used to identify a certain locale.*

2·15 *Cast shadows are also used to create or emphasize a dramatic mood.*

Another important spatial orientation factor is *how the light area on an object turns into the attached shadow area.*

This light-dark characteristic of the attached shadow is sometimes called "shadow gradient," or shading.[4] However, this terminology is somewhat confusing, especially since in television shading refers to the electronic picture control.[5]

We will, therefore, call this change from light on an object to its darker attached shadow area *fall-off.*

Fall-off means the degree to which light changes into the attached shadow area or, when conceiving the light-dark change in terms of time, how *fast* the light drops off into the attached shadow. Fall-off can be *slow* (curved surface) or *fast* (sharp corner).

Fall-off

2·17 *A hard (highly directional) light produces fast fall off. The round surface structure is emphasized. A soft (highly diffused, nondirectional) light produces slow fall-off. The surface structure of the sphere, its volume, however, is now less prominent.*

2·16 *Without the attached shadow, we cannot determine whether the object has a round surface or a sharp corner. When the light on the object surface falls off gradually into its attached shadow, the surface appears to be curved. When the change from light to dark is very abrupt, that is, when the light on the surface falls off into the attached shadow sharply, we perceive a definite corner.*

The speed of the fall-off determines ultimately how the surface structure of an object is perceived. Obviously, the fall-off speed is therefore a very important spatial orientation factor.

The perception of an object's surface structure depends to a great extent on *control of the fall-off speed.* Also, "hard" or "soft" lighting is actually determined by the specific fall-off. We perceive light as hard or soft not so much by the lighted side (which may be equally bright whether lit with a "hard" ellipsoidal spotlight or a "soft" scoop), but rather by the speed of the fall-off.

Fill light is used to "fill" in the dense shadows with a little more light. The speed of the fall-off is reduced.

Lighting not only helps to *reveal* space, it can also *create* space.

Tactile Orientation Lighting for tactile orientation is very closely related to lighting for spatial orientation. Actually, texture is a spatial phenomenon, since a texture, when sufficiently enlarged, resembles the peaks and valleys, the ridges and crevasses of a rugged mountain range. The only difference is that lighting for space is done primarily to orient us better visually, while lighting for texture is supposed to appeal to the sense of touch. As in lighting for spatial orientation, control of the fall-off speed is of the utmost importance.

In order to demonstrate the importance of fall-off control in texture, let us assume that the wrinkles and folds in a cyclorama represent an enlarged surface texture (Fig. 2·20).

2·18 *The fall-off on this curved surface is so fast that you may even perceive a ridge on this curved surface, although the actual surface structure is a smooth, gradual curvature.*

You should, therefore, use only as much fill light as is necessary to overcome this negative "ridge" sensation. Do not use so much fill that the curvature begins to lose its roundness and to appear flat.

If the attached shadow blends with the dark background, you may have to accentuate the dark side of the object with rim or edge light. You can accomplish this edge-light effect very simply by using a kicker light coming from side and back of the object.[6]

2·20 *A hard, highly directional spotlight hits the cyc from the side. The fall-off is extremely fast and the cyc texture (the folds and wrinkles) greatly emphasized (a).*

The very same portion of the wrinkled cyc is now lighted with a soft floodlight from the front (b). The fall-off is slowed down so drastically that there is practically no difference between light areas and attached shadow areas. The cyc lacks texture and appears, therefore, taut.

a

b

As adults, we sometimes forget that our tactile sense is a very important (if not the most direct) means for perceiving our environment, for experiencing the nature of the objects around us. As infants, we tend to learn as much, if not more, about our environment by touching as by looking, smelling, or listening. Only gradually, and after many warnings by our parents not to touch this or that, we do finally manage to drive the tactile sense underground. But the many do-not-touch signs in stores and especially in museums suggest that apparently we still would like to touch objects in order to get to know them better and to enrich our experience.

Johannes Itten, who taught the famous Basic Course at the Bauhaus from 1919 to 1923, put great emphasis on the study of textures. One of the texture exercises in the Basic Course involved making long boards on which a variety of differently textured materials were glued. The students would then run their fingers over these textures with their eyes closed. Itten found that through such systematic exercises the students' sense of touch improved to an amazing degree. In turn, the student learned to appreciate texture as an important design element as well as an orientation factor to the materials used. Itten stated that through such texture exercises, the students developed a real "design fever."[7] An awareness of texture is especially important in television, which, with its low-definition picture mosaic, appeals more strongly to our tactile sense than film, for example. Lighting for texture is, therefore, a very important factor in media aesthetics.

2·19 *Look at this series of illustrations. The camera and the object remain in the same position; only the light source is changed. Try to analyze your perception of the spatial changes by applying the criteria of attached and cast shadows, as well as of fall-off.*

2·21 *To emphasize texture, you should light for prominent cast shadows. A hard spotlight, hitting the texture-producing elements from a low angle, will produce conspicuous cast shadows.*

If the angle of the spotlight is too steep, the cast shadows will lie directly beneath the texture-producing protrusions. The texture remains two-dimensional.

When lighted with a highly diffused floodlight, the absence of prominent cast shadows will again de-emphasize texture.

Besides the attached shadows, cast shadows also help to emphasize texture (Fig. 2·21).

Although the control of shadows is an extremely important factor in the aesthetics of lighting, we must not neglect the *control of light* in orienting the viewer in space.

The most important aspect of controlling light for spatial orientation is *selective lighting.* Selective lighting means simply that we emphasize some picture areas through light, while de-emphasizing others by keeping them relatively dark (Fig. 2·23). Thus we can draw the viewer's attention to certain important picture areas.

We will discuss the control of light more extensively in Chapter 3.

2·22 *Highly directional hard spotlights, hitting the face from a steep angle, create fast fall-off. The facial texture, the wrinkles, ridges and hollows are accentuated. If you want to intensify the rugged or tough nature of your character, such a texture emphasis is appropriate.*

On the other hand, if you want to show the softness and gentleness of a woman, you probably want to reduce, rather than emphasize, facial texture. You must slow down the fall-off with enough fill light so that the face looks fairly smooth. Be careful, however, not to light the face too flat (too much fill); otherwise the face may lose its spatial dimensionality and look flat.

2·23

When you light a face, you light essentially for spatial and tactile orientation. All previously discussed lighting principles apply directly.

Time Orientation Control of light and shadows also helps the viewer to become oriented in time. In its most elementary application, lighting can show whether it is day or night. More specific lighting can indicate the approximate hour of the day, at least whether it is high noon or later afternoon, for example, and the seasons, whether it is winter or summer.

Of course, you must realize that light and shadows alone rarely provide sufficient clues to indicate precisely a specific time of day or a specific season. Nevertheless, if other visual and aural clues specify a certain clock time or season, lighting must at least be consistent with the other time indicators.

Clock Time: Obviously, daytime lighting is brighter, nighttime lighting less bright. In daytime lighting, a turned-on lamp looks wasted; in nighttime lighting, however, it becomes all-important.

Note that in the indoor scenes, background lights are used for the sole purpose of producing one or several prominent cast shadows on the wall or furniture. Other, more accidental, cast shadows (such as the ones on the floor) are usually out of the camera's view and therefore ineffective as time indicators.

Make sure that these prominent cast background shadows are consistent with the attached shadows. If the window of the room is the prominent light source coming from the left, attached *and* cast shadows should be on the opposite side. Since the lighting set-up usually requires the use of several instruments, most of which come from somewhat different directions and angles, you might end up with a variety of multiple cast shadows falling in several directions. This is not too much of a problem, however. As long as the most prominent background shadow is consistent with the cast shadow, or is opposite the major light source, the viewer will most likely ignore the other, less important, cast shadows.

If you intend to light a scene that occurs outdoors in bright sunlight or indoors with a single light source (such as the inevitable bare light bulb in a cheap motel room), you must try to produce only one single prominent cast shadow. For example, a hand reaching for the light switch to turn off the single light bulb in the motel room should not all of a sudden cast multiple shadows on the wall. It would look equally awkward and confusing if the weary explorer who stumbles through the hot

2·24 *To show that it is daylight, the sky (background) is usually bright, the cast shadows are very pronounced. In sunlight, the fall-off is fast.*

In this nighttime scene, the background is dark, and the lighting is highly selective. The shadows are prominent, and the light comes from obvious sources, such as a street lamp or a lighted window.

2·25 *In this daylight interior scene, the window area (upper right) is light, indicating daylight outside, and the general interior lighting is rather flat, filtered by the window, with slow fall-off.*

In this nighttime interior, the window area is dark, the table lamp is turned on, the general interior is lighted for fast fall-off shadows. There are distinct cast shadows. Make certain that the burning lamp is not casting its own shadows, especially when it is reinforced by a light from above.

2·26 *As long as man has lived, he has associated the dark and the shadows with mystery, fear, evil, or death. This association is a simple result of the lack of outer orientation in darkness. The evil spirits lurk in the darkness, waiting for the disoriented victim. Light, on the other hand, has been the symbol of life, spiritual strength, salvation, and courage.*

desert at high noon should be accompanied by a variety of cast shadows falling in all directions. After all, there is only one sun in our solar system.

Seasons: Generally, the winter sun is weaker and colder than the summer sun. Also, the winter sun strikes the earth's surface from a fairly low angle, even at high noon. Cast shadows are longer and not quite so dense in winter as those in summer. The lighting instruments should therefore burn with a high color temperature and a somewhat diffused beam.[8] Since snow reflects a great amount of highly diffused light, the fall-off is generally much slower than in a similar outdoor scene without snow.

Inner Orientation Functions So far, we have concerned ourselves with *outer* orientation through lighting. We have used light to articulate our outer environment. We can now establish, clarify, and intensify what an object looks like, what texture it has, and where it is located in space and time. Through lighting, we can articulate screen space. But with light we can also articulate our *inner* environment of our feelings and emotions—a lighting function we call *inner orientation.*

Specific inner orientation functions of lighting are (1) establishing mood and atmosphere, (2) predictive lighting, and (3) use of light and lighting instruments as dramatic agents.

Establishing Mood and Atmosphere Light, like music, can evoke a great variety of specific feelings within us. Lighting alone may not be able to make us cry or laugh, as music frequently does, but it can certainly indicate to us whether the scene reflects a bright and gay or a mysterious and ominous mood.

2·27 *Look at this low-key scene. The attached shadows have a fast fall-off. The cast shadows are very prominent. The background is kept dark. The base light level (overall illumination) is relatively low." The lighting is selective. The main characteristic of low-key lighting is a dark background and relatively little fill. However, there are instances in which the overall light level is low, in which there are fast fall-off attached shadows and stark cast shadows, but a light background. The lighting in such a scene is still considered low-key.*

2·28 *In this high-key lighted scene, there is an ample amount of diffused light on the set. The fall-off is slow. The background is light. The lighting is not as selective as in the low-key scene.*

2·29 *When the principal light source, the key light, comes from above (eye level), the shadows are expectedly below the protrusions and above the indentations. We experience "normalcy."*

As soon as the light source strikes the face from below, however, the shadows are exactly opposite their expected positions. Immediately, we are disoriented. We affix to this outer disorientation an inner disorientation. The face appears unusual, ghostly, brutal. The seemingly minor position change of the principal light source (the key light) has changed decisively our perception of the person's character.

Low-Key and High-Key Lighting: This kind of lighting has nothing to do with either the intensity or the position of the key light. Rather, the terms "low-key" and "high-key" in lighting are used similarly to the terms "low-keyed" or "high-keyed" as applied to a person. "Low-key" means "down"; "high-key" means "up."

As in every facet of lighting aesthetics, you should realize that there are many variations within the low-key and high-key lighting categories. Some low-key scenes, for example, may be far from mysterious. A tender kiss on a moonlit porch calls for low-key lighting. In this context, the low-key lighting expresses the bright happiness of the lovers, rather than dark, foreboding tragedy.

Generally, however, the overall atmosphere of a scene dictates the lighting for a specific mood. A newscast, which calls for objectivity and authority, requires high-key, objective, and stable lighting. A death watch is usually rendered low-key, unless you want to emphasize the irrationality of death by employing high-key lighting.

Above-Key and Below-Key Light Position: Do not confuse the above-key and below-key light *position* with high-key and low-key lighting. Keep in mind that high-key lighting means a generally bright scene, and low-key lighting generally means a high-contrast, dark scene.

2·30 *The light change in this picture series increases the tension of the event and suggests that the outcome of the scene might not be entirely pleasant for the girl.*

Above-key and below-key light position, sometimes called "reverse modeling," refers to "above" or "below" eye level. Generally, we expect the principal light source (the key light) to come from above. Remember how we perceived an object as concave or convex simply by whether the attached shadows were above the object (below-key light position) or below the object (normal, above-key light position). Watch what happens when we change the illumination of a face from the normal, above-key light position gradually to a below-key light position (Fig. 2·29).

Predictive Lighting Predictive lighting means that the lighting helps to predict, however subtly, a future happening.

Light changes from high-key to low-key, from general to highly specific, from happy to mysterious, from slow to fast fall-off can indicate how the event will go—in Figure 2·30, from stable (normal) to unstable (dangerous situation). By re-

versing this procedure you can predict a happy ending (the famous ray of light) even while the situation still seems rather desperate.

As with any application of media aesthetics, predictive lighting rarely operates alone, but rather in conjunction with appropriate sounds, suspense music, and the like.

Moving light sources are also used in predictive lighting. There is the familiar scene in which the old night watchman discovers that something is not quite right in Building 47, which houses secret documents. We see him getting up, looking left and right, turning on his flashlight. We see the flashlight beam creeping nervously along the long, dark hallway until it finally uncovers—you guessed it—the broken lock, the open file cabinets, the papers strewn all over the floor. Moving car headlights are often used similarly as predictive light sources. They may lead us inevitably to an unexpected event. If used with restraint, the moving light source is a highly effective application of predictive lighting.

2·31 *The sun above the soaring roof of the church—even the light reflections in the lens—add considerably to the spiritual feeling of this scene.*

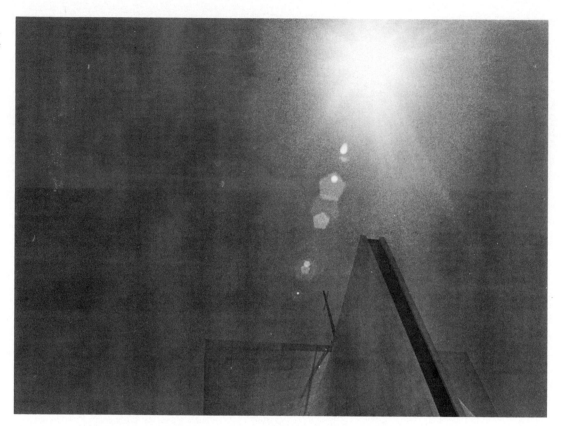

Federico Fellini (b. 1920 in Rimini), an Italian motion picture director, usually works from an overall concept, but develops his story as the film progresses. He mixes symbolic dream images with social realism. For example, he uses lighting instruments as dramatic agents with great virtuosity.

In La Dolce Vita, *he shows a television remote unit covering the events of an alleged miracle. Young children pretend to have seen Holy Mary descend from heaven and heard her speak to them. There is a great amount of confusion. Fellini cuts in close-ups of lighting instruments being turned on, shining their controlled cold light beams over the highly emotional, ecstatic crowd. In order to counterpoint even more the discrepancy between the highly emotionally charged crowd, which represents the uncritical world of blind faith, and the analytical cold and soulless modern age as symbolized by the lighting instruments and cameras, he shows a tight close-up of a huge Fresnel lens bursting in the first seconds of a chilling downpour.*

In 8½, *Fellini uses many lighting instruments, which are arranged in large circles, illuminating the representatives of humanity who, following the director's orders, march willingly, like circus clowns within the periphery of a ring sharply defined by many lights. The lighting instruments and the light, which occasionally shines directly into the camera, are a strong reminder that when properly "enlightened," we may discover that we are all part of a big cosmic joke that some superior power occasionally plays on us.*

Light and Lighting Instruments as Dramatic Agents You can use the light source itself as a highly effective dramatic agent. Showing the light source—the sun or turned-on lighting instruments—can heighten the emotional impact of a scene.

The dim overhead lights in the underground garage, the on-off blinking motel sign, the flashlight shining into the viewer's eyes (camera), as well as the large Fresnel spotlights used as set pieces by many a motion picture director (notably Fellini), are all examples of lighting instruments operating as dramatic agents.

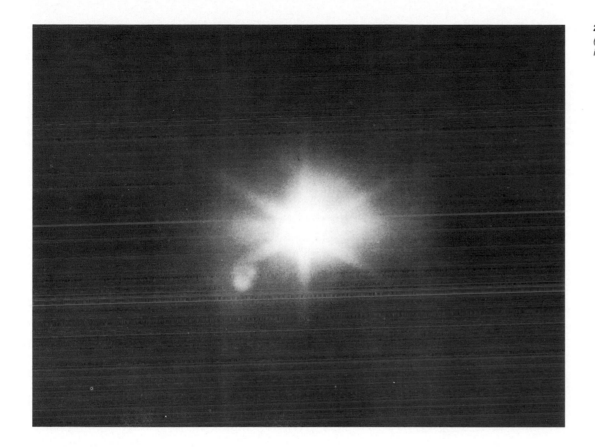

2·32 *A spotlight shining directly into the lens (into the viewer's eyes) can have a brutal, menacing effect.*

Summary

Light is essential for life. It makes things grow and facilitates visual perception. It orients us in space and time. Three areas are important for using light creatively in television and film: (1) the nature of light, (2) external and internal light, and (3) lighting purpose and functions.

Light is a form of radiant energy, which behaves commonly as electromagnetic waves. The so-called white sunlight is a combination of light waves, which, when isolated, are visible as various spectral colors (rainbow colors, ranging from red to violet). Actually, light is invisible. We can see it only at its source and when it is reflected by some object.

Television and film consist of light images. Light is the *materia* for these two media. Both media operate with external and internal light. *External light* is the light that is captured by the lens.

External light is reflected off objects. *Internal light* is the energy used to make television and film images visible. In television, internal light is the electron beam that activates the surface of the television screen.

The *purpose* of lighting is the manipulation and articulation of the perception of our environment. Lighting helps us, or makes us, see and feel in specific ways.

There are two basic *lighting functions: outer*—orientation in our space-time environment; and *inner*—orientation in our emotional environment.

The outer orientation includes (1) space orientation, (2) tactile orientation, and (3) time orientation.

Light orients us in *space* by showing us *what* a thing looks like and *where* it is relative to other things. In this function, the shadows, and the control of shadows, play an important role. Shadows help to define space. The *attached shadow,* which is on the object itself, helps to reveal the *basic form* and dimensions of an object. The *cast shadow,* the shadow that is produced by the object and thrown on part of the object or onto another object, helps to show *where* the object is relative to its surroundings. Cast shadows are often used to break up large monotone surfaces.

The change from light on an object to the darkest part of the attached shadow is called *fall-off.* Fall-off means the degree to which light changes into the attached shadow. When the change is very sharp (for example, at a corner of an object), we speak of a *fast* fall-off; when the change is more gradual (for example, on a curved surface), we speak of a *slow* fall-off. *Fill light* is used to slow down the fall-off.

Lighting for *tactile orientation* is closely related to lighting for spatial orientation. The lighting for texture means emphasizing the spatial unevenness of the object's surface. The faster the fall-off, the more pronounced the texture will become. Slow fall-off counteracts this emphasis on texture.

The control of light and shadows also helps to *orient us in time.* In daytime, the background is usually bright; the overall level of illumination is rather high. In nighttime lighting, the background is usually dark, and the lighted area is highly selective. In interior lighting, daytime scenes have a light window, and generally a bright interior (general lighting); nighttime interiors have dark windows and selectively lighted interiors.

The inner orientation functions include (1) establishing mood and atmosphere, (2) predictive lighting, and (3) use of light and lighting instruments as dramatic agents.

Low-key lighting (fast fall-off, overall light level low, selective lighting, background usually dark) produces a mysterious, "down" mood. *High-key lighting* (slow fall-off, overall light level high; background usually light) produces a happier, "up" mood. *Above-key light position* means that the principal light source strikes the object from above eye level. It creates a normal mood; we expect the light to come from above. *Below-key light position* means that the principal light source strikes the object from below eye level. It carries an unusual, mysterious mood.

Predictive lighting means that the light changes from one mood to another, signaling an impending happening.

Light and lighting instruments can also be used as *dramatic agents.* The light shining into the lens can evoke a feeling of harassment. The lighting instruments shining on a scene seem to illuminate and intensify the scene, not only physically but also psychologically.

Notes

[1] Rudolf Arnheim, *Art and Visual Perception* (Berkeley: University of California Press, 1965), p. 293.

[2] You may want to experiment with manipulating the intensity of the projector bulb, or bulbs, in conjunction with the film itself.

[3] Arnheim, *Art and Visual Perception,* pp. 305–310.

[4] *Ibid.,* pp. 300–303.

[5] Herbert Zettl, *Television Production Handbook,* 2nd ed. (Belmont, Calif.: Wadsworth Publishing Company, Inc., 1968), p. 401.

[6] See Chapter 4; also Zettl, p. 163.

[7] Johannes Itten, *Design and Form: The Basic Course at the Bauhaus,* trans. John Maas (New York: Van Nostrand Reinhold Company, 1963).

[8] Zettl, pp. 154–155.

[9] *Ibid.,* pp. 147–150.

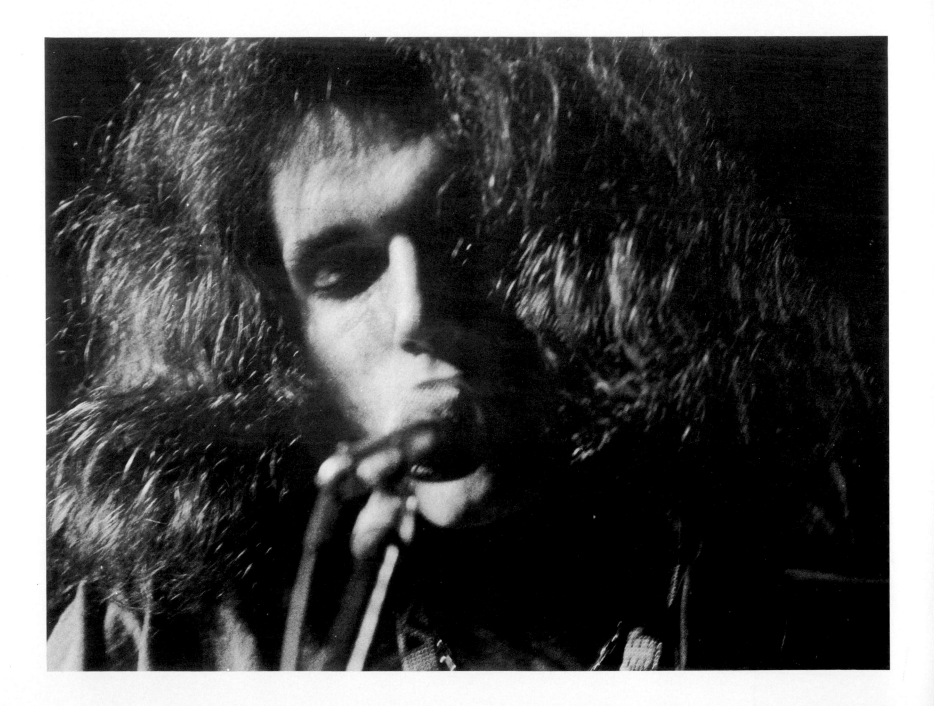

3

Structuring the First Aesthetic Field: Lighting

Structuring the lighting field means to identify certain lighting types and techniques that will help to fulfill any one of the lighting functions discussed in the previous chapter.

Since the *materia* (the material—the stuff) of television and film is light, as pointed out previously, the control of light is of the utmost importance. Basically, you can influence the television and film images by (1) external and (2) internal lighting.

External lighting is the control of light that illuminates an object or scene and is captured by the lens.

Internal lighting, used in television only, is the control and manipulation of the intensity and direction of the electron beam in order to produce "lighting" effects on the television screen.

External Lighting

Most of the lighting functions require careful control of the interplay of light and shadow. As you recall, the shadows give important clues for outer and inner orientation. But there are also times when you must reduce the contrast between light and shadow in order to give the appearance of an even light distribution.

The external lighting that emphasizes dark and light, lighted areas and shadows, is called *chiaroscuro lighting.* The external lighting that de-emphasizes the light-dark contrast is called *flat* or *Notan lighting.*

Chiaroscuro Lighting Chiaroscuro lighting means lighting for light-dark contrast. Chiaroscuro lighting is *lighting for volume and drama.* The basic aim is to articulate space, that is, to clarify and intensify the three-dimensional property of things and the space that surrounds them, to give the scene an expressive quality (Fig. 3·1).

By studying the paintings of the chiaroscuro masters, we can learn a great deal about how to use light and shadows for effective lighting—for helping us to experience an event in a clarified and intensified way.

Functions of Chiaroscuro Lighting Chiaroscuro lighting performs important outer and inner orientation functions.

The *outer orientation* functions are *organic*—to make the scene appear realistic, and *compositional*—to bring the various pictorial elements into balance.

The *inner orientation* functions are *thematic*—to draw attention to the theme or story being told, and *emotional*—to establish or emphasize a mood.

As you can see, the particular lighting of the scene in Figure 3·2 fulfills quite readily all four functions, without one interfering with the other.

If you were now asked to reproduce this scene in the television studio and light it in such a way that it approximates the effect of the La Tour painting, how would you go about it? Would you hand one of the women a lighted candle and let it go at that? Hardly. If you take a closer look at the painting, you will discover that the light is definitely coming from more than one source. Let's light the scene (Fig. 3·3).

It is not uncommon to use several lighting instruments for the effect of a single light source. In studio lighting, you will rarely get a satisfactory effect by simply duplicating the actual light source as depicted in the scene. A single candle will usu-

ally not suffice to create the *lighting effect* of a single candle. The final criterion for effective lighting is not what illumination devices the scene shows (for example, the candle), or what your light-meter reading says, but how the illumination appears on the screen.

Specific Chiaroscuro Lighting Types We can distinguish among three specific chiaroscuro lighting types: (1) Rembrandt lighting, (2) cameo lighting, and (3) silhouette lighting.

Rembrandt lighting means *selective* lighting. You illuminate only highly specific set areas, while leaving other areas in semidarkness or completely dark. The most basic form of Rembrandt lighting is pools of light, which illuminate sharply defined floor areas (Fig. 3·4).

Analysis of Chiaroscuro Lighting

Chiaroscuro is an Italian word, meaning light-dark (chiaro = "light"; oscuro = "dark"). Chiaroscuro lighting borrowed its name and technique from the chiaroscuro painters of the Mannerist (post-Renaissance) and Baroque periods (roughly from 1530 to 1650) who emphasized specific high-contrast "lighting" in their works. Chief among them are the Italian painter Caravaggio (1573–1610), who is commonly considered to be the father of the chiaroscuro school; and the Dutch painter Rembrandt (1606–1669), who brought the chiaroscuro technique to perfection.

3·1 Light Source and Overall Illumination: *The scene seems to be illuminated by an actual light source (usually a single source, such as a candle). The light source is highly specific, illuminating the important aspects of the scene, while leaving others relatively dark. The overall illumination is low-key: the background is generally dark, the overall light level is low.*

Shadow Distribution and Fall-off: *The shadows are prominent and tightly controlled. As a matter of fact, paramount to chiaroscuro lighting is shadow control. Since the light source is very* specific, usually coming from a single direction, the attached and cast shadows are prominent. The fall-off is fast. As you can see, the cast shadows can blend into each other to form large dark areas, which are interrupted by highly specific areas of light. The light area is no longer defined by cast shadows, but the shadow area by light.

Texture: *The highly directional light sources with extremely fast fall-off emphasize texture to a great extent. ["Spanish Wake," courtesy of W. Eugene Smith.]*

3·2 *Organic Function: The scene is lighted in such a way that at first glance all the illumination seems to come from a single source: the candle behind the woman's hand. The lighting performs an organic function: to make the scene appear illuminated by a realistic light source.*

Compositional Function: The light (high-energy) and dark (low-energy) areas should be distributed within the frame in such a way that they balance each other. The light and dark distribution should also contribute to the overall outline, the contour of the pictorial elements. Note how the light profile of the left figure is set off against a dark background, while her darker headdress and coat are contrasted against a slightly lighter background. The light on the right figure emphasizes a stable triangle, which is counterweighted on the left by the light area (face and dress of the person) on the left.

Thematic Function: The lighting clearly emphasizes the theme of the story of the scene: the newborn child. The lighting focuses on the two women and the child. All other aspects of the scene, such as the physical surroundings, remain deliberately in the dark and de-emphasized. Such selective lighting is extremely important in theater lighting. Often, you must direct the audience's attention away from one part of the stage to another by light alone. In television and film, of course, you are greatly aided by the selectivity of the camera. A close-up of a particular object or part of the scene can tell the story quickly and effectively, regardless of whether the lighting is highly selective (as in chiaroscuro) or quite flat. But chiaroscuro lighting can nevertheless help the camera tell the story.

Emotional Function: The chiaroscuro lighting in this painting also helps to set a mood. Although the lighting primarily suggests the miracle and wonder of birth, it also generates warmth, protection, love. The lighting reflects the strong emotions that prevail in this scene—despite the seemingly calm and serene features of the two women. It has drama. [The Newborn Child by Georges de La Tour (ca. 1630). Courtesy of Musées de Rennes.]

3·3 *Lighting Instruments and Major Functions: (1) key light for woman A; (2) key light for woman B; (3) background light to set off woman B; (4) kicker to rim head and shoulder of A; (5) kicker to rim right shoulder and arm of A; (6) back spot to rim hand and illuminate child; (7) soft fill to slow fall-off on A; (8) soft fill to slow fall-off and reveal some detail on back of B.*

3·4

3·5 *This scene reveals the major characteristics of Rembrandt lighting. Above all, there is selectivity; only certain important areas are illuminated. The face of the girl, part of her jewelry, the rim of her arm leading the eye down to the important part of the picture, the book. The rim light (kicker) on her right shoulder and elbow helps the general design and separates her from the dark background.*

3·6 *Now compare the Rembrandt-lighted scene (Fig. 3·5) with this actual Rembrandt painting in terms of major illumination characteristics. [An* Old Woman Reading *by Rembrandt, courtesy of the Duke of Buccleuch; photograph by Tom Scott.]*

Cameo lighting concentrates the viewer's attention on the performers. Generally, there is no set in a cameo-lighted scene. At the most, some set pieces may be spotlighted to define the action radius for the performers and to give some spatial reference points for the camera. Cameo lighting reveals the performer's inner, rather than outer, actions.

Combined with the alive quality and the spatial concentration of the television screen, cameo is an ideal television lighting technique, especially when man's emotions are to be intensified. An additional advantage of cameo lighting is that a set is not needed, since everything but the performer is kept in darkness.

Unfortunately, real cameo lighting is sometimes difficult to control in color television, especially if you must maintain true color values. So far, any extreme dark-light contrast tends to distort color somewhat, especially in the shadow areas.[1]

Silhouette lighting is a hybrid between chiaroscuro and flat lighting. It is chiaroscuro, because of its extreme dark-light contrast. It is flat, because it emphasizes contour rather than volume.

Obviously, you light only those scenes in silhouette that gain by emphasizing the contour of things. A sharp, jagged jazz dance, in which outer movement is of the essence, calls for silhouette lighting. You can use silhouette lighting also for concealing the identity of a person. If you interview someone who has good reason to remain incognito, or show someone cautiously entering a luxurious mansion through the bedroom window, silhouette lighting will help to dramatize both events.

Chiaroscuro Lighting Requirements and Techniques You must realize that each individual scene has its peculiar and unique lighting requirements. What works for one scene may not be appropriate for another. However, most chiaroscuro effects are simple variations of a basic lighting technique.[2]

Cameo Lighting

3·7 Cameo lighting is chiaroscuro lighting pushed to its extreme. The background is always totally dark (contrary to Rembrandt lighting). Only the figures in front are illuminated within restricted performance areas. The lighting is highly directional, producing extremely fast fall-off and prominent, sharply defined cast shadows.

3·8 Cameo lighting is a direct imitation of a cameo stone, where the light figures are sharply set off against a dark background.

Silhouette Lighting

3·9 Notice that silhouette lighting is the exact opposite of cameo. In silhouette lighting, the background is lighted, the figures in front remain unlighted. Silhouette lighting shows only contour but no volume or texture. Silhouette lighting intensifies the outline of things.

Basic Lighting Set-up: The Photographic Principle

3·10 Key Light: principal light source—directional spot.

Key

3·11 Back Light: rims top and separates object from background—directional spot.

Back

Key

3·12 Fill Light: slows shadow fall-off—flood or soft (spread) spot.

Back

Fill

Key

Additional Light Sources

3·13 Side Light: directional spotlight coming from the side (usually opposite key).

Back

Side

3·14 Kicker Light: directional spot from back, off to one side, usually from below.

Back

Kicker (Low)

3·15 Background Light: background illumination (often directional) of background and set.

Background

Back

Kicker

Fill

Key

3·16 Key only. Fast fall-off. Dark side of face and hair blend into dark background. No definite contour. Shape of head remains ambiguous.

With back light, the contour is more clearly defined; we experience more volume.

A back light-kicker light combination with a minimum of front fill suggests moonlight.

Table 3·1

Chiaroscuro Requirements	Techniques
Rembrandt: Highly selective. Fast fall-off.	Maximum directional control. Spotlights with barn doors. Ellipsoidals with shutters. Background lights very important.
Cameo: Foreground figures lighted, background dark. Fast fall-off.	Precisely defined pools of directional light in action areas. Hard spots. Directional fill, if any. Plenty of back light. Minimum of spill. Background unlighted.
Silhouette: Unlighted figures in front of bright background.	Even floodlights on background. No lights in foreground.

Figure 3·16 shows some chiaroscuro effects that are simple variations of the basic photographic lighting principles.

Flat Lighting The opposite of chiaroscuro lighting is flat, or Notan, lighting. Notan is a Japanese word referring to *flat* areas of dark and light in patterns and designs. Flat lighting is lighting for simple visibility. Flat lighting has no particular aesthetic function; its basic function is that of adequate illumination. Flat lighting is emotionally flat, too. It lacks drama.

The fluorescent ceiling lighting in department stores and offices produces intentionally flat lighting. Fluorescent light produces uniform illumination. The highly diffused flat lighting comes from all directions. It has, therefore, extremely slow fall-off and for all practical purposes produces no cast shadows. In flat lighting, we are not aware of any

As long as the back and kicker lights dominate, you can bring up the fill in order to reveal expressions, without destroying the illusion of a moonlit scene.

An extremely bright light source, which will wash out most features, suggests that the person is hit by a flashlight or automobile headlight beam. Usually such a lighting effect is transitory, that is, either the light source moves and strikes the person temporarily, or the person moves in and out of the light beam.

particular principal light source. The light is simply there. Flat lighting resembles very much the light of an overcast day.

Although flat lighting fulfills no particular lighting function, it is, nevertheless, an important lighting technique. Let us review the main characteristics and techniques of flat lighting.

Flat Lighting Characteristics (1) The light comes from no particular direction; it is *omnidirectional.* (2) It is *nonselective;* all areas are equally bright. (3) The attached shadows have an extremely slow fall-off and the cast shadows are practically nonexistent. (4) The lighting is extremely low-contrast. (5) The background, as any other area, is light. Flat lighting is high-key lighting.

Flat Lighting Techniques Generally, you can get a flat lighting effect simply by turning on the fluorescent worklights in your studio or by flooding

the studio with scoops. More often, however, you use the standard photographic principle (key, back, fill) in flat lighting, with the addition of a generous amount of fill light.

In color television, the lighting is usually much flatter than for monochrome television. First, the color camera needs more light than the monochrome camera. Second, the less contrast there is between light and dark areas, the more truly the colors reproduce on the screen (the usual contrast tolerance being 20:1).[3] In flat lighting, all shadow areas are rendered translucent by a generous amount of fill light, slowing the fall-off considerably.

One specific flat lighting technique is sometimes called *limbo.* In limbo lighting the background is evenly illuminated and the object in front of it is lighted with the standard photographic principle. Actually, limbo refers more specifically to a staging than a lighting technique. For example,

Leonardo da Vinci preferred an overcast sky while painting. Under even, diffused light, the colors are less distorted than in bright sunlight with deep shadows. This is also the reason why, traditionally, studio windows are oriented toward the north: the light inside remains more even throughout the day than if the studio were subjected to changing, direct sunlight.

if you are asked to set up a commercial display "in limbo," you need not light specifically for it. It simply means that you push the commercial display in front of a neutral, plain background (usually light) so that the emphasis is on the product and not on the environment.

Film Lighting versus Television Lighting Although basic lighting principles apply to all photographic arts, there are certain operational differences between film and television lighting that sometimes influence, if not dictate, a particular lighting set-up.

Film lighting is set up for *discontinuous, short-duration* action. In film, each scene, if not each shot, is lighted separately. Lighting *control* is extremely *high.* Since all moves of actors, cameras, microphones, and so forth, are carefully planned in advance, the instruments can be placed on the studio floor or hung in the best possible positions. Shadow control is improved by gobos and flags, which are placed in front of the lighting instruments.

Television lighting is most often designed for *continuous, long-duration* action. One of the strong points of television is its fluidity—its ability to capture and intensify a lifelike rhythm. Television can, at its best, be truly alive. In order to preserve this fluidity, the cameras and performers must be able to move freely about the studio floor. Technically, this means that the lighting instruments must be suspended from the studio ceiling, with only a minimum of instruments placed on the studio floor.

Also, lighting for continuous action demands the lighting of overlapping *action areas.* Quite obviously, you can achieve precise Rembrandt lighting more easily in film lighting than in television lighting (unless, of course, you treat television like film, that is, you light for video-taped, short-duration action).

Also, do not forget that various film speeds and television cameras require a certain base light level that might influence lighting aesthetics considerably. You may be very pleased with your chiaroscuro lighting effect in the studio, but if the base light level is too low to activate the film emulsion or the electronic system of the camera, your lighting remains ineffective. Remember that you do not light for the human eye, but for the camera, which then, conversely, must again produce the proper impression for the human eye.

Experimenting with Light So far, we have discussed the well-established external lighting practices and aesthetics that contribute to outer and inner orientation in the context of an actual event. But there is another field in lighting aesthetics, in which light is used for its own sake. Light no longer reveals an event; it *is* the event.

Although experiments with light as a creative medium are nothing new, the use of light as its own expressive medium has been rare in film and even rarer in television. Some attempts have been made here and there to match certain light and color patterns to music. Considering the flexibility of light and its power to create, change, and transform space, more systematic experiments with light in space building and space manipulation should be undertaken, however. One or two simple light modulators (movable objects that reflect light in a variety of ways) can give you some idea of the potentials of light as a creative image medium.

Internal Lighting

Internal light is the energy necessary to produce screen images. Specifically, internal light refers to the electron beam in television. *Internal lighting* refers to control of the electron beam in

To make a simple, yet effective, light modulator, take pieces of a broken mirror and stick them randomly into a rather large (up to basketball size) Styrofoam ball. Hang this light modulator on a string from the lighting grid and shine a highly directional light beam (from an ellipsoidal spot, for example) on it. When you spin the ball, hundreds of light dots seem to float all over the studio, creating a new, exciting spatial environment. By changing the rate of spin or the angle of the light, you can vary the light environment at will.

Using light as materia for creating expressive images is nothing new. Jack Burnham, in his Beyond Modern Sculpture,[1] reports that the first light organs had been developed as early as 1734. Most of the more serious attempts at "light art" were undertaken in the 1920s by a variety of European and American artists.[5] The most systematic experiments were done at the Bauhaus under the leadership of László Moholy-Nagy. He progressed from a simple light modulator made out of paper to his rather complicated Light-Space Modulator, a motor-driven contraption that reflected spotlight beams all over walls and ceilings in controllable patterns.[6]

The light shows that accompany rock-and-roll concerts are another attempt to use light as art, that is, as an artistic event itself. In recent years, light as the materia for artistic expression has become quite common except, ironically, in film and television.

order to produce a variety of specific screen images. As you know, you can control the appearance of an object on television by changing the external light, the light that falls on the object and is reflected by it into the camera. But you can also change the appearance of the object on the television screen simply by manipulating the brightness or contrast controls on your home receiver. In effect, you exercise internal light control; you manipulate internal lighting. Since the electron beam can be manipulated with ease and reliability, internal lighting is an important aesthetic variable. You can control internal lighting by manipulating (1) the *intensity* and (2) the *direction* of the electron beam.

Influencing Intensity You can reduce or increase the contrast between your light and dark picture areas (between light and shadow areas) as well as the overall brightness range of your picture—electronically. Thus, you can control the speed of fall-off electronically. You can increase or decrease the speed of fall-off by sharpening or reducing the picture contrast. You can even reverse the whole grayscale, that is, make the white areas appear black and the black ones white.

Technically, you control the black level of the picture through the pedestal control and the white level of the picture through the beam control.[7]

The most common internal lighting effects through influencing beam *intensity* are (1) reversed polarity and (2) debeaming.

Reversed Polarity Most black-and-white television cameras have facilities (a simple switch) for reversing the polarity of the television image. When the polarity is reversed, the dark areas turn light and the light ones turn dark, much like a film negative (Fig. 3·17).

Technically speaking, the manipulation of the electron beam has nothing to do with the control of light, but rather with the control of electrical energy. However, since the aesthetic effect on the television screen is that of light, we can speak of internal lighting.

3·17 *Besides being a convenient device for changing negative film into positive screen images, polarity reversal can help to create powerful aesthetic effects. As you can see here, a polarity reversal not only changes the outer appearance but also, if not especially, affects the total internal structure of the event.*

3·18 *Here the sculpture is normally lit and electronically adjusted. The fall-off is fairly fast, and there are prominent cast shadows.*

Notice the difference between reducing the external lighting until the screen is uniformly dark and the internal lighting effect of debeaming from a normal image to the blank, light screen.

When the external lighting is uniformly dimmed (all instruments are reduced in intensity at the same rate through the master dimmer), the sculpture retains its light-shadow relationship for some time. The picture simply gets darker, with the sculpture retaining its basic appearance.

3·19 *Now compare the debeaming effect on the same sculpture. The light-shadow relationship changes drastically. The fall-off turns into a light-dark pattern of extreme contrast. The sculpture seems to become its own light source. It starts to glow. It loses its volume and becomes a stark white pattern until it deteriorates altogether.*

Debeaming Debeaming, or clipping the beam, means that the intensity of the electron beam is reduced. In effect, you "clip" the intense highlights in the white level of the picture. The more clipping you do, the less brightness variation you will have in your picture. The picture appears progressively washed out until it deteriorates into a nondistinct light-gray image. Ultimately, you will end up with a blank, light screen. (See Figures 3·18 through 3·21.)

3·20 *Watch how the feeling changes in this debeaming sequence. The dancer and the sculpture are transcended into a single dramatic event.*

3·21 *The soldier is not just dying, he is actually losing his internal structure: his life. The debeaming causes his total disintegration. His life energy, which had previously been formalized in time-bound human actions, transforms back into the timeless original cosmic energy. Debeaming does not just cause a simple change of appearance; it causes a metamorphosis—a structural change.*

3·22

3·23 *Sometimes you may want to combine two or more wipes to produce more complex wipe patterns. New digital systems make it possible to create a great variety of highly complex wipes and video patterns, which can rotate around the screen or oscillate like a pendulum or a windshield wiper.*

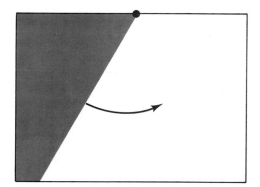

Influencing Beam Direction Besides manipulating the intensity of the electron beam, you can also influence the *direction* of the beam as it travels across the screen to produce controlled or random patterns.

The most frequent directional beam manipulation is used for special-effects patterns, which are generally known as electronic wipes. You wipe out one part of the original picture and supplant it with the image from a different video source, such as a second studio camera, film, slide, or video-tape. Figure 3·22 shows some common wipe patterns.[8]

3·24 *You can also influence the contour of a regular wipe by feeding another energy source into the pattern, such as the audio signal of the accompanying sound, for example. The intensity of the audio signal (volume) influences the size of the pattern, and the frequency of the audio signal (pitch) influences the contour of the electronic wipe.*

3·25 *Certain modified television equipment can be combined with a computer, which can translate an outside energy source (such as an audio signal) to a variety of video patterns. These patterns were created without a camera by an electronic device that does for video very much what the Moog synthesizer does for audio. Electrical energy was made visible on the screen. A regular oscilloscope can perform a similar function.*

Intensity-Directional Manipulation of the Beam

Some internal lighting effects consist of combined intensity and directional beam manipulation. They include (1) keying or matting and (2) video feedback.

Keying or Matting In electronic keying or matting, one picture is electronically cut into the other (keyed into it or matted into it). In black-and-white matting, anything that is black (that is, reflects no, or very little, light) becomes translucent and reveals the picture from a second video source. In color television, everything that is of a selected color—generally blue—will let the picture of the second video source show through. This is called chroma-key matting. Figures 3·26 through 3·29 show some of the more complex key effects.

3·26 *The key effect can be used for rather utilitarian purposes. A dancer can be put easily on top of a staircase, or a scene can be put behind a newscaster.*

3·27 *But the key can also produce a complex image with great dramatic effect.*

Video Feedback Here you photograph an image off a monitor and then feed the photographed image back to the same monitor, repeating this process again and again. Thus, the original image is multiplied very much as with two opposing mirrors.

While with external lighting you manipulate especially *form,* the outer *appearance* of an event, internal lighting changes the *inner structure* of things. Through internal lighting, an object, such as a sculpture, can be transformed into a different

3·28 *Some key effects (a black key in this case— a key with a polarity reversal) can give the startling impression of a shadow becoming independent and taking on its own life. A combination of superimposure and key can create complex images possessing grace as well as strength.*

3·29 *With a double re-entry switcher (the effect signal is re-entered into the switcher to yield yet another effect), you can "fill" the keyed-out contours with picture elements from a third video source, producing stark, if not surrealistic, effects.*

3·30 *Camera 1 photographs object X and feeds it into the switcher on mix bus A. This picture is fed into the studio monitor. Camera 2 photographs the studio monitor, which now displays an image of object X. Camera 2 is fed into the camera 2 position of mix bus B. Cameras 1 and 2 are now superimposed and fed into the line monitor, which shows the multiple images of object X as produced by the closed feedback loop between cameras 1 and 2.*[11]

3·31 *If you move the feedback camera (camera 2) slowly about the face of the monitor, you can get a highly intense, glowing image that weaves back and forth.*

aesthetic event, an electronic happening with its new unique structure. The sculpture is no longer reproduced faithfully on the television screen but is reproduced into a new electronic event. The objects, such as the sculpture, simply serve as basic raw material, basic energy sources, for the internal-lighting event, very much as clay serves as the raw material for the aesthetic event, the finished pot.

Because internal lighting reveals a structural change, a structural metamorphosis in a rather dramatic way, internal lighting is loaded with emotional impact. Internal lighting no longer reflects landscape; it reveals *inscape.*[10]

Be sure to employ internal lighting only when you want the viewer to witness structural changes or when you want him to experience *inner* events. Quite obviously, such a powerful aesthetic device must be handled with extreme caution.

Summary

In this chapter we have considered the major lighting types and techniques of external and internal lighting.

The two basic ways of *external lighting* are (1) chiaroscuro (light-dark) and (2) flat, or Notan, lighting.

Chiaroscuro lighting means lighting for volume. It emphasizes the three-dimensional quality of things. Flat lighting is lighting for simple visibility.

The *functions* of chiaroscuro lighting are (1) organic—to make the scene appear realistic; (2) thematic—to emphasize the theme or the story being told; (3) compositional—to emphasize the design of the picture; and (4) emotional—to establish and emphasize mood.

The *characteristics* of chiaroscuro lighting are as follows: (1) The lighting is specific; only parts of the scene seem to be illuminated, usually by a real light source. (2) The overall illumination is low-key (low light overall level, high-contrast lighting on figures set off against a dark background. (3) There are prominent attached and cast shadows present; attached shadows have a fast fall-off (light areas turn into shadows abruptly). (4) Texture is emphasized.

There are three *types* of chiaroscuro lighting: (1) *Rembrandt* lighting, in which only *highly select* areas are illuminated, while others are kept relatively dark. (2) *Cameo* lighting, in which the foreground figures are lighted, with highly directional spotlights (fast fall-off), while the background remains dark. (3) *Silhouette* lighting, which shows the contour of unlighted figures against a bright evenly lighted background. In silhouette lighting, the figures remain flat. Silhouette lighting is a hybrid between chiaroscuro and flat lighting.

The *characteristics* of flat lighting are these: (1) The light comes from no particular direction; it is omnidirectional. (2) It is nonselective. (3) Attached shadows have an extremely slow fall-off; cast shadows are virtually nonexistent. (4) The images have an extremely low contrast. (5) The background is usually light.

As far as lighting techniques are concerned, *film* lighting is lighting for *discontinuous, short-duration* action. The lighting *control* is *high.* *Television* lighting is generally designed for *continuous, long-duration* action. The *control* is relatively *low.* The continuous action frequently requires the lighting of overlapping *action areas.*

Light can be used as a primary expressive medium, especially when manipulated by light modulators that distribute light in various ways throughout a specific environment.

Internal light is the energy used to make images visible on the television screen, the *electron beam.* *Internal lighting* means *control* of the *electron beam.* Internal lighting can be achieved by manipulating the *intensity* and/or the *direction* of the electron beam. The *intensity* manipulation includes reversed polarity and debeaming. The *direction* manipulation includes controlled special-effects wipe patterns, combined wipe patterns, and computer-controlled line patterns. The *combined* intensity-directional beam manipulation includes keying or matting and video feedback.

In electronic *keying* or matting, one picture is electronically cut into another. *Video feedback* means that a video image as it appears on the monitor is photographed by a camera and fed back into the same monitor. This process repeats itself ad infinitum.

Internal lighting is a powerful aesthetic device since it not only changes the outer appearance of things but especially transforms their inner structure.

Notes

[1] Herbert Zettl, *Television Production Handbook,* 2nd ed. (Belmont, Calif.: Wadsworth Publishing Company, Inc., 1968), chap. 4.

[2] For the basic photographic principle, see Zettl, *Television Production Handbook,* pp. 155–157.

[3] *Ibid.,* pp. 150–151.

[4] Jack Burnham, *Beyond Modern Sculpture* (New York: George Braziller, Inc., 1967), pp. 285–311.

[5] Frank Popper, *Origins and Development of Kinetic Art,* trans. Stephen Bann (New York: New York Graphic Society, 1968), pp. 156–212.

[6] László Moholy-Nagy, *Vision in Motion* (Chicago: Paul Theobald & Company, 1947), pp. 198–203, 239.

[7] Gerald Millerson, *The Technique of Television Production,* rev. ed. (New York: Hastings House, Publishers, Inc., 1968), pp. 18–21, 53–60.

[8] Zettl, *Television Production Handbook,* p. 267.

[9] *Ibid.,* pp. 396–401.

[10] A term coined by Linden (George W. Linden, *Reflections on the Screen,* Belmont, Calif.: Wadsworth Publishing Company, Inc., 1970). See also Gene Youngblood, *Expanded Cinema* (New York: E. P. Dutton & Company, Inc., 1970).

The Extended First Field: Color

Color adds a new dimension to things. It adds excitement and brings joy to our environment. A child likes to play with toys that are brightly colored. In the purchase of a car, for many people the color is as important as the car's performance. When we dress, we make sure the colors go together well. When flipping through the various television channels, we are more likely to pick a color program than one in black and white, regardless of relative aesthetic merit. We stop when the traffic light turns yellow or red; we go on green. Every day, we make many judgments on the basis of color, consciously or unconsciously.

Although a sizable portion of our daily activity is influenced by color, color perception has remained a fickle subject, which so far has defied precise scientific scrutiny and sometimes even common sense. We still do not know exactly why reddish colors seem warm to us, while bluish colors seem cold; or why, when we mix red and green paint together, we get a muddy dark brown, but when we shine a red light on top of a green light, we perceive yellow. Adding a blue light to the red and green light mixture produces a white color. When watching color television, we can see a great variety of colors. When we look closely at the screen, however, there are only a great number of red, green, and blue dots that light up separately or in unison. Why, then, do we see so many colors on the television screen? We do not exactly know. There are some plausible theories; but they often contradict each other and, in the end, fail to tell us precisely why and how we perceive color.[1]

To confuse things even more, color is extremely relative. A certain color does not remain stable under all conditions but changes within different contexts. For example, a certain red looks darker

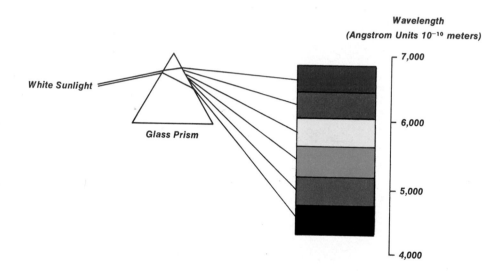

Wavelength
(Angstrom Units 10⁻¹⁰ meters)

White Sunlight

Glass Prism

— 7,000

— 6,000

— 5,000

— 4,000

4·1 When we shine a beam of sunlight through a prism (diamonds or waterdrops will do a similar thing), we see a series of colors, ranging from red to violet. These rainbow colors are called spectral colors because their wavelengths fall into the visible electromagnetic spectrum.

or lighter, warmer or colder, depending on whether it is painted on a highly reflective surface, such as porcelain, or an absorbent one, such as cloth. Also, the red will change, depending on what other colors surround it or how much and what kind of light falls on it.

In spite of this relativity of color and our lack of a precise scientific color theory, we have gathered enough working knowledge to describe and even predict fairly accurately how most of us will perceive and react to certain colors and color combinations. Let's look at (1) what color is, (2) how we perceive color, (3) how color influences our perception, (4) how we mix color, and (5) how color is relative.

What Color Is

Color is specific electromagnetic waves from the visible light spectrum (Fig. 4·1). Color is light that has been divided into one or more visible light waves by some object.

Most often, we see colors as reflected light from which some wavelengths have been filtered out. A red book or a blue ball do not possess these colors; they merely bounce back this part of light they cannot absorb: red and blue. When we gradually take away the light that falls on these objects, they will lose their color. In a dimly lighted scene, such as in moonlight, there are no colors. All objects look gray. When almost all the light that falls on an object is reflected back, we perceive white. When almost all the light is absorbed by the object, we see it as black.

How We Perceive Color

Exactly how we perceive color is not known. But we do know that we can perceive colors (1) objectively and (2) subjectively.

Objective Color Perception Objective color perception means that the eye receives light of a certain wavelength or mixture of wavelengths that is then interpreted as a certain color. In other words, the object reflects a certain color which we can see.

When we look at objects of different colors, we can detect *three basic color sensations.* First, there is the color itself: blue, red, yellow, green. Second, there are different degrees of color strength. Some reds look very deep and intense, others look rather washed out. Third, some colors simply look brighter than others. Some seem to bounce back a lot of light, others not so much light. Therefore, when we squint our eyes, some colors seem brighter than others. These various sensations we call *color attributes.* Color attributes play an important part in color film and color television, especially when the colors must be compatible with black-and-white television transmission. When we speak of colors that are compatible, we mean that they should translate into reasonably clear black-and-white television images.

Color Attributes These are the three color attributes: (1) hue; (2) saturation, or chroma; and (3) brightness, or value.

4·2 *The object reflects parts of the light spectrum, absorbing the rest. The reflected light is focused by the lens of the eye onto the light-sensitive cells of the retina, the cones and the rods. The cones are for bright daylight vision and receive, therefore, also the reflected light that makes up the color. Some cones seem to be more sensitive to the blue end of the spectrum, some to the middle (green-yellow), and some to the red end. The rods help us see when the light is dim. But they do little, if anything, to help us see color. When the cones are stimulated, they fire their electrical charges to the brain, which interprets for us a particular color.*

Hue

4·3 Hue describes the color itself. Blue, red, green, and yellow are color hues. Only the colors of the spectrum are pure hues. Most colors we see are combinations of several wavelengths; the hues are impure.

Saturation

4·4 These colors have different degrees of saturation. Saturation describes the color richness, the color strength. The colors in the first row are highly saturated; in the second row, the colors are less saturated. Saturation depends on how much white light appears to be mixed into a color. Saturation is sometimes called "chroma" (Greek for color). White, gray, and black have no chroma (actual color saturation) and are, therefore, called achromatic.

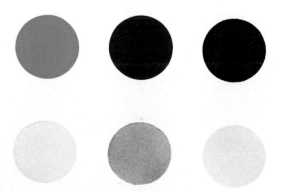

Brightness

4·5 Brightness, or value, indicates how light or dark a color appears in a black-and-white photograph. The brightness of a color depends on how much light the color reflects. Black-and-white television produces images that vary in brightness only. They possess neither hue nor saturation. Color television and film images have, of course, all three attributes—hue, saturation, and brightness. The various degrees of color brightness are measured on a brightness scale, which is identical to the grayscale.[2]

Interrelation of Color Attributes In an attempt to standardize the color attributes and to show their basic interrelation, some color theorists have devised color models. The most common color model is the color solid (Fig. 4·10).

4·6 *The color hues are arranged around the periphery of a circle, called the "hue circle," in their spectral, or rainbow, order. The colors that lie opposite each other are called complementary colors. When two complementary colors are mixed together, they produce an achromatic gray. Color afterimages are complementary to the basic color that produces the afterimage. The green color we see after having stared at a red dot for a while is a complementary color (to the actual red stimulus).*

4·7 *The brightness scale, a regular grayscale, forms the vertical axis around which the hue circle revolves. This axis is called the achromatic axis.*

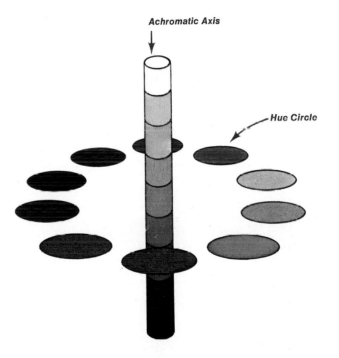

4·8 *The degree of color saturation is indicated by the distance of the color from the achromatic axis, or brightness scale. The farther the color is from the achromatic axis (which has zero saturation), the more saturated the color becomes.*

4·9 *When we combine the brightness scale and the saturation scale, we can show how certain colors vary in saturation, while maintaining the same degree of brightness, or vary in brightness, while maintaining the same degree of saturation. The colors lying on the horizontal axis (x-y) grow from maximum saturation (x) to zero saturation (y). All the variously saturated colors of the x-y axis would photograph in identical grays: a number 5 on the grayscale. Going down vertically, next to the achromatic axis, all the hues have identical degrees of saturation. As you can see, the more the colors are whitelike or blacklike, the less saturation is possible (for example, very light yellows or very dark blues). White and black have no saturation at all.*

Minimum Saturation **Maximum Saturation**

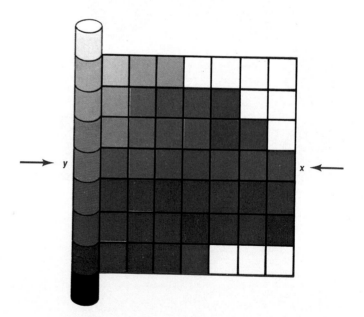

y x

4·10 *When we add the hue circle to our color model, we have what is called the color solid.*

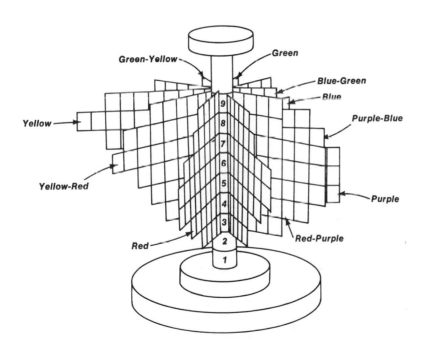

One of the most popular color solids, which was devised by the American painter Albert H. Munsell (1858–1918), is appropriately called the Munsell color system. Twenty basic hues make up the hue circle. The brightness axis (which he called the value axis) is divided into nine steps, ranging from black to white. The saturation is uneven, depending on how much the basic hue can be saturated. The individual hue branches are numbered; so are the brightness steps and the saturation squares. Thus, the appearance of a color can be specified very precisely: a 5Y 8/12 means a fairly warm yellow, rather light (almost to the top of the brightness scale), and highly saturated (12 steps away from the brightness axis).

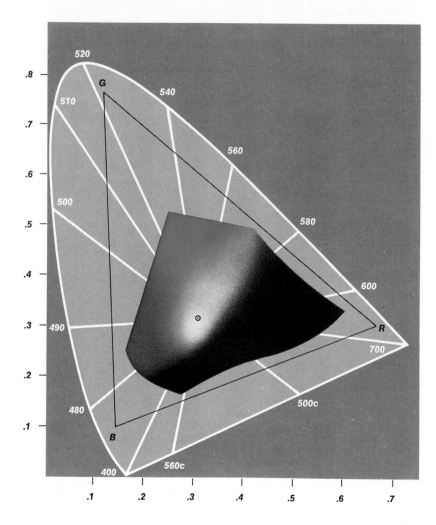

4·11 *The chromaticity diagram enables us to measure precisely (according to wavelengths) various hues and degrees of saturation. "Chromaticity" is a term that describes hue and saturation of a color but not its brightness. The diagram has been devised by the ICI (International Commission on Illumination) and is used as a color map by television engineers the world over. The chromaticity diagram is defined by the three primaries, which are red, green, and blue. As in the color solid, the hues desaturate toward the middle of the horseshoe-shaped curve. The area enclosed in the triangle contains all the hues that color television can produce.*

The color solid represents a reasonably accurate reference to how the three color attributes—hue, saturation, and brightness—interrelate and how they appear to the person with normal color vision. It also shows quite readily on the brightness scale how certain colors will appear on black-and-white television, an important consideration for anyone concerned with the compatibility of color television[4] (Fig. 4·12).

The most common compatibility problem arises from use of colors that reproduce as the same gray on monochrome television. That is, although the hues may vary considerably from one another (reds, greens, blues), they may have the same degree of brightness.

Assuming that the lighting is similar for all colors used in the set, the color solid can tell you quickly which hues have or have not sufficient differentiation in brightness so that they will show up well on black-and-white television.

Another popular color system was devised by the German chemist Wilhelm Ostwald (1853–1932). His achromatic axis is divided into eight gray-scale steps. The various branches of the Ostwald color tree are even, because he desaturated each hue evenly by mixing it with white, gray, or black. Ostwald used a basic fully saturated hue and added white paint. The color (now called "tint") becomes lighter (climbing up on the achromatic

axis) and simultaneously less saturated (moving toward the achromatic axis). By adding black, the color becomes darker (called a shade) and less saturated (moving down and toward the achromatic axis). By mixing gray into the color in increasing amounts, the color (assuming a tone) simply moves closer to the achromatic axis, becoming neither lighter nor darker, but less saturated.[3]

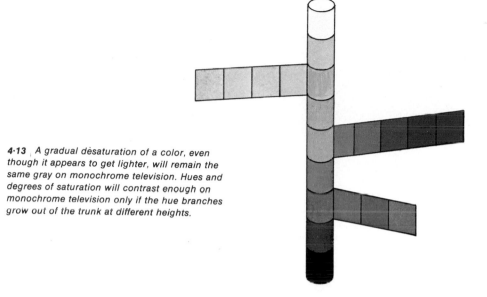

4·13 A gradual desaturation of a color, even though it appears to get lighter, will remain the same gray on monochrome television. Hues and degrees of saturation will contrast enough on monochrome television only if the hue branches grow out of the trunk at different heights.

4·14 The hues that lie on the same horizontal axis of the color solid all have the same degree of brightness—they will show up as the same gray on monochrome television.

4·12

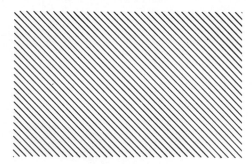

4·15 *Look at the parallel lines without focusing directly on a specific section of the pattern. Can you see the pastel colors that are cutting across the black lines?*

4·16 *The Benham's top will produce a similar sensation. If you spin this pattern slowly (5 to 15 turns per second), you will preceive several pastel colored rings. The colors change when you reverse the spin.⁵ You can perceive the colors even if you spin the top under colored light, or when it is reproduced on a black-and-white television monitor.*

Charles E. Benham (1860–1929), an English newspaperman, experimented extensively in visual phenomena. Gustav T. Fechner (1801–1887), German psychologist, also spent a great deal of effort in trying to explain aesthetic phenomena scientifically. He undertook many experiments with devices similar to Benham's top.

The black-and-white television camera is virtually color-blind. It does not distinguish among hues but principally among degrees of *brightness*. Be reminded, however, that the brightness of a color can be changed quite readily by the amount of light that falls on it and by the surface on which it is painted. If we flood an object with light, its color may climb up several steps on the achromatic axis of the color solid. We will speak about the relativity of color a little later in this chapter.

Subjective Color Perception Close your eyes and press them gently toward each other. Can you "see" some colors? Obviously, we do not need a light stimulus to produce color sensations. Some persons, when under the influence of hallucinatory drugs, have reported vivid color sensations, even with their eyes closed. The color receivers in our eyes (cones) apparently can be stimulated in a variety of ways and coaxed into firing their impulses to the brain. Any on-off stimulation, such as a light flicker or a sharp dark-light pattern with a particular on-off frequency, can trigger a color sensation.

There have been attempts to induce a flicker of a certain frequency on black-and-white television so that the viewer would experience color sensations. The development of the color receiver, however, rendered such experiments unprofitable and quite unnecessary.

But even the modern color television receiver relies heavily on our subjective color perception. After all, we really see on the surface of the tube only a series of separate, discrete red, green, and blue color dots (Fig. 4·17). Depending on how much and in what combination these color clusters are activated by the electron beams, we perceive (obviously subjectively) a wide range of hues.

4·17

4·18 *Detail from* Sunday Afternoon on the Island of La Grande Jatte *by Georges Seurat.* [*Courtesy of The Art Institute of Chicago.*]

The well-known afterimages are also a form of subjective color perception. Why exactly we perceive such afterimages is still subject to speculation. It seems that the eye reacts immediately to the overstimulation of one color by producing the complementary color, and the two, mixed together, neutralize each other into the achromatic gray.[6]

The painting theory of the Pointillists is based on our capacity to mix colors in the mind. Pointillists, such as the French painter Georges Pierre Seurat (1859–1891), built their paintings and color schemes by juxtaposing thousands of separate dots, all consisting of a few basic colors of varying saturation (Fig. 4·18). When seen from a distance, the pure color dots blend into a wide variety of hues.

a

Warm Red **Colder** **Cold Red**

4·19 Watch (or rather feel) how this basic warm red changes into a cold color by adding more and more of a cold blue.

b

Cold Blue **Warmer** **Warm Blue**

This cold blue becomes the warmer, the more warm red is mixed into it.

c

Neutral Green **Warm Green** **Cold Green**

This neutral green can be made into a warm green by mixing it with a warm color (ochre) and into a cold color by adding blue.

How Color Influences Our Perception

Certain colors, or color groups, seem to influence our perception and emotions in fairly specific ways. Although we still do not know exactly why, some colors seem warmer than others; some closer or farther away. A box painted with a certain color may appear heavier than an identical box painted with another color. Some colors seem to excite us, others to calm us down.

Color influences most strikingly our judgment of temperature, space, time, and weight.

Temperature It is generally assumed that red is warm, and blue is cold. There is a tendency to consider all colors of the red (long wave) end of the spectrum warm and all colors of the blue (shorter wave) end cold. This generalization is not too accurate, however. There are certain blues that we experience as warm, and some reds that seem rather cold. Rudolf Arnheim suggests a theory that, though not as yet empirically verified, makes more sense. He contends that it is not the main color that determines the warm-cold effect, but the *color of the slight deviation from the main hue.* Thus, a *reddish* blue looks warm and a *bluish* red, cold.[7]

Interestingly enough, black-and-white television cameras seem to respond to this *secondary hue,* although the black-and-white camera is basically color-blind. A cool, bluish red has a tendency to reproduce darker than expected. A warm red of equal brightness tends to reproduce as a much lighter gray. Cold makeup colors are, therefore, not advantageous for black-and-white reproduction. The cold red of a lipstick or fingernail polish may show up as ugly dark gray or black on the monochrome television screen.

By using cold or warm colors, we can actually manipulate a person's temperature perception. When prisoners complained that their cells were too cold, the color of their cells, rather than the actual temperature, was changed from a cold to a warm hue. Soon thereafter, the prisoners insisted that the cells were now too warm. We can achieve a similar effect on the television screen. By flooding the scene temporarily with warm red light, we can emphasize the intense heat of a fire, an explosion, or the desert sun. A cold blue or blue-green light will actually help the viewer to feel the low temperature as depicted in your screen event.

The temperature effect of color, as any other aesthetic effect, is of course dependent upon the overall context of the event. If we show the red sunset in the Arctic, the viewer will probably not experience intense heat. But if the red sun sets in the desert, the warm hues will more readily feel hot.

Space–Time–Weight Table 4·1 shows how reds (warm colors) and blues (cold colors) can influence our perception of space, time, and weight. Again, these effects are *contextual.* They work only within a positively predisposed context, in a field in which most other aesthetic elements display similar tendencies. A color (or any other aesthetic element) produces a specific perceptual effect only if it operates within a *positive tendency field.*

The customary explanation of why we perceive certain colors as warm or cold is that we associate them with certain warm or cold events. Red is warm because it reminds us of fire, the sun, glowing metal. Blue is cold because we think of ice, the water, the sky.[8] But, as Arnheim correctly points out, the influence of color on our perception is much too direct to be only the product of such associations.[9] There is some evidence that warm colors raise the blood pressure and cold colors lower it.[10]

Table 4·1 Influence of Color on Space–Time–Weight Perception

		Red (Warm Colors)	**Blue (Cold Colors)**
Space	*Size*	Large, expanding	Small, contracting
	Distance	Close	Far
Time		Long	Short
Weight		Heavy	Light

If two identical boxes are painted, one with a cold, light green and the other with a warm, dark brown, the green one will look slightly smaller than the brown one. Under warm light, we tend to overestimate time; under cold light, we underestimate time. Red and highly saturated warm colors look closer than cold colors with similar saturation. A baby tends to overreach a blue ball, but underreach a red one. Light, warm-colored areas seem to expand; dark, cold-colored ones seem to contract.[11]

Emotional Effect Reds and warm colors in general seem to produce more excitement than blues or cold colors. Assuming similar degrees of saturation and brightness, warm colors seem more active than cold colors. Warm, bright colors can make us feel "up," while cold, subdued colors can make us feel "down." The traditional green room of the theater is supposed to make us feel calm and relaxed. The intense red of some rooms is meant to produce just the opposite effect. Some research suggests that extroverts prefer red colors; introverts, blues. Well-balanced, stable people were found to like green best.[12] Do not be misled by these generalizations into believing that there exists a reliable causal relationship between certain colors and emotional behavior. Because you happen to like blue does not necessarily mean that you are an introvert. There is simply not enough scientific evidence to permit such sweeping and far-reaching generalizations. On the other hand, there is enough consistency in the effect of certain colors on our perception and emotional behavior to suggest certain correlations of some reliability. What might be most helpful to you in using color as an effective aesthetic element in television and film is to generalize about color in terms of *aesthetic energy* rather than specific emotional effects. By translating colors into various degrees of aesthetic energy, you can integrate the effect of color more readily with other aesthetic elements which, when working in unison within a tendency field, produce a specific overall emotional effect.

As you can see by Table 4·2, a warm, bright, highly saturated red has more aesthetic energy than a desaturated dull, cold blue. A color has more aesthetic energy when it covers a large, rather than a small, area. We will discuss the interrelationship of color energies more extensively in Chapter 5.

Generally, a high-energy color is an active color. It affects us more readily and more directly than a low-energy color.

Table 4·2 *Aesthetic Energy of Colors*

Attribute	Variable	Energy
Hue	Warm	High
	Cold	Low
Saturation	High	High
	Low	Low
Brightness	High	High
	Low	Low
Area	Large	High
	Small	Low

How We Mix Color

We have already indicated some ways in which we mix colors in our mind. In this section, we will discuss the two major ways of objective color mixing: (1) additive and (2) subtractive. *Additive mixing* means the mixing of colored light. *Subtractive mixing* means the mixing of paint (pigment). Whether you work with additive or subtractive mixing, you need only three basic colors to produce a wide range of other colors. These basic colors are called *primaries* (Figs. 4·20 and 4·21).

Additive Mixing In additive color mixing, we *add* red light, green light, and blue light of certain intensities together to produce a variety of color sensations. Thereby, the colored lights do not filter each other out but combine into specific colors.

As pointed out before, color television works on the very same principle. The screen of the color receiver is lined with many dots, which are arranged in groups of red, green, and blue. They are activated by three electron guns, each one hitting with its beam either the red, the green, or the blue dots. If we now change the intensity of either, or all, of the beams, we create a variety of colors. If all three beams activate the dots fully, we get white. If the guns are turned off, we get black. If the red and green guns fire, but not the blue, we get yellow, and so forth. Since the color dots lie very close together, we perceive them together as various color mixtures.

4·20 *The additive (light) primaries are red, green, and blue.*

4·21 *The subtractive (paint) primaries are magenta (bluish red), yellow, and cyan (greenish blue).*

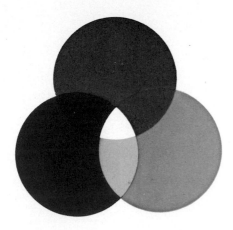

4·22 *Here we can see the result of mixing the three light primaries. All three light primaries are produced with slide projectors containing a red, a green, and a blue slide respectively. If we add green to the red light, we get yellow. If we add blue instead, we get magenta. If we add green and blue together, we get cyan. If we add all three light primaries together, we get white. If we turn all projectors off, we obviously get black.*

If we now put each projector on a separate dimmer, we can produce a great number of different hues by simply varying the light intensity of either, or all, of the projectors. If, for example, we project the red color at full intensity and dim the green (with the blue projector turned off), we will no longer get a yellow, but a brown color.

If we watch a black-and-white program on a color set, we actually watch a red-green-blue program, in which the three electron guns fire together at a variety of uniform intensities (from full-white to middle-gray to off-black).

Subtractive Mixing Here we filter out, or subtract, from white light all colors except the one we want. If we want red, we use a filter that prevents all other colors from reaching the eye except red. A red flower has such a filter built in; so has red paint. Blue paint subtracts from the total light spectrum (white) everything but blue, which it reflects back. By combining two or more such filters (or by mixing paint), we can again achieve a wide variety of hues. An artist's palette is ample proof of such color variations.

Since we use red, green, and blue, which, when added, yield a maximum variety of hues, we can assume that we need filters that are red-absorbing, green-absorbing, and blue-absorbing when attempting to mix colors by subtraction.

True enough, the three subtractive (paint) primaries turn out to be the red-absorbing cyan (greenish blue), the green-absorbing magenta (bluish red), and the blue-absorbing yellow. A painter would refer to the subtractive primaries simply as red, blue, and yellow. In color photography, which uses the subtractive color process, we must be more accurate. Figures 4·23 through 4·26 show how the principle of subtractive color mixing is basically used in photography.

In essence, yellow, magenta, and cyan dyes act as filters, which, when white light is passed through them, work in combination to reproduce the original color of the photographed event.

4·23 Each primary filter subtracts the light passed by the other two. A yellow filter absorbs blue light, letting green and red pass. (Yellow = minus blue.)

4·24 A magenta filter absorbs green light, letting blue and red pass. (Magenta = minus green.)

4·26 When all three subtractive primary filters overlap, we get black. They swallow one another's light—until no light is passed any longer.

When mixing yellow, magenta, and cyan paint together, we should get black. But all we get is a muddy brown. Even the best artist's paints have only imperfect color filters (pigment), which always pass extraneous light. Therefore, when the subtractive primaries are mixed together, they cannot absorb all the light. The reflected light makes the color appear as a dark brown.

4·25 A cyan filter absorbs red light, letting green and blue pass. (Cyan = minus red.)

4·27 *Color film is made up of six different layers. The top emulsion is sensitive to blue light; the second layer is a yellow filter to absorb all the blue light before it can reach the third layer, the green-sensitive emulsion. The fourth layer is sensitive to red light. The fifth and sixth layers are the film base with a light-absorbing backing.*

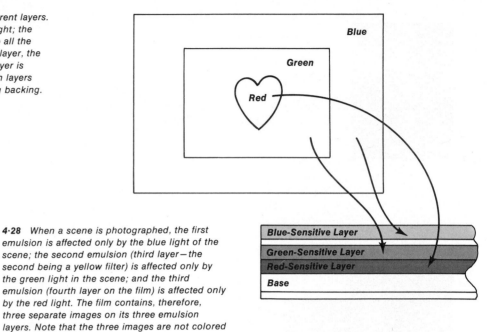

4·28 *When a scene is photographed, the first emulsion is affected only by the blue light of the scene; the second emulsion (third layer—the second being a yellow filter) is affected only by the green light in the scene; and the third emulsion (fourth layer on the film) is affected only by the red light. The film contains, therefore, three separate images on its three emulsion layers. Note that the three images are not colored as yet.*

4·29 *They become colored only when processed. During processing, the blue-affected emulsion turns into a yellow filter of varying density; the green-affected emulsion turns into a magenta filter; and the red-affected emulsion turns into a cyan filter. When white light is passed through these filters, they operate in combination and produce, subtractively, a color image very similar to that of the original event.*[13]

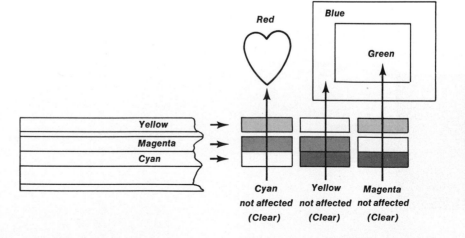

The knowledge of how the color attributes (hue, saturation, and brightness) interact and influence our color perception and how additive and subtractive mixing principles are used in television and film will help you, not only in achieving faithful color reproductions with the media, but especially in your experimentations with intentional color distortions.

Even in black-and-white photography, we can use color filters that help to differentiate the brightness scale of the photographed color scene. For example, if we want to have a light blue, such as the sky, come out a relatively dark gray (low end of the brightness scale), we use a filter that blocks some of the blue light: medium yellow. A light-green filter will make the reddish skin tones appear as a slightly dark, suntanlike gray. Table 4·3 outlines some of the most common applications of color filters in black-and-white photography.

Table 4·3

Scene	Effect	Filter	Scene	Effect	Filter
Sky and clouds	Heightened cloud effect, yet natural	Medium yellow	*Snow*	Heightened contrast between light and dark (accentuates ridges, etc.)	Medium yellow
	Dark sky, white clouds	Orange			
	Very dark sky, very bright white clouds; dramatic	Red		Exaggerated contrast (ski goggles are usually medium yellow or orange to accentuate imperfections in the snow for the skier)	Orange
	Extreme contrast: black sky, brilliant white clouds; special effect (night scene)	Dark red			
Fog (landscape)	Foreground pieces appear quite dark; silhouette against soft, light-gray background	Blue	*People (portraits, etc.)*		
			Outdoors	Accentuated skin tones, but natural looking	Light green
Haze (landscape)	Reduces atmospheric haze	Medium yellow	*Indoors*	Suntan	Light green
				Light, yet accentuated skin tones	Medium yellow
Flowers and grass (colorful landscape)	More contrast between flowers and grass; bright flowers against dark grass	Medium yellow			

You may want to manipulate the colors of the scene *externally* by using various color filters or colored light for illumination. But you can also manipulate your colors *internally* by controlling in a specific way the electron beams that affect the light primaries of color television or the chemical process that produces the subtractive primary filters in color film. *Internal color manipulation* is quite similar to internal lighting. Colors on television need no external color stimulus. The electron beams that activate the red, green, and blue dots on the television screen can be produced and controlled without any outside light source. Since you can manipulate each of the primary colors independently, you can produce an almost endless variety of colors and color combinations. In film, you can create color varieties by influencing the various emulsions chemically. For example, you can use the various grays of a black-and-white film as the basic light stimulus for the color-film emulsions, which, when chemically dyed, produce color images of the black-and-white film. In television, you can "colorize" a black-and-white video tape by tinting it in a particular hue. A special device, sometimes called Cox box, can tint the dark picture areas of the black-and-white scene in one hue, the light ones in another.

How Color Is Relative

As helpful as the theoretical color systems are for standardizing the appearance of color and for making color more manageable in television and film, they cannot account for all the variables that might influence our color perception. One and the same red may look lighter or darker, purple or even black, bright or dull, strong or weak, depending on what kind of light or how much light falls on it, on what colors surround it, and even on whether or not we know what kind of red it should be. Four important factors of color relativity are (1) color constancy, (2) surrounding light, (3) surface reflectance, and (4) surrounding colors.

Color Constancy Take a yellow pencil and move it from the light into the shade. Is it still yellow? Of course; at least it appears to be the same yellow. Even when only part of the pencil is in the shade, you still "see" the pencil as uniformly yellow. Let's do another brief experiment. Take a book that is uniformly colored, such as a specific red. Now place it in such a way that only part of it is in the light. Take a sheet of typing paper and roll it up so that it forms a narrow tube. Look through the tube at the part of the book that is in the light. Now move the tube into the shadow area. Do you notice a difference in color? Of course you do. If you had to assign the color of the book in the light and the color of the shadow area to the numbers of the Munsell color system, you would be surprised how far apart the two reds lie on the color solid.

But, when you put the tube aside and look at the book again, it looks uniformly red. Why? Because perception is guided, not only by what we actually see (the retinal stimulus) but also by what we *know* about an event. More importantly, the colors of the book are not seen in isolation but as a *whole* relative to the book's surroundings. We perceive *contextually*.[14]

In relation to its surroundings, we assign to the pencil a uniformly yellow color and to the book a uniformly red color, regardless of the actual color variations our retina may receive. Only when we separate the colors from the experiential context (the whole pencil or the whole book) are we able to perceive the color variations that are actually there. Such "constancy" effects in perception are

not limited to color or brightness but extend over the whole perceptual field. In order to function properly and efficiently in our ever-changing, moving environment, we must try to introduce some order and stability.

Unfortunately, the color camera (television or film) knows nothing about contextual requirements for color constancy. Through close-ups, it can readily divorce an object from its context, reporting naively the colors it actually sees. If part of the face turns purple or green, the color camera faithfully reproduces the purple or green. Devoid of their context, these colors appear on the concentrated space of a screen (especially a television screen) as they are, not as they should be. When parts of the face are purple on the television screen, we *perceive* these parts as purple. If a pencil appears half yellow and half green on the screen, we perceive it as two-colored even if it turns out that the pencil is actually painted a uniform yellow.

Because of this apparent difficulty in maintaining color constancy on the television screen, we must pay special attention to avoid even minor color distortions as much as possible. Especially the skin tones, which are the only color reference the television viewer has by which to adjust his set, must be reproduced as faithfully as possible. This is another reason why in color television we must use a generous amount of fill light. The lighter (more transparent) the shadow areas are, the more truly the colors reproduce.

Surrounding Light Colors change depending on *how much* and *what kind* of light falls on them.

Amount of Light Since color is basically reflected light, we need a certain amount of light so that some light can be reflected by the object after partial absorption.

4·30 *Under adequate light, the objects can reflect their full colors. But when we reduce the light, less and less light is reflected by the object. The colors lose their hues. Like the baselight requirement of the television camera or the color film, colors, too, need a certain amount of light to make the true hue of objects visible.*

4·31 *A full moon, for example, emits enough light for us to see the general objects, but not enough light to reflect back the colors after partial absorption. The moonlit scene is, therefore, largely colorless. Night scenes should have highly desaturated colors (approaching dark gray) except in places where objects are fully or partially illuminated by an artificial light source.*

Sometimes moonlight effects are achieved by shooting a daylight scene with a special dark red filter that renders the scene properly monochrome dark. The dark red filter makes the blue sky and the green trees and grass appear dark gray and black.

While too little surrounding light influences all three attributes of color (hue, saturation, and brightness), too much light can distort the brightness of a color. This distortion is especially significant when colors are to be reproduced in black and white (such as monochrome television, for example).

Most incandescent lamps used for television or film lighting burn at a color temperature of 3,200 degrees Kelvin. At this color temperature, the light source emits a white light. When the color temperature is lowered (through dimming, for example), the light becomes progressively more reddish. If the color temperature is raised (by increasing the voltage to the lamp), the light becomes progressively more bluish.

Kind of Light Our perception of certain colors is also influenced by the kind of light under which we see the colors. No light is pure white. Rather, every light that surrounds us has a specific color tinge. Sometimes the light that we encounter outdoors has a bluish tinge; sometimes, especially at sunset, the light is reddish and warm. A fluorescent indoor light is bluer (and more like outdoor light) than a low-wattage incandescent indoor light. This bluishness or reddishness in light is called the *color temperature.* It is measured in degrees Kelvin.[15]

4·32 Colors that may be perfectly compatible under normal lighting conditions (that is, they reproduce in distinct steps of gray on black-and-white television) may appear uniformly light when flooded with too much light.

Even black may photograph as white when subjected to an overdose of light. As much as we should be aware of color distortion in dense shadow areas, we should not flood the object with too much light and eliminate the shadows altogether. Besides losing important spatial definition, we also run the risk of having all colors appear as washed-out grays on a black-and-white television screen. When photographing faces, such brightness distortions are especially detrimental.

If you want the color scene to remain stable, you should not dim any lights. In any case, do not dim any lights in action areas, since the lowering of the color temperature will visibly increase the red in skin tones. Without accurate skin tones, the television viewer is bereft of his only color standard, crude as it may be.

Do not use fluorescent lighting for makeup, scene painting, or costumes, especially if you then use incandescent lighting for the show. The blue tint of the fluorescent lamps will cause you to use reddish colors, which look even redder under the normal incandescent studio lighting.

Because of the reddish nature of incandescent indoor lighting and the bluish tinge of outdoor light, there are different films for indoor and outdoor use. The indoor film is slightly more bluish to counteract the low color temperature of indoor lights; the outdoor film is more reddish than the indoor film, to counteract high-temperature, bluish outdoor light.

You can change the color of an object almost totally by illuminating it with *colored light.* A white wall will appear red under red light, blue under blue light, green under green light, and so forth. Since white reflects all colors of the spectrum equally, it will reflect any colored light that shines on it. You can, therefore, literally paint with light. Remember, however, colored light will mix *additively,* not subtractively.

When the object is painted a specific color, however, the colored light mixes with the colored object subtractively. A red apple does not turn yellow under a green light (as it would if the colors would mix additively) but changes, rather, into a muddy black (the green light acts like a filter, blocking the red light reflection from the apple). A blue light blocks both green and red; a green apple and a red apple will both look black.

When working with colored lights (incandescent lighting instruments with color gels), make sure that the colors of the lights and the color of the objects illuminated reinforce rather than cancel each other. A green light may look very impressive on the white background. But when striking a performer, it will turn even the healthiest face color into a sickly gray. Remember also that on the television or small film screen, a uniformly colored object that is partially illuminated by colored light appears to have two colors. Unless you want to achieve special effects, stay away from colored lights in action areas.

Surface Reflectance A color changes depending on what surface it is painted on. If the surface is very dense and reflective, such as enamel, the color will look more vivid than when used on a highly absorbent surface, such as velvet.

When painted on a light-reflecting surface, color reflects a large amount of light. Its brightness registers high. When the same color is painted on a light-absorbing surface, its brightness is considerably lower. The color appears darker. Highly starched cotton or silk, therefore, reflects its color quite readily to the surrounding areas, such as the face and arms of the performer.

A dense, reflecting set will also cause considerable color spill, which can easily be picked up by the performers who work close to the set. More absorbent materials will help to minimize this reflectance problem.

Surrounding Colors A color is greatly in- fluenced by the color, or colors, by which it is sur- rounded. Generally, the foreground color takes on a tint that is complementary to the surrounding color. Such an influence of background (surround- ing) color on the foreground color is called *simul- taneous contrast.* (One color calls forth simul- taneously its contrasting, or complementary, color.)

Simultaneous contrast can also cause an un- desirable color tinge of parts of the scenery or even costumes. For example, if we place some light-gray or off-white set pieces in front of the customary chroma-key blue background, they will assume a slight yellow tinge. We can, however, easily counteract this simultaneous contrast ef- fect by giving the set pieces a very light blue wash.

Color vibrations that are caused by comple- mentary colors of equal brightness and saturation make a title card hard to read. Also, comple- mentary colors of equal brightness reproduce as the same gray. The card becomes, therefore, il- legible on black-and-white television.

4·33 Since the light (yellow) background makes the foreground color (gray) appear darker than it really is, and the dark (blue) background color makes the foreground color (gray) appear lighter than it really is, the gray on the dark (blue) back- ground must be darkened if both gray circles are to appear as approximately the same gray.

Note that the circle on the yellow background has a blue tinge; the one on the blue background seems slightly yellow.

4·34 *When we surround a certain color with its exact complementary color, the foreground color appears more vivid. This red disk looks more brilliant and saturated when surrounded by its complementary blue-green than by gray, for example. The blue-green surrounding color induces in us a complementary afterimage (red), which, when combined with the red dot, produces a supersaturated hue. If you juxtapose highly saturated complementary colors of equal brightness in a tight pattern, the colors reinforce each other to such an extent as to produce color vibrations.*

4·36 *If background and foreground hues are too similar, the title card is again very difficult to read. Also, the brightness contrast is not sufficient for good black-and-white transmission.*

4·35 *Color vibrations can provide an exciting visual experience. On television, however, color vibrations are less desirable. Scenery or clothing that has narrow, contrasting color stripes is especially prone to color vibrations. When reinforced by the electronic scanning of the television camera, such vibration effects can bleed through the whole or parts of the picture, as seen on the right shoulder of the newscaster (left screen area). Even black-and-white patterns can cause such vibration effects on color television. They are sometimes called moiré effects. [Photograph printed by courtesy of Station KTVU, Oakland, California.]*

4·37 *This title card has good legibility. The color of the letters is sufficiently different in hue and brightness so that the color can be read equally well in color and in black and white.*

Summary

In this chapter we have discussed five major aspects of color: (1) what color is, (2) how we perceive color, (3) how color influences our perception, (4) how we mix color, and (5) how color is relative.

Colors are specific waves from the visible light spectrum. Color is reflected light that has been specially filtered by an object. When light is divided by a glass prism, we can see the spectral (rainbow) colors. They range from red to violet. Objects do not possess color; they merely reflect back the colored light they are not able to absorb.

We *perceive* color (1) objectively and (2) subjectively. *Objective color perception* means that the colors we see are actually present. The eye reacts to certain light waves and the brain interprets these stimuli into specific colors. We can perceive three specific sensations of color, called attributes: hue, saturation (or chroma), and brightness (or value).

Hue describes the color itself, whether an object is red, yellow, or blue. *Saturation* describes the color richness, the color strength. A deep, rich blue is highly saturated. A similar blue that looks washed out has a low saturation. *Brightness* indicates how light or dark the color appears in a black-and-white photograph. Brightness is measured by the grayscale.

The interrelation of the three color attributes has been standardized by theoretical color models, the *color solid* and the *chromaticity diagram.* The color solid shows the most obvious variables of hue, saturation, and brightness, as they appear to us. The chromaticity diagram orders hue and saturation by their respective wavelengths. It does not classify brightness.

Subjective color perception means that we can perceive color by stimulating our perception by means other than colored light or by mixing colors in our heads. Physical pressure on the eyes or chemical stimuli directly on the brain can cause color sensations. Also, certain black-and-white patterns (either stationary or rotating) that cause a certain on-off sensation in the eye can cause pastel-like color impressions. The afterimage is also a form of subjective color sensation.

We can *mix* colors in two ways: *additively* (by mixing colored light) and *subtractively* (by mixing paint). Television works on the additive mixing principle. It produces a wide variety of colors by stimulating clusters of the three light primaries — red, green, and blue — in different combinations and degrees. Film works on the subtractive principle, by filtering out certain colors by means of the three subtractive (paint) primaries: yellow, magenta (bluish red), and cyan (greenish blue).

When the light primaries are added, they give white. When the paint primaries are added, they produce black (by filtering each other until no light passes).

There are four variables that influence how we perceive color: (1) color constancy, (2) surrounding light, (3) surface reflectance, and (4) surrounding color.

Color constancy helps us in perceiving a color as uniform, despite variations. Even if a yellow pencil is partially in the shadow (and therefore differently colored there), we perceive it to be uniformly yellow because we relate it to its context. The color camera, however, isolates colors from their context and thus interferes with color constancy.

Surrounding light can influence a color, depending on how much and what kind of light falls on the colored object. Under normal daylight, the objects reflect their full colors. But when it gets darker, the colors lose their hues. Under moonlight (very little, diffused light), all objects look uniformly gray.

Colored light can change any object's color. Colored light is generally undesirable in television lighting since it distorts the skin tones—an important color reference.

A highly *reflecting surface* makes a color appear more vivid and usually brighter than when painted on a light-absorbing surface, such as cloth.

A color is influenced by the color or colors that *surround* it. A light background makes the surrounded color appear darker; a dark background makes the color appear lighter. The background color usually gives off a complementary tinge to the foreground color. This color influence is called *simultaneous contrast.* A background color tends to reinforce the foreground color, if it is complementary. The foreground color becomes supersaturated.

Notes

[1] Conrad Mueller and Mae Rudolph, *Light and Vision* (New York: Time-Life Books, 1966).

[2] Herbert Zettl, *Television Production Handbook,* 2nd ed. (Belmont, Calif.: Wadsworth Publishing Company, Inc., 1968), pp. 199–200.

[3] Egbert Jacobson, *Basic Color* (Chicago: Paul Theobald & Company, 1948), pp. 31–32.

[4] Zettl, *Television Production Handbook,* pp. 200–201, Plate III.

[5] Joseph Cohen and Donald A. Gordon, "The Prevost-Fechner-Benham Subjective Colors," *Psychological Bulletin,* vol. 46 (1949), pp. 97–136.

[6] Compare: Daniel J. Weintraub and Edward L. Walker, *Perception* (Monterey, Calif.: Brooks/Cole Publishing Company, 1966), pp. 64–68.

[7] Rudolf Arnheim, *Art and Visual Perception* (Berkeley: University of California Press, 1965), pp. 327–328.

[8] Faber Birren, *Color Psychology and Color Therapy,* rev. ed. (New Hyde Park, N.Y.: University Books, Inc., 1961), p. 168.

[9] Arnheim, *Art and Visual Perception,* p. 326.

[10] *Ibid.,* p. 327.

[11] Gyorgy Kepes, *Language of Vision* (Chicago: Paul Theobald & Company, 1944), p. 139. See also Birren, *op. cit.*

[12] Faber Birren, *Color in Your World* (New York: The Macmillan Company, 1962), pp. 25, 37, 143.

[13] Compare: Life Library of Photography, *Color* (New York: Time-Life Books, 1970).

[14] Rudolf Arnheim, *Visual Thinking* (Berkeley: University of California Press, 1971), pp. 37–53.

[15] Zettl, *Television Production Handbook,* pp. 154–155.

Structuring Color: Functions and Composition

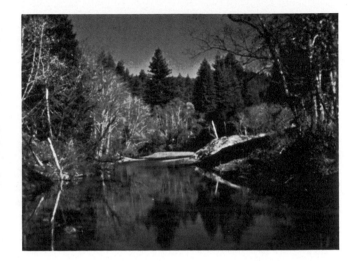

5·1

Structuring color means to use color for a specific purpose in the overall quest of clarifying and intensifying experience. To do so effectively, one must have some insight into the principal *functions* of color: (1) informational, (2) expressive, and (3) compositional.

Informational Function

The informational function of color is to tell us more about an event than is possible without color. For instance, a color reproduction tells us more about the *appearance* of the event than a black-and-white rendering (Fig. 5·1). The colors not only make the event appear *more realistic,* but also give us specific information about its condi-

tion: just what blue the sky is or what green the trees are.

In medicine, also, the diagnostician must rely heavily on the informational function of color. A difference in color may signal health or sickness. It goes without saying that in medical photography (still, television, and film) accurate color renditions are an absolute must.

Colors help to *distinguish* among objects and to establish an easy-to-read code. There is the red, green, or yellow apple, the girl in the orange dress, the fellow with the blue coat. The many wires in a telephone cable are color-coded so that each wire can be easily identified and matched at both ends of the cable. Map makers use special color codes that enable us to "read" a certain variety of data quickly and accurately; such a code can indicate various elevations, for example. We also know that strict observance of the red-green-yellow color code in a traffic light is literally a matter of life and death.

Within the context of the informational function of color, our primary task is to make one color as distinguishable as possible from the next. Considerations concerning color harmony remain secondary. Our main objective in informational color is *clarity.*

Since color television shows are still received by many people in black and white, we must supplement the color coding with other informational clues, such as written or spoken words. It is not enough for the announcer to identify a particular person by the color of her dress; he must also describe her exact location on the screen. To say "the girl in the orange dress" is of little help to the viewer of black-and-white television, especially if there are several girls on the screen.

For many centuries, man has used color to symbolize certain events, beliefs, and behavior. Thus, color can symbolize death, love, hate, faith. But such symbolic associations are *learned.* They are, therefore, subject to habits and traditions of people, which can vary considerably from culture to culture, and from period to period. Color symbolism also changes with the experience context. As a religious symbol, white signifies purity, joy, and glory. In war, it means surrender.

Such expressions as blue blood, purple joke, greenhorn, red-light district, blue laws, feeling blue, to be in the red or black, scarlet woman, black sheep, yellow coward, or blacklist are examples of color symbolism that apply especially to English-speaking countries. When translated into another language, however, the color symbolism may lose its meaning. Table 5·1 lists some symbolic color associations that are commonly understood in the Western world.

When you use color symbolically, make sure that you have firmly established the context within which you use the symbolic associations and espe-

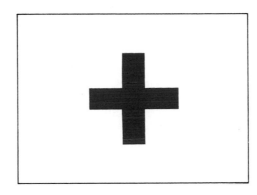

5·2 *The symbolic use of color is part of its informational function.*

Table 5·1

Color	Association
White	Enlightenment, purity, faith, glory, salvation (orientation through light)
Black	Death, evil, mourning (disorientation through absence of light)
Red	Love, passion, fire, blood (extreme emotions)
Blue	Loyalty, compassion, truth
Green	Hope, eternal life

Sergei Eisenstein in his Film Form and Film Sense *devotes a whole section (No. 3: Color and Meaning) to the symbolic use of color. But, inadvertently, his essay reveals more about the problem of precise symbolic associations through color than about the informational function of symbolic color itself.*[1]

cially that a majority of your audience is familiar with the symbolism used. A symbol whose referent is unknown serves no purpose whatsoever. Beware, therefore, of unexplained or obscure color symbolism, especially in television and film. Quite contrary to a painting or a novel, which yields readily to close and repeated examination, television and film events are not that easily revocable for closer study. Their color symbolism must carry and reveal its meaning instantaneously.

The problem of symbolic color is quite apparent: An understated color symbol may remain undetected and ineffective; an overstated one may prove too obvious to the sensitive viewer.

If you establish a new symbolic color-event association, you must provide the audience with enough clues so that it can *learn* this new association.

Expressive Function

The expressive function of color is to make us *feel* in a specific way. First, colors can express the *essential quality* of an object or event. Second, color can add *excitement and drama* to an event. And third, color can help to establish a *mood.*

Expressing Essential Quality of an Event
How would you react to black toothpaste, even if there were overwhelming evidence that black toothpaste cleaned teeth better and prevented tooth decay more effectively than white toothpaste? Or how would you feel if a doctor, who is about to perform major surgery, were dressed in red and orange and the operating room were painted in pink candy stripes?

Package designers are very careful to choose for their products colors that we associate most readily with their essential quality. White, or at least mint-green, toothpaste seems to be better suited to keep teeth white than black or dark brown toothpaste; we associate white more readily with cleanliness than dark brown or black. But black or dark purple appear to be quite appropriate for a spicy perfume, since these colors suggest forbidden love or secret passion.

If the essential quality of the product is softness (such as hand lotion or tissue paper), we expect the color of such a product to express this quality. Desaturated pastel colors are therefore most appropriate to express softness. Strong spices, on the other hand, are best expressed by strong, highly saturated colors.

A dark, warm brown, or a neutral off-white, seems to express the objective, unbiased judicial activity in a courtroom more readily than a bright, highly saturated red. A soothing green reflects more appropriately the cool efficient activity in an operating room than would a shocking pink.

Here again, it is not so much the color itself, the hue, that we associate with the quality of the object or the event but rather *the energy of the color.* In the high-energy emotional environment of a carnival, gay, high-energy colors are well suited to express the joyful, noisy nature of the event. But we tend to associate the cool, rational activity of a science laboratory most readily with low-energy, cool colors.

Sometimes color is used to symbolize extreme states of emotion. You may project red flashes over the entire screen to express someone's intense moments of rage or love. Cool-colored scenes may indicate extreme sadness, sorrow, or disillusionment. A less extreme method is to distort natural hues into a hot or cool direction, depending on the specific expressive color function.

Providing Excitement and Drama
Colors can provide excitement and drama for an event. The colorful uniforms of the marching band, the color-

ful costumes of dancers, the red flashing light of the police car or emergency vehicle, the colored spotlight on the stage, the spectacular colors of a sunset or sunrise are but a few examples of how colors can excite us and intensify an event dramatically.

Though quite established in the art of painting, color has only recently gained its independence as an expressive element in film and television. As in an abstract painting, where color is used not for an event but *as the event itself,* color can be used as the basic expressive element in television and film. The use of colored light as an expressive element has been popularized by the light shows that frequently accompany rock-and-roll concerts. But they have also gained respectability as an independent art form and can be found in many museums around the world.

In television and film, such pure color experiences are extremely rare and therefore far from being an accepted means of expression. The most consistent experiments with color as an independent expressive medium have been undertaken by the National Center for Experimental Television in San Francisco. The Center has successfully built and used a color synthesizer, which produces predictable and repeatable color patterns on the television screen without the aid of a television camera.

Whenever color is used abstractly, that is, as the principal *materia* for an aesthetic television or film event, it is usually presented in conjunction with another abstract experience: sound. The combining of colors and sounds is, of course, the most natural thing to do. Aesthetically, we tend to react quite similarly to colors and sounds. Think how often we use musical terms to describe colors and color terminology to describe certain musical sounds. We speak of "shrill" and "loud" colors, and harmonic or dissonant color combinations. There are warm sounds, blue notes, colorful notes or sound combinations.

The expressive function of colored light, long ago recognized by the artists who crafted the stained-glass windows of the Gothic cathedrals, has been rediscovered and applied in various ways since 1714, when the Jesuit priest and mathematician Louis-Bertrand Castel constructed the first color organ.[2] Other pioneers, like Adrian Bernard Klein, who published a treatise on the expressive function of color, Colour-Music: The Art of Light, as early as 1927, L. Moholy-Nagy (see Chapter 1) and Gyorgy Kepes (professor at the Massachusetts Institute of Technology and author of numerous works on visual perception and the structure of art), with their Bauhaus-inspired light experiments in the 1920s and 1930s, were the forerunners of the more recent highly sophisticated light art by the Group Zero of Düsseldorf, Germany, and the Groupe de Recherche d'Art Visuel of Paris, France.[3]

5·3 *Look at these color patterns and try to "hear" them. Do they both sound the same? What are the differences? You probably notice that the pattern of the figure at the top sounds shrill, high-pitched. The pattern in the bottom figure is low-pitched, full, more harmonious.*

This close relationship between colors and sounds has been used, for example, to teach deaf people to talk. Machines, like the Chromalizer, convert sounds into simple colors. The deaf person tries to adjust his speech sounds in such a way that they match sample color patterns of specific words.[4]

Any attempts, however, to find a system in which colors and sounds can be matched aesthetically have failed thus far. Sir Isaac Newton, for instance, constructed a color-sound scale, in which each individual note of the diatonic scale was matched with a specific color: C = red, D = orange, E = yellow, F = green, G = blue, A = indigo, and B = violet.[5] The problem with this notation is that although each of the individual notes might correspond to the assigned color in feeling, the combination of notes, as in a chord, rarely matches similar combinations of assigned colors. A chord is something quite different from the sum of its individual tone components. The same is true of color. A color pattern has an expressive quality that is quite different from the way each individual color feels. To match color and sound successfully, we must rather compare the *energy level* of the *sound combinations* to the *energy level* of the *color pattern.*

In certain instances, however, we may find that we can single out a particular color attribute (such as hue, saturation, or brightness) and match it (Table 5·2) with the corresponding sound attribute (such as pitch, timbre, and dynamics).[6] We can express the color-sound attribute relationships in a simple formula:

$$\text{Hue (color frequency)} = \frac{1}{\text{Pitch (sound frequency)}}$$

$$\text{Saturation (color complexity)} = \frac{1}{\text{Timbre (sound complexity)}}$$

$$\text{Brightness (color reflectance)} = \text{Dynamics (sound reflectance)}$$

In color-sound association, we can match attributes of color and sound that have a common variable. The common variable for color hue and sound pitch is frequency; for color saturation and sound timbre, it is complexity; for color brightness and sound dynamics (loudness), it is reflectance.

This means that red (warm hue, low frequency) is most readily and harmoniously associated with high, shrill notes (high pitch, high frequency). A saturated green (simple waves) relates to a mellow timbre (viola) with many overtones (that is, complex waves). A color with much brightness (high reflectance) relates to a loud sound (high reflectance).

Table 5·2 **Color-Sound Attribute Association**

Color Attribute	Sound Attribute	Common Variable	Relationship		
Hue	*Pitch*	*Frequency*	*Inverse:*		
(red end of scale)	high, shrill		color:	long waves, low frequency	
			pitch:	high frequency	
(blue end of scale)	low, mellow		color:	short waves, high frequency	
			pitch:	low frequency	
Saturation	*Timbre*	*Complexity*	*Inverse:*		
high	rich (cello)		color:	simple waves	
			timbre:	complex waves	
low	lean (flute)		color:	complex waves	
			timbre:	simple waves	
Brightness	*Dynamics*	*Reflectance*	*Direct:*		
high	loud		color:	high reflectance	
			sound:	high reflectance	
low	soft		color:	low reflectance	
			sound:	low reflectance	

Establishing Mood The expressive quality of color is, like music, an excellent vehicle for establishing or intensifying a mood. Warm, highly saturated, and bright colors of the red end of the spectrum obviously exert a fair amount of energy and therefore suggest a gay, happy mood or an energetic event. Cold, subdued colors of the blue end of the spectrum will do the opposite. However, as with all color events, there are innumerable variations to this admittedly gross generalization.

An especially violent scene may gain in intensity when presented in a low-energy cool color scheme. Warm, gay colors may serve as chilling counterpoint to a death scene. Whether or not we should use colors harmonically or contrapuntally depends to a great extent on the context of the total event and on what overall aesthetic effect we may want to achieve.

A most effective way of using color for establishing or intensifying mood is to give the entire scene a single hue tinge. In the film *A Man and a Woman,* for example, most scenes are presented in subtle, single-hue tones, each expressing the prevailing mood of the scene. There are the warm, sepia-colored moods of love and passion and the cool-colored hues of frustration and anxiety. Only the dream sequences suddenly jump into a vivid, highly saturated color scheme, intensifying the irrationality and surreality of the subconscious.

In using color for establishing mood, you should pay particular attention to the relative *warmness* or *coldness* of the color, and its overall *aesthetic energy.* Generally, you can easily attach similar labels to the mood of a scene. There may be a high-energy, hot scene or a low-energy, warm scene. There may be a high-energy, cold scene or a low-energy, cold scene or any combination thereof. By using the color energy table (see Chapter 4, page 70), you can then easily find the color or

5·4 *One way of achieving a low-definition appearance is to show the event in a subdued color scheme. The colors are less saturated and fall more or less into a warm or cold tendency field.*

We can make a scene even more low-definition by giving the whole scene a common color tinge that corresponds with the general mood of the event (warm = up; cold = down).

color combination that fits harmoniously or the ones that provide the necessary counterpoint relative to the other aesthetic elements in the tendency field of the event.

Sometimes, you may find that a certain event is best clarified and intensified by omitting color altogether. The criterion for whether or not to shoot a scene in color should certainly depend, not on whether or not you have access to color equipment, but rather on the internal structure of the event and the depth you intend to reveal.

If the event is extremely *internal,* color may hinder rather than help its intensification. An intimate love scene, a mother nursing her baby, a wounded soldier waiting helplessly on a battlefield, a person finally confessing his secret aspirations and anxieties to his friend usually carry so much expressive energy that color is, at best, un-

necessary as intensifier. More importantly, however, color might make such internal events too external. Presenting the bodies of two lovers in "living" color could lure the viewer to *look at* rather than *look into* the event. To portray the internal condition of an event means to *penetrate* outer reality. But since the color on recognizable images (people or objects) emphasizes the *appearance* of things, it may hinder rather than help our looking into the event. Color draws attention to the outer, rather than the inner, reality of an event. If we want to penetrate the outer reality of things so that we can perceive their intimate essences, we must de-emphasize rather than focus on appearance. We should, therefore, render the outer appearance of things low-definition.

When or when not to use color should no longer present too difficult a problem for you. If color, even

We can achieve further low-definition by eliminating color altogether. In black and white, the outer event often serves as an extension of the inner event.

If the black-and-white image is further reduced in definition, we are not only permitted but also often compelled to deal with an inner reality. In order to perceive the total gestalt of the event, we need to supply, in our psychological closure and subjective completion, elements of the inner structure, as well as the outer form.

when used expressively, prevents you from perceiving an event in all its depth and subtleties, use black and white. If color helps to clarify and intensify an event, use it. Obviously, if colors are needed for providing more information about an event, black and white no longer suffice. If you are after sheer excitement and spectacle, color is a must.

Generally, however, the more intimate, the more internal, an event becomes, the more you can treat outer reality low-definition. The more low-definition the outer reality should be, the less important color becomes. Color intensifies landscape, not necessarily inscape (internal event, scope of emotions).

The switch from black and white to color proved especially difficult for film and television directors who had been primarily concerned with communicating inner reality (for example, Federico Fellini and Ingmar Bergman). They discovered that while spectacle translated quite readily from black and white into color, they needed a new approach to the scenes dealing with inner events. They found that they had to explore thoroughly the expressive functions of color and their peculiar aesthetic requirements before they could use color to match the aesthetic quality of their black-and-white films.

Compositional Function

Colors contribute greatly to the general form of the television or film image. As in a painting, colors help to define certain screen areas, that is, they emphasize some areas and de-emphasize others. We may select a certain color as the focal point in the screen area and then distribute the other colors accordingly to achieve a balanced pictorial composition. Or we may choose certain colors or a certain color combination that will help to produce a predetermined overall energy level. When colors are used for such purposes, we speak of the *compositional function* of color.

Generally, we aim at a *harmonious color combination,* a juxtaposition of colors that go together well. This means that we should be able to detect certain color relationships that yield rather easily to the perception of a dynamic pattern. In an effective color composition, colors are no longer random; each one of them has purpose.

There are several ways of approaching the problem of color composition. The usual one is to look at the hue circle of the color solid and to specify certain colors that interact most readily with each other. Another way, and probably the most flexible, is to translate the colors into degrees of aesthetic energy and then to bring the various energies into balance or purposeful conflict.

Unfortunately, some of the relativity factors of colors can cause a dissonant color pattern, even if you have selected the hues carefully by the hue criteria as outlined above. For example, a red may overpower the complementary green, if the red area is much larger than the green area. Again, highly saturated colors may clash, whereas the same hues may harmonize well when less saturated. Once more, you may find it more convenient to translate the colors into *aesthetic energy* (see Table 4·2). You can then establish a pattern in which the *color energies,* rather than merely their hues, are brought into balance.

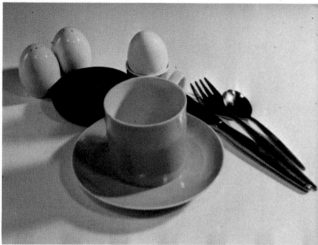

Color Mixture by Hues

5·5 *We can use saturation and brightness variations of a single hue and accent them with black and white.*

5·6 *Those colors that lie next to each other on the hue circle usually go together well. By changing the saturation of each of the adjacent colors, we can achieve a wide variety of hues, all of which fall readily into a harmonious color pattern.*

This energy distribution of color works especially well in scene design and costuming. Generally, you should try to keep large set areas in a rather uniform, low-energy color scheme, but then accent with high-energy accessories, such as bright curtains, pillows, furniture upholstery, flowers, rugs, and the like. This gives you more control over the total effect.

Similarly, you can keep your general color scheme of the costumes rather even and conservative, but then energize the scene by colorful, high-energy costume accessories, such as scarves, shirts, belts, and the like.

When dealing with color energies, you can incorporate the compositional function of color more readily into the general aesthetic energy field than if you were dealing solely with the relationships of hues. As a matter of fact, by trying to balance color energies rather than hues, you may discover exciting new color combinations that defy tradition but not our quest for clarified and intensified experience.[7]

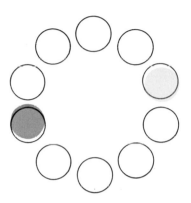

5·7 *Colors that lie opposite each other on the hue circle are complementary and form a contrasting, but harmonious, combination. Remember, however, that highly saturated complementary colors reinforce each other. If the color pattern is rather narrow, this reinforcement can cause color vibration.*

5·8 *If we superimpose an equilateral triangle over the hue circle, the tips of the triangle point to colors that usually harmonize quite readily.*

In television, the variables such as amount of light, reflectance of surface, response of the color camera and its associated equipment make extremely difficult an accurate prediction of how colors will actually appear on the screen. The best way to see how a color reproduces is to test it out on camera under the actual production condition. Unfortunately, it is very hard for a cameraman and director to properly compose a shot according to the energy requirements of the color, since all camera viewfinders and most preview monitors are in black and white. Only the master (line) monitor is usually in color. Neither the cameraman nor the director has, therefore, a real chance to work on the composition of the picture before it is punched up on the line. Obviously, all preview monitors and camera viewfinders should be in color. Set designers, too, should have a simple color chain and lighting setup available for testing their color designs.

a

b

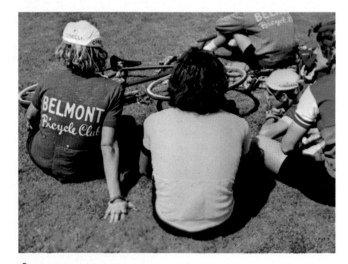

c

5·9 *For example, you can balance a high-
energy color area with another high-energy color
of equal magnitude (a). Or you may want to
balance a high-energy color with a larger, low-
energy area (b). Or you may place the high-energy
color in a suitable place within the screen (see
Chapter 6) and distribute the other, more low-
energy colors around the high-energy focal
point (c).*

Summary

Structuring color means to use color for a spe-
cific purpose. There are three principal *functions*
of color: (1) informational, (2) expressive, and (3)
compositional.

The *informational* function of color is to tell
more about an object or event. Color can help to
render the scene more *realistically.* Color can help
us to *distinguish* among objects and to establish
an identification *code.* The *symbolic* use of color
is part of its informational function. But symbolic

associations are learned. The symbolism must be known to the audience in order to be effective.

The *expressive* function of color is to make us *feel* in a specific way. First, colors can express the *essential quality* of an object or event. Package designers use certain colors to have us associate certain feelings and attitudes with their product (white toothpaste, black perfume wrappings, and so forth).

Second, color can provide drama and excitement. Colorful uniforms of a marching band, the flashing red light on the police car, or the colored spotlight on stage are examples of this color function. Color can also be used as the *event itself.* Color no longer is part of the event; it *is* the event. In abstract paintings and light shows, color is the principal *materia* for the aesthetic event. There is a close relationship between color and sound in their expressive qualities. We can associate most readily color hue and sound pitch, with frequency as the common variable; color saturation and timbre, with complexity as the common variable; and color brightness and sound dynamics, with reflectance as the common variable.

Third, color can establish a certain mood. Generally, warm, high-energy colors contribute to a happy mood; cold, low-energy colors to a somber mood. Sometimes, it seems best to subdue the color scheme or to omit color altogether in order to reveal and to intensify an *inner* event. Low-definition color (subdued color scheme or single hue), or even low-definition black and white, de-emphasizes the outer appearance of things and draws attention to the *inner reality* of the event. The more intimate, the more internal, the event is, the more outer reality can be treated low-definition. The more low-definition outer reality should be, the less important color becomes.

The *compositional* function of color is to help establish form. Colors can define certain screen areas. They can emphasize some areas and de-emphasize others in order to bring the energies of the pictorial elements into a balanced, yet dynamic, interplay.

Color composition can be achieved by making use of the color theory as exemplified by the color solid. Generally, brightness and saturation variations of a single hue harmonize well and can be easily accented with black and white. Also, the hues that lie close to each other, opposite each other (complementary), or at the tips of an equilateral triangle on the hue circle, harmonize readily with one another.

A more flexible, if not more effective, way of composing with color is to translate the various colors into color energies and to distribute the energies within the television or film screen so that they contribute to an overall dynamic pattern (see Table 4·2).

Notes

[1] Sergei Eisenstein, *Film Form and Film Sense,* ed. and trans. Jack Leyda, in one volume (New York: World Publishing Company, 1957), pp. 113–153. Also see Faber Birren, *Color Psychology and Color Therapy,* rev. ed. (New Hyde Park, N. Y.: University Books, Inc., 1961), pp. 162–173, and *Color in Your World* (New York: The Macmillan Company, 1962), pp. 91–108.

[2] Jack Burnham, *Beyond Modern Sculpture* (New York: George Braziller, Inc., 1967), p. 286.

[3] Howard Wise, "Kinetic Light Art," *American Home* (October 1969), pp. 26–32.

[4] John Rowan Wilson, *The Mind* (New York: Time-Life Books, 1964), p. 121.

[5] Birren, *Color Psychology,* p. 153.

[6] For an explanation of sound elements, see Chapter 15.

[7] When you deal with color energies in pictorial composition, you are actually working with vectors and the structure of a vector field. Compare the discussion of vectors in Chapters 6, 8, 11, and 13.

6

The Two-Dimensional Field: Area

Look at the opposite page. It is empty, neutral space; but, like a television or film screen, it provides a spatial field that is clearly defined by height and width.

The screen provides us with a new, concentrated living space, a new field for aesthetic expression. It helps us to tame space. We are no longer dealing with the real space we walk through and live in every day, but rather with *screen space.* We must now clarify and intensify experience within the context of screen space. Not what we might see but what the *camera* sees becomes of primary importance.

Let's examine these three major structural factors of screen space: (1) area orientation, (2) size, and (3) the basic screen forces.

Area Orientation

A painter or photographer has free choice in the basic orientation of his picture. He may want a frame that is taller than wide for a skyscraper or a horizontally oriented format for the wide expanse of a desert landscape. He can have a round, or even irregularly shaped picture. In television and film, we do not have this format flexibility. Television and film screens are always horizontally oriented. Why? Because we live and operate basically on a horizontal plane. When we talk, we usually stand next to, rather than on top of, each other. A distance of two hundred miles is nothing unusual to us; a height of two hundred miles is another story. A six-hundred-foot-high tower is a structural adventure; a six-hundred-foot-long building is simply large.

6·1 *The screen, like the empty page, represents defined space—an area within which we can orient ourselves. Its borders provide a spatial reference that allows us to assess the spatial relations within the screen, and to assert our position relative to it. We can now say where a thing is relative to the four borders.*

6·2

6·3 *In a 3:4 aspect ratio, the difference between width and height is not too drastic to emphasize unduly one dimension over the other.*

Sometimes, the 3:4 aspect ratio is expressed as a 1:1.33 ratio. For every unit in height, there are 1.33 units in width.

6·4 *We can change a horizontal into a vertical screen orientation or change from an establishing long shot to an isolated, intimate close-up quite easily and smoothly within this 3:4 aspect ratio.*

Aspect Ratio The ''classical'' motion picture screen and the television screen have a 3:4 aspect ratio; the screens are three units high and four units wide (Fig. 6·2).

The wide motion picture screen with its yen to engulf us with spectacle (Fig. 6·5), stretches into an extremely wide, wrap-around aspect ratio, ranging from 3:6.18 to as much as 3:7.5.

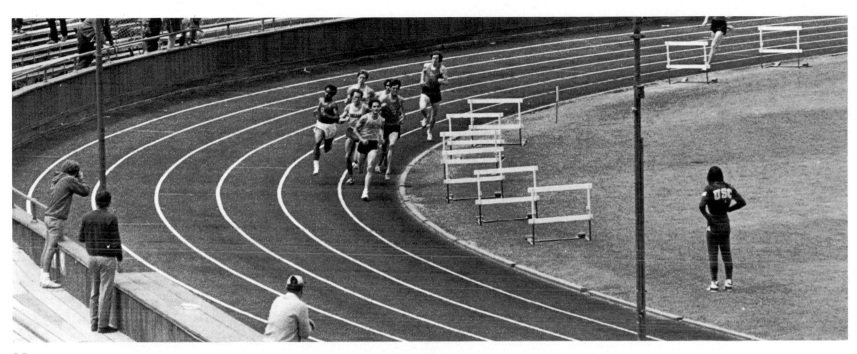

6·5

The usual wide-screen, or cinemascope, motion picture screens have a minimum ratio of 1:2.06 and stretch to 1:2.50.

As you can see in Figure 6·6, however, it is rather difficult to isolate a single pictorial element or action on the wide screen. There are always some extraneous elements left to fill the sides of the screen. In this respect, the wide motion picture screen is very much like the theater proscenium. The viewer is not necessarily restricted to looking at the main action but can focus on any part of the

6·6 *Quite obviously, compositions and actions that need a large horizontal space become super-dramatic within such a horizontally expanded aspect ratio. It supports large, external action.*

6·7 *In this long shot of a sidewalk café scene, all actions are equally important. As a director, you must control the actions at the side tables as well as the main action at the center table.*

scene he pleases. This puts a particular burden on you as a director. When you move in from a long shot to a close-up, you still have "peripheral" picture elements left over that need your full attention. (See Figure 6·8.)

Changing the Aspect Ratio Since the early days of the motion picture, attempts have been made to change the fixed aspect ratio of the screen whenever the pictorial content demanded such a change. Especially in the days of the silent film, when story and concepts had to be communicated by visual means only, the masking or, rather, "blacking out" of parts of the screen was a common cinematographic technique. Today such techniques have, at least partially, been revived.

By relegating certain pictorial elements that are part of the scene to masking devices, we can give the viewer the impression of a changed aspect ratio.

6·8 *But, unless you move in for an extreme close-up of the center table action, the side tables still figure prominently in the picture. You cannot, therefore, ignore the action at these side tables.*

6·9 *One of the most popular effects is the "iris" effect, which looks like a strong spotlight concentrated on part of the screen.*

6·10 *Masking the sides or the bottom and top parts of the screen can change the normal screen aspect ratio into a vertical or an extreme horizontal direction.*

6·11

D. W. Griffith (1875–1948), one of the most creative American film producer-directors of the silent film era, was especially fond of screen masking. One of the more successful masking effects occurred in a spectacular battle scene in his Intolerance. *In order to make a soldier's fall from high atop the walls of Babylon more dramatic, Griffith changed the horizontal aspect ratio into a vertical one by masking both sides of the screen (Fig. 6·11).*

The problem with any masking device is that the viewer remains very much aware of the basic, actual screen borders. After all, the physical borders of the screen are the primary spatial frame of reference. Just look at your television set. No matter how much of the screen area is blacked out or masked with graphic elements, you can see clearly the physical borders of the screen. Hence, you instinctively relate the events on the screen, including the masking devices, to the original screen borders. It is, therefore, an aesthetic fallacy to believe that a quad-divided screen would fool

6·12 *By filling both sides of the wide movie screen with buildings, we build a vertical screen space within which the height of the cathedral is properly intensified.*

the viewer into believing that he is watching four independent television screens; all he perceives is a *divided* screen, *not* multiple screens. The same is true of a movie screen, unless the viewer walks into a totally blacked-out theater and is never aware of the actual dimensions of the movie screen. The actual screen borders remain a primary spatial reference for him, even if the screen is divided into several areas.

Of course, the moving camera can quite easily overcome the basic graphic restrictions of the fixed aspect ratio of the screen.

6·13 *We can emphasize the feeling of forced inactivity of these people by squeezing them into the exaggerated horizontal space of a train or streetcar.*

6·14 *If the complexity of the subject and/or scene warrants such a treatment, we may want to divide the basic screen area into several secondary independent picture areas.*

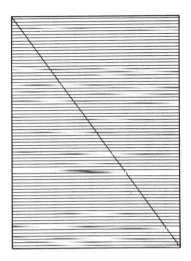

6·16 For example, we could try to change the scanning pattern from a horizontal to a vertical orientation. The screen could then be simultaneously masked to fit the new scanning pattern.

There is certainly enough aesthetic justification for experimenting with a flexible aspect ratio of the television and film screens.

6·17 In film, additional screen units could be added for a horizontal or vertical emphasis. The aperture of the projector could be coupled with the screen to change its aspect ratio accordingly.

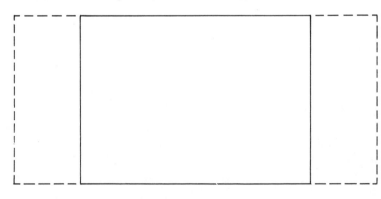

6·15 We can start with a close-up of the bottom of a tall tower that fills most of the screen area. By tilting up, we reveal and emphasize dramatically the height of the structure, while never once wasting much of the screen sides. This tilting technique is especially helpful on television, since the television screen area is frequently too small to show effectively a tall vertical structure in its entirety. A pan sideways will similarly dramatize the horizontal dimension.

Size

Have you ever felt ill at ease when watching a motion picture spectacle on the small television screen? Some motion pictures that are designed for the large cinemascope screen do not seem to come across as well on the television screen. Apparently, physical size has a great deal to do with how we perceive and feel about certain screen images.

Image Size The image size on a motion picture screen is many times larger than on a television screen (minimum width for cinemascope screen: 50 feet; largest television screen, measured diagonally: 48 inches).

This does not mean, however, that you see nothing but giants on the movie screen and dwarfs on television. As with color constancy, our perception is guided by *size constancy,* which means that we perceive people and their environment as normal-sized, regardless of whether they appear as immense images on a cinemascope screen or as very small images on an 8-inch television set. As long as we know how large or small an object should be, how far it seems to be away from us (the observer), or judge its size by its context, we perceive it in its normal size, regardless of whether we sit close to the screen or far away or whether we see it in a close-up or a long shot.

And yet, image size is a very important aesthetic factor. A large cinemascope image simply feels more overpowering than a small television image; it is visually "louder" than the small image, especially when the curved screen wraps the image half-way around you. An image, when large, has more energy than the same image when small. Just think of how you felt when you were in the presence of an exceptionally large thing: a huge

Size constancy, similar to color constancy, aids us in maintaining perceptual stability. It makes possible our perception of the approximate size and shape of an object no matter whether we are close or far in relation to the object or from what angle we look at it.

Size constancy is truly a contextual phenomenon, since it is the context within which we see an object that supplies us with the necessary clues for perceiving the object's actual shape and size.[1]

6·18 *Look at these figures. With no other contextual clues, we perceive ellipses of various shapes.*

6·19 *But as soon as we are provided with a different experience context, such as phonograph records, we no longer perceive variously shaped ellipses but round disks as seen from various angles.*

6·20 *A good clue to the size of an object is seeing it next to a familiar object. How big is this chair? We cannot tell as long as it is isolated from its environment. Our only contextual reference here is the picture frame. Since we know from experience approximately how big a chair is, we assume that the framed image represents a normal-sized chair.*

As soon as we include more perceptual clues in the context, however, we can make more accurate judgments about the chair's actual size. We can see quite easily that the wicker chair is indeed quite small. But is it really? Or is the other chair simply superlarge? We will have to add another clue to the perceptual context before we can estimate the actual size of the wicker chair more accurately.

When finally shown in the context of the universal size reference: man, the size of the chairs and their true relationship become immediately evident.

6·21 *We perceive a face unchanging in size, regardless of whether we see it as a close-up or in a long shot. By knowing an object's size, we can similarly judge its distance from us by how big we see it.*

When showing an object on the screen, make sure that you have included in your shot or shot sequence enough perceptual clues for computing actual size and shape. When you observe an actual event, you can quickly find perceptual reference points (such as distance from the object or other objects with which you are familiar) simply by looking around. But you have no such control over screen images.

6·22 *Another important clue to the size of an object is how far it is away from us. The closer an object is, the larger the image we perceive. The farther away it is, the smaller the image we perceive. If we, therefore, know or can estimate how far an object is away from us, we automatically compute its size. Since we can see that these arches recede into the distance, we perceive them as having the same size.*

6·23 *Since we can assume that airplanes fly at some distance from each other, airplane 3 does not seem smaller than airplane 5 but simply farther away.*

We can see only what the camera has pre-seen for us. If the camera has not included enough contextual clues for us to judge the size and shape of an object, we have only the screen borders left to help us make some perceptual guesses.

6·24 *This disk seems large, because it is large relative to the area of the screen.*

This disk, however, seems small, since it is small relative to the area of the screen.

Inclusion of some size references of course helps us judge the disk size much more accurately.

skyscraper, a giant ocean liner or airplane, the interior of a Gothic cathedral, a crowded football stadium, a mass rally. You probably did not feel any smaller physically than in any other environment, but the largeness of your environment probably overwhelmed you somehow. The mere energy of largeness can inspire awe. Large things just do not seem to be as manageable as small things. You have less control over them, which makes them appear more powerful than small ones.

People and Things The overwhelmingly large cinemascope screen images present to you a spectacle. *People* as well as *things* attain spectacular proportions, not only physically but also psychologically. The simple act of a man walking down a country road becomes a grand gesture. On the small television screen it remains a simple act.

In Stanley Kubrick's *2001,* things such as the spaceship floating majestically across the giant screen, have as much or more impact on the viewer as the fate of the crew. On the small television screen, however, people, not things, would have to supply the content and carry most of the show's impact.

In effect, we look *at* the spectacle on the large movie screen but (when properly handled) *into* the event on television. We *observe* the large images on the large movie screen; but we *participate* in the inductively presented event on television.

When the action is squeezed from the large-sized cinemascope screen to the small television screen, not only is the image *size* drastically influenced but also the *timing,* the perceived *pace* of the event. As the space (image size) is reduced on the small television screen, so is time. Consequently, what appears to be normally paced on the large screen can look ridiculously fast on the small television screen. We can notice this event acceleration not only in the movements of the performers on the screen but also in the camera movement and especially in the cutting rhythm. We will discuss this time phenomenon more extensively in Chapters 12 and 13.

Stanley Kubrick (1928–), American motion-picture director. Especially known for his films Dr. Strangelove, Lolita, 2001: A Space Odyssey, *and* Clockwork Orange.

Deductive Visual Approach

6·25 The large area of the cinemascope screen allows us to present a whole vista, an overview, without losing much scenic detail. In film, we usually move deductively from an overview to scenic detail.

Inductive Visual Approach

6·26 *On the other hand, the relatively small television screen area is more suited to close-up detail than to wide vistalike overviews. We can, therefore, take advantage of this spatial characteristic and establish a scene inductively; that is, we can move from several details to the overview or simply present a series of details that the viewer can combine in his head into the overall scene. This inductive technique requires that we analyze each scene very carefully and select those characteristic scenic details that readily relate to one another to form a complete, sensible whole.*

Field Forces within the Screen

In our effort to tame space aesthetically, we have established the television and motion picture screens as a new field of operations. The screen is our new principal frame of reference for the events happening within it. Within this new spatial frame of reference, highly specific field forces begin to operate. They are quite different from those of a nondefined field, such as our actual three-dimensional environment.

In order to clarify and intensify events within the new operational spatial field, you should know something about these six major types of field forces: (1) main directions, (2) magnetism of the frame and attraction of mass, (3) asymmetry of the screen, (4) figure-ground, (5) psychological closure, and (6) vectors.

Main Directions The main directions of a rectangular television or motion picture screen are horizontal and vertical. By emphasizing one or the other main direction, we can suggest a feeling of low-energy, calmness (horizontal), or high-energy, excitement (vertical). A purposeful distortion of these main directions can lead to heightened aesthetic energy, an intensification of the screen event.

Main Directions: Horizontal

6-27 *Horizontal lines suggest calmness, tranquility, rest. We feel normal when operating on the familiar horizontal plane. Emphasizing the horizontal within the frame suggests normalcy; it gives us a feeling of stability.*

Main Directions: Vertical

6·28 *Vertical lines are more powerful, more exciting, than horizontal ones. The pull of gravity charges them with extra energy. A vertical orientation suggests power, drama, but also formality and strength. A vertical direction is more dynamic than a horizontal one.*

6·29 *The vertical orientation of a Gothic cathedral (Gothic period roughly from 1150 to 1400) reflects man's orientation upward, toward God. Life on this earth was simply a preparation for the real life in heaven. People lived and worked strictly "in dei gloriam," for the glory of God.*

6·30 *The Renaissance, the rebirth of classical Greek architecture (roughly from 1400 to 1600), emphasized the importance of man. The buildings, including the cathedrals, were horizontally oriented, hugging the earth, rather than trying to leave it. "In dei gloriam" was supplanted by the "in hominis gloriam," for the glory of man.*

Main Directions: Vertical-Horizontal

6·32 *A combination of horizontals and verticals reflects our normal world; it makes us feel that we are standing upright on level ground. Most of our physical environment—the buildings we live in, the furniture—are verticals perpendicular to level ground.*

6·31 *Today, the vertical orientation of the sky-scraper suggests man's mobility, his earth-defying adventurous spirit. It reflects the dynamism of modern man.*

Tilting the Horizontal Plane

6·33 By tilting the horizontal plane within the screen, we can create an intense feeling of disorientation. The normal upright position on a horizontal plane is utterly disturbed. When we sit close to a large screen, the tilted horizon effect can cause extreme psychophysical discomfort—in extreme cases even nausea.

6·34 We can use the powerful disorienting effect of the tilted horizon line to signify or intensify extreme physical or mental stress or simply to make a scene appear more dynamic, more energetic.

The tilted horizon on the screen is similar to the tilted horizon effect when we sit in an airplane that banks sharply in a turn. The universal reference, the horizontal plane of the earth, seems out of whack. We accept the airplane as the stable element, rather than the earth; and the horizon, rather than the airplane, seems to be doing the tilting.

6·35 There is little doubt which building looks more dynamic. But we must be careful with overemphasizing the dynamism of a scene through disturbing the horizontal orientation. If we want to suggest energy, bustling activity, progress, and the like, the dynamic rendering of a building as in scene (a) is highly appropriate. But if we want to emphasize stability, conservatism, reliability, we may want to show the buildings more securely oriented as in scene (b).

a

b

Magnetism of the Frame and Attraction of Mass The frame of a picture field, the edges of the screen, exert a strong pull on objects near them. Especially the corners (where the forces of the two main directions, height and width, converge) attract near objects with great force. Sometimes this magnetic pull of the frame is so strong that it counteracts our natural reaction to gravitational pull. Try to determine for yourself how the magnetism of the frame operates on the disk which is placed in different parts of the screen. Cover the right half of the illustrations in Figure 6·36 and mark the direction of the pull for each frame with a lightly penciled arrow. Then check yourself against the diagrams at the right.

Mass attracts mass. This is also true of the "mass" of screen images, which we call *graphic mass.*

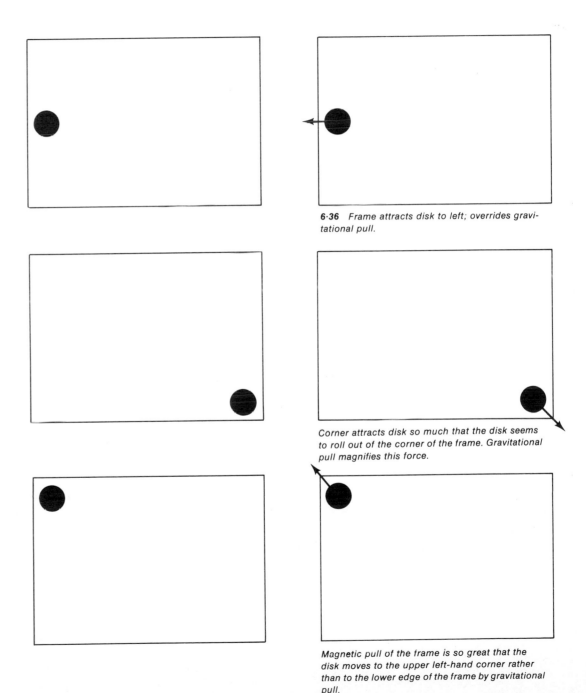

6·36 *Frame attracts disk to left; overrides gravitational pull.*

Corner attracts disk so much that the disk seems to roll out of the corner of the frame. Gravitational pull magnifies this force.

Magnetic pull of the frame is so great that the disk moves to the upper left-hand corner rather than to the lower edge of the frame by gravitational pull.

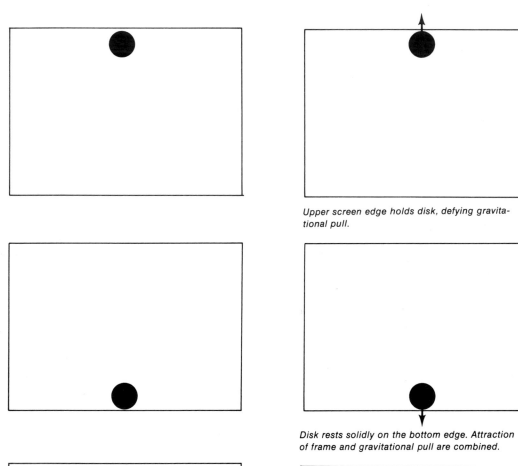

Upper screen edge holds disk, defying gravitational pull.

Disk rests solidly on the bottom edge. Attraction of frame and gravitational pull are combined.

When the disk is exactly in the middle of the screen, it is most stable. All pulls are perfectly equalized.[2]

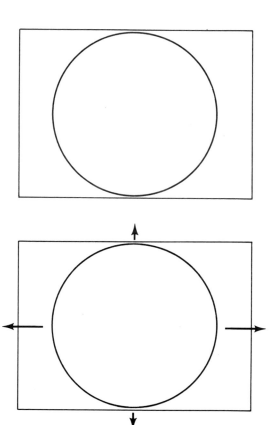

6·37 *If the disk is wedged into the screen, the disk seems to expand in all directions. It seems to burst out of the confinement of the frame and grow larger.*

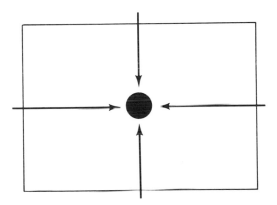

6·38 *Conversely, if the object is centered within the picture field and far away from the screen edges, the concentrated "heavy" space surrounding the object seems to compress it, making it appear smaller than it really is.*

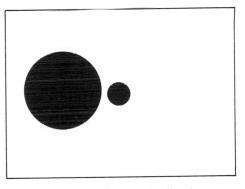

6·39 *Graphic mass attracts graphic mass.*

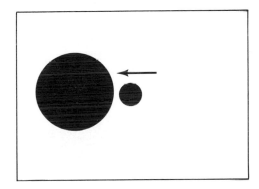

The larger the mass, the larger its attractive power. The larger graphic mass attracts the smaller one and not vice versa.

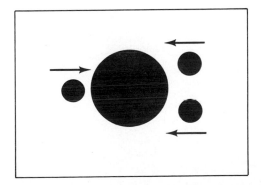

The large mass is more independent than the smaller masses. The larger graphic mass is more stable (less likely to move) than the smaller ones.

6·40 In this painting by Antonello da Messina *(ca. 1430-ca. 1479), The Calvary, the upper edge of the frame pulls the Christ figure up. This pull emphasizes His hanging from the cross (or, actually, from the top of the frame).* [Courtesy of Koninklijk Museum voor Schone Kunsten, Antwerp.]

If the same scene were framed differently, with more headroom provided, the attraction of the lower screen edge would begin to operate. Christ would no longer be hanging as much as standing on the lower edge of the frame.

6·41 *Similarly, placing the lineman close to the upper screen edge makes him seem to "hang" more perilously in space than if he were placed nearer the middle of the screen.*

6·42 *Although in actual conversation these two people sit comfortably close together, they seem too far apart on the screen. The magnetism of the screen edge seems to pull them apart.*

The next time you watch a film or a television show or when you leaf through a magazine, see whether you can identify and analyze some of the magnetism of the frame and attraction of mass principle. Take a look at Figures 6·40 through 6·49 and note how the magnetism of the frame and the attraction of mass can work *for,* but also *against,* your aesthetic efforts.

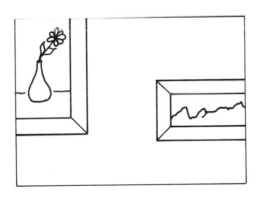

6·43 *We encounter a similar problem if we hang pictures at a "normal" distance from one another in our set. The edges of the screen attract the pictures. They appear, therefore, pulled apart.*

To make pictures look normally spaced, we must crowd them. The attraction of graphic mass (among the pictures) then counteracts the pull of the frame.

6·44 *Here, the pull of the frame works for us. The girl has no chance to run away; the magnetism of the frame holds her firmly glued to the screen edge.*

6·45 *Unless we want to intensify the roundness of someone's head and the coarseness of the features, do not frame it like this. As you can see, the pull of the frame makes the head appear so large that it no longer fits the restricting confinement of the screen. Her head seems so big that it literally bursts the frame.*

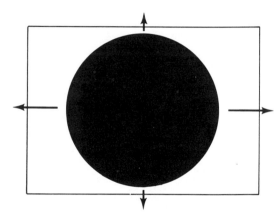

6·46 *But if we want to emphasize the width of an automobile, the pull of the screen edges becomes a definite graphic asset.*

6·47 In this example, the pull of the frame is equalized. The object within the frame attains maximum stability.

6·48 When the pull of frame is eliminated, the object in the screen center appears compressed by the surrounding space, emphasizing its isolation.

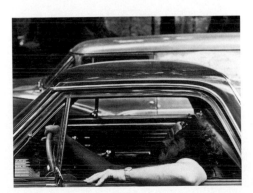

6·49 This man seems to rest his elbow on the lower edge of the frame rather than on the car window. This type of framing is often irritating because the frame acts as a structural substitute for the object and allows no image projection beyond the frame.

Screen-Left and Screen-Right

6·50 We tend to pay more attention to an object when it is placed on the right side rather than on the left side of the screen.[3] Notice how the focus is determined not so much by the subject as by whether it is placed screen-left (camera-left) or screen-right (camera-right). When the man is on screen-left (camera-left), we are more interested in the film than in the man. When he is screen-right, however, we pay more attention to him than the film.

6·51 Even though the woman on the left is pictorially "heavier" than the man on the right, we nevertheless tend to focus on the man on the right. When sides are reversed, the woman (now on the right) becomes more conspicuous.

In interview shows, we should always favor the guest, not the host. Therefore, we should place the guest screen-right. (Unfortunately, most hosts place themselves into the more prominent screen-right position.)

This asymmetry of screen-right and screen-left — that is, whether one side of the picture draws more attention than the other regardless of picture content — has been a source for confusion and debate for some time. Alexander Dean (1893–1949), who taught play directing at Yale, claims that the audience-left side of the stage is "stronger" than the right side, since the audience has a tendency to look left first and then to the right.[4] Heinrich Wölfflin (1864–1945), a prolific writer on various subjects in art history and theory, claims that the right side of a painting is "heavier" than the left. He says that we have a tendency to read over the things on the left quickly in order to come to the right side where "the last word is spoken."[5] He demonstrates quite convincingly with several illustrations how the character of a painting changes when its sides are reversed. Rudolf Arnheim distinguishes between an "important, central" left side and a "heavy, conspicuous" right side.[6]

It may well be that our attention relative to screen-right and screen-left varies with the screen size. When looking at a large frame, such as the proscenium opening or the cinemascope screen, we may well look first at the more comfortable left side, and then wander over to screen-right. But if the frame is small enough to allow an overall, iconic view, such as the TV screen, relatively small paintings and etchings, or magazines, the right side is definitely more conspicuous than the left side. In fact, some magazines charge more for an ad when placed on the right-hand pages than on left-hand ones.

Screen Up-Down

a

b

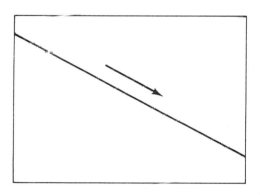

6·52 *Take a look at these slants. Which one seems to go up and which one down?*

6·53 *Most likely, you marked (a) as the uphill slant and (b) as the downhill slant. Apparently, the right side as the heavier side of the screen gives us the finishing point rather than the starting point of the slant. Of course, any movement along either slant will override this graphic up-down sensation.*

6·54 *Heavy trucks or bulldozers seem to have a more difficult climb from right to left than from left to right, since they have to overcome the natural flow of the graphic downhill slant.*

6·55 *Movement along the left-right downhill slope appears to be swifter than on a right-to-left slope because the downhill slant helps to pull the object down. Similarly, objects seem to fall more heavily from left to right (creating a downhill movement) than from right to left.*

Asymmetry of the Screen Asymmetry of the screen means that we do not divide our attention equally between the left and the right side of the screen area. We tend to focus more readily and carefully on objects on the right than on the left side of the screen. This right-left asymmetry also determines whether we perceive a slant as going uphill or downhill.

6·56 *Look at this very basic design. You see most likely a disk in the middle of the screen. Why do you not perceive the circle as a hole in the screen? Because your perception is conditioned by the most likely, rather than the least likely, events and occurrences.*

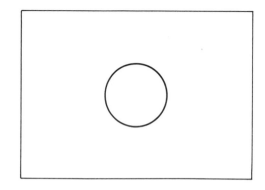

6·57 *Here is an example of a figure-ground ambiguity. Which is the figure and which is the ground? Are the two profiles the figure, or is it the vase in the middle?*

Figure-Ground One of the most elemental structural forces operating within the screen is the figure-ground phenomenon. We organize our environment into stable reference points against which the less stable elements can be assessed and checked.

Our figure-ground perception is such a natural activity and so obvious that it should not need special elaboration. The letters on this page and the illustrations certainly appear as figures and the page as ground. But there are instances in which the figure-ground relation becomes ambiguous or in which we may want to reverse the figure and ground for special effects.

Let's assume—in Figure 6·57—that the vase in the middle is the figure. What graphic characteristics can you assign to the figure that are different from the ground?

1. The figure is thinglike. You perceive it as an object. The ground is not. It is merely part of the "uncovered" screen area.

2. The figure lies in front of the ground. The vase lies obviously on top of the screen.

3. The line that separates the figure from the ground belongs to the figure, not to the ground.

4. The figure is less stable than the ground; the figure is more likely to move than the ground.

5. The ground seems to continue behind the figure.

But when we now assume that the two profiles are the figures, and the vaselike area the ground, all of the above-mentioned characteristics apply this time to the profiles and not to the vase. But even though we can reverse the figure-ground relationship, we cannot have it both ways simultaneously. Whenever we assign one graphic element the function of figure, the other part assumes automatically the function of ground.

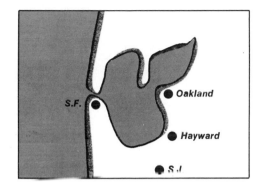

6·58 Maps, which show large water areas set off against some land areas, are especially susceptible to figure-ground reversal. If the water areas (ground) are lighter than the land areas (figure), we may perceive the water areas as the figure and the land areas as ground, confusing the water with the land areas. In such cases, we must eliminate the figure-ground ambiguity as much as possible. Here are a few suggestions:

Make the land areas lighter than the water areas. Paint the water with a cool, dark blue and the land areas with a warm green or brown. The light, warm colors appear closer to the viewer than the cool, dark colors.

Render the land areas three-dimensionally or at least give the appearance of raised land areas by painting in an attached shadow

6·59 If the design is simple, a very startling and expressive effect can be achieved through figure-ground reversal. [Courtesy of Eaton Corporation.]

6·60 *Contrary to the static and fixed figure-ground relationship in a painting or a still photograph, the figure-ground relationship changes with the camera's particular field of view. In this series of shots, note how the various objects change from figure to ground.*

Like other structural forces, the figure-ground phenomenon can work aesthetically for or against us. Let us now examine some other variations of the figure-ground phenomenon that are especially characteristic of television and film.

We are so used to seeing the figure move relative to the stable ground that we maintain this relationship even if the ground moves against the stationary figure. As is well known, we can trick the viewer very readily into "seeing" a car racing through the downtown streets, simply by photographing the stationary car against the rear screen projection of moving streets. We will discuss this motion reversal more extensively in Chapter 12.

6·61 *The electronic key effect changes all positive dark areas into holes through which we can see the ground.*

6·62 *With the aid of a double re-entry switcher, the holes can be filled with another image. Thus, the figures serve merely as a stencil for another ground. The figure appears as the negative element, the ground as the positive one. Thus, the viewer can be shaken out of his perceptual complacency into a new visual awareness. As with all special effects, we must of course be very careful when and how we apply these perceptual shock techniques.*

We can achieve especially effective figure-ground reversals through certain matting effects. If the versatility of electronic switching equipment (double re-entry switcher, joy stick, digital effects generator, and the like) permits, we can have any number of images oscillate dramatically from figure to ground and vice versa. The examples in Figures 6·61 and 6·62 might give you some ideas as to the virtually endless variety of figure-ground reversals through matting. In general, however, the low-definition image of television requires a clarification and intensification of the figure-ground separation rather than a camouflaging of it.

6·63 *Look at these random dots. As soon as you see them, you are trying to order them in some way, to make "sense" out of the randomly spattered spots. You are trying to establish a pattern. What pattern do you most likely see? Do not force yourself. Just relax and let the pattern come to you. Now take a pencil and mark the most obvious connections and relationships.*

6·64 There is a great likelihood that you grouped the dots into this pattern, or at least into one very similar to it. Why? Because it is the nature of perception that we try to organize such a random field into as simple and stable a pattern as possible. Notice that you needed only minimum information to arrive at certain structures: triangles, squares, lines. You filled in mentally the rest of the visual information that was necessary to arrive at these simple configurations—to arrive at an organized pattern. This process is called psychological closure.

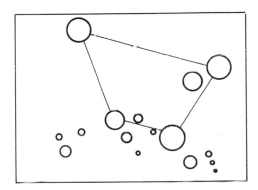

6·65 Let's apply sharpening to the above pattern. Simply enlarge two isolated dots and see what happens. The dots now have become very strong visual stimuli for a new, simpler, and more stable pattern: a larger trapezoid. In this process of sharpening, you applied conversely some leveling. You ignored certain dots that did not quite fit the pattern.

6·66 In a gestalt, all its individual elements operate in relation to the whole. In this "triangle" each dot fulfills a vital gestalt function. If any one were missing, we would not be able to arrive at a gestalt, the triangle. At best we might "closure" the two dots into a straight line.

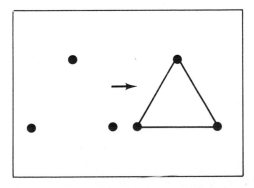

Psychological Closure The act of taking a minimum of clues and filling in mentally nonexisting information, to arrive at an easily manageable pattern, is called psychological closure (Fig. 6·70).

Leveling and Sharpening Whatever elements did not fit the pattern were left out, like the dots in the upper left-hand and lower right-hand corners, and the one next to the big triangle and the big square in the middle. Isolating or eliminating such confusing detail is called *leveling*. Adding information because we do not have enough stimuli to form a pattern or because the pattern is too ambiguous (too similar to the random information or simply not clear enough in terms of basic structure) is called *sharpening*.

Gestalt The new structure that is created through psychological closure is often called *gestalt* (German for form, configuration, shape). A gestalt is not simply the sum of its elements, but more so. It *consumes* its elements into a larger whole.

6·67 The relationship of the parts to the whole in a gestalt becomes even more apparent in a musical chord. Play (or try to hear) these three notes in sequence.

Now play (or try to hear) them as a chord. The resulting sound is entirely different from that of any of its three parts. As with the dots, the three notes have been consumed by the new structure, the new gestalt.

6·68 *Note that we need a certain amount of minimum information to apply psychological closure. If the information falls below the required minimum, we cannot find the appropriate pattern; the stimuli remain random. But then, all of a sudden, closure works; we are able to transcend at an instant the low-density information into a clear pattern: a gestalt.*

6·69 *In film, psychological closure is often mandatory in order to fill in visual or story detail that has been purposely omitted. For example, in this montage from Sergei Eisenstein's* Potemkin *(we will talk about montage in Chapter 13), the actual event, the hitting of the bullet, is almost automatically filled in through psychological closure.*

Sergei Eisenstein (1898–1948), Russian motion picture director and film theorist. His films include Potemkin *(1926),* Ten Days That Shook the World *(1928),* Alexander Nevsky *(1938), and* Ivan the Terrible *(1943–1946).*

6·70

The low-density (possessing relatively small amount of visual information due to the limited number of scanning lines) television picture relies quite heavily on our facility for psychological closure. Although our persistence of vision ("seeing" something for a short period after it has already been removed from our vision) helps us to perceive the scanning dot of the TV image as a complete image, we need to apply psychological closure to relate the low-information patterns on the screen into meaningful visual images.

Low-density information is aesthetically often desirable, since it requires us to apply a fair amount of psychological closure, that is, a filling in of missing external (form) or internal (story or psychological) information. This means that we must pay close attention to what is being presented and draw from our own experience in order to perceive the appropriate gestalt. We can no longer remain passive spectators. Low-definition images force us to become active participants. Watching low-density pictures on television for three hours requires, therefore, a good deal more effort than watching the same thing as a high-definition motion picture.[7]

Of course, a low-definition image is valuable aesthetically only if it *facilitates,* rather than hinders, psychological closure. Whenever possible, arrange the picture elements in such a way that they form easily recognizable patterns of simple geometrical figures (Fig. 6·71).

One word of caution, however. Because of our desire to perceive our environment in simple patterns rather than random objects, we have a tendency to perceive things together, that is, to apply closure to things even if they obviously do not belong to each other (Fig. 6·72).

a

6·71

6·71

b

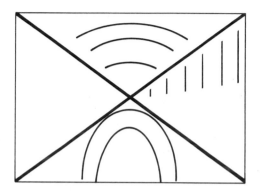

We know that people apply psychological closure to formulate specific patterns. But is the process of psychological closure predictable? Can we predetermine what stimuli are necessary for someone to perceive a particular pattern? Can we deduce any principles of psychological closure? Yes. Three gestalt psychologists, Wolfgang Köhler (1887–1967), Max Wertheimer (1880–1943), and Kurt Koffka (1886–1941), helped to develop three major principles of psychological closure: (1) proximity, (2) similarity, and (3) continuity.

c

6·72 When isolated by the camera from their actual spatial context, oddly juxtaposed objects seem even more likely to be grouped into perceptual patterns regardless of content.

One element that facilitates psychological closure enormously is sound. This is why sound is so important for the low-definition television medium: to supply necessary additional information for psychological closure. We will treat this subject more extensively in Chapter 15.

Proximity: *When similar elements lie in close proximity to each other, we tend to see them together. Because of attraction of mass, we connect more readily those elements that lie closer together than those that lie farther apart.*

6·73 *Here we see horizontal rather than vertical lines because the horizontal dots lie closer together than the vertical dots.*

Now we perceive vertical lines, because the vertical dots are closer together than the horizontal ones.

Here we tend to see four narrow columns rather than three fat ones.

Similarity: *Similar shapes are seen together.*

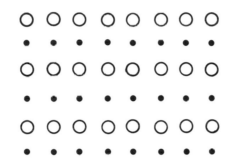

6·74 *All these dots are equally spaced. Yet we see horizontal lines since we tend to see similarly shaped objects together.*

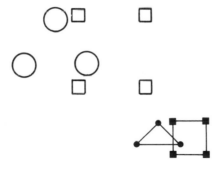

Here the similarity overrides the proximity. We see a triangle and a square intersecting.

Continuity: *Once a dominant line is established, its direction is not easily disturbed by other lines cutting across it.*

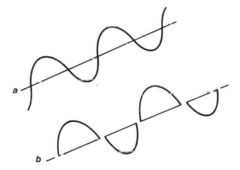

6·75 *We see a curved line being intersected by a straight line (a), rather than four odd-shaped forms attached to each other (b).*

Actually, these three principles of psychological closure (proximity, similarity, and continuity) are all based on our desire to establish "visual rhythm." We will therefore propose this overriding perceptual principle: We tend to combine (see together) those elements that are easily recognizable as occurring at a certain frequency (number of similar elements) within a certain interval (distance from one another) or that pursue a particular action.

Vectors Probably the strongest forces operating within the screen are *directional forces,* which lead our eyes from one point to another within, or even outside of, the picture field. These forces can be as coercive as real physical forces. We call these forces *vectors.*

A vector on the screen indicates a main direction that has been established either by implication, such as arrows, things arranged in a particular line, people looking in a specific direction, or by actual screen motion, such as a man running from screen-left to screen-right or a car traveling from right to left or toward or away from the camera.

In television and film, where you must deal with implied as well as real motion on the screen, the proper understanding and the handling of vectors become extremely important. Once you have grasped what vectors are, how they interrelate and interact with other visual and aural elements, you can use them most effectively, not only to control screen directions but also to build screen space and event energy within a single frame or over a series of frames.[8]

Vector Field In structuring screen space, we work no longer with isolated vectors but with *vector fields.* A vector field is a combination of various vectors operating within a single picture field (single frame), from picture field to picture field (from frame to frame) or from screen to screen (multiscreens).

You can find vectors also in music or even in the structure of a story—in any aesthetic element that leads us into specific space-time, or even emotional, directions. The more complex vector fields include *external* (vectors outside us) as well as *internal* (vectors inside us) *vectors.* For the present, however, let us concentrate simply on the visual vectors that operate within or relative to the television or film screen.

Vector Types If you examine carefully the various ways a visual vector operates, you will most likely find three principal types of vectors: (1) graphic vectors, (2) index vectors, and (3) motion vectors.

Graphic Vectors: These vectors are created by stationary elements that are arranged in such a way that they *lead* our eyes in a particular direction (Fig. 6·77).

Index Vectors: An index vector is created by something that *points* unquestionably in a specific direction (Fig. 6·78). A person looking in a particular direction also represents an index vector.

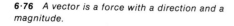

6·76 *A vector is a force with a direction and a magnitude.*

6·77

6·78

Motion Vectors: A motion vector is created by an object that is actually moving or *perceived as moving on the screen.* (Obviously, a motion vector cannot be illustrated with a still picture. You can perceive a motion vector only by watching a moving object or by perceiving it as moving on the television or movie screen. A blurred still shot of a moving object, therefore, does not represent a motion vector.)

Vector Magnitude The vector magnitude indicates the degree of its *directional force*—the amount of energy we perceive. An arrow, somebody pointing, a rocket going up, a football player racing across the field are examples of *high-magnitude* vectors.

Continuing and Converging Vectors All types of vectors can be (1) *continuing* or (2) *converging.* Continuing vectors *succeed* each other in the *same direction.* Converging vectors *oppose* each other. They reverse, or at least abruptly change, directions.

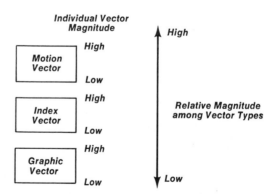

MV (Motion Vector) > *IV (Index Vector)* > *GV (Graphic Vector)*

6·79 *Generally, motion vectors have a higher magnitude than index vectors, and index vectors have a higher magnitude than graphic vectors. Of course, we can have strong and weak vectors within each category. There are strong and weak graphic and index vectors, as well as strong and weak motion vectors. The magnitude of a vector depends on many factors, principally on how definitely our eyes are led in a particular direction (graphic speed) or how fast an object moves.*

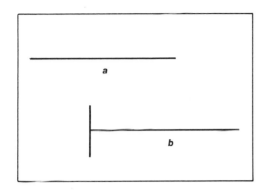

6·80 A vector of high magnitude we call simply a strong vector; one with low magnitude, a weak vector. For example, a simple line can be called a graphic vector. It is fairly weak, however, since we cannot tell exactly in which direction it is pointing. The vector is ambivalent. It can lead either from left to right or vice versa.

As soon as we establish a point of origin, a stop at one end, the line changes from a relatively weak, ambivalent, bidirectional force, into a stronger, unidirectional one. The graphic vector now acts more like an index vector. It leads our eyes more definitely into a specific direction. It has, therefore, increased its magnitude.

6·81 A combination of the various types of vectors all leading in the same direction increases their magnitude. The combination of graphic vector (track), index vector (spectator), and motion vector (runners) is stronger than any one of the individual vectors.

6·82 Let us assume that we perceive a bus moving on the television screen. Note how in this series of shots simulating a moving bus the right-to-left (left-oriented) motion vector consistently is maintained. The motion vector continues.

Long shot of bus, traveling screen-left. The motion vector is left-oriented (assuming that the bus is actually moving on the screen. As you see it here in this illustration, the bus represents an index vector).

Medium shot of the same bus. Left-oriented motion vector continues

Close-up of the same bus. Motion vector continues.

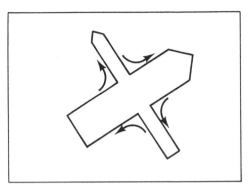

6·83 *Here we have two vectors intersecting. Because the vectors have a fairly high magnitude, we continue each vector in its particular*

direction. We perceive this figure as two arrows intersecting rather than as a new,

starlike gestalt. (Compare the principle of continuity, page 139.)

6·84 *In this shot, the left-right index vector converges with a right-left index vector. The street sign points in the opposite direction from the car. The index vectors (sign and car) converge.*

6·85 *The index vectors in this conversation are converging in a single two-shot as well as in the successive close-ups.*

6·86 *A jagged line, for example, looks more exciting and energetic than a straight one. The vector change increases the graphic force emitted by the line. Just think of the graphic line as a diagram for actual movement, such as a football player zigzagging across the field. He will certainly exert more energy by constantly changing his direction than if he were to run in a straight line.*

In contrast to a zigzag line, a curved line suggests a smoother, more gradual directional force. It represents a more gentle directional change, a more gradual convergence of vectors.

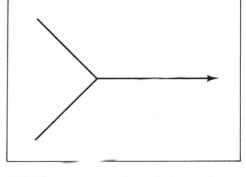

6·87 *When two vectors of a particular magnitude converge, the resulting third vector has a higher magnitude than either of the original two. This is why an arrow points so powerfully in a particular direction.*

Continuing Vectors: If the various types of vectors (graphic, index, motion) all point in the same direction, the vectors are *continuous.* The combined vectors can be continuous within a single shot or a succession of shots.

Continuing graphic vectors greatly facilitate psychological closure and our perception of gestalt patterns. Once we have established a vector of a high magnitude (pointing definitely in a specific direction—exerting directional energy) it is not easily disturbed by other graphic elements.

6·88 *A similar vector convergence occurs at the corners of a frame. In each corner of the screen, the two major vectors (height and width) converge, forming a third higher-magnitude vector leading out of the field. The screen corners act, in effect, like rather blunt arrow points. This is one of the reasons why the screen corners have such a high degree of magnetic attraction, as we have discussed earlier in this chapter.*

Converging Vectors: Contrary to the continuing vectors, which generally *carry the action forward* in a particular direction, the converging vectors often *collide,* or at least change direction abruptly. Such a directional change can create or increase the aesthetic energy of an event.

So far, you have learned the basic types of external (screen) vectors and their major attributes: magnitude, and continuing or converging directions. How the vectors operate within the screen, from shot to shot, or from screen to screen, will be discussed repeatedly in the following chapters. The proper manipulation of vector fields might well be the most important aspect of television and film aesthetics.

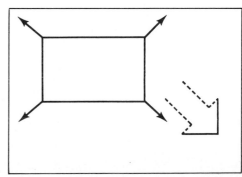

Summary

In this chapter we have discussed the two-dimensional field, the area of the television or film screen and its basic structural elements and characteristics.

The television or film screen provides us with a new, concentrated living space—a new field for aesthetic expression. There are three major structural factors of screen space: (1) area orientation, (2) size, and (3) basic screen forces.

Area Orientation Contrary to the picture area in painting and still photography, which can have any shape and orientation, the television and film screens are rectangular and horizontally oriented. The "classical" film screen and the television screen have a 3:4 aspect ratio. This means that the screen is three units high and four units wide. This aspect ratio permits easy framing of horizontally as well as vertically oriented objects or scenes.

Most new motion picture screens are horizontally stretched in order to provide a larger, wrap-around vista. We can change the aspect ratio by blocking certain screen areas or by attempting to physically alter the film screen area or the television scanning pattern. The television and film screens are horizontally oriented, since we basically experience our world on a horizontal, rather than a vertical, plane.

Size Although we do not necessarily perceive the film images as oversized and the television images as undersized, the sheer size of the images has some aesthetic consequences. A large cinemascope image feels more overpowering than the small television image of the same event. A large image carries more aesthetic energy than a small one. People as well as things attain spectacular dimensions in film. In television, the mere spectacle of things is de-emphasized; but human actions gain special prominence.

The large film screen permits a deductive approach to story telling (moving from the overall view to detail); television works best inductively (moving to the total event through a series of details). In film, we are apt to *look at* the event; in television, we can more readily *look into* the event.

Field Forces There are six major types of field forces:

1. Main directions: Horizontal lines suggest calmness, normalcy. Vertical lines suggest power, formality, strength. A combination of vertical and horizontal reflects our normal world. It suggests that we are standing upright on level ground. When the horizontal line is tilted, we become unbalanced and disoriented. A tilted horizon line, therefore, suggests instability or powerful dynamism in an otherwise stable, or even static, shot.

2. Magnetism of the frame: The edges of the screen and especially the corners exert a strong pull on objects within the frame. Moreover, mass attracts mass. Similarly, graphic mass attracts graphic mass (objects within the screen). The larger graphic mass is usually more stable than the smaller one. The smaller graphic mass is dependent; the larger more independent.

3. Asymmetry of the screen: We tend to pay more attention to an object when it is placed on the right side of the screen than if it is on the screen-left. A diagonal going from the bottom of screen-left to the top of screen-right is an uphill slant; from top left to bottom right, a downhill slant.

4. Figure-ground: We seem to organize a picture field into a stable ground against which less stable figures operate. The figure exhibits certain

spatial and graphic characteristics, the most important of which is that the figure seems to lie *in front of the ground*. Certain figure-ground reversals can be distracting but can also contribute to startling and expressive effects.

5. Psychological closure: Whenever we are confronted with pictorial elements, we tend to organize them into a pattern of simple geometrical figures, such as triangles, squares, and the like. We can perceive such patterns, even if we have only a minimum of information, by mentally filling in the missing information. This filling-in process is called psychological closure. The pattern that we get through psychological closure is called gestalt. In a gestalt all elements operate in relation to the whole. The whole gestalt is larger (through psychological closure) than the sum of its individual parts.

6. Vectors: A vector is a force with a direction and magnitude. In television and film, we operate with three principal vectors: graphic, index, and motion. A *graphic* vector is created by stationary elements that are arranged in such a way as to lead the eyes to a particular direction. An *index* vector is created by an object that points unquestionably in a specific direction. A *motion* vector is created by an object that is perceived as moving on the screen.

Each vector can have a variety of magnitudes (strength). In general, however, graphic vectors have less magnitude than index vectors, which again have less magnitude than motion vectors. The higher magnitude vector can override the lower magnitude vector.

Vectors can be continuous or converging. *Continuous* vectors succeed each other in the same screen direction. *Converging* vectors point or move toward each other.

Notes

[1] Rudolf Arnheim, *Visual Thinking* (Berkeley: University of California Press, 1971), pp. 37–53.

[2] Rudolf Arnheim, *Art and Visual Perception* (Berkeley: University of California Press, 1965), pp. 1–6.

[3] Heinrich Wölfflin, *Gedanken zur Kunstgeschichte* (Basel: Benno Schwabe & Co. Verlag, 1940), pp. 82–96.

[4] Alexander Dean, *Fundamentals of Play Directing* (New York: Farrar and Rinehart, Inc., 1946), p. 132.

[5] Wölfflin, pp. 82–90.

[6] Arnheim, *Art and Visual Perception,* p. 23.

[7] See: Marshall McLuhan, *Understanding Media* (New York: McGraw-Hill Book Company, 1965), pp. 311–319.

[8] Compare: Andrew Paul Ushenko, *Dynamics of Art* (Bloomington: Indiana University Press, 1953), pp. 60–119. See also: Kurt Lewin, *A Dynamic Theory of Personality,* trans. Donald Adams and Karl Zener (New York: McGraw-Hill Book Company, 1935).

Structuring the Two-Dimensional Field:
Interplay of Dynamic Vectors

Structuring the two-dimensional field means making the various screen forces *work for,* rather than against, *us,* so that we can show events on the screen with clarity and impact.

A painter or still photographer strives for a total compositional effect in a picture. He tries to arrange static pictorial elements within the frame in such a way that they look and feel inevitably right. Once he has achieved such an arrangement, the composition is finished; it will not change.

Not so in television and film. Not only do most pictorial elements shift constantly within the frame, but they also change from one picture to the next (from shot to shot, from scene to scene). We no longer deal with structural permanence, but with *structural change.*

The old method of composition, that is, the pleasing arrangement of essentially static pictorial elements within a single frame, no longer suffices. Rather, we must now think in terms of *structuring dynamic vector fields.*

When dealing with vector fields, *changing directional forces* become the *essential structural elements.* Using vectors as structural elements does not mean that we must, or should, give up some of the traditional graphic elements and

compositional principles as used in painting or still photography. But the vector concept helps us to extend the traditional principles readily into a process of interacting structural forces, a process of interacting vector fields. In the context of vector fields, we can arrest and investigate structural forces within the screen, whether the picture images are moving or not. In many instances the moving camera can compensate for the moving image and can stabilize the composition similar to that of a still shot. In other instances, the vector field might extend beyond a single shot to a shot sequence. We must then find structural principles that can adequately deal with this type of *changing* image structure. Each individual shot can be judged only as to its structural field in the context of previous and following shots and vector fields. For example, the arrangement of objects within the screen of a single shot may look totally unbalanced when examined by itself; but when the same shot is seen as part of an extended shot sequence, its composition may look perfectly acceptable (Fig. 7·1).

The specific structural principles and demands of a shot series will be taken up in more detail in Chapters 11 and 12.

Stabilizing the Two-Dimensional Field: Vector Distribution

In stabilizing the two-dimensional field, we must try to distribute the various vectors and the graphic weight of the objects within the screen in such a way that no single force or element is unduly emphasized.

 7·1

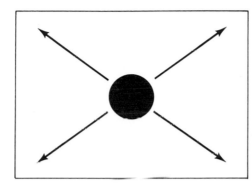

7·2 As indicated before, the most stable position within the screen is screen-center. In this position, the object's relation to the screen borders, especially the corners, is symmetrical. The graphic vectors as exerted by the corners are symmetrical in direction and magnitude.

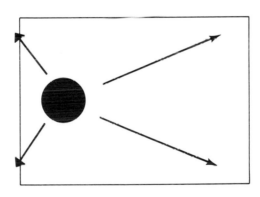

7·3 If the object is not centered, the vectors are no longer symmetrical. The mass of the object, which generates a graphic weight, is no longer held in check by equally strong vectors. Vectors on the left gain more magnitude than vectors on the right because of the object's close proximity to the left screen edge.

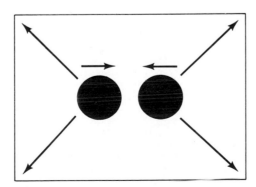

7·4 We can correct this vector imbalance by centering the object (often called rather ambiguously "to frame up") through movement of the object or camera or by "counter weighting" it with a similar object. The second object restores vector symmetry, although the vectors have now attained new magnitudes.

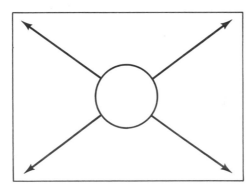

7·5 *A thoroughly stabilized vector field, such as a centered or symmetrical arrangement of picture elements, reflects solidity to the viewer. It is the least dynamic pictorial arrangement, which when overused can easily lead to boredom; but it is a perfectly sensible arrangement whenever straight information is to be communicated.* [*Photograph printed by courtesy of Jerry Jensen.*]

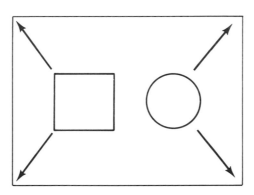

7·6 *Putting a newscaster to one side of the screen makes little sense. The vectorial instability of such a pictorial arrangement will prove a detriment to communication rather than an asset. Such framing introduces unnecessary tension into a fundamentally stable and direct event.*

The off-center position, however, is fully justified if the opposite screen side is filled in by other visual elements. Thus, the total two-dimensional field is once again stabilized. [*Photograph printed by courtesy of Jerry Jensen.*]

7·7 *Look at this screen event. This girl, looking at us (the camera), is properly centered within the screen. Mass and vectors are symmetrically distributed. But watch what happens as soon as she turns her head. By looking to the side, she will create a new index vector.*

The more she looks toward screen-left (to her right), the more magnitude the index vector gains. The index vector has reached its maximum magnitude when she appears in profile, looking directly screen-left. The index vector must be counteracted. We accomplish this by strengthening the graphic vectors (a) that pull in the opposite

direction from the index vector as well as providing enough space for the strong index vector (b) to run its course, that is, to "travel" far enough so that its energy is largely absorbed by the time it hits the barrier of the screen edge. Just how much space we should leave when somebody looks toward the side of the screen (usually called "nose room") can now be readily determined: enough room to reduce the magnitude of the index vector to such a degree that it can be counterbalanced by the mass of the figure and the graphic vectors pulling it toward the opposite screen edge.

The symmetrical arrangement of mass looks balanced only if all vectors are adequately stabilized. Strong vectors pulling in one direction can easily override the centrally located mass (see Figure 7·7).

You treat motion vectors the same way. When panning with the moving object, you should always pan ahead enough, that is, leave enough space in front of the moving object, so that the strong motion vector has room to expand. If you do not sufficiently "lead" the moving object, the screen edge toward which the object moves will appear as a barrier to the motion. You will not be able to see where the moving object is going. The motion will look cramped and hampered.

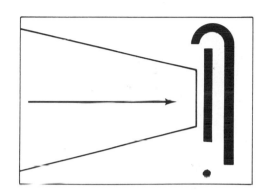

7·8 *Of course, we can also absorb the energy of a vector by placing an object in its path. This is especially effective in the control of graphic and index vectors.*

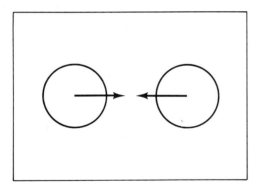

7·9 *Or we can counter a vector with another, converging vector.*

7·10 *With a moving image, we must adjust for vector changes continuously with the camera. Here is an example where converging index and motion vectors (assuming that the runners are seen as moving on the screen) change into continuing vectors. When this happens, we must allow extra screen space in order to absorb the combined vector magnitude.*

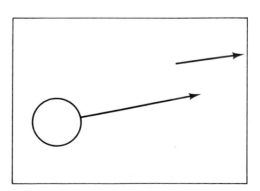

Direct and Indirect Focus

7·11 *If one or several index vectors point to the same target object, we speak of direct focus.*

7·12 *Indirect focus means that the index vectors are redirected by an intermediary before reaching the target object. Index vector (a) is pointing to the intermediary (b) and redirected by (b) to the target object (c). We can use the indirect focus to prolong suspense and to increase tension. It is visually more complex and less blunt than the direct focus.*

Extending the Vector Field

Sequence and Multiscreens Even though the direct or indirect focus extends over a shot sequence (in Figure 7·13, two shots only), we place the objects in each of the shots as though they were together in a single shot.

Essentially, all we have done is to present a simultaneous event sequentially. The vectors should always *help* the viewer to conceive the sequentially arranged images as a *single,* whole event.

The *position of the target object* is, therefore, greatly influenced by the direction of the vectors in the previous shot. Since the index vectors in the first shot of Figure 7·13 point from screen-right to screen-left, the target object in the following shot is placed screen-left—at the end of the extended index vector.

7·13 *Although the borders of the screen are a definite and necessary spatial limit, the vector field can easily extend beyond these limits. In a direct or indirect focus, for example, the target object may well lie outside the screen area.*

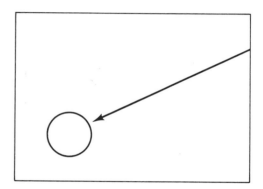

When using two or more separate screens, we must be especially careful to control the vectors of the individual screens so that they combine into an organic and sensible overall vector field. Basically, there is not much difference between multiscreen vector structures and those of sequential shots, except that the overall multiscreen vector structure is always present in its totality. Figure 7·15 gives examples of structuring the vector fields of three screens so that they combine rather easily into a larger, overall structural field.

7·14 *If, for example, we show close-ups of people watching a tennis game, their index vectors will tell the viewer where the ball is without actually seeing the players in action. We should make sure, however, that the final index vectors are followed up by the target object in the proper position at the end of the extended index vectors. This is especially important, if we shoot out of sequence and intercut the audience reaction shots in the editing room.*

7·15

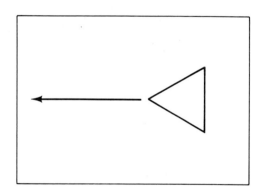

7·16

In the three-screen shot series shown in Figure 7·16, the left-to-right index vector is opposed by a right-to-left index converging vector.

Object Framing When showing only part of an object or a person on the screen, we must frame the object in such a way that the viewer can easily fill in the missing parts and perceive the object in its totality. In vector terminology, we must arrange the vector field within the screen area in such a way that the vectors (graphic or index) extend easily beyond the screen area in order to facilitate psychological closure.

7·17 *In this figure, we obviously do not perceive parts of people standing in front of incomplete buildings, although this is exactly what we actually see. We extend the figures and buildings beyond the frame according to what we know by experience the event to be. We apply psychological closure to perceive a total gestalt.*

7·18 In this close-up we perceive the total person, even though only part of his head and his body are actually visible.

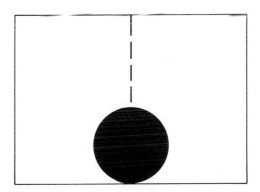

There are instances, however, in which improper framing may lead to premature psychological closure. The image contained within the frame no longer stimulates us to extend the vector field *beyond* the screen edges for closure, but we perceive quite readily a complete gestalt within the frame, even if the frame actually shows only part of the object.

7·19 Look at the framing of this head and analyze it in terms of structural field forces. First, the head seems to be glued very solidly to the lower edge of the screen (attraction of frame plus gravity stabilizes the object). Second, the stability is increased by its location on the center line of the screen. Third, and most importantly, there are enough visual clues to reduce the shape of the head (through leveling) to a simple, self-contained, highly stable shape: a circle. Since we have applied closure within the frame, we feel no need to extend the vector field beyond the frame. As a result, the head has become a self-contained independent unit: the head seems disconnected from its body, resting, like John the Baptist's head on Salome's platter, on the lower screen edge.

7·20 *Similar premature closure problems occur whenever the frame "cuts off" objects or persons at their natural dividing lines. You should, therefore, place objects or persons within the screen in such a way that the natural dividing lines fall either within or without the screen edges. Thus, we are more likely to extend the graphic vectors beyond the screen for proper psychological closure.*

7·21 *These houses are cut off at their natural dividing lines. We cannot tell whether there are only two houses or a row of houses.*

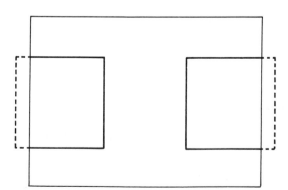

Now we are forced to apply closure outside the screen; we perceive a row of houses.

Stabilizing the Two-Dimensional Field: Distribution of Mass

As pointed out before, in film and television we work mostly with moving images, with a changing structure within the two-dimensional field of the screen. However, there are occasions in which the screen is subdivided into rather stationary sub-areas and in which we must deal with the proper distribution of picture areas—*graphic masses*. Our main concern now is to divide the two-dimensional field into proper proportions. Fortunately, when dealing with proportions, we are aided by an impressive amount of knowledge that has been compiled over many centuries by architects, painters, mathematicians, designers, and, more recently, photographers.

We will, therefore, indicate briefly only those aspects of proportions that seem especially relevant to television and film. Specifically, we will discuss (1) area proportion and (2) object proportion. *Area proportion* refers to the different *screen areas* and how they relate to one another. Screen areas can be formed by subdivisions of the screen through lines, letters, people, scenery, dark and light, or color patterns. *Object proportion* refers to the various sizes of objects and how they relate to one another. Object proportions tell us how large or small an object appears on the screen relative to others and to the screen area itself.

Area Proportions Before discussing the area proportions in terms of graphic mass, let us look at the relative tensions of area proportions in terms of vectors (Figs. 7·22, 7·23, 7·24).

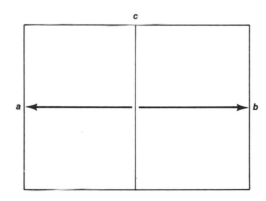

7·22 *Think of the screen edges (a) and (b) as reaching into the screen and trying to pull whatever object they can grasp toward themselves. The dividing line (c), located at screen center, is at rest because the pulls of the screen edges (a) and (b) are equally strong. We can call these pulling forces vectors (a) and (b). Because these vectors are equally long and strong, the symmetrically divided fields are also at rest.*

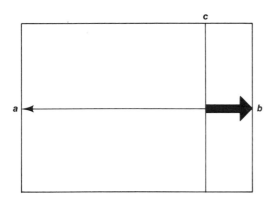

7·23 *Now let's move the dividing line over to screen-right. More. Even more. At this point, vector (a) has to stretch so far that it can barely hold on any longer. Vector (b), however, pulls with strength and confidence. It will surely win out over (a) and pull the dividing line toward point (b), the right screen edge. The vectors are grossly imbalanced; so are the two fields. There is excessive tension between the screen areas. The division of the total screen is ill-proportioned.*

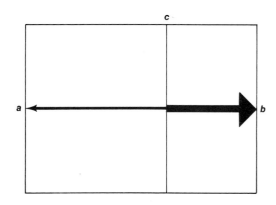

7·24 *Now let's give vector (a) a fighting chance and move the dividing line back a little toward screen center. Vector (a) is not desperately reaching any more, but it, too, has a comfortable grip on the dividing line. Each vector exerts a pull on the line, which creates a certain tension between the two fields. But the tension is tolerable, if not pleasing. The two fields differ from each other just enough to be clearly recognized as asymmetrical fields; yet they are similar enough to be easily related to each other. The division of the total screen area is well-proportioned.*

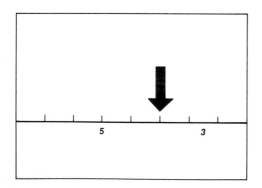

This type of division, which creates such a pleasing proportion, is called the Golden Section. It measures roughly three units by five units. (The short part is three units long, the long part is five units long.) The Golden Section has been used successfully by artists in many fields for thousands of years.

The question of discovering proper proportions and using them with consistency in the various forms of art has been of major concern to artists for many centuries. The Egyptian temples and wall paintings, the Greek and Roman buildings and sculptures, the churches, palaces, and paintings of the Renaissance, the modern skyscraper, magazine layouts or automobile design, all reveal man's preoccupation with proportional harmony. Amazingly enough, the proportions as revealed by the Egyptian and Greek temples, by a Gothic cathedral, or a Renaissance palace still seem harmonious to the twentieth-century man.

Obviously man has, and always has had, a built-in feeling for what proportion constitutes. But since we are never satisfied with feeling alone, but want to know why we feel a particular way and what makes us feel this way—mainly to make emotional responses more predictable—man has tried to rationalize about proportional ratios and to develop proportional systems. Mathematics, especially geometry, was of great help to people who tried to find the perfect, divine proportional ratio. One charming illustration of this point is a statement by Albrecht Dürer, the famous German Renaissance painter (1471–1528). In the third book of his *Proportionslehre* (*Teachings on Proportions*), he writes: "And, indeed, art is within nature, and he who can tear it [art] out, has it. . . . And through *geometrica* you can prove much about your works."[1]

Today, where standardization and interchangeability are essential for mass production, proportional systems that would satisfy the efficiency requirements of the machine as well as the aesthetic requirements of man have, once again, become of major concern to artists and scientists. Even in the layout of a magazine page or a television title or in the construction of scenery, ready-

made proportional systems are often effectively applied. Besides the *Golden Section,* another widely used proportional system is the *Le Corbusier Modulor.*

The Golden Section

The smaller section is to the greater as the greater is to the whole. Thus:

$$\frac{BC}{AB} = \frac{AB}{AC}$$

This proportion continues ad infinitum. If we fold the BC section to the left into the AB section, we will again have created a Golden Section. Now, the whole line is AB, and the larger section CB, the smaller AC. Thus:

$$\frac{AC}{CB} = \frac{CB}{AB}$$

The familiar pentagram, or five-pointed star, is a series of Golden Sections. Each line divides the other into a Golden Section proportion.

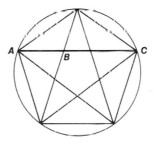

This proportion was produced by calculating minds from ancient Egypt to the Renaissance. Although the Egyptians knew about the Golden Section proportion and used it extensively in their architecture, sculpture, and painting, the Greeks are usually credited with working out the mathematics of this proportion and relating it to the proportions of the human figure. Later, Leonardo da Vinci, the great Italian Renaissance painter, scientist, and inventor (1452–1519), spent much time proving and making public the validity of the mathematical formula of the Golden Section, worked out by the Greek philosopher and mathematician Pythagoras as early as 530 B.C.

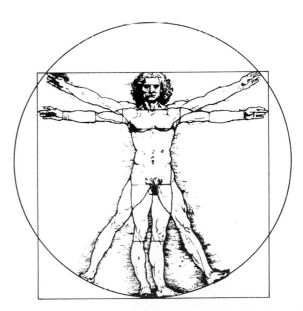

When dealing with structuring the two-dimensional field of the television or film screen, this proportion still serves a significant, though perhaps less divine, function. Especially in television and film graphics you may want to apply the Golden Section proportion with some accuracy. The following figure shows you how you can divide a line into the Golden Section proportions or extend a line for the Golden Section.

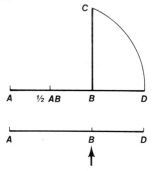

In the above, the line to be extended: AB. Draw a perpendicular line at B with the height of AB. This is point C. With a compass at ¹/₂ AB draw an arc from C to the extended line AB. It cuts the extended line at D. You have now a line AD, with the Golden Section at B.

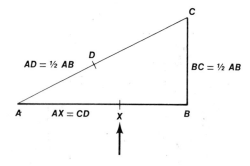

In the above, the line to be divided: AB. Draw a perpendicular line at B with a height of ¹/₂ AB. This is point C. Draw a line from A to C. On the AC line, mark off the distance of ¹/₂ AB (which is the same as BC) from point A. This is point D. Transfer the distance CD to the original AB line at A. AB is now divided into the Golden Section at point X.

The Modulor

The well-known contemporary Swiss-French architect Le Corbusier (Charles E. Jeanneret, 1887–1965) developed a proportional system that is essentially a refined version of the Golden Section. This system, which he calls the Modulor, is also based upon the proportions of the human figure, more specifically upon the proportions of a six-foot man.

All the Modulor proportions are presented in a gradually diminishing scale of numbers.[2] Here, in Corbusier's diagram, all numbers are in centimeters (1/100 of a meter).

In this diagram, all numbers are in millimeters (1/1,000 of a meter).

Figures 7·25, 7·26, and 7·27 can give some idea of how to apply the Golden Section proportion in structuring the two-dimensional field.

Although you may now be convinced that the Golden Section can provide area proportions that are, indeed, divine, do not go overboard with it. Use it only if it truly helps to clarify and intensify your message. For example, do not put a newscaster into the Golden Section simply because you feel that such a graphic maneuver would create enough tension to keep the viewer glued to the set. If the newscaster lacks dynamism in personality as well as message, the divine screen division will do little to improve the communication situation. The newscaster will merely look off-center.

Graphic Mass and Graphic Weight As soon as you get away from obvious linear screen divisions, such as a Golden Section division, and begin to wrestle with several independent sub-areas within the screen, you may find it easier to consider them as graphic masses rather than linear intersections.

Every graphic mass operating within a clearly defined two-dimensional field, such as the television or film screen, carries a specific graphic *weight,* which is not unlike the weight of an actual object. Thus, in order to stabilize a variety of areas within the screen so that they form a structural whole, you can balance the various graphic masses relative to their individual graphic weight rather than vectors.

What exactly determines graphic weight? Table 7·1 lists the most common graphic weight factors.

7·25 *The church spire in the foreground divides the screen at the Golden Section vertically.*

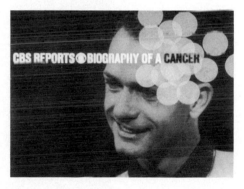

CBS REPORTS ⊕ BIOGRAPHY OF A CANCER

7·26 *This title is placed in such a way that it divides the screen area horizontally and vertically according to the Golden Section proportions.*

Table 7·1 Factors Influencing Graphic Weight

Factor	Heavy	Light
Dimension	Large	Small
Shape	Simple, geometrically compact	Irregular, diffused
Orientation	Vertical	Horizontal
Color	Hue: warm Saturation: strong Brightness: dark	Cold Weak Light
Location	Corner Upper part of frame Right	Centered Lower part of frame Left

7·27 *The Golden Section is especially effective in dividing clean, horizontal lines.*

Figure 7·28 shows a television title slide in which vectors and graphic weights determine relative stability and tension.

Structural Rhythm It may be easier for you to cope with the constant structural change of the television and film images if you consider area proportions as part of a *rhythmic* phenomenon.

7·28

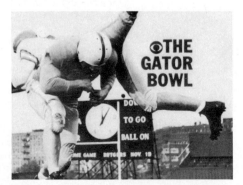

In Figure 7·29, most likely you perceive the rhythm in the first drawing as an even beat; and the rhythm in the other as a more accented beat. Visual rhythm, like rhythm in sound, depends on accent, on a beat which is created by a recognizable recurring element.

Quite obviously, the beat in Figure 7·30(a) is more regular than that in (b) and (c). The accents (vectors and graphic weight) are more evenly distributed; the structure of the two-dimensional field is more stable. In Figure 7·30 (b and c), the vector and graphic weight distribution becomes progressively uneven; the structure of the two-dimensional field becomes progressively labile.

The overall rhythmic structural concept will serve as a ready indicator of relative stability within the two-dimensional field. Such a structural rhythm will also prove helpful when you want to match pictures and sound. We will discuss such matching procedures in Chapter 15.

Object Proportions Object proportions indicate the size relationships among various objects as shown on the screen. As with area proportions, we can increase or decrease the tension within the screen through manipulating object proportions.

We can *increase* the structural tensions within the two-dimensional field (and therefore energize the screen event) by exaggerating the object proportions; we can *decrease* the tensions by presenting the object proportions as close to normal (real-life proportions) as possible.

Because of the size constancy phenomenon (as discussed in the previous chapter), we do not perceive an immense wheel attached to an undersized motorcycle frame; rather, we perceive the wheel as *emphasized,* not oversized (Fig. 7·31).

A deliberate distortion of object proportions is, of course, a common practice in commercials.

7·29 Try to "listen" to the rhythm in this visual arrangement.

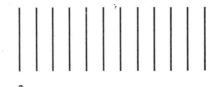

a

Now "listen" to this arrangement. Do you "hear" a difference? How exactly do the rhythms of the two visual arrangements differ?

b

7·30 Again, "listen" to the following visual patterns and try to perceive the rhythmic variations. Especially, try to determine which of the patterns tend toward a stable structure and which toward a more unstable structure.

a

b

c

7·31 *In this wide-angle lens distortion of object proportions, the energy of the visual event is greatly heightened.*

7·32 *We judge the object size by how much larger or smaller it is than the human figure. The human figure is an accurate universal reference for object size. The superpower of many cartoon characters is a direct result of exaggerated object distortion: the undersized hero manages without fail to defeat the oversized world around him. Much of a cartoon's energy derives from tension created by deliberate distortions of object proportions.*

Balance

"[Our organism] strives to obtain a maximum potential energy and to apply the best possible equilibrium to it."[3]

You probably noticed that the various structural arrangements as illustrated did not have the same degree of balance, that is, the same degree of structural stability. Some looked more at rest, while others appeared to have more internal tension; they looked more dynamic.

Balance *does not* automatically *denote maximum stability within the screen.* If this were true, pictorial elements would always have to be symmetrically arranged.

Rather, balance can be expressed in *degrees* of structural stability, especially in television and film where the pictorial arrangements are often in a constant state of flux.

The three most basic structural variations of balance are (1) stabile, (2) neutral, and (3) labile.

7·33 *In a stabile balance, vectors and graphic weight are evenly distributed. A symmetrical balance is the most stabile one. The tension is low.*

7·34 *In a neutral balance, vectors and graphic weight are asymmetrically distributed. But the tensions within the picture field are fairly evenly distributed. The Golden Section, for example, creates an asymmetrical, but neutral, state of balance.*

7·35 *In a labile balance, vectors and graphic weights are pushed to their structural limits. This means that the slightest change in the field structure would lead to an unbalanced picture field. The tension is high.*

Whether the balance is stabile or labile is largely a matter of communication *context*. If the event we want to communicate is to express extreme excitement, tension, or instability, the pictorial equilibrium should reflect this instability. The picture balance may very well be labile. On the other hand, if we want to communicate authority, permanence and stability, the pictorial arrangement should, once again, intensify this tendency by a stabile balance.

When working in television and film, you must learn to "feel" balance quite readily. Like the ballet dancer or the champion athlete, you must be able to react to the structural demands of the moment immediately, intuitively, and naturally. The degree of balance must suit the demands of the moment. The fluctuating vector field does not tolerate long and tedious structural contemplations. You must *sense* the most effective pictorial structure and put it into operation with sureness and courage. Television and film, like dance and music, demand immediate action.

Ultimately, structuring the two-dimensional field means to bring the changing visual elements within the screen into a balanced, yet dynamic, and rhythmic interplay that is in accord with the intended communication and that transmits to the viewer structured, organized aesthetic energy.

Summary

Structuring the two-dimensional field means making the various screen forces work for, rather than against, us. Since the pictorial elements in television and film are usually in motion, we must deal with structural change rather than structural permanence. By translating the pictorial elements into dynamic forces, vectors, and graphic weight, we can control the structure of a shot or a shot sequence, whether the images are moving or not.

Structuring the two-dimensional field encompasses two major processes: (1) stabilizing the two-dimensional field through *vector distribution* and (2) stabilizing the two-dimensional field through *distribution of mass.*

In a *symmetrically structured* field, all vectors are equally distributed. They are equal in length and magnitude. If any vector (such as an index vector of someone looking into a particular direction) gains in magnitude, the object must be shifted within the screen in such a way as to counteract the specific vector. An index or motion vector must have enough screen space to run its course. If the index or motion vector is too close to the screen edge, it tends to collide with the edge, creating perceptual interference. Someone looking toward the edge of the screen must have enough "nose room" so that the index vector energy can be properly absorbed by the screen space. The same goes for a motion vector. The object must be allowed screen space in which to move; we must *lead* the moving object with the camera rather than follow it.

A vector can also be absorbed by another object that blocks its path and energy.

A specific vector structure is called direct focus or indirect focus. *Direct focus* means that one or several index vectors point directly at a specific target object. Two people looking at a book is an example of direct focus. *Indirect focus* means that the index vector, or vectors, are redirected by an intermediary before reaching the target object. Two people who focus on somebody (intermediary) looking at a book (target object) is an example of indirect focus. Indirect focus makes the visual event more complex and can intensify the scene.

The structure of a vector field can *extend beyond the screen area.* If the target object is not visible in a shot, but is followed up in the next shot, the vector field is extended into a *shot sequence.* Example: Two people looking screen-right. Next shot: close-up of book (target object).

A vector field can also be extended simultaneously over several screens. Care must be taken that the vectors facilitate the perception of a whole event, especially if the contents of the shots are not obviously related to one another.

When showing only part of an object, as in a close-up for example, the object must be framed in such a way that the vectors extend easily beyond the frame, helping the viewer to perceive the total object through psychological closure. We should avoid framing an object in such a way that the incomplete object leads to premature psychological closure. This can happen readily if the screen edges coincide with the natural cut-off points of objects.

If the screen is to be subdivided into rather stationary areas, we are more concerned with the *distribution of graphic mass.* This distribution of mass manifests itself in (1) area proportions and (2) object proportions.

Area proportion means the division of the total screen into harmoniously related subareas.

The *Golden Section* is a proportional standard by which a line is asymmetrically, yet extremely harmoniously, divided. The division of a line by the Golden Section is approximately in a ratio of 5:3,

that is, the longer part of the line is five units long; the shorter part, three units.

The *Modulor,* which is a more practical version of the Golden Section, gives a series of dimensions for areas that relate asymmetrically, yet harmoniously, to one another.

When dealing with area proportions, we must consider the *graphic mass* and its *relative weight.* Some graphic elements are heavier than others, depending on their location within the screen (proximity to the screen edges), the size, shape, basic orientation (vertical or horizontal), and their color.

When judging area proportions, thinking in terms of *structural rhythm* is a helpful device, especially in the face of constant structural change.

Object proportion indicates the size relationships among the various objects shown on the screen. By manipulating object proportions, we can, as with area proportions, increase or decrease the tension of the two-dimensional field.

When the object proportions are highly exaggerated, the tension is increased. If the object proportions are kept close to normal (the way we actually perceive them), the tension is minimized.

The *universal reference* to the actual size of an object, regardless of how it is represented by the screen image (that is, whether the object occupies a large or small portion of the screen area), is the *human figure.*

Balance does not denote maximum stability of the structural field. Rather, the structural field can have stabile, neutral, or labile states of balance. In a *stabile balance,* vectors and graphic weight are evenly distributed. The most stabile balance is a symmetrical field structure. In a *neutral balance,* vectors and graphic weight are asymmetrically distributed. The tension among the pictorial ele-

ments, however, is fairly evenly distributed. In a *labile balance,* vectors and graphic weight are pushed to their structural limits. The tension among the various pictorial elements is extremely high.

Ultimately, structuring the two-dimensional field means to bring the visual elements within the screen into a balanced, yet dynamic, and rhythmic interplay that helps to clarify and intensify the basic message.

Notes

[1] Translation by the present author. The original reads: "Dann wahrhaftig steckt die Kunst in der Natur, wer sie herausreissen kann, hat sie. . . . Und durch die Geometrika magst du deine Werks viel beweisen." In Johannes Beer, *Albrecht Dürer als Maler* (Königstein i. T., Germany: Karl Rebert Langewiesche Verlag, 1953), p. 20.

[2] For more information on the Le Corbusier Modulor, see Le Corbusier [Charles E. Jeanneret-Gris], *Modulor,* 2nd ed., trans. Peter de Francia and Anna Bostock (Cambridge, Mass.: Harvard University Press, 1954); and *Modulor 2* (London: Faber & Faber, Ltd., 1958).

[3] Rudolf Arnheim, *Toward a Psychology of Art* (Berkeley: University of California Press, 1966), p. 45.

The Three-Dimensional Field: Depth and Volume

In television and film, as in painting and still photography, we must *project* the three-dimensional world onto a two-dimensional surface. Fortunately, the camera and its optical system transact such a projection rather automatically. Again fortunately, we are quite willing to accept such a projection as a true representation of *all three* dimensions: height, width, and depth (Fig. 8·1a).

In television and film, as in painting and still photography, the third dimension is strictly *illusory* (Fig. 8·1b). Amazingly enough, the illusory third dimension, depth, proves to be the most flexible screen dimension in film and especially in television. While the screen width (x-axis), and height (y-axis) have definite spatial limits, depth (z-axis) is virtually infinite (Fig. 8·1c).

When examining the factors that contribute to the illusion of depth in television and film, do not forget (1) that it is what the *camera* sees, not what you see, that is important and (2) that, contrary to painting and still photography, the viewpoint (camera position) and the event itself (objects, people) usually change even within a relatively short event sequence.

Specifically, you must consider the conventional graphic projection peculiarities and techniques of a third dimension on a two-dimensional screen surface, as well as the space-manipulative properties and characteristics of lenses, the camera position and movement relative to the event, and the motion of the event, that is, the positions and movements of the event elements (objects, people) relative to one another.

We will, therefore, discuss these four points: (1) volume duality, (2) graphic depth factors, (3) depth characteristics of lenses, and (4) the z-axis motion vector.

a

b

c

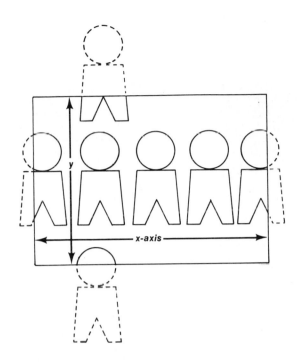

The x and y coordinates locate precisely a point within an area, such as the screen. A point within the screen can be assigned an x-value, indicating its relative width, that is, its position on the x-axis, and a y-value, indicating its relative height (where it is on the y-axis).

8·2 This illusory third dimension, the z-axis, is especially important in television, since the other principal spatial dimensions of the television screen, height and width, are rather limited compared to the wide motion picture screen, for example. As you will see, the articulation of the z-axis (z-axis staging and blocking) is one of the principal factors of spatial control in television.

The camera, very much like the human eye, has no trouble looking along the z-axis all the way to the horizon without having to be moved. Therefore, it can take in a great number of objects that are stationed along the z-axis and can cope successfully even with extremely fast movement toward and away from the camera (z-axis movement). Horizontally and vertically, the camera is much more restricted in terms of field of view and object movement.

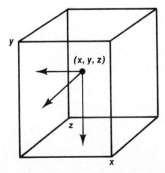

To locate a point precisely within a volume, a third coordinate, the z-axis, becomes an essential dimension. The z-value indicates the point's relative depth, how far it is away from the frontal plane.

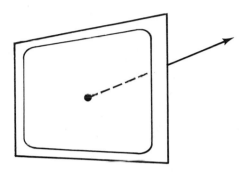

8·3 Notice that without stereoprojection (as most films and all television shows are presented, at least for the time being), we perceive the z-axis to originate from the screen, going backward. The closest object seems to lie on the screen surface; it does not seem to extend beyond it toward us, the observers. In stereovision, the objects extend beyond the screen toward the observer; we perceive them relative to us, not to the screen surface.

8·4 *Let us define positive and negative volumes. A positive volume has substance. It is solid, can be weighed, touched. It is a clearly described mass. Positive volumes are trees, people, rocks, pillars.*[1]

Volume Duality

When we look at the cloudless sky, we do not experience any depth. Empty space gives no clues to distance. There is nothing that is either near or far away from us.

As soon as we look down and see the houses, trees, people, and cars, however, we can now tell quite readily which things are closer to us and which are farther away. The various objects have helped to define the empty space and made it possible for us to perceive distance—a third di-

8·5 *A negative volume is empty space. It is the space described by or around positive volumes. The hole in the doughnut, as well as the space around it, is a negative volume. The empty space as defined by these beams and the lamp post, the inside of an empty box, and the space described by the walls of a room are examples of negative volumes.*

mension. We can say that positive volumes have articulated the negative volume of empty space.

The interplay between positive and negative volumes is called *volume duality*. The control of volume duality—how the positive volumes articulate the negative space—is an essential factor in the manipulation of three-dimensional space and the illusion of depth in television and film. We will treat this subject more thoroughly in Chapter 9.

Graphic Depth Factors

8·6 *Look at this photograph and try to identify as many as possible of the factors that contribute to the illusion of depth.*

First, notice that some objects are partially hidden "behind" other objects. They overlap partially.

The farther away the objects are (boats, people, hills), the higher up they climb in the picture field, and the smaller they appear.

Parallel lines, like the side of the boat and edges of the boardwalk, seem to converge in the distance.

The objects in the foreground are more clearly defined than those in the background.

The light and shadows indicate volume, that is, the presence of a third dimension.

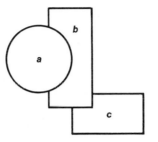

8·7 *Object (a) is partially covering object (b), which again is partially covering object (c). Although all three figures obviously lie on the same plane (this page), (a) seems to be in front of (b), which itself seems to lie in front of (c) but behind (a).*

8·8 *Any object that is partially blocked from our view by another object must lie behind this object. Even with other depth clues missing, we perceive a third dimension by readily assigning partially overlapping objects a "behind" and an "in front" position.*

8·9 *The medieval painters relied heavily on overlapping planes to indicate depth in their work. In this detail from* The Meeting at the Golden Gate, *one of the many excellent frescoes in the Arena Chapel in Padua, Italy, by the Florentine painter Giotto (ca. 1267–1337), we can see how effectively overlapping planes were used to indicate depth. The only depth confusion arises from the merging halos of Joachim and Anna—caused by the fading of the contour of Joachim's halo at the point of overlap.* [Courtesy of Museo Civico di Padova.]

We can now name these depth clues: (1) overlapping planes; (2) relative size; (3) height in plane; (4) linear perspective; (5) aerial perspective; and (6) light, shadows, and color.

Overlapping Planes One of the most direct *graphic depth cues* is a partial overlap. As soon as we see one object partially covered by another, we perceive the one that is doing the covering as lying *in front of* the one that is partially covered.

Relative Size If we know how big an object is or if we can guess its size by its contextual clues (other known objects), we can tell fairly accurately how far away it is from us by how big it appears to us—by the size of its screen (or retinal) image.

Height in Plane Assuming that there are no contradictory distance clues (such as overlapping planes, for example), and that the camera is shooting parallel to the ground (Fig. 8·12), we perceive an object as farther away the higher it is in the picture field (the closer it is to the horizon line).

8·10 *The larger a subject or an object appears relative to the screen borders, the closer it is to the viewer (the camera)—appropriately called close-up. The smaller a subject or an object appears relative to the screen borders, the farther away it seems (such as in a long shot, for example).*

8·11 *If we know that two objects are similar or identical in actual size, we perceive the smaller screen image as the farther object and the larger screen image as the closer object. Because of our facility for size constancy (see Chapter 6), we do not perceive the smaller image as the smaller object and the larger image as the larger object; we perceive them equal or similar in size but lying at different points along the z-axis (closer to or farther away from the camera).*

8·12 *The line of people is higher in this picture than the foreground figure.*

8·13 In this sixteenth-century Persian painting, overlapping planes and especially height in plane serve as major distance clues. [From Persian Painting, text by Basil Gray, p. 77. Courtesy of Editions d'Art Albert Skira.]

8·14 If the object moves higher than the horizon line, the object no longer seems farther away but appears to float.

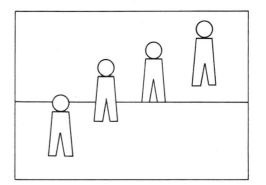

If the horizon line is not seen and the objects move up within the screen area, we assume that the horizon line lies outside of the screen. We perceive, therefore, the objects not as floating up on the screen, but as lying at various distances from us (or the camera).

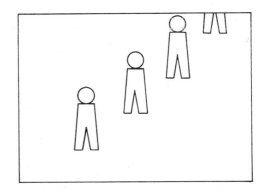

If an object is to appear to lie beyond the horizon, it must move down again at the horizon line.

8·15 *Although the balcony (fire escape) is closer to the upper screen edge, it still appears closer to the camera than the windows of the building opposite to it, even though they are close to the bottom edge of the screen. Height in plane is no longer an accurate distance clue since the camera no longer shoots parallel to the ground.*

You must realize, however, that the horizon line shifts constantly with a moving camera. When shooting straight up from the bottom of some building to the top, or straight down from the roof to the street, height in plane no longer serves as a reliable distance clue.

Linear Perspective Linear perspective is also a very powerful and very convincing means of creating the illusion of depth on a two-dimensional surface. We are so used to seeing parallel lines converge that if we draw receding parallel lines actually parallel, we perceive the lines as spreading.

All equally spaced objects appear to lie closer together in the distance than in the foreground. We perceive background space as "shrunk" compared to foreground space. (See Figure 8·16.)

8·16 *When we stand on a straight road or a railroad track, we see the highway or tracks get narrower in the distance until they finally seem to converge at one point.*

8·17 *In this architect's drawing of an Italian palazzo, all the prominent horizontal lines (graphic vectors) converge at one point. We call this perceptional phenomenon linear perspective.*

Vanishing Point

Horizon Line
(Eye Level)

8·18 *The point at which all parallel lines converge and discontinue (vanish) is aptly called the vanishing point. The vanishing point always lies on the horizon line, at eye (camera) level.*

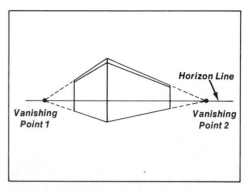

8·19 *If we look down on an object, the eye (camera) level is above the object. Therefore, the horizon line, and with it the vanishing point, lies above the object. We see the object—in this case the bridge—from above.*

8·20 *If we are below the object and look up, the eye (camera) level, the horizon line, and the vanishing point lie below the object. We see the object, the bridge, from below.*

8·21 *If we see two sides of a building, with one corner closest to us, we perceive two sets of converging lines going in opposite directions. We have, therefore, two vanishing points. But note that the two vanishing points lie on the horizon line; after all, we look at both sides of the building from the same eye level. This is called two-point perspective.*

Horizon Line and Eye Level: The horizon line is an imaginary line parallel to the ground at eye level. More technically, it is the plane at right angles to the direction of gravity that emanates from the eye of the observer at a given place. If you want to find the eye level and the horizon line, simply stand erect and look straight forward. The eye level is where you do not have to look up or down.

8·22 *In order to find exactly how the spaces shrink in the distance, we simply divide the converging space by diagonals. The middle of a section of two converging lines is not the arithmetic middle, but where the diagonals intersect. By repeating such a diagonal division, we can easily see how objects seem to lie closer the farther they are away from us.*

Attempts in using linear perspective to create the illusion of depth on a two-dimensional surface were made by many painters long before the Renaissance; but it was not until the first half of the fifteenth century that Italian artists established scientific laws of linear perspective, such as the horizon line and the vanishing point.

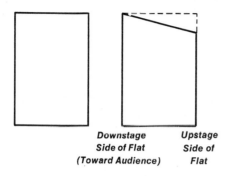

**Downstage
Side of Flat
(Toward Audience)** **Upstage
Side of
Flat**

8·23 *Forced perspective is most useful in the theater, where the spectator remains immobile in relation to the stage, that is, where his viewpoint does not shift. This side elevation of scenery shows how converging lines are built into the set as well as the floor covering. It has little application, however, for a mobile camera in television and film, especially since certain lenses can produce a similar effect much more easily.*

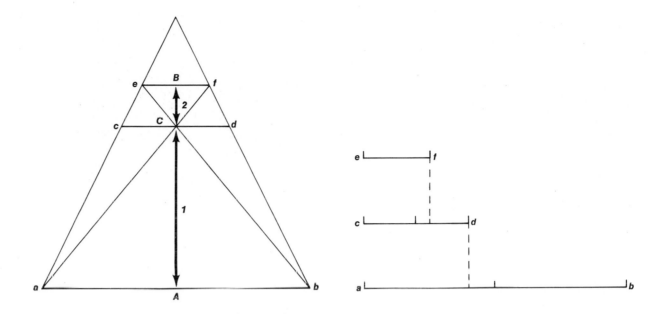

8·24 *With this woodcut, one of the masters of the Renaissance, the German painter Albrecht Dürer (1471–1528) illustrated some of the techniques used by the artist to assure correct foreshortening (linear perspective). [Taken from The Complete Woodcuts of Albrecht Dürer edited by Dr. Willi Kurth. © 1946 by Crown Publishers, Inc. Used by permission of Crown Publishers, Inc.]*

This "shrinking of space" in the background when dealing with linear perspective is an important concept in animation. For example, if a car is drawn speeding along the z-axis, it must cover quite a bit of distance along the z-axis (moving up in the screen area and getting smaller); but as it gets closer to the horizon line, it does not cover so much ground and the rate of its diminishing size, too, slows down. In other words, it has to travel farther and faster in the foreground than in the background.

If a car is to move from A to B at approximately the same speed, it obviously will take as long to travel from the start (A) to the midpoint (C) as it takes from the midpoint (C) to the finish (B). But look: distance 1 (AC) is considerably longer than distance 2 (CB). The car must therefore cover more ground in the beginning, and less later on.

Also note that the car diminishes much more quickly in size in the first half than in the second half of its travel. In the first half (distance 1), it shrinks in width from a–b to c–d at the midpoint, which is much less than half of its original width; but in the second half of its travel (distance 2) it shrinks only from c–d to e–f, which is not quite half of its midpoint width. The size relationships of stationary objects follow, of course, a similar pattern.

Lateral movement is also influenced by this "shrinking of space" phenomenon of linear perspective. Watch some clouds go by. The clouds closer to you seem to move much more rapidly than the ones in the background, even if they actually all move at the same speed. Similarly, if you want to show clouds move across the screen, you must make the ones in the foreground move faster than the ones in the background (which may seem to hardly move at all). In applying this principle, you can indicate depth by having the frontal plane move faster across the screen than the background planes.

8·25 *The Dutch painter Vincent van Gogh (1853–1890) made great use of the crowding effect. Notice how he indicates depth simply by drawing the lines for the grass in the background closer together and, at the same time, by making them less detailed and less distinct. [Courtesy of the Metropolitan Museum of Art. Gift of Mrs. J. H. Rossbach, 1964.]*

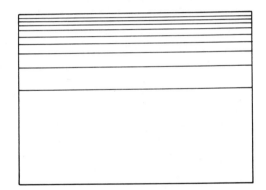

8·26 *Because of this "crowding" effect of distant objects, we can create the illusion of depth simply by crowding parallel lines or even dots toward the upper part of the screen.*

Whenever the viewpoint of the spectator or camera remains constant, we can apply what is generally called *forced perspective.* Forced perspective means that the scenery and some properties are constructed in such a way that they accelerate physically the convergence of lines and trick the spectator into perceiving greater depth than actually exists. (See Figure 8·23.)

8·27 *The foreground objects in this picture are sharp and dense; the background, however, gets progressively less distinct. This density gradient is called aerial perspective.*

Aerial Perspective There is always a certain amount of moisture and dust in the atmosphere. We see, therefore, objects that are close to us somewhat sharper than those which are farther away. In fog this difference in sharpness, in image density, is very much pronounced.

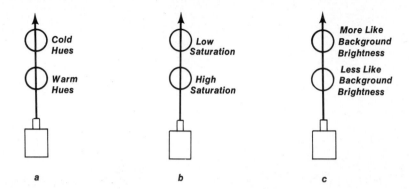

Cold
Hues

Warm
Hues

a

Low
Saturation

High
Saturation

b

More Like
Background
Brightness

Less Like
Background
Brightness

c

8·28 *In terms of color, warm hues seem to advance, cold hues seem to recede (a). Highly saturated colors seem closer than less saturated colors (thus they add also to the aerial perspective effect) (b). Assuming that the background is fairly dark (low degree of brightness), the brighter colors (high position on the brightness scale) advance, and the colors with a low brightness recede. If the background is light (high degree of brightness), the opposite occurs (c).*

We can say that the more the brightness of an object assumes the brightness of the background, the farther away from the observer (the camera) it appears. Practically, if the background is rather dark (which is the usual background condition), we should put more light on the foreground objects than on the background objects. Low-key lighted scenes (dark background and brightly lighted foreground with fast fall-off shadows) are usually more plastic (reveal more depth) than high-key lighted scenes (light background with slow fall-off).

In aerial perspective, colors, too, lose their "density" and become less saturated the farther away they are from the observer (camera). Also, distant colors take on a slightly blue tint. When painting background scenery, for example, depth may be intensified by painting the background objects slightly bluer and less sharp than the foreground objects.

A large depth of field de-emphasizes the aerial perspective effect; a *shallow depth of field intensifies* aerial perspective.[2]

Light, Shadows, and Color In the absence of more persuasive depth clues, or in tandem with other depth clues, light, shadows, and color can help to produce a depth illusion on a two-dimensional surface.

As indicated in Chapters 2 and 3, chiaroscuro lighting basically emphasizes *volume,* the three-dimensionality of things. Both attached and cast shadows contribute greatly to the perception of volume and depth.

Depth Characteristics of Lenses

The optical characteristics of lenses can greatly enhance or hinder the illusion of a third dimension. In general, *wide-angle lenses exaggerate* several *depth clues* and, therefore, the illusion of a third dimension; *narrow-angle lenses* produce the opposite impression. They *reduce the illusion of a third dimension.*[3] Again, when we speak of narrow-angle (long focal length) or wide-angle (short focal length) lenses, we include in these definitions the narrow and wide-angle positions of the zoom lens.

Overlapping Planes Whatever lens is used, overlapping planes serve as an important depth clue. However, while in the wide-angle shot we can draw on several other important depth clues, overlapping planes often become the only, or at least the most prominent, indicator of a third dimension in a narrow-angle shot.

Relative Size Relative size—that is, how large we perceive objects relative to each other and to the screen—is greatly influenced by the wide-angle and narrow-angle lenses.

8·30 Relative size is greatly exaggerated by the wide-angle lens. Objects close to the camera are very much enlarged; those farther away from the camera are reduced in image size quite drastically. Note the difference between image size of the two men. Because of this exaggerated difference in image size, the illusion of a third dimension is greatly enhanced. We perceive one man to be farther away from the other than he really is.

8·29 Overlapping planes are faithfully recorded by the wide-angle lens.

When shot with a narrow-angle lens, the image size of the two men becomes more similar. They seem, therefore, to be standing much closer together than they really are. The narrow-angle lens seems to have shrunk the space between them.

Overlapping planes remain as the major depth clue in the narrow-angle lens shot. In fact, the narrow-angle lens tends to reduce a three-dimensional scene to a flat picture of overlapping planes.

8·31 *Because of the undue enlargement of objects that are close to the lens and the rapid decrease in size of objects that are just a little farther away, the wide-angle lens can produce object distortions when used for close-ups. Although such distortions may be quite effective in some cases, they are usually less desirable on faces.*

8·32 *The wide-angle lens creates a forced perspective. It makes the parallel lines converge faster than we normally perceive. Combined with the exaggerated relative size effect, the forced linear perspective contributes to a powerful depth illusion.*

A narrow-angle lens counteracts the normal convergence of parallel lines and thus reduces illusion of depth through linear perspective. In addition to reducing the convergence of lines, it shrinks space and makes objects appear closer together than they really are. Notice how the loading doors and wooden beams of the pier are pushed together by the narrow-angle lens and are pushed out by the wide-angle lens.

Height in Plane As long as the camera is parallel to the ground, height in plane does not differ enough between wide-angle and narrow-angle lenses to either contribute to or take away from the illusion of depth.

Linear Perspective Generally, the use of wide-angle or narrow-angle lenses influences the magnitude of the z-axis vector. A *wide-angle lens* (short focal length) *increases* the illusion of depth; the *z-axis vector* is accelerated—it *gains in magnitude.* A *narrow-angle lens* (long focal length) *decreases* the illusion of depth; the z-axis vector is decelerated; it *loses in magnitude.*

Aerial Perspective We can achieve aerial perspective by manipulating the depth of field and by making use of *selective focus.*

If we place objects at different distances from the camera along the z-axis, some objects will appear in focus, and some out of focus. The portion of the z-axis in which the objects appear in focus is called *depth of field.* A depth of field can be shallow or great. If the depth of field is shallow, only a relatively small portion of the z-axis (or objects placed therein) is in focus. If the depth of field is great, a large portion of the z-axis (or objects placed therein) is in focus. The depth of field depends on the focal length of the lens, the lens (diaphragm) opening, and the distance from the lens to the object.

Usually, wide-angle lenses have a greater depth of field than narrow-angle lenses. Close-ups (regardless of the lens used) have a shallower depth of field than long shots.[4] (See Figure 8·33.)

8·33

8·34 A wide-angle lens usually has a great depth of field. It de-emphasizes aerial perspective.

A narrow-angle lens has a shallow depth of field. It emphasizes aerial perspective. The foreground is in focus, and the area immediately behind is out of focus. Selective focus means that we control the precise portion of the z-axis to be in focus. Naturally, we need a shallow depth of field for selective focus. We can either focus on the foreground, with the middle and backgrounds out of focus; or on the middleground, with the foreground and background out of focus; or on the background, with the foreground and middleground out of focus.

The most natural selective focus is to have the foreground in focus, and the background out of focus. Note that with the loss of density in the background, we also see less detail.

8·35 If we want to shift emphasis from one location to another along the z-axis without changing the shot (through dolly, zoom, cut, or dissolve), we can change the focus from one part of the z-axis to another. This is called "rack focus." Notice how the emphasis shifts from foreground to background by means of selective focus.

Leonardo da Vinci described vividly what happens in aerial perspective: "The air tints distant objects in proportion to their distance from the eye. . . . Suppose several buildings are visible over a wall which conceals their basis, and suppose they all extend to the same apparent height above the wall. You wish to make one in your painting appear more distant than another. Conceive the air to be hazy, since in such air you know that distant objects like the mountains, seen through a great mass of air, appear almost blue. . . . Therefore paint the first building beyond the aforesaid wall in its own proper color and make the more distant building less sharply outlined and bluer, and a building that is twice as far away, make it twice as blue, and one that you wish to appear five times as far away, make it five times as blue. This rule will make it possible to tell from the picture which building is farther away and which is the taller."[5]

8·36 *With a wide-angle lens, the object changes its size more drastically and seems to travel farther and faster along the z-axis than with a narrow-angle lens. The z-axis vector has a high magnitude.*

Z-Axis Motion Vector

Motion along the z-axis is one of the strongest indicators of depth. A z-axis motion vector is created whenever the camera dollies or zooms or when the object moves toward or away from the camera. We will talk about z-axis motion in more detail in Chapters 10, 11, and 12. Right now, let's examine the z-axis motion vector and its influence on the illusion of depth.

Z-Axis Motion Vector through Object Motion

Contrary to lateral object motion, which can be extremely hard to follow if it is close to the camera, z-axis motion (toward and away from the camera) is fairly easy to control, no matter how fast the object may be moving. When moving away from the camera along the z-axis, an object appears to get smaller. As indicated earlier, the size reduction is rapid in the z-axis portion close to the camera and becomes more gradual the farther back the z-axis extends. If the object travels toward the camera, the reverse happens. The image size of the object becomes gradually larger at the far end of the z-axis and then gets rapidly bigger when close to the camera.

8·37 With a narrow-angle lens, the object changes its size much more gradually. The object seems to move more slowly. In fact, a very narrow angle lens can virtually eliminate the feeling for movement along the z-axis. The object does not seem to change its size perceptively even if it is traveling a considerably large distance along the z-axis. The z-axis vector has a low magnitude.

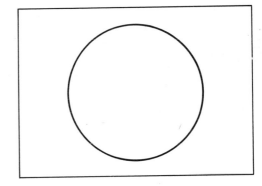

8·38 We can achieve the illusion of z-axis motion by simply reducing or increasing the object size. When projected on a screen, the circle does not seem to get bigger or smaller but rather to move toward or away from the viewer.

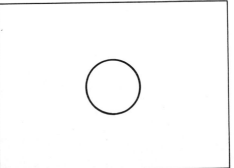

If we want to exaggerate the speed of an object traveling along the z-axis, we should use a wide-angle lens (zoomed out). If we want to reduce the speed, or virtually eliminate the motion, we should use a narrow-angle lens (zoomed in).

The reduction of speed with a narrow-angle lens is especially effective if we want to intensify the frustration of running and reaching the destination only with great difficulty, if at all. Typical examples are: lovers running toward each other and not reaching each other fast enough; someone running away from danger and not getting far fast enough; running in a dream, or when not in full control of body or mind.

Z-Axis Motion Vector through Camera Movement We can create a powerful z-axis motion vector (actually an induced motion vector—see Chapter 12) by dollying past objects that are placed along the z-axis or by zooming in and out.

By zooming in and out, we can achieve the fastest z-axis actions without any difficulty. When we do a fast zoom-in, the object seems to hurl along the z-axis toward the screen and, if the zoom is fast enough, crash through the screen right toward the viewer. A fast zoom back has the opposite effect: the object seems to shoot toward the background, surely crashing into something beyond the horizon.

Obviously, we must be very careful with fast zooms; the viewer may easily become annoyed when bombarded by objects shooting at him through the screen. We should consider fast zoom motions a special effect reserved for special occasions.

8·39 *When we dolly past objects that are placed along the z-axis, the volume duality between the positive volumes of the objects and the negative volumes of the space between the objects changes continually. The objects close to the camera grow in size quickly when the camera dollies past them, with the background objects remaining relatively unchanged in size. Through use of a dolly, we experience a continually changing spatial relationship, a changing perspective. When we dolly in or out, we seem to be moving into or out of the scene.*

Wide-angle lenses exaggerate the perspective change and the speed of the dolly. The z-axis motion vector has a high magnitude.

Narrow-angle lenses de-emphasize the perspective change and slow down the perceived speed of the dolly. The magnitude of the z-axis vector is low.

8·40 *When we zoom in or out along the z-axis, the volume duality does not change. The space between the space modulators and their size relative to one another do not vary individually; the size relationships remain constant throughout the zoom. There is no perspective change. All that happens is that the various objects seem to get bigger, and therefore closer, and that the objects close to the camera move out of the frame on a zoom-in. The opposite occurs on a zoom-out. Quite contrary to the dolly, which seems to move us into the scene, the zoom appears to make the scene come to us or to move it away from us.*

Note that camera movement with a narrow-angle lens is visually not appropriate since it exaggerates even the slightest camera wobble, thereby causing the whole picture to jerk erratically.

The reason for the constancy in volume duality and perspective during a zoom is that only some lens elements move, but not the camera. Hence, a constant spatial relationship from camera position to the scene is maintained throughout the zoom. In a dolly, the camera moves, the viewpoint and with it the spatial perspective changes therefore.

Summary

In television and film, the three-dimensional world must be projected onto the two-dimensional surface of the screen. Although the third dimension is illusionary, it proves to be aesthetically the most flexible of the dimensions. While the screen width (x-axis) and height (y-axis) have definite spatial limits, depth (z-axis) is virtually limitless. Therefore, the camera is much less restricted in its view and movement along the z-axis than horizontally and vertically.

There are four important points that describe the aesthetics of the three-dimensional field in television and film: (1) volume duality, (2) graphic depth factors, (3) depth characteristics of lenses, and (4) z-axis motion vector.

Volume duality is the interplay between positive volumes (objects that have substance and that can be touched, weighed) and negative volumes (empty space that surrounds, or is described by, positive volumes). A room has a volume duality. The negative volume (the inside space of the room) is defined by the positive volume of the walls. The control of volume duality is an essential factor in the manipulation of three-dimensional space.

The *illusion of depth* on a two-dimensional surface can be achieved by (1) overlapping planes (objects that partially overlap each other), (2) relative size (if two objects are known to be similar in size, the one closer to the camera has a larger screen image than the one farther away), (3) height in plane (assuming that the camera shoots parallel to the ground, we perceive an object as higher on the screen the farther away from the camera it is), (4) linear perspective (parallel lines converge toward the distance at the vanishing point, which lies on the eye-level horizon line; equally spaced objects appear to lie closer together the farther they are from the camera), (5) aerial perspective (foreground objects are sharp and clear, while background objects seem less sharp), and (6) z-axis motion vector.

In general, wide-angle lenses (short focal length) or zoom lenses at the wide-angle position exaggerate the illusion of a third dimension; narrow-angle lenses (long focal length) or zoom lenses at the narrow-angle position reduce the illusion of a third dimension.

Wide-angle lenses exaggerate relative size (foreground very big, background very small) and linear perspective (lines converge more quickly). There seems to be more space between objects than there really is when seen with a wide-angle lens. Narrow-angle lenses do just the opposite: they de-emphasize relative size (foreground and background objects appear similar in size) and linear perspective (resist the converging of lines). The space between objects seems to have shrunk. Narrow-angle lenses produce a flat picture in which overlapping planes remain as major depth clues.

Narrow-angle lenses have generally a shallower depth of field than wide-angle lenses. Narrow-angle lenses, therefore, contribute more to aerial perspective than wide-angle lenses. But both lenses can be used for selective focus (keeping only a short portion of the z-axis in focus, while the rest is out of focus) if the depth of field is kept purposely shallow for all lenses.

The z-axis motion vector (object or camera motion along the z-axis) is a strong depth indicator. Wide-angle lenses usually exaggerate the speed of the object or camera motion. The z-axis vector has a high magnitude. In contrast, narrow-angle lenses

de-emphasize the speed of the object or camera motion. The z-axis vector has a low magnitude.

While in a dolly the perspective of the objects along the z-axis (volume duality along z-axis) changes, it remains constant during a zoom. In a dolly, we seem to move into or out of a scene. A zoom seems to bring the scene toward us or move it away from us.

Notes

[1] László Moholy-Nagy, *Vision in Motion* (Chicago: Paul Theobald & Company, 1947), p. 241.

[2] Herbert Zettl, *Television Production Handbook,* 2nd ed. (Belmont, Calif.: Wadsworth Publishing Company, Inc., 1968), pp. 50–53.

[3] *Ibid.,* pp. 42–71.

[4] *Ibid.,* pp. 50–53.

[5] Leonardo da Vinci, *Trattato della Pittura* (ca. 1500), as quoted in Daniel J. Weintraub and Edward L. Walker, *Perception* (Monterey, Calif.: Brooks/Cole Publishing Company, 1966), pp. 25–26.

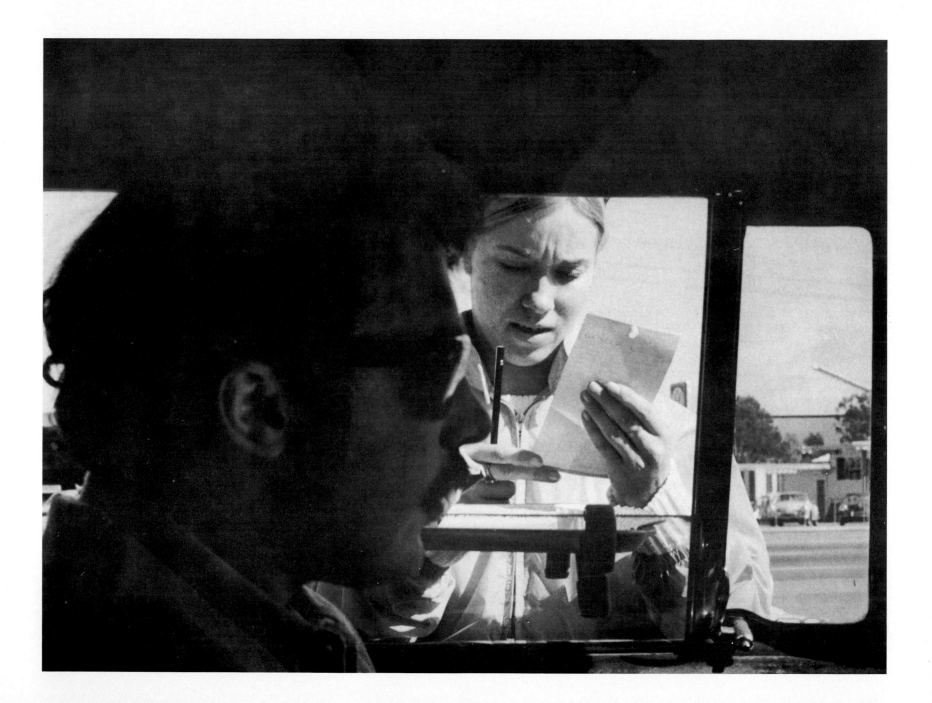

Structuring the Three-Dimensional Field: Building Screen Volume

9·1 As soon as we tilt down the camera so that we can see the tree close to us, the houses that are a little farther away, and the mountains on the horizon, we can recognize a foreground plane, a middleground plane, and a background plane. The three-dimensional field has now attained a structure. We have articulated the three-dimensional field in its most basic way.

So far, we have discussed some of the basic graphic and photographic factors and principles for projecting our three-dimensional world onto the television or film screen and for creating the illusion of depth on a two-dimensional picture plane. We will now examine how to *structure* the three-dimensional field.

Most basically, we structure the three-dimensional field into various *depth planes,* or *grounds:* a foreground, a middleground, and a

background. As pointed out before, if we take a picture of the blue, cloudless sky, we have no indication of depth. The space is simply there, but it has not been converted into "place," into a structured field in which we can perceive distances relative to us, the observers.

As you remember, when structuring the field in television and film, we must take into account the element of *change,* the movement of the event itself, the movement of the camera, and the movement of the sequence of shots. A camera that dollies past a row of columns, performers moving in front of the camera, a zoom, or a cut from one camera to another all create a *changing structural pattern,* a changing three-dimensional field. For example, when the camera is zooming in, the foreground may disappear, with the middleground taking on the role of the foreground, and the background becoming the middleground. Also, with multiple cameras shooting from various directions, viewpoints shift radically within the three-dimensional field.

To structure the three-dimensional field for the television or film screen, we should pay special attention to these five points: (1) creating a volume duality, (2) articulating the z-axis, (3) z-axis blocking, (4) double z-axis staging, and (5) building z-axis space.

Creating Volume Duality

Designing scenery for television or film and blocking action for the camera are actually nothing but a careful interplay of positive and negative volumes.

Structuring the three-dimensional field means a careful control of volume duality.

"The function of the architect is to be able to convert sheer space . . . into place."[1]

9·2 *As soon as we put things into the studio, we are modulating the negative volume of the empty studio with positive volumes. By properly placing the positive volumes within the negative studio volume, we create a series of smaller negative volumes.*

"Proper placement" of positive volumes means that scenery, set pieces, properties, people, and equipment are placed in such a way that the large negative volume of the studio is modulated and articulated into smaller, organically related negative volumes. Thus, the positive volumes act as space modulators. They create a place in space.

Diamond Set Piece →

Sculpture on Riser

Hanging Sculpture

Plastic Sheet

Staircase

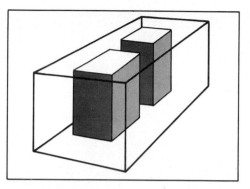

9·3 *Volume duality can vary in degree. When we use many and/or large space modulators, the positive volume might outweigh the negative one.*

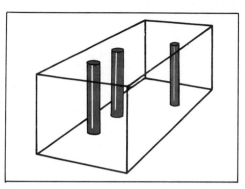

9·4 *With only a minimum of space modulators, or at least small or thin ones, the negative volume remains light, though it is highly articulated.*

9·5 *In this medieval chamber, positive volumes certainly overpower the cramped negative volume of the interior. Thick walls, and solid furniture give this room a "heavy" feeling. One feels boxed in, if not imprisoned. [Taken from* The Complete Woodcuts of Albrecht Dürer *edited by Dr. Willi Kurth.* © *1946 by Crown Publishers, Inc. Used by permission of Crown Publishers, Inc.]*

9·6 *In contrast, this more modern interior hallway has a preponderance of negative volume, articulated by a few carefully placed positive space modulators. It has an open, spacy feeling.*

9·7 *In this ruin of a medieval castle, positive volumes outweigh by far the negative space of the rooms inside. Like Egyptian pyramids, or modern bunkers, the heavy positive volumes protect the restricted living space inside, but also inhibit freedom.*

9·8 *These bridge pillars define and articulate the space around them, thus clarifying and intensifying an otherwise rather insignificant landscape.*

Too much positive volume can confine movement; it can make us feel restricted, boxed in. A large, well-articulated negative volume, on the other hand, invites mobility; we can easily move about; we can breathe freely. Too much negative volume, however, can reflect a certain emptiness. We feel alone, cold, isolated, lost.

9·9 The Gothic cathedral emphasizes negative volume: the wide expanse of the church interior. The positive space modulators, such as walls and pillars, are kept to a bare structural minimum. They seem to serve primarily the definition and articulation of the vast negative volume of the interior space.

9·11 This sculpture by the English artist Henry Moore (1898–) shows a masterful handling of volume duality. The holes in the sculpture are so well placed and defined by the positive volumes that they attain positive spatial characteristics. As in a figure-ground reversal, the holes represent no longer a nothingness, a thing that is not there, but rather a variety of negative volumes that counteracts and supplements the positive volume variety. [Reclining Figure by Henry Moore (1939). Collection The Detroit Institute of Art. Gift of The Friends of Modern Art.]

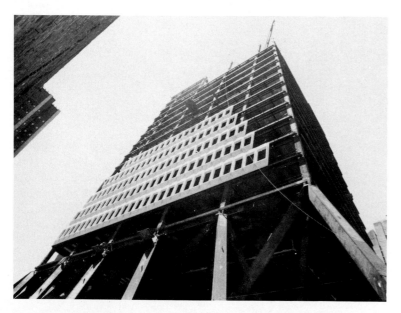

9·10 In modern structures, steel, glass, concrete, and plastics permit the definition of a maximum of negative volume with a minimum of positive volume. This provides for large, open living and working space. It suggests a certain freedom and boldness of action.

One of the most direct and highly effective applications of volume duality is the open set. "Open set" refers to scenery that is not continuous. The set is not closed or boxed in by connected walls but consists of only the most important parts of the room, such as a door, some furniture, a few separate single flats.

The open-set method is especially effective for television. First, as pointed out previously, television builds its screen events inductively, bit by bit, close-up by close-up, in a mosaiclike fashion. While the wide motion picture screen not only allows, but frequently demands, large vistas, the relatively small television screen is most effective

9·12 *In the open set, we modulate rather than merely describe the negative volume of the studio by the positive volumes of scenery and set properties. Modulating the negative volume means transposing it into an important scenic element. The spaces between the flats are no longer empty holes, but appear as "solid" walls much as the positive flats themselves. Proper lighting is essential to transpose negative space into "positive" scenic elements. We cannot light anything behind the openings, otherwise the spaces between the flats would, indeed, appear as holes rather than solids.*

9·13

with the intimate close-up. A continuous set, which is often essential for the movie vistas, is often quite superfluous for the inductive building of scenic space in television.

Second, the open set allows for free, continuous movement of cameras, microphone booms, performers, and even scenery. It also permits a great variety of unrestricted points of view (camera shooting positions). Again, in film the availability of simultaneous shooting positions is not so important as in television, since the film camera usually shoots from one position at a time. The "viewpoints" are later assembled in the cutting room into a continuous whole.

The positive volumes that serve as space modulators range from set pieces such as sculptures and flats, plastic sheets, set properties (pipes and the like) to performers and cameras (Fig. 9·13). They are carefully spaced so that they provide clearly defined negative volumes with a minimum of highly flexible positive volumes. The flexibility factor, that is, the possibility of a constant *change* in volume duality, is of course essential for a spatial *event.* Thereby, the dancers and the moving cameras act as mobile space modulators.

Since the choreographical objective is spatial change, the set pieces and set properties (usually stationary in a normal open set) are made movable. The dancers are thus able not only to explore the negative space through their movements but also to change it at will by moving the space modulators themselves.

Articulating the Z-Axis

Articulating the z-axis means to use positive volumes along the z-axis and the optical characteristics of lenses so that the viewer will perceive the various depth planes in a specific way. By placing objects and people along the z-axis in a specific way and by using either wide-angle or narrow-angle lenses (or zoom positions), we can make the viewer distinguish between foreground, middleground, and background rather readily, or not at all, or to sense things being close together or far apart—physically as well as psychologically.

We have already talked about how the various lenses influence the viewer's perception of depth (Chapter 8). We will now stress the *aesthetic effects* of depth manipulation.

9·14 *Look at these three traffic situations. One shows fairly light traffic (a). In the next (b), the traffic is heavier. The third (c) shows fairly heavy traffic. Actually, all three shots were taken from the same position within seconds of one another.*

a

But each shot was taken with a different lens. Shot (a) was taken with a wide-angle lens. In this volume duality, negative space prevails. The forced perspective and the exaggerated relative size make the cars appear much farther apart than they actually are. Traffic appears to be light. Shot (b) was taken with a normal lens. The perspective and the relative size factors appear in this shot approximately as we normally see them. The traffic conditions are accurately reflected in this shot. Shot (c) was taken with a narrow-angle lens. The volume duality has shifted to a predominant positive space. The linear perspective is minimized. The cars are reduced in size much more slowly toward the background than in the wide-angle shot. The z-axis space is shrunk and the cars seem much more crowded than they actually are. Traffic appears heavy.

b

c

Narrow-Angle Lens

9·15 *The narrow-angle lens intensifies close-ness, crowdedness. The narrow-angle lens not only crowds these signs, but suggests visual pollution.*

9·16 *The individual pillars are crowded together into a single, massive support. With the reduction of negative space, the volume duality has given way to a mass of positive volume.*

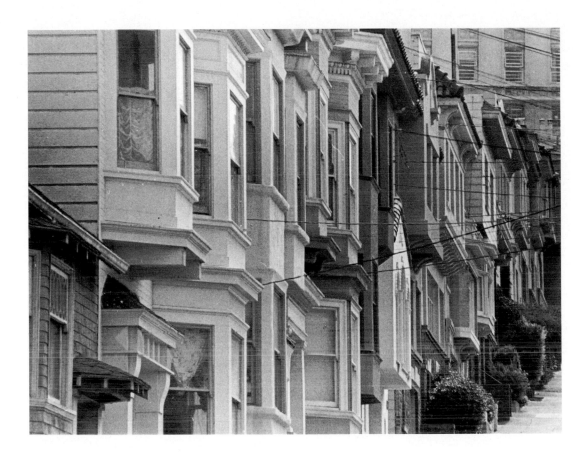

9·17 *When spatially condensed by the narrow-angle lens, this street assumes a crowdedness that carries certain psychological and social connotations, such as closeness, if not crowded-ness, and little room for expansion. Similarly, when people are crowded together by the narrow-angle lens, the collectiveness of the people (loss of individuality, sameness of behavior, collective goals, raw irrational power) is suggested.*

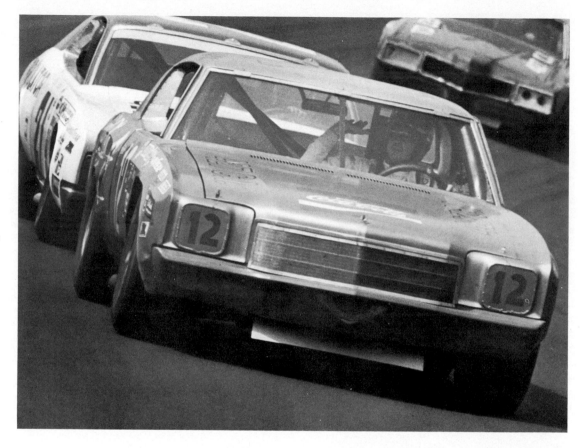

9·18 *Extreme closeness can suggest danger, especially when applied to fast-moving vehicles. The precariousness of auto racing is highly intensified by the narrow-angle shot. [Photograph courtesy of Don Hunter.]*

9·19 *Such depth distortions through a narrow-angle lens can, of course, also work to disadvantage. We are certainly familiar with the deceiving closeness of the pitcher to home plate. Since the cameras must remain at a considerable distance from the action, most sports are covered with the zoom lenses operating at a fairly long focal-length position (thus acting like a narrow-angle lens). Hence, it is often quite difficult to judge actual distances and to tell with accuracy exactly who is ahead of whom.*

Wide-Angle Lens

9·20 The wide-angle lens increases the feeling for depth, and makes the shot more dramatic. This street seems to stretch for miles.

9·21 A feeling of depersonalization and mechanization is created by this wide-angle shot of a large reading room. The immenseness of the spatial environment is reducing man's position in it and his power over it.

9·22 A wide-angle lens shot can provide a prominent foreground piece, which helps to push back the middleground and background objects for an intensified illusion of depth. We can dramatize objects and events.

9·23 *The power of things, such as automobiles or trucks, is aptly dramatized by the wide-angle shot.*

9·24 *Ordinary shots become highly dramatic when shot with a wide-angle lens. By shooting through prominent foreground pieces, the middleground or background object is emphasized by a primary frame (the screen) as well as a secondary frame. Such secondary frames focus the viewer's attention directly on the middleground or background object. The shots gain thereby in aesthetic energy.*

9·25 *Extreme wide-angle lens distortions can carry powerful psychological implications. The emphasis on the bottle suggests the man's dependence on it.*

9·27 *We can use extreme wide-angle lens distortion subjectively, to communicate visually the inner stress and feelings of the character. Ordinarily, however, such distortions are aesthetically distracting rather than helpful. Remember that any distortion, including z-axis, must be justified within the total context of the scene. Such visual distortions should help to clarify and intensify the event, not distract from it.*

Sergei Eisenstein speaks about visual counterpoint, which includes what he calls "conflict of volumes and spatial conflict." The wide-angle lens contributes greatly to an intensification through visual counterpoint.[2]

9·26 *Ordinary gestures can become menacing or suggest irrationality when optically distorted.*

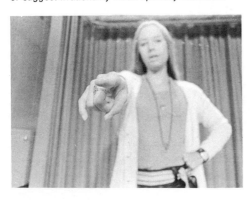

As important as the illusion of depth is to reflect outer reality, we will find that the clarification and intensification of inner reality often forces us to break the rules and conventions that we have just established. It is typical of creative man to search continually for ways and means to look deeper into himself, if not the whole universe, and to search for new and more effective ways to communicate his insights to his fellowmen.

9·28 A superimposition, for example, leads to an image in which the illusion of depth has been largely eliminated. By supering one image over another, the objects seem to become transparent; they no longer overlap but rather intersect. We can no longer tell, therefore, which object lies in front of the other. The usual figure-ground relationship and the overlapping planes are dissolved by the superimposition into a complex array of intersecting images. By collapsing separate viewpoints or separate events onto the same two-dimensional picture plane, we remove the viewer from his normal perceptual expectations and give him not only a more complex view of things but especially a deeper insight into the event. A super can very well reveal the structure of an event.

Sometimes, a super can suggest a strong internal relationship between seemingly unrelated events. The super can evoke a surrealistic, or dreamlike feeling in the viewer. A favorite method is to present dream images over the sleeping person's face by superimposition.

Z-Axis Blocking

As much as a superimposition reduces the illusion of depth, z-axis blocking emphasizes it. In fact, z-axis blocking is one of the major devices for obtaining the illusion of a third dimension on the two-dimensional television screen.

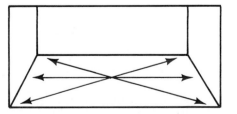

9·29 When we block action on the theater stage or for the motion picture screen, we probably block more lateral or diagonal action than upstage-downstage (z-axis) action.

9·30 In fact, lateral action is generally preferred in theater, since the theater stage is usually wider than deep. The wide motion picture screen, too, allows for effective lateral action.

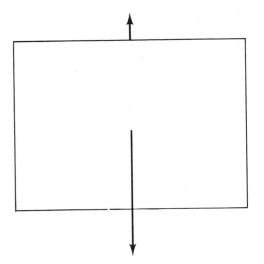

9·31 *The television screen, with its limited picture field, however, cannot tolerate even moderate lateral action without having the camera pan or truck with the action. As already pointed out, staging and blocking along the z-axis become a major, if not essential, structural device for television.*

9·32 *When blocking for television, we can have the action literally weave along the z-axis with great effectiveness. Here is an example of the numerous and varied possibilities in z-axis blocking.*

Scene: Two people (A and B) arguing; A finally gives up and leaves. Note how in this storyboard the action moves along the z-axis in a rather tight pattern. We can, of course, use similar blocking patterns for a great variety of scenes.

9·33 *Blocking along the z-axis also helps greatly in staging crowd scenes on television with relatively few people. Note that the people are all stretched along the z-axis, with overlapping planes and relative size providing ample depth clues.*

Double Z-Axis Staging

Double z-axis staging allows a quick transition from one environment into an entirely different one, with the performer remaining fairly stationary. This technique is especially useful in television when we want to shoot long, uninterrupted sequences.

Changing backgrounds, through rear screen projection or chroma-key matting, will have a similar effect. By simultaneously changing our shooting angle and background, we increase the illusion of environmental change.

Note that the important factor in double z-axis staging is the *background.* We must have a different background for each camera position in order to transport the performers into different environments through cutting. If, however, we want to have the performers remain in the same environment, we must make sure that the backgrounds for each camera (or camera position) have *enough continuity* for the viewer to perceive a single, specific locale.

The same scene shot from another angle reveals how sparse the "crowd" really is. If we intend to cut to another camera, as for close-ups, we should have the second camera fairly close to the first so that the z-axes are identical or at least run pretty much parallel to each other.

On the wide motion picture screen, we cannot stage a crowd scene quite that easily. Even if we shoot along the z-axis, we will need quite a few people to fill the wide expanse of the cinemascope screen. Generally, we create a more effective crowd scene by shooting from an angle and also from above. The wide screen needs many people to make a crowd.

9·34 *In double z-axis staging, we position two cameras at approximately 90 degrees from each other so that the z-axes cross. The performer stands where the z-axes intersect. Camera 1 shoots toward background A, and camera 2 toward background B.*

A simple cut from camera 1 to camera 2 transposes the performer instantly from environment A to environment B.

The double z-axis technique is also effective in dance numbers. With no effort at all, we can instantly transport the dancers from one environment into an entirely different one.

9·35 *Note that the backgrounds for cameras 1 and 2 relate sufficiently so that we perceive the same locale in subsequent shots. This spatial continuity, the continuity of locale, is especially important if we engage in over-the-shoulder, reverse angle, shooting.*

Building Z-Axis Space

Building z-axis space means the manipulation of the three-dimensional field not from a single point of view, within the context of a single shot, but rather from several points of view, within the context of a *shot sequence.*

Z-axis staging and blocking can aid greatly in building screen space. The z-axis vector assures visual continuity. We can link continuing as well as converging vectors conveniently by blocking the action along the z-axis. Also, blocking along the z-axis and the use of appropriate lenses (or zoom lens positions) gives a great flexibility in the manipulation of volume duality and especially in providing the screen images with the desired level of aesthetic energy. The articulation of the z-axis is of special importance to the building of screen space in television.

9·38 *The continuity of screen space is violated if we bridge too much space too abruptly, especially if we try to maintain the illusion of a real three-dimensional environment. If we cut from an extreme long shot to an extreme close-up, the viewer is very likely to lose his spatial orientation. Besides, the sudden change in image size disrupts the structure of the two-dimensional field equally severely (the vectors do not develop dynamically). In order to maintain some continuity in screen space, we must proceed more gradually either by cutting in a medium shot or by zooming or dollying in before the cut. You should stay away from a dissolve, since the temporary overlap of the two images is apt to destroy the three-dimensional field. At best, a dissolve will look messy.*

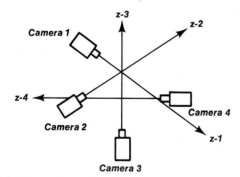

9·36 *Since each camera, or camera position, projects its own z-axis, the combination of any of these z-axes must finally contribute to a unified three-dimensional field. Building screen space extends now over a single shot to a shot sequence.*

9·37 *For example, z-axis vectors are reversed when we shoot from opposite directions. What was the foreground in shot 1 becomes the background in shot 2. If we want to maintain the same depth effect in shot 2 as in shot 1, the background of z-axis 1 must serve equally well as a prominent foreground piece for camera 2.*

Summary

Most basically, we structure the three-dimensional field into various depth planes, or grounds: a foreground, a middleground, and a background. In order to establish such depth planes, we must articulate the z-axis with positive space modulators — people or objects that are placed along the z-axis. Structuring the three-dimensional field includes (1) creating and controlling volume duality, (2) articulating the z-axis, (3) z-axis blocking, (4) double z-axis staging, and (5) building z-axis space.

As soon as we put things into the empty studio, we are modulating the negative space of the studio with positive volumes. The positive volumes define space; they create a place in space. Structuring the three-dimensional field means a careful control of *volume duality.* In such a volume duality, the positive volumes or the negative volumes can dominate. When the positive volumes prevail, the space looks crowded; it makes us feel restricted. A large, well-articulated negative volume, however, invites mobility; it feels open, spacy. In some cases, the precisely defined negative volumes take on a positive character. They no longer look like empty space but as real structural elements much like solid objects.

The *open set* is an application of volume duality to scene design. "Open set" refers to scenery that is not continuous but consists of pieces of scenery and set props that modulate the negative space of the studio without restricting the camera's point of view or travel.

Articulating the z-axis means to use positive volumes along the z-axis and the optical characteristics of lenses so that the viewer will perceive the various depth planes in a specific way. Narrow-angle and wide lenses used on an articulated z-axis can cause a variety of different aesthetic effects.

Generally, narrow-angle lenses squeeze space; they crowd things together and give a feeling of crowdedness, closeness, collectiveness, solidity. Wide-angle lenses increase the feeling of depth and make shots more dramatic. Extreme wide-angle lens distortions carry powerful psychological implications, such as superintense emotions and actions.

Z-axis blocking — blocking the action so that it weaves around the z-axis — is especially effective for the small screen area of television. It increases greatly the feeling for depth and contributes to the aesthetic energy of the scene.

Double z-axis staging allows a quick transition from one environment to another, with the performer remaining fairly stationary. Such a staging technique is especially important when we want to shoot long, uninterrupted television sequences.

Building z-axis space means the manipulation of the three-dimensional field not only from a single point of view, within the context of a single shot, but also from several points of view (camera positions or angles), within the context of a shot sequence. The z-axis is a great aid to building continuous screen space, since the vector continuity is easily controlled in z-axis blocking and staging.

Notes

[1] George W. Linden, *Reflections on the Screen* (Belmont, Calif.: Wadsworth Publishing Company, Inc., 1970), p. 132.

[2] Sergei Eisenstein, *Film Form and Film Sense,* ed. and trans. by Jack Leyda, in one volume (New York: World Publishing Company, 1957), pp. 46–63.

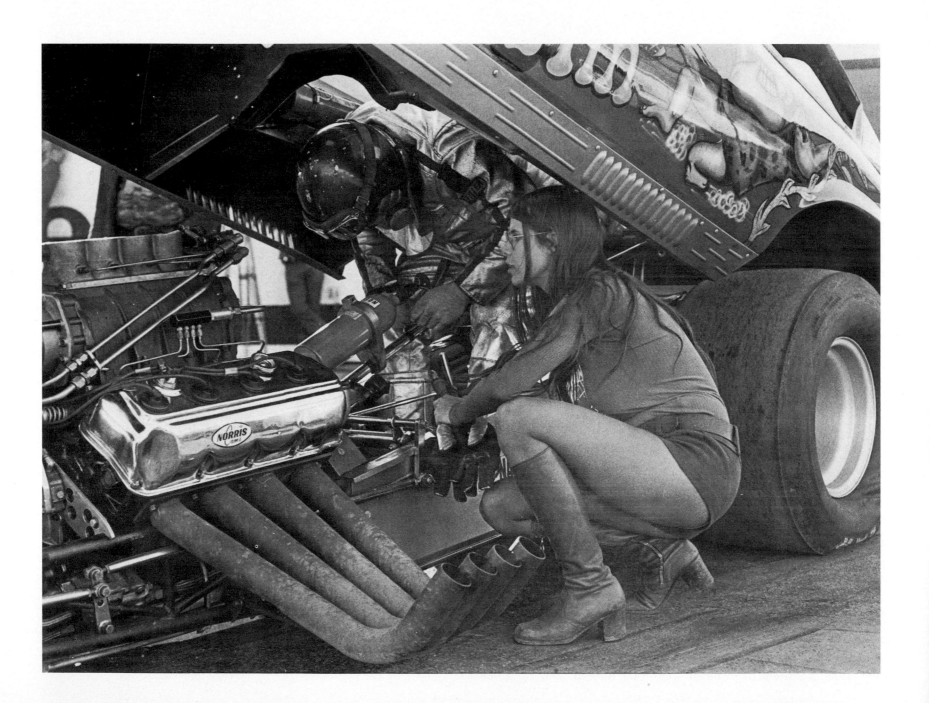

Building Screen Space: Visualization

Visualization means building screen space. Making use of what you have learned about the structural forces within the two- and three-dimensional fields, how would you visualize, that is, see as screen images, the following shot instructions?

Video	Audio
1. CU of car	. . . and note the extra width of this sleek beauty with its elegant European-styled radiator grill.
2. CU of car	The long, low lines give this car a sporty elegance.
3. CU of car	. . . Be careful, Joe, there may be a bomb in it!
4. CU of car	The President has just entered his limousine and is proceeding down Waller Street to the Parkview Villa.

Although the video instructions all read the same: "CU of car," the various contexts as provided by the audio column probably prompted you to see each close-up in a specific way.

Seeing individual shots or short shot sequences in a specific way is called *visualization.* It requires us to look at an event from a particular viewpoint. The *context* for the shot, that is, the event itself with its preceding and following shot sequences, usually determines the basic viewpoint.

Here is another assignment: Visualize a face.

Have you done it? Which one did you see? Exactly how did you see it? How would you show it on a movie screen? Now realize that you probably had little difficulty picking a very specific face and visualizing it from a fairly specific point of view. You may have had some trouble actually "seeing" the face in your mind; nevertheless, you are pretty much aware right now of whose face you would pick and how you would shoot it. You have provided consciously or unconsciously a *specific context* for your visualization that ruled out a million other possibilities. The context was probably that of a previous experience; you chose most likely someone you know. The specific viewpoint you picked was one that most readily revealed the face as you remember it, that fulfilled the medium requirement (whether you visualized it for the wide movie screen or the small, intimate television screen), and that reflected your personal way of seeing things in general, your personal style.

Whatever prompted you to visualize a specific face in a specific way, the overriding *guiding principle* for any visualization should be the *clarification and intensification* of the event for the viewer.

Again, the clarification and intensification depend on your viewpoint, which in turn is suggested by the overall event context. Here is an example of visualizing a shot for simple clarification:

Video	Audio	Visualization
CU of can (indication of viewpoint)	Be sure to buy this can with the yellow brand X wrapper (indication of event context)	

All you want to do here is to show the can as clearly as possible so that the viewer can learn more about brand X. The can is centered within the screen; the vector field is stable. The can is close enough for the viewer to read the label. No attempt is made to dramatize the event unnecessarily.

Now an example of intensification:

Video	Audio	Visualization
CU of can	Get away from it, it may be a bomb!	

In this instance, the context demands that you visualize the can in such a way as to reveal its potential danger. You must dramatize the shot, load it emotionally, create impact. Therefore, the vector field is purposely structured for tension. The horizon is tilted; the mass of the can leans heavily against the frame; the vectors of the can lead to the upper right-hand corner of the screen, their magnitude increased by the pull of the combined corner vector of the screen. The labile arrangement of the object within the frame reflects and intensifies the precariousness of the event. The shot is properly visualized.

Let us now discuss some of the more basic visualization factors relative to *viewpoint.* These are (1) field of view, (2) above and below eye level, (3) subjective camera, and (4) angles.

Field of View

Most basically, our viewpoint can vary in terms of field of view, that is, how much territory the shot includes and from how far away we seem to look at the event (Fig. 10·1).

But exactly how big is a close-up, a medium shot? How much territory, that is, how much of the event, should a long shot take in? How big should the steps (changes in image size) be between an extreme long shot and a CU? These field-of-view designations are relative and depend, like other viewpoint factors, largely on the context and our interpretation of the event (Fig. 10·2).

Let's do a similar sequence of shots, but this time not simply for the purpose of looking *at* the game, that is, to transmit the action as faithfully and clearly as we can (clarification sequence), but rather to look *into* the event, to show the power of the game and to reveal the physical and aesthetic energy of the event (Fig. 10·3).

10·1 *Look at this sequence of shots: (a) extreme long shot (XLS); (b) long shot (LS); (c) medium shot (MS); (d) close-up (CU); and (e) extreme close-up (XCU).*

a

b

10·2 *In this shot sequence, the XLS of the playing field is used more to provide color and atmosphere than to orient the viewer as to just where the football practice is taking place.*

This step from the overhead XLS to the LS of the playing field is quite extreme, but it is entirely acceptable to the viewer in this context. We have simply moved from a shot that established the theme (football game) to the locale (specific place and teams).

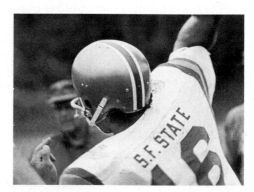

This step from the LS to the CU of the individual player helped the viewer to see better; to be better able to make his own judgment about the quarterback's actions.

c

d

e

10·3 *Obviously, you start quite a bit closer. The LS is almost as close as the CU was in the previous shot sequence.*

The subsequent shots get similarly closer. Our orientation has shifted from an outer to an inner one. The visualization for this sequence is guided by the intensification of the event. The steps from an LS to an XCU are considerably less abrupt than in the first sequence, yet they carry more aesthetic impact and drama.

Most communications media, especially film and television, can assume several communication roles and functions. Most basically, they can look at an event, into an event, or create an event.

Looking at an event means simply that we have the camera report an event as faithfully and as completely as possible. The medium takes on a simple transmission function. When we change a camera viewpoint, it is done simply to clarify the event, but not necessarily to dramatize it. Most live telecasts of sports events or other special events fall into this category. The medium merely reports what is going on. Cinema verité is a similar filmic attempt to look at an event as objectively as possible.

Looking into means to scrutinize an event with the camera as closely as possible, to look behind its obvious outer appearance, to probe into its structure, its very essence. Frequently, the camera reveals more than we could see merely by looking at the event.

But the medium can also create an event. The camera, then, uses the actual event strictly as raw material for its creation. The new event created by the camera exists only on the screen—nowhere else. Sometimes, even the camera is no longer necessary for the medium-created event. In film, the film emulsion can be activated directly by the artist, rather than by the camera-mediated light variations. In television, the scanning beam in the monitor can be directly influenced by electronic energy; the stimulus does not have to come from the television camera chain.

10·4 *Camera looks at. The camera merely reports what is in the museum as objectively as possible. It looks at this sculpture with detachment.*

10·5 *Now the camera looks into the event, the sculpture. It reveals aspects of this sculpture that we ordinarily would not, and probably could not, see.*

Note, however, that the camera does not add any elements that do not belong to the event itself; we still see the sculpture as it is, but we see into it. The camera looks into the event more subjectively—it assumes its own point of view. The camera intensifies the event.

10·6 *In this instance, the medium creates its images, using the sculpture as the raw material, the basic energy, for the screen event. But the new event is possible only on the screen.*

Above and Below Eye Level

For some time, kings, school teachers, preachers, judges, and gods knew that sitting up high had very important effects. Not only could they see better and be seen more easily, but also they could look down on people, and the people had to look up to them.

This physical elevation has strong psychological implications. It immediately distinguishes between inferior and superior, between leader and follower, between those who have power and authority and those who have not.

The camera can do the same thing. When we look up with the camera, the object or event seems more important, more powerful, more authoritative than when we look at it straight on or even look down on it.

When we look down with the camera, the object usually loses somewhat in significance; it becomes less powerful, less important, than when we look at it straight or from below.

Like the tilted horizon, the above and below eye level shooting evokes in the viewer a strong aesthetic reaction. He very readily assumes the camera's viewpoint and identifies with its superior above eye level position and its inferior below eye level position.

10·7 *The speaker seems to gain in authority, strength, persuasiveness, and even power as the camera assumes a looking-up position.*

10·8 *The power of machinery, too, is empha-sized by shooting from below. This loader seems to be quite a bit stronger and more powerful than when shot from above.*

10·9 *Any machines that are primarily designed for destruction usually look more menacing and powerful when shot from below than from above or straight on.*

10·10 *Even the perception of movement varies with whether we observe the motion from below or above. This car, for example, seems to be able to go faster when we look up at it and somewhat slower when we look down on it.*

Subjective Camera

The possibility of the viewer assuming the camera's viewpoint and position has prompted the film maker and television artist to use the camera *subjectively.* When used subjectively, the camera no longer looks at an event but seems to *participate* in the event. The camera assumes the role of a person who is moving about his surroundings, who participates actively in the happening. Other people in the event turn directly to him (the camera) and engage him in their actions. And, since the viewer can identify with the camera, that is, can assume the camera's point of view, he should therefore also be able to assume the role of the camera and participate directly in the event.

Unfortunately, this ideal transformation of the viewer from event-spectator to *event-participant* rarely occurs, even if the camera is used subjectively. Most often, the viewer remains in his seat *observing* the screen event. He does not necessarily feel catapulted out of his seat onto the screen, moving about the other screen images.

In certain instances, however, the subjective camera can entice the viewer at least to associate very closely with the camera's point of view, if not its position. When this association happens, the viewer may participate in the event not only psychologically (a strong *feeling* of being part of the event) but also kinesthetically (a *physical* reaction to the event, like yelling, clapping, and the like).

The subjective camera technique seems to work best when the viewer feels strongly *motivated* to participate in, rather than merely observe, the event. The most effective motivational factors seem to be (1) a strong delineation of protagonist and antagonist so that the viewer can easily choose sides, (2) a highly precarious situation including physical discomfort or psychological stress, and (3) a situation in which the viewer's curiosity is greatly aroused.

10·11 *Statues of famous people are built either superlarge or are put on pedestals in order to force people to look up to them, thereby making the viewers assume an inferior position relative to the statues.*

Phrases like "the order came from up above," "moving up in this world," "looking up to and down on" instead of looking up and down at, being "on top" of the fortune wheel or the world, are all manifestations of the strong association of physical vertical positioning with the feelings of superiority and inferiority.

"Due to the identification of his eyes with the camera viewpoint, the film [and television] viewer is subject to an experience of bi-sociation. Though he is literally in his seat, he negates that perspective and identifies with the screen perspective."[1]

In a boxing match, as in most sports, the viewer is bound to take sides. Once he has identified with the protagonist, there is a good chance that the viewer will become so involved that his reactions are kinesthetic (physically engaging in some boxing movements to help the protagonist in his fight). When we have motivated the viewer to that extent (or almost that much), we can successfully switch to a subjective camera.

Once the viewer is deeply engaged in the action, a shift of the camera viewpoint from the objective two-shot to the subjective one-shot of the antagonist (who is directing all his action to the lens—and therefore to the viewer) seems a logical, organic intensification of the event rather than an artificial, inconsequential camera trick. Since the camera is now used subjectively, the viewer may even try to duck the final knock-out blow delivered to him (the protagonist) by the antagonist; at least he will feel deeply involved in the protagonist's fate when the subjective camera goes out of focus and begins to convey the defeated boxer's "loss of consciousness."

Unfortunately, our hero was badly hurt and had to undergo an operation. Will the operation be successful? Will he ever see again? The camera again assumes a subjective role by looking up at the surgical team. Now you have not only motivated the viewer through a strong identification with the protagonist, but you have presented him with an additional factor: that of a precarious situation, involving both physical and psychological stress. The camera racks slowly into focus, looking up into the happy faces of the operating team. He (the protagonist-viewer) can see again! Because of the strong empathic involvement of the viewer with the protagonist under duress, the subjective camera simply underscores, but does not superimpose, the viewer's event participation.

10·12 *Another way of providing the proper motivation for the viewer to accept more readily a subjective camera is to show a precarious situation and then suddenly draw the viewer into it. For example, this sniper is shooting at anything that moves. The police are carefully inching toward his stronghold.*

Suddenly he turns the gun on the viewer (pointing it directly into the lens). The camera has become subjective.

10·13 *If the viewer's curiosity is sufficiently aroused, he will again associate quite readily with the camera's point of view. This young woman has an important appointment with the head of the communication department. She is new to the university and doesn't know anyone. Hesitatingly, she knocks and opens the door. What will he be like? We see her enter the front office. But then the camera goes subjective and we, with the girl, meet the friendly secretary directly. The camera goes objective again, and we observe the secretary leading the new girl into the department head's office. Once again, the camera goes subjective. We no longer observe how the girl is meeting the department head, but through the subjective camera we meet him too. Like the girl, we participate in the event.*

A very popular, yet rarely successful, subjective camera technique is to tie the camera onto a racing car, hang it around the ski racer's neck, or tie it even to the skis, dolly it along the street. The assumption is that this type of subjective camera will make the viewer experience driving a race car, skiing down a steep slope, or walking along the street. Unless the viewer is highly motivated, such a position switch does not occur in the viewer. Often, the viewer witnesses nothing but a landscape rushing by, a blur of snow, or ski tracks shooting up the screen, or a street moving about the screen. This type of subjective camera may perhaps indicate to the viewer the speed, or the relative precariousness of the event, but he remains in most cases the *observer*. Skiing down a slope and witnessing the snow rush by are simply two different types of experience.

The direct-address method of television, where the performer speaks directly to the viewer, is also a form of subjective camera. The camera assumes the viewpoint and position of the viewer. The successful television performer frequently considers the television camera as the viewer, talking literally through the lens to the viewer inside this curious

box. He does not consider the camera merely as a machine that is capable of transmitting his remarks to the millions of people "out there in video land." This type of subjective camera is much more successful in television than in film. In television, the viewer is used to an intimate, close relationship with the performer and, most often, with the event. The performer literally comes to his home. The performer is part of the viewer's daily home routine. Naturally, the viewer feels in close communion with the performer and his action. He feels, therefore, quite at ease and natural when the performer speaks to him directly on the screen.

Film is quite different in this respect. The viewer looks up to the film actors; they are not part of his daily routine, they represent something special. They are stars. The viewer would, therefore, get uncomfortably jolted out of his fantasies and the security of his darkened and popcorn-sweetened environment if the screen image were suddenly to make direct contact with him. We should stay away, therefore, from having the film actors or performers directly address the audience, unless we have motivated the viewer enough so that he will accept such a violation of aesthetic distance.

"When the camera tracks through a room or dollies down a street, the room or the street becomes an actor on the screen; and the changing, sometimes swinging direction of the camera also becomes an invisible actor shaping the visual space. The spectator is literally nowhere in relation to movement. For it is not the same thing to watch a street move and to walk down a street."[2]

Angles

When we shift the camera's viewpoint, we create a variety of *angles,* a distinct vector field that can help in the task of clarifying and intensifying a particular event on the screen. Although we have already talked about the various aesthetic implications of certain shooting angles (especially shooting from above and below), let us take another brief look at camera angles and how they can help in the clarification and intensification task.

Angles Depend on Context As pointed out before, the camera viewpoint and with it, of course, the whole vector field of angles, depends to a large extent on the *event context.*

Let's go downtown together and observe a variety of people entering an exclusive, expensive department store for women. Here is what we observe:

Event 1 A woman does some browsing in an expensive department store since she has some time to spend before her champagne luncheon with the other women from the club. She enters the store swiftly and surely, much like entering a supermarket. She knows where to go. She knows that the sales staff are here to serve *her.*

Event 2 Another woman, who cannot afford to shop in such an expensive store, has saved up some money to buy a present for her friend who is more impressed by fancy labels than product quality. She enters hesitatingly, does not quite know what to say to the hostess who greets her at the entrance and feels quite embarrassed by the cool stares of the salesladies.

Event 3 A little girl wanders into the store. Her mother is busy talking to a friend right outside the store. She simply wants to look at all the wonderful things in the store.

10·14 *Event 1: The woman pays the cab driver, walks quickly to the store and enters without stopping. She gives the hostess a polite smile and proceeds to the elevator. She is obviously doing a routine thing. The shooting angles, therefore, should comply with the routine character of the event. They, too, are normal, routine. There is a minimum in viewpoint shift, the vector field is stable. Angles should contribute more to the clarification than to the intensification of the event.*

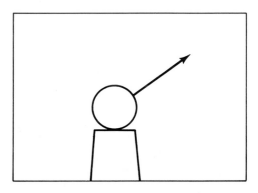

10·15 *Event 2: This woman feels insecure when entering. Viewpoint from below. The building looks threatening to her. Camera looks up on building. She looks through the door. Hesitates. Viewpoint from inside the store. She enters. Looks at hostess. From below up to the hostess. Store looks immense. Wide-angle lens distortion, slightly from below. Depending on whether you want her to gradually gain more confidence or become progressively more ill at ease, the angle vectors will either stabilize or become progressively more labile.*

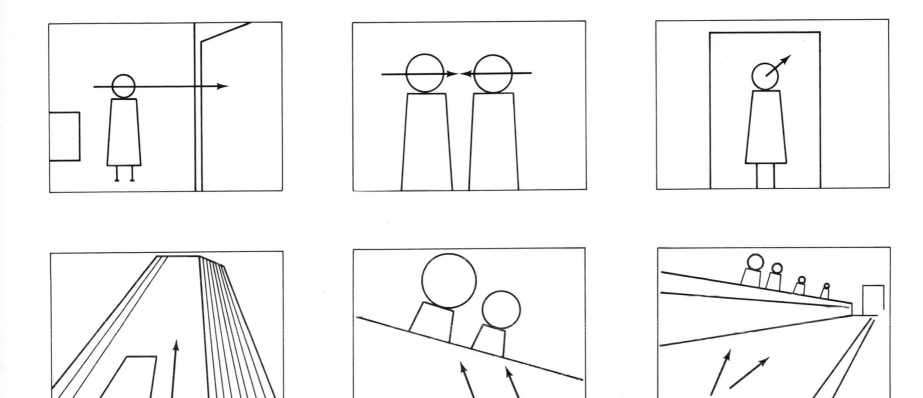

Now try to visualize the three events. How do the different event contexts influence your camera viewpoints? What are your predominant angles?

Without trying to tell you specifically how you should look at these three events, Figures 10·14 through 10·16 offer some suggestions about the principal structure of the angle vector field as determined by each specific event context.

10·16 *Event 3: From above to show small girl. Then from below to indicate her viewpoint (almost subjective camera). Saleslady being kind, shot straight on, looking down. Girl walking through store. From below, approximating her point of view. If you want to show that the girl gets more and more frightened, your viewpoints become more and more subjective and the angles more extreme (the vector field, therefore, more labile). To show her delight in this new adventure, the angles normalize.*

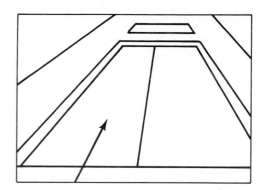

In each of the three events, the *context,* that is, the thematic implications, suggests a rather specific visualization approach.

Angles Build Screen Space Whether we are visualizing for the clarification of an event or for its intensification, or both, we inevitably build screen space. Careful selection of shooting angles within the shot and from shot to shot creates a vector field that varies in structure as well as magnitude. If the angle variation is extreme, the vector field usually gains in magnitude; if the angle variation is moderate or light, the vector field has generally a lower magnitude. In any case, angles contribute to a vector field that involves the viewer in new spatial relationships. He will no longer simply observe a reproduction of actual space, but rather will experience a new spatial phenomenon: *screen space.* We must be careful, of course, that the screen space makes sense to the viewer, that is, that he is able to apply psychological closure to the spatial bits and pieces as presented on the screen. He must be able to experience screen space as a gestalt. The vectors of the screen space must have some coherence, some continuity.

Sequential Screen Space When we build screen space sequentially, from shot to shot, shooting angles can help greatly in establishing visual continuity, a coherent vector field.

Angles for Continuity: When we shoot a scene discontinuously for later editing, a change of angles between shots and key actions will generally help us avoid jerky action later when the shots are finally assembled.

If you do not change angles from shot to shot, the viewer expects to see each principal vector continue in the direction and magnitude established in the originating shot. Any slight misalignment from shot to shot will make the vector continuity seem uneven and jerky. (See Figure 10·17.)

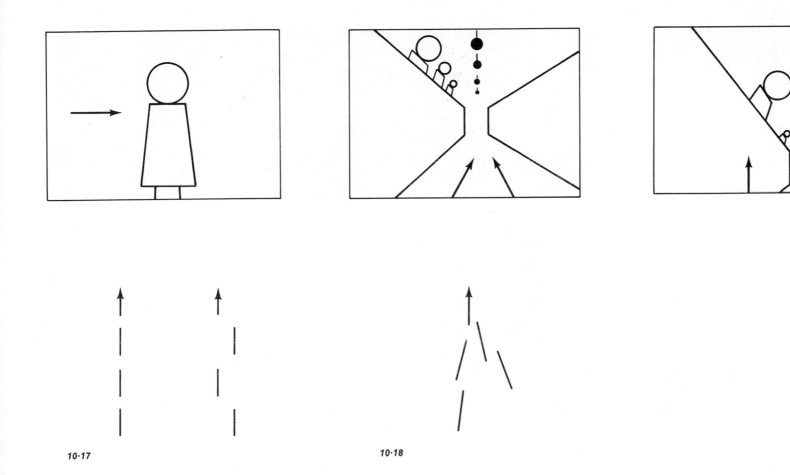

10·17 10·18

By changing the angles from shot to shot, however, you establish a whole *vector field* in which the individual vectors no longer continue each other but simply follow a general direction, a directional tendency. Precisely because of the directional shifts (through the various angles), the principal vectors often reinforce one another from shot to shot, thereby letting the viewer experience not only a more complete but also a more intensified screen space. (See Figure 10·18.)

10·19 *In this dancing sequence, the various camera angles intensify the upward movement.*

10·20 *The absence of angles makes the same dance sequence less dramatic, even if the field of view (from medium shot to close-up) is appropriately changed.*

Viewpoint-Angle Consistency: If we show a person looking at something and then let the viewer see what the person is looking at, we must match the camera's viewpoint with that of the person.

When we shift viewpoint (camera position) organically, the viewer will not feel jolted into a new position and environment but will simply experience a heightened sense of active participation. He will see more and will feel what he sees more intensively.

One word of caution, however. *Do not be angle crazy.* Especially if your job is simply to report an event or if the context calls for a single point of view, try to keep your camera in one place. For example, there is no need for you to shoot a newscaster from below eye level, then from above, then from left, then from right, especially if all he does is read the weather report.

A dull, uninteresting speech will not become any more exciting even if you use many and extremely varied angle shots. As a matter of fact, you will probably destroy with your visual acrobatics the little information the speaker has to give his audience.

Whenever you are called upon to report an event as faithfully as possible, you should try to maintain a single point of view (camera position) whenever possible. In a multiple-camera set-up, keep the cameras as closely together as space and maneuverability permit. When cutting from one to the other, merely change the field of view but not the angle. This type of shooting assures maximum clarity and a minimum of visual confusion.

10·21 *In this shot, we establish a definite, strong index vector, pointing to the right.*

A different point of view would create a conflicting vector field; it would interfere with the building of an organic screen space structure.

When revealing what the woman is pointing to, the camera must assume her point of view.

10·22

Simultaneous Screen Space Through superimposition, matting, or multiscreens, we can show a variety of angles simultaneously. In effect, we establish a unique vector field that can exist only as screen space. After all, in real space we cannot be in two or more places at once; therefore, we can observe an event only from one point of view at a time. This simultaneous display of various points of view provides a new visual experience that permits the viewer to look *into* the event and, if done effectively, to experience the very essence, the basic structure, of the event. The new vector structure can transcend the original event into a new, synergetic field of experience that, though it is based on the original event, puts out a greatly increased amount of aesthetic energy (Fig. 10·22).

Angles Set Style Even when the context, the thematic implication, of the event dictates to a large extent a basic use of angles, we still have a rather wide latitude in what angles to use and how to use them. This means that our visualization is

still finally determined by our basic *aesthetic concept* of the event and our sensitivity to the requirements and potentials of the medium with which we communicate this event. Therefore, the angles we choose will, in connection with the total structure of the vector field, help to set *style.*

As all good things, style should remain subtle. It should not draw attention to itself, but should simply support you in your basic task of effective *communication.* Like your handwriting, your shooting angles should *not become the communication,* but should be simply a *reflection of your personality* and aesthetic insight.

Visualization, then, implies that you choose your fields of view and your (the camera's) viewpoints within the event's context in order to clarify and intensify the event for the viewer, and to do so with style.

Summary

Visualization means building screen space. It means looking at a scene from a particular viewpoint, and seeing screen images in a specific way. Usually, visualization is guided by the event context.

The basic visualization factors relative to viewpoint are (1) field of view, (2) above and below eye level camera position, (3) subjective camera, and (4) angles.

Most basically, a shot can vary in terms of *field of view,* that is, how much territory the shot covers, such as an LS, an MS, or a CU.

When the camera looks *up at an object* or event from below eye level, the object or event appears to be more powerful, more authoritative than when the camera looks at it straight or looks down on it. When we look *down* on an object with the camera, the object loses its significance.

Subjective camera means that the camera no longer simply looks at an event but participates in it. The camera assumes the point of view of a person with whom the viewer should ultimately identify.

When the camera shifts its viewpoint from one position to another while covering an event, it creates a variety of *angles.* Camera or shooting angles depend on the event context.

Angles are especially useful for building *screen space.* Camera, or shooting, angles create a vector field that varies in structure as well as magnitude. If the angle variation is extreme, the vector field usually gains in magnitude. If the angles are moderate, the vector field has a lower magnitude. Camera angles no longer represent the spatial reality of the actual event; rather, they represent a new phenomenon: *screen space.*

Building sequential screen space means that screen space is developed from shot to shot, from scene to scene, from sequence to sequence. Angles help the vector continuity.

Simultaneous screen space means that the various camera angles are represented on the screen image simultaneously, through superimposition, matting, or multiscreens.

Finally, angles help to *set style.* Like handwriting, camera angles can express the personality and creative trademark of the television or film artist.

Notes

[1] George W. Linden, *Reflections on the Screen* (Belmont, Calif.: Wadsworth Publishing Company, Inc., 1970), p. 26.

[2] *Ibid.,* pp. 25–26.

The Four-Dimensional Field: Time and Motion

Aspects of Time

The study of the four-dimensional field, the various aspects of time and motion within the context of television and film, is one of the most important steps in our factor analysis. After all, the essence of television and film is the *moving* image. You remember that we said in the beginning of this book that the *materia* of television and film, the stuff television and film images are made of, is light. But it is light in *motion.* The screen images of television and film have little permanence. They do not exist as things; they are transitory. As in real life, change is the essence of the four-dimensional field in television and film. Television and film demand the articulation and manipulation not only of a spatial field, but also of a *space-time* field. Structuring the four-dimensional field means achieving a spatial-temporal order.

The concept of vectors and vector fields includes the time element. As pointed out before, the *vector fields* in television and film are not static, but are *continually changing.* Motion (force in a particular direction with a certain magnitude—speed) is an intrinsic element of a vector. A vector is created, not only by a stationary arrow that points in a particular direction but also by the one that flies off the bow toward the target.

We should now lay the groundwork for structuring the four-dimensional field by discussing some of the most basic field elements: the major aspects of time and motion.

Man has always been concerned with time. We are born and die at a certain time. We experience recurring phenomena that suggest the passage of time: day and night, the months, the seasons. We experience periods of activity and nonactivity and of bodily wants and needs and their satisfaction. We learn how to record the past, and we live in the present. We try to predict the future, to cheat human mortality; at least we try to prolong our life span as much as possible. We construct theories and beliefs that suggest another life after death. We seek to manipulate, to control time.

In our efficiency-oriented society, time has become an important *modern commodity.* It has gone far beyond its former spiritual and ethereal importance. Today, time has attained a new existential significance. Time is money. There are time salesmen and time buyers who bargain shrewdly for the price of various segments of time. They have tables that list the price of time. Some of the broadcasting time sales rate cards point out that no time is "sold in bulk."

Time is an essential factor in measuring the worth of work. Efficiency is assessed not only by what you do, but especially by how fast you can do it. We build machines that break down or at least become inefficient at a particular time, and we accelerate this carefully calculated obsolescence with periodic style changes. When traveling, we are inclined to measure distances no longer by spatial units but by units of time. It is three hours to Europe and three days to the moon.

Computers that perform intricate operations with the speed of light, space travel, the discoveries in nuclear physics have all contributed to a new space-time concept. At least they have demanded of us a new, intense, and unprecedented awareness of time. We have become a mobile society: physically as well as psychologically, if not spiritually.[1] Time and motion have become almost the essence of life. We are, indeed, a *now generation*.

Small wonder, then, that the new time concept, this now factor, has prominently entered all fields of the arts. We can find the artist trying to manipulate time and motion in painting, sculpture, and still photography, as well as in the more obvious motion arts, such as theater, dance, music, film, and television. The ultimate instrument with which we express our now-consciousness is television. It allows clarification and intensification of an event while the event is going on, and this clarified and intensified event can be experienced instantaneously by an almost unlimited number of widely dispersed people.

"Space-time stands for many things: relativity of motion and its measurement, integration, simultaneous grasp of inside and outside, revelation of the structure instead of the facade. It also stands for a new vision concerning materials, energies, tensions, and their social implications."[2]

11·1 This cubist painting by Picasso shows various sides of the object simultaneously. It implies a shift in viewpoint, that is, the viewer's moving about the object. Also, the pattern of this painting suggests a certain rhythm, which we can easily sense as a type of motion. [Daniel-Henry Kahnweiler by Pablo Picasso (1910). Oil on canvas, 39⅝" x 28⅝". Gift of Mrs. Gilbert W. Chapman. Courtesy of The Art Institute of Chicago.]

11·2 *In this abstract-expressionist painting by the American painter Franz Kline (1910–1962), we experience an immense sense of motion. We can literally relive and move with the energy of the powerful brush strokes.* [Bigard by Franz Kline (1961). Oil on canvas, 92" x 68". Collection Carter Burden, New York.]

11·3 *The French painter Marcel Duchamp (1887–1968) shows frozen elements of motion in this painting. It closely resembles time-lapse photography.* [Nude Descending a Staircase, No. 2 by Marcel Duchamp (1912). Oil on canvas, 58" x 35". Courtesy of the Philadelphia Museum of Art: The Louise and Walter Arensberg Collection '50–134–59.]

11·4 *Some contemporary painters are so time-conscious that they create a variety of vibrating patterns that seem actually to move. [Blaze I by Bridget Riley (1962). Courtesy of Richard L. Feigen & Co., New York.]*

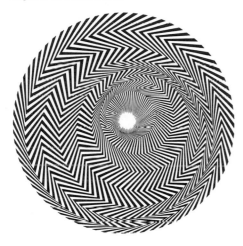

11·5 *The sculptors, who heretofore simply arrested motion in one immobile pose, are now creating works that actually move. The American Alexander Calder (b. 1898) is one of the foremost kinetic sculptors. He has produced a great variety of mobiles. [Big Red by Alexander Calder (1959). Sheet metal and steel wire. 114" long. Collection Whitney Museum of American Art. Gift of the Friends of the Whitney Museum of American Art.]*

Other sculptors built works whose only purpose is that they move. One sculptor was so obsessed with the idea of change that he built a huge blocklike thing of ice in front of the Museum of Modern Art in New York and gleefully watched it decay in the hot sun.

What Is Time?

"Time is a fable and mystery: it has ten thousand visages, it broods on all the images of the earth, and it transmutes them with a strange, unearthly glow. Time is collected in great clocks and hung in towers, the ponderous bells of time throng through the darkened air of sleeping cities, time beats its tiny pulse out in small watches on a woman's wrist, time begins and ends the life of every man, and each man has his own, a different time."[3]

What is time? We do not know. All we really know is how to experience time in the form of duration, recurring phenomena, cycles, rhythm, motion. We can measure it. We live, love, suffer and die with and through it. But we do not exactly know what it is. We get different answers to the seemingly simple question of what time is depending on whom we ask. The philosopher gives us one set of answers, the physicist another. The artist may be concerned only with that aspect of time that suits him best in his quest to clarify and intensify experience with a specific medium, such as television or film. And this is exactly what we will do: select and discuss those aspects of time and motion that seem most relevant to our media, television and film, and that help us best in effectively structuring the four-dimensional field.

Types of Time

First of all, we must distinguish between the time the clock shows and the time we feel. We all have experienced at some time an endlessly long five minutes, while at other times an hour seemed to pass in seconds. Obviously, the time we feel does not always correspond with the time we measure. In television and film we must, of course, work with both types of time. The time that we measure by the clock is appropriately enough called *clock time,* or *objective time.* The time we experience is called *psychological time,* or *subjective time.*

Objective Time Objective time is what the clock says. It is measured by observable change—by some regularly recurring physical phenomenon, such as the movement of stars, the revolution of the earth around the sun, or the moon around the

earth, or some artificially induced regular motion, like the wheels of a clock.

The most accurate device we have so far to measure objective time is the cesium atom, which oscillates 9,192,631,770 times a second.

Day and night cycles, as well as the seasons of the year, are also manifestations of objective time. They comprise observable, and therefore measurable, change.

Subjective Time Subjective, or psychological, time is *felt time.* Regardless of what the clock says, we may experience a short or long duration, and we may judge an event as seeming brief or long. While the clock time can be measured by very precise units, subjective time is more elusive. It is more a state of *quality* than quantity.

How long, then, is an event in terms of subjective time? Or shall we rather say, how *intense* is an event in terms of subjective time? Subjective time seems to be determined more by the *density* of an event and our involvement in it than by its progression—the relative clock-time duration of the event.

Think of some examples when you have experienced "short" and "long" periods of subjective time.

To the casual observer, a chess game may seem exceedingly slow. But when we are involved in playing the game, time seems to fly. Similarly, if we are involved in a film or television show, we are not any longer aware of clock-time duration; we are much more concerned with the event itself. Whether we experience an event as brief or long seems to depend on the degree of our involvement. The more involved we are in the event, the shorter it seems. The less involved we are, the longer it seems. Subjective time, then, is a function of the *density of involvement.*

The density of the event itself can also influence our feeling for time. If the event has a high degree of density, that is, many elements occurring simultaneously or in rapid succession, time seems to pass faster than if we watch a low-density event. Again, a high-density event, such as a fast football game or car race, involves us more readily and more deeply with its high energy (high-magnitude vectors) than a low-density event (listening to a speaker with nothing to say) with its low energy (low-magnitude vectors).

Waiting, of course, is an incredibly low-density event, which consists of nothing but time passing. Since we are looking *forward* to an event to happen rather than participating in one, the subjective time during the waiting period seems to stretch endlessly.

There are rare instances when total involvement in an event seems to make us independent of time altogether. The ecstasy of love, the unreality of death, or the experience of extreme beauty or fear may let us feel the instantaneousness of eternity—the timelessness of total involvement. After such an experience, we simply cannot tell how long it lasted; all we remember is a degree of intensity. The vector simply increases in mass, in magnitude; but it no longer has a direction.

Biological Time

There is a type of subjective time that operates quantitatively, which means that it tells us when to do certain things. All living things seem to have a biological clock built into them. Migrant birds return when their biological clock says it is time to return, regardless of the prevailing weather conditions back home. Some plants open and close according to their biological clock time, not because it is night or day, or hot or cold.

Each of us has awakened many times just before the alarm clock went off. The biological clock told us when it was time to get up. The biological clock is set by habit. If we gradually change sleeping and waking hours, the biological clock resets itself to the new schedule. But if we change a schedule abruptly, the biological clock keeps on ticking faithfully according to the old time schedule. This can be quite annoying or exhausting, especially during travel. When everyone is ready for bed in the new location, we start feeling wide awake and alert. And when the biological clock tells us that it is the time we normally go to bed, the people in the new location, whose biological clocks are set differently, are ready and eager to start a new day. This type of biological time upset is called "circadian cycle (or rhythm) desynchronization." ("Circadian" comes from the Latin circa (about) and dies (a day), referring to the approximate day-night cycles of biological clocks.) Fortunately, the biological clock will adjust after a while to the new working and sleeping rhythm.

Although biological time does not directly help to structure the four-dimensional field, it nevertheless contributes to the readiness of the viewer to respond properly to our communication. If he is dead tired when watching the program, we will certainly have a more difficult task to arouse his aesthetic sensitivities than if he is wide awake. In television, we should at least consider adjusting programming to the general waking and sleeping habits of our audience. Also, we should be sensitive to the general mood and receptiveness of the audience as dictated by the biological clock. In mid-morning, when the audience is wide awake and full of energy, it may tolerate, if not demand, a higher-energy program than late at night, when the biological clock of the viewer tells him to relax and be comfortable.

Zeno of Elea, Greek philosopher, ca. 490–ca. 430 B.C. He was greatly influenced by the philosophy of Parmenides (ca. 500 B.C.), who proposed that the ultimate reality is motionless, finite, and that change is strictly an illusion. Do not confuse Zeno of Elea with Zeno the Stoic (335–265 B.C.).

Time Theories

There are several major theories that try to explain the phenomenon of time in its most obvious existential manifestation: as a mode of motion, and as a continuum that we constantly divide according to our experience into past, present, and future.

Anything that deals with time and motion has, of course, some bearing on media that communicate essentially through moving video and audio images. However, we will select and concentrate only on those theories that seem especially useful in explaining one of the most fundamental structural differences between television and film, that of *motion*. This basic structural difference, the series of static, discrete images of film and the continuous scanning of the electron beam in television, may well be the key to each medium's unique aesthetic requirements and potentials.

The time theories of Zeno and Bergson prove most helpful in this undertaking. We will compare Zeno's motion paradox to film motion and Bergson's time concept to television motion. Then we will examine the concept of the instantaneousness and irrevocability of the moment within the context of film and television.

Zeno and Film Zeno would have been delighted with film, because it would have been living proof for his basic theory that motion is nothing but an illusion.

Like most Greek philosophers, Zeno tackled the problem of time by analyzing motion. He saw motion basically as an infinite number of "frozen" positions in space.

Applying rigorous logic, he developed eight by-now-celebrated and often refuted *paradoxes of motion.* Basically, he asserted that if a thing moves, it either moves where it is or where it is not. However, it cannot move where it actually is, because there it is at rest. Where it is about to move toward, it is not as yet. Since the thing cannot exist where it is not, it cannot possibly move there, either. Therefore, he concluded, motion is impossible.

Here is one of his paradoxes that is especially relevant to our discussion of the basic structural unit of film:

So long as anything is in a space equal to itself, it is at rest. An arrow is in a space equal to itself at every moment of its flight and therefore also during the whole of its flight. Thus the flying arrow is at rest.[4]

(Having heard that motion is impossible, one of Zeno's students reportedly got up and quickly walked away.)

11·6 *At position 1 (beginning of its flight), the arrow occupies space from A to A$_1$; at position 2, it occupies space from A$_1$ to A$_2$; at position 3, the space from A$_2$ to A$_3$, and so on, ad infinitum. At every instant of its travel path from A to B, the arrow is actually at rest. The arrow is always at a particular point. (This concept of motion is, therefore, referred to as the "at–at" theory of time.) But how can it then be in motion? How, for example, can we get the arrow from static position 1 to static position 2, especially since the positions lie infinitely close together? Motion, therefore, is an absurdity. So concludes Zeno. Fortunately, nobody shot an arrow at him to disprove his point.*

11·7 *Photography certainly seems to prove Zeno's point that objects in motion are actually at rest at various points in space. In all these photos, which depict a variety of motions, the objects appear to be at rest. Their travel through space was evidently so minute that to the camera they were indistinguishable from objects at rest.*

11·8 *A stroboscopic photograph of an arrow in flight seems to provide even more proof for Zeno's argument. The strobe light, which illuminates an event at very short intervals, shows the various positions of the arrow during its movement.*

The faster the strobe light flashes, the more snapshots of the action (static images) we get, and the closer they lie together. The action is simply broken down into a greater number of spatial positions. But again, in each of these positions, the object seems to be at rest. What if we could get a strobe light that could flash infinitely fast? We would then get an infinite number of static images, all lying infinitely close to one another, but still describing the flight of the arrow from A to B. But since we have an infinite number of static positions within the finite unit of time, how then can the arrow move? Thus goes Zeno's argument.

11·9 *Obviously, Zeno could have (and probably would have) used film as a fitting example for his motion theory. Much like a strobe light, film takes a number of snapshots of a moving object. Each of the snapshots, each frame, however, shows the object at rest.*

When we enlarge a film frame, we really cannot tell whether the object was in motion when the picture was taken, or whether it was stationary.

Calculus works on the Zeno principle: it breaks down motion, or irregular motion such as velocity, into an infinite number of infinitely small instances, which can then be observed and measured. The speedometer of your car is actually applied calculus. It shows how fast your car travels at every instant. Whether you glance at it for a while or just for a brief moment, the speedometer reports accurately the speed you are going.

In order to measure instantaneous velocity, a mathematical limit must be established between a given point (x_1) and another point (x_2) and their corresponding times (t_1 and t_2). In effect, clock readings are taken at point 1 and point 2, whereby the distance between the two points is made to approach zero.

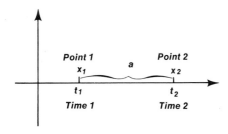

Distance a, which is $x_2 - x_1$, is being shrunk to a particular, infinitely small point, at which instantaneous velocity can be measured. Therefore, if

$$\frac{x_2 - x_1}{t_2 - t_1} = \lim_{\Delta_{t \to 0}} \frac{\Delta x}{\Delta y} = a\ number$$

This, then, is the instantaneous velocity at a given point.

In determining the instantaneousness of the present, the now, we could conceivably substitute space 1 for point 1 and space 2 for point 2, and the past for time 1 and the future for time 2. The result of the mathematical limit should be instead of the concrete number, the now, the present. Therefore, if

$$\frac{x_2(Space\ 2) - x_1(Space\ 1)}{t_2(Future) - t_1(Past)} = \lim_{\Delta_{t \to 0}} \frac{\Delta x}{\Delta t} = the\ Now.$$

11·10 *All film does, then, is show a number of static positions, each of which is slightly advanced from the previous one (assuming a stationary camera).*

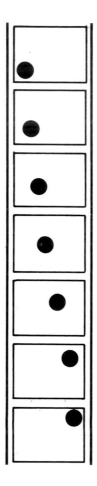

The film motion, like the motion of Zeno's arrow, is a paradox. Film does not move. It moves only in our imagination, in our mind. The only actual motion in film occurs when the projector pulls frame after frame in front of the light source. But as soon as the film has reached the gate for actual projection on the screen, it stops. *The projected image, therefore, is also at rest.* The important thing to remember is that the *basic structural unit, the film frame, shows the object at rest.*

Film is visualized calculus. In calculus, as in film, change is broken down into a series of small, discontinuous, static increments. Thus, the variations of change can be isolated and "frozen" long enough to be observed and measured. Similarly, change can be controlled by manipulating in a certain way these individual, discrete increments.

The only actual movement of the film, the movement from frame to frame, from supply reel to take-up reel, is a convenient, though nonessential method of projecting a series of successive static images onto the screen. Assuming a projection rate of 24 frames per second, we could conceivably use 24 slide projectors and fire them one at a time within the one second. The net effect would be exactly the same as that of the "moving" film.

The same is true of film. Once we have broken down an action into a series of small, discontinuous, static increments (frames), we can then carefully examine the individual increments of change. Moreover, we can now manipulate these individual frozen increments of the action. We can leave them in their original sequence or we can change them around. We can add some or cut some out or even put in some parts from an entirely different action. We have now *full control* over how we want the action perceived. We have control over the very structure of the four-dimensional field of film.

We will discuss the various possibilities and principles of motion structure in film in the next two chapters.

Bergson and Television Contrary to Zeno, who saw motion as a series of discrete, static positions, and time as a string of discontinuous, immobile moments, *frozen nows,* Bergson contends that time is a *dynamic process,* a continuous flow of duration, or *durée,* as he called it. For Bergson, the now cannot be arrested. It is in constant flux, changing continually from future into past. Therefore, Bergson argues, Zeno is definitely wrong in assuming that the flight of the arrow can be broken down into a series of static positions. The arrow simply flies from the bow to the target in one continuous motion. According to Bergson, the flight of the arrow is one single, indivisible event, during which the arrow is never at rest. The arrow is never in one specific position at any given moment, since there is no way in which the arrow can move from one immobile position to the next. Bergson replaced the "at–at" theory of motion with a "from–to" point of view.

Like time, the arrow's motion is for Bergson a continuous interpenetration of the before and after. It is an interlaced, continuous flow.

Zeno's "at–at" theory states that a moving object is at a particular spot at each moment, and therefore at rest.

Bergson contends that the motion of an object is indivisible and simply goes from one point to another point at the end of the movement.

"Take the flying arrow. At every moment, Zeno says, it is motionless, for it cannot have time to move, to occupy at least two successive positions, unless at least two moments are allowed it. At a given moment, therefore, it is at rest at a given point. Motionless in each point of its course, it is motionless during all the time that it is moving.

"Yes, if we suppose that the arrow can ever 'be' in a point of its course. Yes again, if the arrow, which is moving, ever coincides with a position, which is motionless. But the arrow never 'is' in any point of its course. The most we can say is that it might be there, in this sense, that it passes there and might stop there. It is true that if it did stop there, it would be at rest there, and at this point it is no longer movement that we should have to do with. The truth is that if the arrow leaves the point A to fall down at the point B, its movement AB is as simple, as indecomposable, in so far as it is movement, as the tension of the bow that shoots it. As the shrapnel, bursting before it falls to the ground, covers the explosive zone with an indivisible danger, so the arrow which goes from A to B displays with a single stroke, although over a certain extent of duration, its indivisible mobility. Suppose an elastic stretched from A to B, could you divide its extension? The course of the arrow is this very extension; it is equally simple and equally undivided. It is a single and unique bound."[5]

11·11 *Contrary to the static, discrete film image, the television image is always in motion even if it displays an object which is not in motion. It relies on the constantly moving electron beam for its existence. Because the mosaic dots of the television screen light up only temporarily and change their brightness according to how hard they are hit by the electron beam, the television image is never complete. While some of the screen dots are activated by the electron beam, others are rapidly decaying. The projected television image is, like Bergson's arrow, never at rest at any given moment. It is in a continuous state of change. Television motion, with its interlaced scanning, is a continuous process. It represents, as Bergson would say, an interpenetration of the before and after. Contrary to the basic structural unit of film, the frame, which is a concrete static image, the basic structural unit of television is a continual flow, an image in flux, a process.*[6]

Henri Bergson (1859–1941), French philosopher, dealt with the problems of time, free will, and the whole of human existence.

The Instantaneousness and Irrevocability of the Moment

When is now? Right now! When? Your now has just passed. Now you are still thinking about it, but it has not yet come about. Too late, it again has eluded you. It is already past.

Can the now be pinpointed and frozen, so that it becomes a spot in time? A specific instant in the time continuum? Or is it something that continuously comes and goes, something that is in constant flux, always between the "not yet" and "has been"?

Again, we are confronted with two basic time concepts: (1) the time continuum, which consists of a series of discrete nows, *states of being,* and (2) a continuum that consists in a process, to which change is essential and in which the nows are in a continual state of coming and going, in a *state of becoming.*

Quite obviously, concept 1 relates directly to the structural unit of film; and concept 2, to the

structural unit of television. (In the following discussion, television means *live television,* that is, the medium transmitting an actual, rather than a recorded, event.)

The Now and Film In film, the time continuum is broken down into a series of separate, discrete, frozen nows (Fig. 11·12) Each frame represents an arrested now, a *state of being.* We have an accurate record of this now—as it was. In reality, the film is a selection of *past* moments. *The film is a record of the past.* As such, the film yields to maximum manipulation. Each frame is a fairly permanent picture, an actual photograph of an event that has already passed, a picture that we can now hold, look at, enlarge, study, cut, project, replay. The moment as captured by film has become revocable, at least in the form of a re-created filmic image.

An event is optically gathered and focused by the lens onto a grid pattern in the main camera tube, called target. You may think of the target as being a sieve, with thousands of tiny little holes, which divides the clear optical image of the event into a fairly coarse mosaic pattern. The highlights of the photographed scene consist of light "mosaic tiles," the shadows of dark ones. An electron beam then scans each row of the mosaic, reporting into the electrical amplification system whether the individual tile was light or dark. The beam scans first the odd-numbered lines of the mosaic pattern—lines 1, 3, 5, and so on. Then it jumps back and scans the even-numbered lines. This is called interlaced scanning. Once the odd-numbered and even-numbered lines are scanned once, we speak of "a television frame." This process happens 30 times per second.

In the receiver, the very same thing happens. The television screen is coated with a fluorescent substance, which, again, represents a field of tiny mosaic stones. As soon as the electron beam scans over them, they light up temporarily, depending on how hard they are hit by the beam.

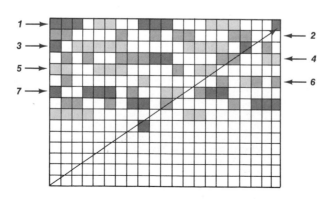

The harder they are hit by the beam (high intensity), the brighter the individual dots light up, indicating the light picture areas. Sometimes the beam is so weak that they do not light up at all. They remain dark, indicating the shadow areas.

Since the movements of the electron beam in the camera and the home receiver are synchronized, the receiver reflects accurately and instantly what the camera sees.

The Now and Television In live television, the time continuum is represented by an integrated, continuously moving image (Fig. 11·13). The now cannot be pinpointed; it is in constant flux. The television image is never quite complete as an entity, a picture that can be looked at, cut, worked with. Each television frame is in a *state of becoming*. While each film frame is a record of the past, the *television frame is a reflection of the living present.* It lives and changes almost instantaneously with the actual now, the now of the event itself. The television nows are in the present. As such, the moment as reflected by live television is *irrevocable.*

The Past–Present–Future Phenomenon According to our everyday experience, we divide the time continuum into the past, the present, and the future (Fig. 11·14). We remember the past, things that have happened to us, and anticipate the future, things that might happen. But again, what about the present? Do we remember it? No, because then it would already be past. Do we anticipate it? No, because then it would be the future. What we do with the present is *experience it.* While the past and the future are subject to scrutiny, the present is not. We can, for example, examine the past, keep records of it, reconstruct it, rethink it. The future we can talk about, think about, plan for; and in many cases we can use scientific methods to predict it with amazing accuracy. But we can do none of these things with the present. As soon as we *think* about the present, it has happened already or not as yet; hence, we cannot actually think the present. The present, therefore, is *pure, unadulterated experience.* It permits no critical examination; it simply happens. *The present is a true happening.*

11·12 Now₁ →

Now₂ →

Now₃ →

Now₄ →

Now₅ →

All "Nows" are in the past

In concept 1, we can isolate the various states of being. We can pinpoint the now and freeze it and use it as the immobile fulcrum for the past and the future. The now is very much like the instant within a motion, which can be arrested through differential calculus for closer examination. (See page 252.)

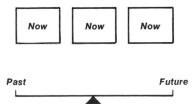

In concept 2, the now cannot be arrested. The present, the now, is that state of flux in which future and past interpenetrate each other.

11·13

TV "Now" = Actual "Now"

11·14

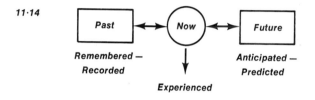

Past — Remembered — Recorded

Now

Future — Anticipated — Predicted

Experienced

11·15

A Theory

Past Closed

Present

Future Open

B Theory

Event x

w

z

"Future at" Event w, but "Past at" Event z

A and B Time There exist an A theory and a B theory of time, which deal directly with the division of the time continuum into past, present, and future. Although the A and B theories differ basically in terms of whether statements are true or false, or neither true nor false, when speaking about past or future events, we will just use the one aspect of the A and B theories that is especially relevant to television and film.

The A theorists make a clear distinction between past and future (Fig. 11·15). The past is *closed;* the future is *open.* This means that we cannot undo or cause a past event. But we can speak of causing a future event. We can have a record (such as a photo) of the past, but not of the future. The past has happened; it is a closed, examinable entity. The future is still open to all sorts of possibilities.

The B theorists claim that there cannot be a clear distinction between past and future, because there is no distinct event that is uniquely present (Fig. 11·15). As we just said, as soon as we label an event, it has already happened (and therefore it is a past event) or it is yet to happen (and therefore comprises the future). Therefore, an event is not intrinsically past or future, but simply earlier than (past at) or later than (future at) some other chosen event or events. Since the now is fleeting and not static, constantly moving along the time continuum, the events are constantly changed from future to past.

Einstein's birthday, for example, was a future event for Newton, while Aristotle's birth was a past event for him. If we take Mozart's birth as the chosen event (the assumed present), then J. S. Bach's birth was part of the past, and Brahms' birth was part of the future.[7]

Saint Augustine and the Present Fifteen centuries ago, Saint Augustine felt that the rigid division of time into past, present, and future was incorrect, since whenever we speak of the past or the future, we do so in our very present, right now. Therefore, he claimed, there can only be *a present of things past, a present of things present,* and *a present of things future.* Past and future are simply states of the present, since we can only think of them now, at the present time (Fig. 11·16).

Again, it is the now that continually shifts time from a future to a past state. But, Saint Augustine points out, time present, the now, "has no space." It is not spatial, as future and past, but simply a mode.[8]

The past as well as the future can be fixed as a place in the time continuum (Fig. 11·17). We can establish a time location, such as July 29, 1887, or March 9, 2001. *Past and future* are aspects of *objective time.*

But, as Saint Augustine correctly observed, the present has no such place. It is an experience, a mode, not a date. We may do well, therefore, not to look at the present as a quantity (like the past and the future), but as a *quality.* As a qualitative phenomenon, *the present belongs to the subjective time,* not to the objective time. Therefore, we should no longer try to affix quantitative characteristics to the now, such as *how long* it lasts, *when* it is, or *where* it is, but rather qualitative ones, such as *how intense* it is or how complex it is, how deep it goes. Looking at the present as a state of emotional involvement, its duration is entirely subjective, totally dependent on what we feel. Hence, the now can be "long" or "short," depending upon how intensely we get involved in the event.

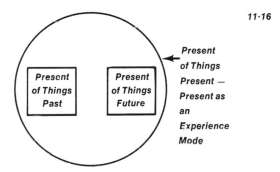

11·16

Saint Augustine, Aurelius Augustinus (354–430 A.D.), Bishop of Hippo in North Africa, was a Christian theologian and philosopher. He became a Christian under the influence of Saint Ambrose, Bishop of Milan.

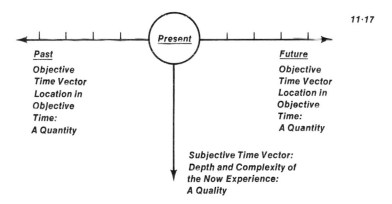

11·17

Time Direction Everyday experience in life gives us enough evidence that time moves relentlessly forward, that the past precedes the present, and the present the future. We experience birth before death, and we move from cause to effect. Entropy works in only one direction, from an organized system to a loss of organization, from a greater energy input to a lesser output. We have come to believe, therefore, that the flow of time is irreversible, that the "arrow" of time moves in one direction only.

But, as we can see from our previous deliberations, whether time moves forward or backward depends on our position relative to the past and the future. If we move the "event-present," we get a variety of past-future configurations (compare B theory). Since the past and future events are actually dependent on our present view of them (compare Saint Augustine), which may be very subjective (the present being subjective time), the fundamental question for us is no longer whether time moves in a particular direction but *how we perceive the direction of time.* The arrow of time, the time vector as a factor in the four-dimensional field, is aesthetically determined. For example, when we watch the outer event of a plant growing, we will certainly chart its growth in a specific, linear time progression: from the seed to its fruit-bearing maturity, to its decay.

After having internalized, that is, thoroughly absorbed, the event, however, we may not "see" this event in quite this order. We are no longer restricted by its timebound physiological progression. We may first see the plant in full bloom, then how the fruits tasted, then how we prepared the soil and planted the seeds. Obviously, the logical, unidirectional cause-effect continuum no longer applies. We have begun to manipulate the event to make it more impressionable. We have begun

with a clarification, and especially an intensification, of the event.

As a matter of fact, even if we usually order past events chronologically, in a strict progression that leads from the events farthest away from what we call the present to the dates closest to it, we do not remember everything in quite that orderly a fashion. We usually remember things not necessarily by when they happened, but by *how much they impressed us.* Although the past now has become part of objective time, we still remember it as subjective time, in terms of experience depth. This concept, as you will see, is very important in television and film.

How do all these various time concepts and theories relate to the four-dimensional field of film and television? Let's find out.

Film and the Time Vector

We have already pointed out that film consists of a series of frozen nows, states of *being,* that represent a record of a previous event. As records, we said, the individual film units can be examined and manipulated to a high degree.

As frozen instances, as concrete records of a previous event, we can now reconstruct the event in an entirely different time order, or we can use parts of this event and of any other recorded event and construct another event, a *filmic event.*

Manipulation of the Past–Present–Future According to the B theory, the past, present, and future in film depend entirely on where we want to set the filmic present, the event that then divides the rest of the film into future and past events. In

fact, the direction of the time vector is completely under our control. We can work from cause to effect or from effect to cause. For example, we can begin the film with people admiring a painting in an exhibit, and then follow it up showing the artist conceiving and finally painting the scene, and end the film with the artist handing his painting to a member of the exhibit jury. Or we can start with the exhibit, then switch to the artist beginning to work on this painting, then switch back to the jury, then back to the artist and the period during which he thinks about doing this painting, then to someone buying the painting, then to the artist showing the finished painting to his friends. Sometimes, film makers flash in briefly the events that had already happened before the scene that depicts the filmic now, or perhaps events that will happen later in the film.

Reversal and Repetition of Time Vector As a matter of fact, we can reverse an event simply by running the film backward (Fig. 11·18). If the event is associated with time direction, that is, if we are quite familiar with what comes first and what second or how the motion should proceed, such a vector reversal can be quite comic. We all have seen at one time or another a film run backward of someone running, eating, or drinking, jumping from a diving board into a pool, and the like. The time reversal is highly noticeable, if the action is asymmetrical, if one action can easily be recognized as the earlier, another as the later action.

In a symmetrical event (Fig. 11·19), however, where cause and effect cannot be identified so easily, such as in a tennis game, the time vector can be reversed at will, without the viewer ever noticing it. Such a vector reversal is possible only because from the present vantage point, the total series of discrete instances, as recorded on the film, are actually parts of a past event.

11·18

 11·19

We can also repeat an event as often as we like. Such repetition is especially effective if we want to show how the same cause can have different effects in different contexts (Fig. 11·20).

Film and the Subjective Now With the recorded instances, the fixed former nows, we can pick any instant and reconstruct it in a clarified and intensified way. We can, for example, stretch or condense the reconstructed now, repeat it, or show different aspects of it. This reconstructed now yields to a manipulation of subjective time, of how dense the moment is relative to intensity (vector magnitude) and complexity. In other words, the individual film units, the frames, enable us to control to a large extent the subjective time vector of the reconstructed now.

Intensity Control Regardless of whether the original event is high-energy (high physical or psychological energy, such as a football game or a tense courtroom drama) or low-energy (waiting, dull lecture), its energy becomes subject to entropy (running down) as soon as the event has been recorded on film.

The frozen moments of the original event can no longer change with us; they have become static. In most instances, we must therefore combat this entropy by re-energizing the screen event in such a way that it at least comes close in intensity to the original event.

11·20

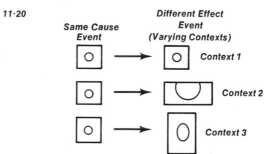

To manipulate the intensity of the filmic event, we of course use all the various audio-visual resources available. (We will speak about the audio techniques in the last two chapters.) In the picture portion of television and film, these intensification techniques involve structuring the one-dimensional field (lighting techniques), the two-dimensional and three-dimensional fields (visualization), and the four-dimensional field (the deliberate control of subjective time). The specific manipulation of the subjective time of the now may require that we increase the density of the moment, that is, either use slow motion or at least stretch (increase the number of frames) some of the event factors. Or we may want to decrease the density of the event, so as to intensify its acceleration.

Let's use an automobile crash, for example. The re-created now is the moment of impact. Just while the impact occurs, action is accelerated. Fast cuts. Close-ups. We decrease the density of the actual event by cutting out some frames, but then we increase the density again by splicing in various close-ups of the collision. Then we may stretch the action either by freezing a frame or by slow motion (increased density). Then we can again switch to accelerated motion, watching some parts fly about. What we do, in fact, is control the *rhythm of the event*

Complexity Control Each moment, even the simplest one, is highly complex. While you are reading this, you are aware of many things around you. You are also consciously or unconsciously aware of past and future events. You may remember examples from your experience that might better explain the phenomenon of now-intensity, and you may also worry about all the other things you ought to be doing instead of reading this chapter. And just think of all the other events going on at the same time somewhere else. The degree of complexity and the intensity of your awareness of these factors will again influence the experienced duration of the now.

The concreteness of the individual film unit, the frame, gives us a free hand in the manipulation of the now-complexity. Let's use the accident example again. If we want to show the complexity of this moment, the now of the accident, we can intercut different viewpoints of the same moment, including rapid switches from objective to subjective camera, and the events that occur simultaneously ("meanwhile-back-at-the-ranch" events).

Although such simultaneous complexity is closest to reality when shown at the same time on one screen or at least on multiscreens, the linear nature of film makes it perfectly feasible to show this now-complexity sequentially. We are perfectly

The "classical" films or any other pieces of art resist entropy (running down of energy) because they carry a universal message (form and content) that is not easily rendered useless by contextual change.

Also, there is some justification to the "hot news" concept. Usually, news events are important only within their immediate context. As long as the recorded news gets communicated while relatively little change has occurred, it still carries a certain amount of energy. The longer we wait, however, the less relevant the recorded event becomes — the more rapidly the event energy dissipates.

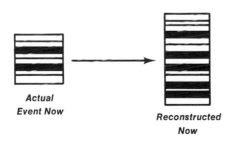

Actual Event Now

Reconstructed Now

11·21 *Control of subjective time of now: manipulation of event density; manipulation of event rhythm.*

Actual Event

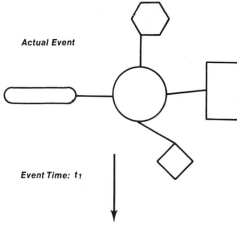

Event Time: t₁

11·22 *Complexity of the now expressed simultaneously within one screen (supers, split screen, matting) or on multiscreens.*

Reproduced Event

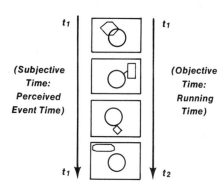

Complexity of the now expressed sequentially on one screen, moving from t₁ → t₁ (subjective time) to t₁ → t₂ (objective time).

Event and Reproduced Event

willing to accept a progression from a specific spot in the time continuum, a specific now, to another spot in the time continuum, which still signifies this very now. In other words, we can express the complexity of the now quite readily by moving from time$_1$ to time$_1$ in terms of subjective time, but actually from time$_1$ to time$_2$ in objective time.

To say it again: Since film consists of a series of frozen nows, discrete states of being of a previous event, the subjective time of the new, re-created now can be manipulated, that is, clarified and intensified, at will. So can the time vectors relative to past, present, and future. *Filmic time is totally medium-dependent.*

Television and the Time Vector

In our whole discussion on time and television, you should think of television performing its most distinctive function, the *live* transmission of events When events are recorded, many of the aesthetic principles of film apply also to television.

Contrary to film, the basic unit of television, the television frame, consists of an ever-changing picture mosaic. Each television frame is in a continual state of becoming. The basic television unit is an integrated, continuously moving image.

Live television reflects almost instantaneously the actual event. *The television image changes with the event.* Aesthetically, the now of television is equal to the now of the actual event.

As such, the sequence of the actual event, the basic time vector of the event, cannot be reversed when shown on live television. Obviously, you cannot show the artist selling his picture at the exhibit, and then move backward in time and show him painting it. Television reflects accurately the objective time of the now, its existential instantaneousness and irrevocability. The progression of an event can be revoked only after it has been recorded, but then it is already a replay of a past event. When watching a live telecast, the event moves constantly from the future into the past, with the present being an ever-moving *durée,* an interpenetration of the before and after.

Manipulation of the Past–Present–Future The past and the future are, as in reality, constantly changing phenomena, determined by the elusive, yet ever-present experience of the now. In live television, we work with a remembered past-present, the unexaminable, uncritical intuitive perception of the present-present, and the anticipated future-present. We cannot arbitrarily manipulate their order.

As with the live event itself, we cannot reverse the time vector, the "arrow of time." We are tied to the direction of the event itself.

Television and the Subjective Now The now of the television event is equal to the now of the actual event in terms of objective time, that is, the instantaneous perception by the observer of the actual event and by the television viewer. But the now of the actual event and that of the televised event are *unequal* as to subjective time, that is, the intensity and complexity of the now.

Intensity Control As with film, we can control to some extent the intensity of the television now and therefore the subjective time, the experienced duration, of the now.

First and foremost, we can control the *intensity of the event* itself. In television, controlling the event is much more important than in film, where we always have a chance later to edit out the superfluous parts, emphasizing the high-energy parts, or even to reshoot some scenes for high-energy effect. In live television, the event happens only

once; it is irrevocable. It is therefore imperative that we stage the event for the medium (z-axis; simultaneous, multicamera viewpoints; attention to detail in set-up and action) or that at least we familiarize ourselves (in our function as director) with the event so thoroughly that we can reflect its intensity accurately, or even increase its intensity, without distorting its original intent. In any case, we have no chance for any ex-post-facto doctoring. We must manipulate the event aesthetically while it is going on, right in the act of becoming. We must live with the event, so that the viewer can do likewise.

Besides controlling the event itself, there is the *medium* with its various aesthetic characteristics that help us to clarify and intensify the now, the living moment of an event. By simply cutting from a long shot to a close-up, we displace an event not only in space but also in time.

We intensify the event both graphically and temporally. The close-up represents a subjective time vector of an increased magnitude. Zooming in and out are more deliberate spatial methods of spatial and temporal displacements. In a fast zoom in, for example, the subjective time vector increases in magnitude and thereby intensifies the event for the viewer. Other medium techniques, such as shifts in points of view and the resulting angles, shooting from below and from above eye level, and the like, all influence the density of the television event and, in turn, the intensity of the perceived moment, the subjective perception of the now.

The important thing to remember, however, is that these medium manipulations must occur *with* the event; they must follow the rhythm of the event organically. Since television *reflects,* rather than reproduces, a live event, the medium should not superimpose its own rhythm but rather should support, that is, clarify and intensify, the event's

original rhythm. In this we have one of the basic differences between the filmic now and the live-television now: the filmic now usually establishes its own event-rhythm; the television now reflects (often in a clarified and intensified way) the rhythm of the original event (Fig. 11·23).

Since there is practically no time lapse between the actual event and the television transmission of this event (the event is transmitted with the speed of light—the fastest speed possible in this universe), there is *very little,* if any, *entropy,* that is, loss of energy. We should not try to intensify unduly the energy of the event simply because we want to involve the viewer as much as possible. It is a positive trait of television to be able to reflect accurately the various energy levels of an actual event. If the now, the moment of the original event is low-energy, dull, we should reflect it on television the same way. The rhythm of life, the fleeting moment, is comprised of stresses and strains, of energy peaks and low points, of high-magnitude and low-magnitude now vectors. This rhythm can, and should, be accurately transmitted with all its ups and downs by the television medium. Take a baseball game, for example; often there is practically no action before the event suddenly and literally explodes—but again only for a relatively short period of time. These low-energy nows, however, must be accurately reflected as such in a live telecast. Do not try to intensify such dull moments by an unnatural medium manipulation, such as shooting extremely close up all of a sudden, zooming in and out, or—even worse—by cutting to so-called color shots, which usually show the little boy eating his hot dog, smearing mustard all over his face while proudly wearing the home-town baseball hat.

As soon as the event is recorded (video tape or film), entropy sets in. We must combat this energy loss by editing before reshowing. It is no accident

Each place has its own time. Just think of the difference between San Francisco and New York. Each city is on its own time. When it is 8:00 A.M. in San Francisco, it is already 11:00 A.M. in New York. Let's shrink this distance more and more, say to about a few feet. Therefore, the time difference shrinks accordingly. If you and your friend stand a few feet apart, each one of you has his or her own time, though the actual difference is very small. Whenever asked for the correct time, a wise old professor used to say: "On this side of the watch it is 12:45, but I don't know what time it is on the other side of the watch." Cutting from a long shot to a close-up represents a similar spatial, and also a temporal, displacement.

11·23

that the slow periods are generally cut out before reshowing the event at a later time. As pointed out before, the rhythmic requirements of the re-created event are quite different from those of the live event. The condensing of the event to its "highlights" is often a necessary re-energizing procedure when the event is replayed at a later date.

Complexity Control The complexity of the moment, the complex now of an event, does not change, whether we cover the event by film or by television. The reflection of this complexity of the screen, however, differs somewhat between film and television. While in film we can reconstruct the complexity of the moment in the editing room, literally creating a new now, in live television we are pretty much bound to the momentary complexity of the actual event, or at least to the events that are actually occurring at the same time. Take, for example, the firing of a big rocket that takes astronauts to the moon. In film, we can reveal the complexity of this moment with intercutting past and future events that are all relevant to this moment, such as the anticipation of the astronauts of the successful orbiting or moon landing, flash-

backs of their long, hard training for this very moment, scientists who have worked on the rocket, and so forth.

In live television, we can intercut only what is actually taking place at this very moment, such as the control-room technicians performing their actual jobs for the lift-off, people watching outside, the rockets actually firing, the astronauts inside the capsule, the President watching the whole thing on television, and the like. The various activities are shot as they occur in the sequence of the actual event and are combined sequentially into a larger now-gestalt, a sequentially enlarged moment.

You may argue at this point that presenting the complexity of the now as a series of sequential events is structurally much more akin to the linear sequence of highly controllable individual frames in film than to the totality of the now as expressed by the living, changing television mosaic. And you are quite right. Ideally, the simultaneous events that make up the complexity of the now should be reflected on television as a single moment and not sequentially.

Fortunately, we can meet this structural requirement rather easily by showing the multifaceted moment through superimposition, split screen, or other matting devices. Such treatment of moment complexity works fairly well as long as the event can tolerate such complex, low-definition, impressionistic images. For example, if we want to show the instantaneousness, irrevocability, and complexity of the movement of two dancers, we can effectively intensify the event and reflect its complexity by supering or keying other camera fields of view and viewpoints of the same event, the dancers.

If the televised event, however, is to communicate a great amount of specific information, such as the director who is directing a television show in the control room, the technical director, the cameraman and the performer, the video tape room, the camera controls, for example, we need a

A multiscreen television set with stereo, or four-channel sound, has long been overdue. Unfortunately, so far the aesthetic demand for such a technical modification of the television medium has not been recognized either by producers or consumers of the television experience. As soon as this multiscreen medium potential has been properly understood and propagandized, the complexity of the moment can be given its proper aesthetic form.

series of high-definition images that show simultaneously the complexity of the moment. Obviously, a multiscreen presentation of these events is a logical answer. Like the television director who can watch on his preview monitors a variety of simultaneous, often widely separated events, the viewer should similarly be able to experience such a simultaneous event complexity.

A multiscreen television presentation of simultaneous events or parts of the event (Fig. 11·24) during the same now seems to be an aesthetic necessity. After all, *the multiscreens are a simple and organic extension of the mosaic image of television.* To show the now-complexity linearly rather than iconically (so that you can, as when looking at the small compact icon painting, grasp the individual event images simultaneously) is a violation of one of television's unique and most important structural potentials.

11·24

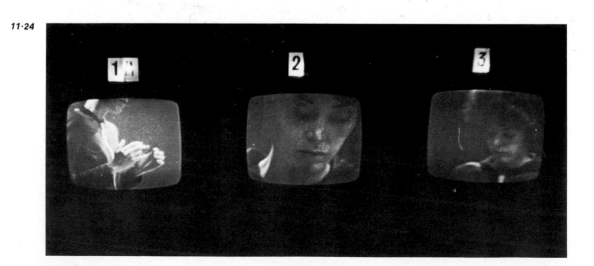

Quite contrary to filmic time, which is almost completely medium-dependent, *television time* is primarily *event-dependent.* The *rhythm of the television event* is merely a clarified and intensified *reflection of the actual event rhythm.* While *film* presents a *reconstructed experience of the now, television* reflects the *pure experience* of the now of the actual event.

The basic rhythm in live television is organic— very much like breathing, running, working, or dancing.

Television Recordings

What happens to the time manipulation on television when we use as program material, as we do most of the time, television recordings, such as video tape and film? Before we can attempt to answer this question, we must briefly distinguish between the various types of television recordings: (1) unedited video tape of a live television show; (2) an edited video tape; and (3) film.

Unedited Video Tape of a Live Television Show: If the video tape or kinescope was simply a back up of a live television show, the tape is rhythmically identical to that of the live show. It is necessarily event-bound in terms of event sequence, energy, complexity.

When shown at a later date, however, we must consider the following time factors: (1) Part of the audience may have seen the event live, or heard about it through other communication media, and will, therefore, get somewhat impatient with the rhythm of the live event (showing faithfully the slow as well as the fast nows). This is especially a problem in sports, when the audience might know the outcome of the event. All slow periods in the event, which might have proved immensely dramatic and necessary for the intensification of the event (magnification of the subjective time vector of the now), contribute to a decreasing time vector magnitude (slow, uninteresting rhythm) during the reshowing. (2) If the viewer is totally unaware of the fact that the event is delayed, his intensity of involvement may be quite similar to watching the event live. But still, his aesthetic experience is based on

pretenses. He is fooled into a pseudo-experience of becoming, a changing with the event, an experiencing of the living present, when actually he is presented a record of the past. A picture of an event, as true as the picture may be, is simply not the event itself. The question of whether or not the viewer can be tricked into believing a recorded show to be a live event is no longer an aesthetic, but an ethical, one. (3) As soon as the original event is over and exists merely as a recording, entropy sets in. Thus, even if the video tape is an accurate record of the live telecast, it has lost some of its original energy.

Edited Video Tape and Film: Edited video tape and film are so similar in their manipulation of time that we can discuss them together. Both edited video tape and film work with bits and pieces of a series of past events, totally independent of the sequence and intensity of the original event. We create a new space-time event by manipulating the order and density of the individual basic units of the film and video tape. As such, edited film and video tape are largely medium-dependent. The new event is a medium event, not a simple reflection or reproduction of the original event.

There is one final factor that we must take into consideration, however. This factor concerns the rhythm that is inherent in the television medium. Whatever the original source of the video tape may be—a live event or a carefully edited film—it still will have to undergo the translation process

into a constantly moving, constantly changing mosaic screen image. The television image translates the original data into a fleeting image, into a process of becoming, at least as far as the screen images are concerned. This means that even if we manipulate an event drastically through editing, we should still try to maintain or adhere to the organic rhythm of live television, which reflects structurally the act of becoming rather than isolated states of being, a durée rather than a series of "at–at" instances. We will refer once again to the rhythmic media requirements of film and television in Chapters 12 and 13.

When showing a wide-screen theater-type motion picture on television, we are faced with several aesthetic problems. The obvious difficulties are spatial. The wide-screen "landscape-type" images lose in magnitude and importance on the intimate television screen. The deductive linear visual motion picture approach is often ill-suited to the inductive, mosaiclike television gestalt. But the most serious problem is not that of space but of time. Most often, the fast, staccato rhythm of the concrete film images, which can be an effective aesthetic energizer for the large-screen image, is ill-suited for, if not totally contradictory to, the more organic, lifelike durée rhythm of the fleeting television image. Generally, the motion picture rhythm seems erratic, inorganic, and artificial when experienced on television. The rhythmic discrepancy between the original time structure of the film and the television-mediated experience of that film increases, rather than decreases, communication noise.

Summary

Television and film images do not exist. as things, but as happenings. Time and motion are essential aesthetic factors in television and film.

We can distinguish between *objective time* (clock time) and *subjective time* (psychological time). *Objective time* is what the clock says. It is measurable time. *Subjective time* is felt time. It is more a state of quality than of quantity. The density of the event (many things happening within a certain period of objective time) and of our involvement (degree of becoming absorbed in our activity) influences subjective time. High involvement means that the subjective time is perceived to be short. Low involvement causes subjective time to be perceived as slow.

Of the many time theories, the ones by Zeno and Bergson seem most appropriate to explain the fundamental time and motion differences between film and television and to point out the structural differences between the two media.

Zeno claims that motion is actually an illusion, since the moving object seems basically at rest at any of the infinite points along its path. This "at–at" theory corresponds closely with film, in which a motion is dissected into a number of snapshots. Each of these snapshots (frames) shows the object at rest. The *basic structural unit of film,* the frame, shows the *object at rest.* When these frames are shown in rapid succession, the object seems to move. But the motion is strictly an illusion.

Contrary to Zeno, who saw motion as a series of discrete, static positions and time as a string of discontinuous, frozen nows, *Bergson contends that time is a dynamic process,* a continuous flow or duration (*durée*). Bergson contends that the motion of an object is indivisible and that it simply goes from the starting point continuously to the finish. This time-motion concept is very similar to the continuous motion of the scanning beam. The projected television image is never at rest but is in a *continuous state of change. The basic structural unit of television is a continuous flow,* an image in flux, a *process.*

While film deals with a series of discrete frozen nows that are actually *records of a past event,* television (live television) is a *reflection of the living present.* Since the film nows are records of the past, they are revocable. The moment, as reflected by live television, however, is irrevocable. Like the real present, it changes continually from the future into the past.

According to our everyday experience, we divide the time continuum into *past, present,* and *future.* We can think consciously about the past and the future. We remember the past and anticipate or try to predict the future. But we cannot be consciously thinking about the present, the now. All we can do is experience it. We can say that past and future are aspects of objective time. The present, however, belongs to the subjective time. *Past and future* are *quantitative* time definitions. The *present* is a *qualitative* one.

Our everyday experience provides us with enough evidence to convince us that time is *unidirectional* — that is, it moves from the future to the past. However, this time vector can seemingly be reversed in film, since we can manipulate the discrete units of the film (records of past events) at will. Indeed, in a symmetrical action (tennis match, for example) we cannot tell whether the film runs backward or forward, unless the action changes into an asymmetrical one, when the play-

ers leave the court, for example. The now in film can also be manipulated, and can be stretched or shortened, intensified or made less intense. In film, the event rhythm can be controlled. *Filmic time is medium-dependent.*

In live television, the television image changes only with the event. Aesthetically, the television now and the event now are simultaneous. Similar to the live event, the time vector in television cannot be reversed. We are tied to the direction of the event itself. *Television time is event-dependent.*

In film, the complexity of the moment can be shown sequentially, ex post facto. In television, the complexity of the moment should be shown simultaneously on multiscreens, which are an organic extension of the television mosaic.

Television recordings and television editing are closer to the filmic time than to television time. The argument that the average viewer cannot tell whether an event is live or recorded is no longer an aesthetic one, but an ethical one. The fact that someone can be fooled into mistaking a recorded event for a live television event does not render the time theories invalid; rather it points to the increased responsibility of the television producer to remain honest.

Notes

[1] See Alvin Toffler, *Future Shock* (New York: Random House, Inc., 1970).

[2] László Moholy-Nagy, *Vision in Motion* (Chicago: Paul Theobald & Company, 1947), p. 268.

[3] Thomas Wolfe, *The Web and the Rock* (New York: Grosset & Dunlap, Inc., 1938), p. 626.

[4] *Encyclopaedia Britannica* (Chicago: Encyclopaedia Britannica, Inc., 1966), vol. 23, p. 945.

[5] From *Creative Evolution* by Henri Bergson. Translated by Arthur Mitchell. Copyright 1911, 1939 by Holt, Rinehart and Winston, Inc. Reprinted by permission of Holt, Rinehart and Winston, Inc. (The quotation is from the 1944 Modern Library edition, pp. 335–336.)

[6] Although Bergson uses film to explain some of his theories of *durée* and the concept of becoming, his general theory of *durée* is much more closely related to the process of television than to that of film. Compare *Creative Evolution,* pp. 330–335.

[7] Richard M. Gale, ed., *The Philosophy of Time* (Garden City, N. Y.: Doubleday & Company, Inc., 1967), pp. 169–178.

[8] Augustinus, Aurelius, Saint. *The Confessions of St. Augustine,* trans. E. B. Pusey (Chicago: Henry Regnery Company, 1948), Book XI, sections x–xxxi.

Structuring the Four-Dimensional Field: Timing and Motion

Timing

Both objective and subjective times are important elements in structuring the four-dimensional field. Objective time deals with all clock-time events of a show, such as how long the television show or the film runs, how long the scenes are, or what time span is covered within the show. With subjective time we are, as you know, more concerned with the duration the viewer feels, and the intensity of the moment he experiences. Often, the objective and subjective time manipulations overlap. This means that we find ourselves juggling objective times not so much to structure clock time but to structure subjective time. For example, we may shorten a scene here, a shot there, and cut out certain sections of the film or video tape altogether in order to achieve a certain overall *time feeling,* an overall pace.

We will now classify the major variations of objective and subjective times in order to establish *types of time.* The objective and subjective time types will greatly facilitate *timing* — the manipulation and control of *time.*

Types of Objective Time For all practical purposes, we can distinguish among six different types of objective time in television and film: (1) spot time, (2) running time, (3) story time, (4) shot time, (5) scene time, and (6) sequence time.

Spot Time Spot time depicts the actual spot when an *event happens.* The motion picture begins at 7:00 P.M. and ends at 9:10 P.M. These are spot times. In television, spot times are listed in a second-by-second breakdown in the log. When the tower clock strikes midnight in a mystery film, it designates a spot time. The high-noon arrival of the train falls also into the spot-time category. (See Figure 12·1.)

Running Time Running time indicates the overall *length* of the television show or film. The average motion picture feature has a running time of approximately two hours. There are television shows with a running time of 15, 30, 60, or 90 minutes. Commercials run anywhere from 10 to 60 seconds. Generally, television shows are shorter than feature films. The practical reason for the shorter running times in television is that they allow for more program variety and especially for more commercials. The shorter running times in television compared to feature films are also justified aesthetically. Watching television is more demanding on the viewer than watching a wide-screen motion picture. The relatively low-definition mosaic image of television plus the inductive visual approach requires much more attention and even participation than the high-definition, linear motion picture presentation. This low-definition mosaic of television is also one of the reasons why sound is so much more important in television than film. We will talk about this aspect of sound later in this book.

Similarly, a repetition of short commercials is often more effective than a single presentation of a longer one. Again, the short available running time of the commercial forces us to cram into it a great amount of information. This increased density (if done properly) is not only more intense and com-

pelling than if spread out in a longer running time, but it is also structurally closer to the iconic now of the television image than a long, obviously linear event presentation. (See Figure 12·2.)

Story Time Story time shows the objective time span of an event as depicted by the screen event. For example, if we depict in a film the life of John F. Kennedy from his birth to his death, the story time spans 46 years (from 1917 to 1963). The story time can be only one minute or thousands of years, all covered within the running time of a 30-minute television show, for example. The story time in a live television show (or a video-taped record of the live show) is equal to its running time. Obviously, we cannot condense the duration of the event (story time) when covering the event live. Most story times in film, however, do not correspond with the film's running time. (See Figure 12·3.)

There are, however, some notable exceptions. One of them is the French film *Rififi* by Jules Dassin, which shows a bold burglary in its actual time from beginning to end. For *Rififi*, running time and story time are identical.[1]

Sequence Time Sequence time is that part of the running time of the film or television show that spans a sequence. A sequence in film or television is the sum of several scenes that form an organic whole. A sequence comprises a part of the whole story with a clearly identifiable beginning and end. John F. Kennedy's war years or his career as a United States senator would be sequences. The sequence time, however, would not be con-

12·1 *Spot time signifies the "at" position of an event in the time continuum.*

12·2 *The running time indicates a "from–to" position in time continuum. It specifies objective duration of an event.*

12·3 *Story time shows the period of a story (event) spanned in the film or television show. Story time usually moves from a specific calendar date to another or from one clock time to another.*

Story time is totally independent of running time. You can show the first 28 years of J. F. Kennedy's life in the first 30 minutes running time of the film, and devote the remaining 90 minutes to the last 18 years of his life.

12·4 *Sequence time is a subdivision of running time.*

cerned with the four years he served in the United States Navy during World War II (these would be part of the story time), but merely with how much film or television running time it takes to cover this sequence, such as 10 to 30 minutes. We can include the time it takes to play an act (a major division within a play) in the sequence category. (See Figure 12·4.)

Scene Time Scene time is the part of the running time it takes to cover a scene. A scene is a clearly identifiable part of an event. It is a small structural or thematic unit. A scene is usually defined by the action that plays in a single location within a single story time span. For example, a short sequence of shots that shows the Japanese destroyer slicing Kennedy's PT boat in two would be a scene within the sequence of his war years.

We can expand a scene to include short actions that play in various locations and times as long as they refer directly to a single event within the story. For example, if we want to show flashes of Kennedy's thoughts during the ramming of the PT boat, we may splice into the scene brief shots of related happenings, such as his being tackled by a big guard during football, the faces of relatives, and so on. But all these shot flashes relate directly to the one event that makes up the scene, the ramming of the PT boat. (See Figure 12·5.)

12·5 *Scene time is part of the overall running time. It is a subdivision of sequence time.*

Shot Time Shot time measures the actual duration of a shot. A shot is the smallest convenient operational unit of a film or a television show. It is the interval between two distinct video transitions, from splice to splice, or from cut to cut, dissolve, or wipe. The shortest possible shot in film is the length of a single basic unit of film: a single frame. Naturally, when we project a single frame, it merely flashes on the screen for a fraction of a second. (In

the normal 24-frames-per-second 16mm sound speed, the shortest "shot" would last only $1/24$ second.) Most often, even the shortest flash shot is composed of at least three frames. In television, a shot can be as fast as we can switch from one video source to another. (When editing video tape, the shortest shot can be no faster than $1/30$ second, which comprises a fully scanned television "frame.") As we discussed before, television shots are usually longer than film shots, especially in live television, in which the camera looks more leisurely, though more intently, at or into the event than does the film camera. (See Figure 12·6.)

As we have seen, the clock time and the story time represent simple positions within the time continuum, the hour of the day and calendar dates. The running time indicates a fixed duration of a screen event, regardless of content and subdivisions. Running times are factual times, which can be, and often are, independent of aesthetic considerations.

The sequence, scene, and shot times, however, are aesthetically very important structural elements. Controlling these three types of time influences not only the subjective time experience of the viewer (that is, whether he perceives a scene as slow or fast regardless of the actual running time), but also, if not especially, the overall rhythm of the film or television show. Compared with music, the shots are like the individual bars, dominating the essential rhythm. The scene times act like musical phrases, which consist of a series of bars. And the sequence times are like segments of a movement or even like the movements themselves. Altogether, these times determine the overall rhythm of the composition.

Timing, then, means the utmost control of shot, scene, and sequence times, so that they form a dynamic, rhythmically stimulating pattern within the given running time of the overall show. Proper

timing requires a good stopwatch, but especially it requires a good sense of rhythm. You must "feel" into the time structure of an event and try to intensify this feeling through careful manipulation of sequence, scene, and shot times. This manipulation is especially important in film and filmically treated television recordings. Do not be misled by some especially beautiful visual sequence that you do not want to mutilate in any shape or form. If the sequence happens to be too long in the context of the overall rhythm of the event, you must cut it to its proper length. Sorry.

In live television, however, the internal timing (the interrelation of sequence, scene, and shot times) is frequently determined by the event itself. In sports, for example, baseball has a decisively different rhythm from football, and golf from ice hockey. The internal divisions within these events, as determined by the running time, or by the natural developments of the games, like scores, time-outs, key plays, and the like, force an automatic organic division of the running time of the total event. But even then, if we are not attuned to the natural rhythm of the event, we may, through frequent cutting, for example, upset if not destroy the natural time structure of the event. Such mistakes in timing may upset the unsuspecting viewer very much, and he may put the blame on the players rather than on us for this rhythmic discrepancy.

Grasp of the overall rhythmic structure of an event and sense of timing become especially important when we must decide on where to place the commercials within a televised event. Whether we write a television show or edit film for television, we must be very careful to place the commercials in such a way that they fit rhythmically. We should not just place them right before the climactic actions, simply in order to prolong the suspense or to keep the viewer glued to the set. The placement of commercials within the context of the structure

of timing vectors, the overall event rhythm, can *help* greatly in delineating more precisely scenes or sequences or to provide important rhythmic release from high-magnitude vector fields of time.

Types of Subjective Time The classification of subjective times is, of course, somewhat more difficult than that of the measurable objective times. As you remember, our experience of subjective time depends on the density of the event as well as the intensity of our involvement in it. Our experience of subjective time is, therefore, dependent upon a great variety of context variables, such as the story itself (interesting, compelling, funny, dull), intended audience, production techniques, and the like. These variables make it difficult to predict accurately the effect of subjective time.

The difficulty of predicting subjective time (perceived, rather than measured, duration) does not mean, however, that we cannot manipulate subjective time, at least to a certain degree. In fact, we should always pay particular attention to the subjective time of each show segment, and, finally, of the whole show—whether the show seems to drag, or race along unnaturally fast.

Customarily, subjective times are categorized into pace, tempo, and rate. *Pace* refers to the speed of the overall performance: slow, fast, moderate, dragging. *Tempo* is the speed of the individual program segment. Both a slow and a fast segment may be part of a slow pace, for example. *Rate* refers to the speed of the individual performance. One actor may have a slow part, another a fast part. We can compare tnese three categories of psychological time with the structure of an essay. Pace is the whole essay; tempo is the paragraph; rate is the individual sentence. The interrelation of pace, tempo, and rate provides for the show rhythm.

12·6 *Shot time measures the duration of a shot. It is part of the running time and a subdivision of scene time.*

A shot is the smallest convenient operational structural unit in film or television. It is the interval between two distinct video transitions, such as cuts, dissolves, wipes.

A scene is a clearly identifiable, organic part of an event. It is a small structural (action) or thematic (story) unit. It usually depicts or refers to a single action. It usually consists of several shots.

A sequence is the sum of several scenes that comprise an organic whole. A sequence has a clearly identifiable beginning and end within the total portrayed event or event sequence.

12·7

a

Show Pace: Perception of Overall Show

Beginning End

b

Show Pace

Sequence Pace

c

Sequence Pace

Scene Pace

d

Sequence

Scenes

**Shot
Times**

In practice, however, pace, tempo, and rate are not always easily distinguishable. At times, each part seems to have its own pace or rhythm.

We may find it easier, therefore, to apply the concepts of pace and rhythm to the overall show as well as to the various parts of the show.

We have, thus, (1) overall show pace and rhythm, (2) sequence pace and rhythm, (3) scene pace and rhythm, and (4) shot time and rhythm. In all cases, *pace* refers to the *perceived duration* of the show or show segment. *Rhythm* connotes the *flow* of the show or show segments.

Since the shot is the smallest unit in the time structure of an event, it cannot have a pace. Only a series of shots can have a pace, which we then call, for convenience's sake, scene. But an accumulation of shots can have rhythm, that is, the shot series can be composed of shots with long and short *shot times.*

Show pace refers to how fast or slow we perceive the overall show to be (Fig. 12·7a). Although pace is largely independent of objective time, it is, nevertheless, influenced by the running time. If a show spans three, or more, hours, we certainly run the risk of boring the audience more readily than with a 30-second commercial. Our physical disposition quite naturally influences our perception of pace. If we are tired, time is more likely to stretch than if we are fresh and alert. *Show rhythm* means how well the parts of the show relate to each other sequentially, how well the show *flows.*

Control of the pace of the individual show parts (sequences) determines the show rhythm. If the individual show parts are paced erratically, without relating to one another organically, we cannot achieve a flow; the show rhythm, and with it the whole pace, suffers. For example, if we have an overly long sequence within a fast-paced show, viewers become conscious of objective time. They

wonder when the segment will finally end. Event quality (subjective time) switches to event quantity (objective time).

Sequence pace (tempo) refers to the perceived duration of a sequence (Fig. 12·7b). A sequence can appear too fast or too slow relative to the overall show, to other sequences, or to the scenes that make up a particular sequence. *Sequence rhythm* depends, in turn, on the distribution and pacing of the scenes that make up the sequence.

Scene pace (tempo) refers to the perceived duration of a scene relative to its sequence or to other scenes (Fig. 12·7c). *Scene rhythm* depends on the tertiary motion beat as created by the shots.

Shot time refers to the perceived duration of a shot (Fig. 12·7d). It can be short, normal, long, and so on. It is most noticeable when the shots cut to match music. *Shot rhythm* refers to the beat established through a series of shots that do not as yet comprise a scene (smallest *organic* show unit comprised of a series of shots). Rapid-fire shots can, of course, increase the intensity of the felt moment. A shot that lasts for a relatively long time usually contributes to a slow, tranquil scene rhythm. Rarely, however, does (or should) the viewer become aware of the timing of the shot itself. The shot, like the bar in music, should contribute to the beat (and thus to the rhythm) of the scene. But, like the moment, the shot itself should remain timeless.

Performance pace (rate) refers to the perceived speed of a performer's actions. If the action is exceedingly slow, the performance pace will most likely be slow, too. However, do not forget that even slow action may contribute to a fast-paced scene, depending on how intense the actor's performance is. *Performance rhythm* refers to the *flow* of actions and the variety of timing within the scene. A totally even performance will probably appear much

Motion

slower and less intense than a more varied one in which a performance beat is introduced. The success of comedy, for example, depends to a large extent on the performance rhythm, that is, on the precise timing of the actor's lines.

A performer who lacks energy and intensity—one who does not seem to be involved in his role—obviously projects a slow performance pace. A high-energy, alive performer, on the other hand, projects an up-beat, rather fast performance pace. Since subjective times vary with the respective perceived intensity, that is, the degree of viewer involvement, the performance pace can appear fast although the actor's movements and actions may be relatively slow and deliberate.

Again, although the objective types of time have a definite influence upon the subjective types of time, the final perception of the subjective times—the experienced duration of a show—depends entirely on how much the viewer is involved in the total screen event. It finally depends upon his degree of empathy relative to the event. If a show keeps our interest, time seems to fly. If it does not hold our interest, we get bored. Timing, therefore, is more than the mere stopwatch control of running time; it is rather a matter of event intensity and viewer empathy.

As you have heard many times by now, motion is one of the essential structural elements in television and film. Fortunately, since we have been dealing with the concept of vectors all along, the idea of motion is nothing particularly new. Structuring the four-dimensional field, that is, controlling the moving images on the screen aesthetically, is simply an extension of the vector manipulation within the two- and three-dimensional fields. Except that now we are primarily concerned with *motion vectors.*

These four motion concepts are particularly important in structuring the four-dimensional field: (1) the motion paradox and relativity, (2) slow and accelerated motion, (3) motion and mass, and (4) types of motion.

Motion Paradox and Relativity What is motion? Motion is a change of position of a body in relation to another body. If we stand still and watch a thing move, we see it change its position from a "before-position" to an "after-position." But if we move with the object, we may not perceive the object as being in motion. This is the *motion paradox:* An object can be in motion and at rest at the same time. (See Figure 12·8.)

a

12·8 *Riding in an airplane, you are in motion relative to the more stable earth, but when sitting in your seat, you are at rest relative to the plane itself (a).*

When you walk toward the front of the plane, you have a more complex motion relationship. You are moving slowly relative to the people who are seated in the plane. But you are moving even faster than the plane relative to the earth (b). If you have no reference points for your relative spatial displacement, you cannot tell whether you are in motion or not. At night, with the shades drawn in the extremely smoothly flying airplane, you cannot tell whether or not you are in motion, at least you have no idea of how fast you are going.

b

c

Regardless of how fast a spaceship is traveling toward the moon relative to its position change from earth to moon, its motion approaches zero relative to the other spaceship during docking (c).

Sometimes this motion relativity can play tricks on us, especially if we are confused about which object is moving and which is stationary. (See Figure 12·9.)

In the car-bus example, you automatically assume that the larger bus is the more stable element as compared to your small car. Therefore, you assume quite readily that you are in motion, while actually the larger object, the bus, has started to move.

Whenever we perceive motion, we establish a frame of reference by which to judge the motion. This frame of reference makes motion more direct; it strips the motion of its confusing relativity. What we do is establish "from–to" vectors relative to "at" positions. We establish a ground against which the less stable figure can move. (See Figures 12·10 and 12·11.)

As you can see, the frames of reference for motion can vary. We perceive a moving object relative to its *immediately* more stable environment.

We establish what Duncker calls a hierarchical relationship of dependence. There are certain objects that quite naturally serve as "frames of reference" for others, such as the street for the person, and the man for the fly. We perceive the *dependent* object as the more *mobile,* the *independent* as the more *stable* one. In other words, we establish a relatively stable ground and a relatively mobile figure.[2]

Because we so readily establish hierarchical fields of reference for moving objects, according to our everyday experience, we can reverse this hierarchy on the screen without destroying our customary perception of motion (Fig. 12·12).

12·9 *When you sit in your car next to a large bus, waiting for the stop sign to turn green, you may get the feeling that you are moving backward, while actually the bus is impatiently inching forward.*

Sitting in a train alongside another train can give you the same startling sensation. When the other train starts to move out slowly, you may have the feeling that your train is rolling backward. Or the reverse can happen. When your train starts moving, you may feel that the other train is slowly moving backward.

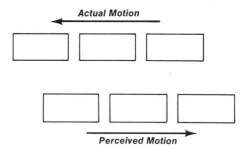

12·10 *The television or film screen is the most basic stationary reference for movement within the screen. We judge the spatial location of an object relative to the screen borders.*

Karl Duncker (1903–), German gestalt psychologist, who was especially concerned with the processes of visual perception.

12·11 *If we show someone walking along a downtown street, the houses—and not the screen—become the primary stationary reference. We see the person's position change relative to the houses, not the screen.*

If a fly buzzes around the person walking along the street, we judge the motion of the fly most likely against the relatively more stable person, rather than against the houses.

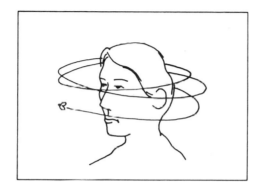

Rear Screen
Projection
Moving Street

Person Stationary

12·12 *For example, if, instead of having the person walk past the houses, we actually have the houses moving past the stationary person by means of rear-screen (process-screen) projection, the viewer still perceives the person moving past the houses. He will not "see," as is normally the case, the actual displacement of the houses on the screen, with the person remaining at the same screen position.*

We are all familiar with the many stock applications of rear-screen projections in which actually the ground moves, with the figure remaining stationary, such as the stationary car "racing" through the rear-projected city street, the close-up of the train or stagecoach interior, with the window showing the landscape going by (*literally* this time, not just seemingly). But the viewer is not about to give up his reference system, which he has established through countless actual experiences. He simply *knows* that the street does not walk past the stationary person or race away from the stationary car. He therefore perceives the figure as moving and the ground as stationary, regardless of what the screen actually shows.

In some cases, however, we may become confused as to what is moving and what is not, especially if we have trouble establishing a proper dependence between moving figure and relatively stable ground. If, for example, we begin a sequence with a subjective dolly shot down an empty street, the houses and the street actually move on the screen. Since the only stable reference to the moving street and houses is the screen itself, we may perceive the street as moving, rather than ourselves seeming to walk along the street as intended. As we pointed out in an earlier chapter (Chapter 10), this type of subjective camera works only if the subjective point of view is properly motivated and the figure-ground reversal is properly prepared.

If, for instance, we show a man walking down the street first and then switch to a subjective camera, viewers are more apt to identify with the moving figure and to perceive the street as the stationary ground than if we start out right away with the dolly shot.

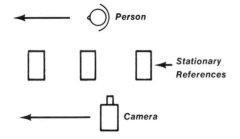

12·13 *If we truck along a moving object at the same speed, we must include some stationary reference points, if we want the viewer to perceive the object as moving.*

When seen on the screen, these "stationary" reference points will be the "moving ground," and the figure (the object originally in motion) will not change its location significantly on the screen. However, once again, we readily adjust what we actually see (figure stationary, ground moving) to what we expect (figure moving, ground remaining stationary). If there are no stationary reference points, we perceive the object as stationary, which it actually is, relative to the screen borders. Both motions (object motion and camera truck) cancel each other, rendering the motion meaningless.

We should, therefore, make sure that we have prominent stationary space modulators for the truck and dolly shots that help to define the camera action. Foreground columns, trees, furniture, or people will all serve as things to truck past, or more technically, as stationary space modulators against which our (the camera) motion can be referenced.

Slow and Accelerated Motion We say an event is in *slow motion* if it appears to be moving considerably slower on the screen than while being photographed.

Actually, slow motion is more a function of event *density* than of motion. Normally, film breaks down an event into a number of fixed units (frozen nows), frames, and projects these units again sequentially within a specific time unit. For example, if we divide a moving object into 24 individual frames during one second of its travel and then project these 24 units within the same time span of one second, we will perceive the moving object on the screen as normal (assuming that we do not distort the motion optically or through a moving camera).

But if we increase the speed of the film while photographing the moving object—let's say to 48 frames per second—and then play them back at the customary (for 16mm film) 24 frames per second, we have actually broken down the motion into a greater number of fixed states, frozen nows, each one differing only slightly from the other. (See Figure 12·14.)

An object in slow motion seems not simply to move slower than usual; but, as Arnheim has properly observed, it seems to be moving through a denser medium that appears to cushion the effect of gravity and make the motion "woolly and soft."[3] The object moves, indeed, through a denser atmosphere: through a more densely constructed film, through an increased sequential unit density. This unit density (the great number of fixed instances projected within a relatively short time unit) cushions the motion vector. Not only does the motion vector seem to have less magnitude, but also its direction seems to be more labile. It no longer has to obey the physical laws of gravity to which we are accustomed. Slow motion introduces a feeling of unreality or surreality. We would not be too shocked, or even too surprised, if, after a perfect slow-motion dive, the champion diver would float back out of the water onto the diving board. The density of the film would, like a trampoline, simply absorb and then reverse the motion vector.

Because of this "density variable," we cannot achieve the same slow-motion effect simply by having the object move a little more slowly in front of the camera, while we are shooting at normal speed. Without increasing the information density, a dancer who deliberately slows down her movements will simply appear to be moving more slowly; but she will not attain the floating quality of slow motion.

12·14 *The more frames we use for the breakdown of a particular unit of motion, the more minute the progression of the object's location becomes from frame to frame; the more slowly the objects seem to progress across the screen; and the slower the motion that we perceive.*

We may view the *freeze frame* in a similar way. A freeze frame shows **arrested motion**, not a picture of no-motion. A freeze frame has a high degree of unit density; a specific frozen instant is picked out of the total movement and repeated over and over again.

Slow motion in television is somewhat of a paradox. Since the basic unit of television is not a frozen moment, a fixed now, but a changing process, an act of becoming, it cannot be manipulated quite so easily as the fixed unit of the film. Also, television's dependence on the real time of the actual event makes any motion manipulation difficult aesthetically, if not invalid. Instant replays during a live sports coverage are an aesthetic discrepancy, even if you are given additional information of the event.

Since in live television the time of the actual event and of the television showing of this event are identical, a motion manipulation of the event is, quite obviously, impossible. You can only distort motion once it has become a fixed, manageable unit, which means that the event has to be recorded first before it can be revoked and replayed, such as a slow-motion instant replay. As a recording, you can then apply aesthetic principles of motion manipulation and control, which are very similar to those used in film.

In television, as in film, slow motion and the freeze frame are variations in information density. For slow motion, the television playback device picks out parts of the action and scans them more frequently than others. In a freeze frame, one part of the action is singled out and scanned over and over again. As in film, slow motion in television does not mean that the event is made to move more slowly, but that the event is broken down into a **greater number** of action units within a given time or into **repeated** action units. The event density is, therefore, increased even in television slow motion. The moment is re-created in a distorted way.

Accelerated motion, like slow motion, is actually a film density function. The original event is divided into relatively **few individual** motion instances, each one differing considerably from the other. (See Figure 12·15.)

When projected at the normal projection speed of 24 frames per second, the object seems to leap across the screen. Its motion is not merely faster than normal, but **more erratic,** more jumpy. The motion seems animated, artificially induced. And so it is, actually. The comic energy of a cartoon or the old silent movies is based precisely on this low-density acceleration. The vector field is highly labile; the vectors no longer complement and control one another in direction and magnitude; they seem to dart happily from one corner of the screen to another.

For example, the low-density accelerated motion can turn the normal walk of a person into a jerky, frenzied event. He accelerates frantically along the street and around corners, as if pulled

12·15 *The fewer frames we use for capturing a particular movement, the more abrupt the progression of the object appears from frame to frame. Therefore, the event appears to be accelerated.*

We can use the film density variations to make extremely fast motions, such as explosions, or extremely slow motions, such as the growing of a plant, perceivable. Although such manipulations are normally used for informational purposes only, they are nevertheless subject to the same aesthetic considerations as other, less utilitarian, motion manipulations. The slowing down of extremely fast motion seems to increase the density of the field that the vectors have to penetrate. The accelerating of extremely fast motion seems to decrease the field density.

Vsevolod Illarionovich Pudovkin (1893–1953), Russian film maker and film theorist.

by a giant rubber band. Sometimes he seems to be self-propelled, shooting unpredictably through the low-density atmosphere which offers little, if any, resistance to his motion.

In other cases, the deliberate reduction of information can lead to highly dramatic effects. One of the most striking examples of a dramatic use of low-density accelerated motion appears in Sergei Eisenstein's "Odessa Step Sequence" from his film *Potemkin*. In a brief scene, he shows the death of a woman fatally shot by advancing soldiers. He intensifies her death by eliminating all nonessential frames from her fall. Consequently, the woman does not simply collapse; she is smashed to the ground by the bullets. The jerky action of her death also implies that she was not simply an innocent victim of an uprising, but that she had been ruthlessly murdered.

We must be careful in using *accelerated motion* in *television*. Like slow motion, it cannot be used directly, but only as a manipulation of a recorded event. If we use accelerated motion within a show that is very much dominated by a natural, lifelike rhythm, the accelerated motion may very well cause a rhythmic discrepancy. If, however, we construct an event from recordings of various events in a filmlike way, accelerated motion of various event aspects may prove effective in breaking the linearity of events and simulating subjective time. Generally, accelerated motion is especially powerful (comically or otherwise) since (1) it is concentrated on the small screen area (which tends to speed up motion vectors), and (2) it contrasts sharply with the organic lifelike rhythm of television.

Slow motion and accelerated motion can be extremely effective devices for structuring the four-dimensional field. Slow motion can literally and aesthetically stretch the moment. It can give

a "close-up of time," as Pudovkin called it.[4] Accelerated motion can hurry us along; rush us through time.

Slow and accelerated motions are important factors for establishing the *event rhythm*.

Here are some examples of time close-ups through slow motion:

Example 1 A skier at the start of an important downhill race. He hears the second-by-second countdown. He pushes himself out of the gate. But this very precise moment is often the slowest in the whole race. He has to overcome his inertia. A slow-motion effect at this point can intensify these agonizing moments.

Example 2 A fumble during a championship game. A loose ball. Everyone is trying to recover it. This is the moment for slow motion. The ball rolls and bounces agonizingly slowly—but the movements of the players are even slower. They move through a very dense atmosphere to try to catch the ball, which itself seems to be strangely free of the pull of gravity.

Example 3 Same game. The score is tied. The last seconds of the game bring the chance for a field goal. Everything depends on one kick. Close-up of ball. It is kicked. The ball flies in slow motion—up, up, up, up. Very slowly. And moves between the goal posts. The game is won.

Example 4 A dance. The two dancers seem to move effortlessly. A lift. The lift is shown in slow motion. Both dancers seem to defy gravity; they seem to have left the earth. The moment is greatly intensified.

Example 5 A scene in a drama. Two people are arguing. Both are extremely upset and can barely control their emotions. He wants to strike

her in desperation. Slow motion. Subjective camera from his point of view. Everything moves in slow motion. Flashes of past and future events. Back to normal. The crisis is over. Happy end.

We must be even more careful about when and how to use accelerated action. As mentioned earlier, accelerated action often produces a comic effect, which can be deadly if we seek to intensify a superdramatic moment.

But if we simply reduce the density of a moment by carefully clipping the action, we may accelerate an event quite forcefully.

Example 1 A fight scene. Items fly through the air. Chairs and tables are knocked over. But before any of these items reaches its destination, we clip the action. The chair falls only half-way to the floor; the bottle thrown is clipped in mid-air by a cut to another shot.

Example 2 Love ecstasy. None of the action is ever completed. A series of hands grasping, lips searching, bodies touching—but all incomplete actions until the event climaxes in a slow-motion sequence of a timeless moment. In *Clockwork Orange,* Stanley Kubrick uses accelerated motion for a love scene and slow motion for a fight scene, with startling effect.

Motion and Mass Our perception of motion on the screen is, as in real life, influenced by the mass of the moving object. Mass means all the matter a body contains; aesthetically, it is characterized by an object's perceived size, shape, volume, and weight. A body of large mass resists being moved in the first place and, once it is moving, resists any alteration of its motion. Newton's law of inertia can be applied to aesthetics. Inertia is the tendency of a body at rest to remain at rest

and of a body in motion to remain in motion. If we have a body with large mass, we must exert strong force to get it moving. The faster we want the initial acceleration to be, the harder we must push. Once the object is rolling along, however, we need a similarly strong force either to change its direction or to stop it. Once we have established a strong motion vector through the movement of a large-mass object, the vector stability is not easily disturbed. We need a strong counterforce to change its direction or to absorb its magnitude. (See Figure 12·16.)

The next time you watch a cartoon, pay particular attention to how motion of an object is intensified by showing the effects of inertia. (See Figures 12·17 and 12·18.)

The influence of inertia on the mass of an object (object distortion) is quite evident when applied to the motion of a train (Fig. 12·19).

By using the appropriate focal length lens, we can emphasize this inertia effect on moving objects. The wide-angle lens (or lens position) stretches the object. It exaggerates acceleration and speed. The narrow-angle lens squeezes the object. It exaggerates deceleration.

Since the greater the mass, the greater the inertia, the object distortion is more pronounced in large, voluminous, heavy objects than in small, light ones. (See Figure 12·20.)

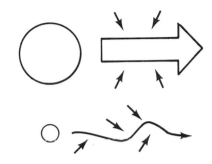

12·16 *The greater the mass of an object (body) the greater its inertia. The motion vector of a large-mass object is more stable and therefore less easily disturbed than that of a small-mass body.*

Speaking primarily of the relative dynamics of immobile pictures (paintings, photography, and the like), Moholy-Nagy attributed so much importance to object distortion as an indicator of motion that he boldly proclaimed: "Distortion equals motion."[5]

Sir Isaac Newton (1642–1727), English physical scientist and mathematician. His pioneer work on motion, astronomy, and the theory of gravitation has been instrumental in the development of the relativity theory. He also did extensive work on light and color.

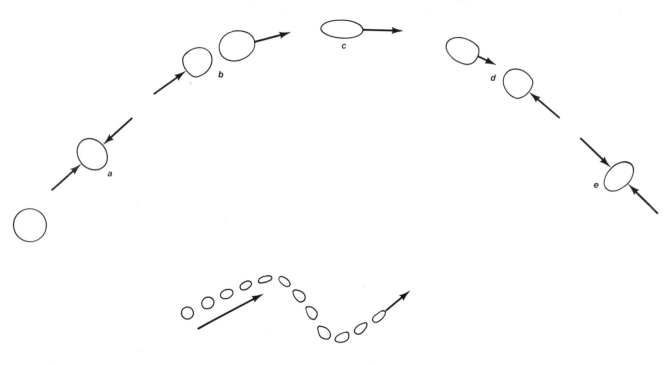

12·17 *When a ball is kicked, the force of the kick must overcome the ball's inertia. Since the ball is pushed, the back part moves first while the front part still resists being moved (a). Once the back of the ball has transferred its force to the front part, the front part is doing the moving. The front of the ball is pulling the back part, which is simply hanging on. Therefore, the ball seems elongated (b). Also, if the ball flies through the air at high speed, it streamlines itself slightly to minimize wind resistance (c). When the ball decelerates, the opposite object distortion takes place. Now the motion inertia (motion vector) of the ball must be stopped (d). The force stopping the ball first squeezes the front part of the ball, with the back part still in motion. Then the counterforce reaches the back part of the ball, too. The ball looks terribly squeezed while being stopped (e).*

12·18 *This is how the exaggerated object distortion of a bouncing ball would look.*

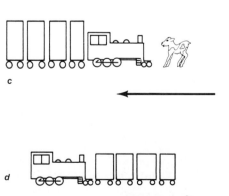

12·19 *With the locomotive in front, it overcomes the initial inertia of its cars by pulling. The train, therefore, stretches out (a). When moving at a fast speed, the train stretches out even more, indicating that the locomotive is exerting more and more pull. Also, the train is getting streamlined (b). When stopping, the locomotive acts as the braking force. The cars behind, which still maintain the motion inertia, get squeezed (c). When the locomotive pushes the train, the cars get squeezed, too, during the initial starting motion (d).*

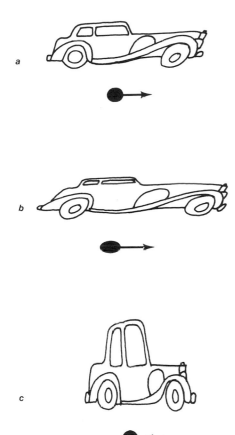

12·20 *A cartoon distortion of an accelerating (a), speeding (b), and decelerating (c) car shows the influence of mass and inertia on the shape of an object.*

Types of Motion In television and film, we are confronted with many different movements. The performers move about, the camera dollies and trucks along with the action, and there is the movement created by the shift of viewpoints through cutting. Let's label and order these motions so that we can work with them and discuss them more easily.

We can identify three basic motions: (1) primary motion, (2) secondary motion, and (3) tertiary motion.

Primary motion is *event motion* in front of the camera. Primary motion includes the movements of the performers, the movement of a car—anything that actually moves in front of the camera.

Secondary motion is *camera motion.* Secondary motion includes camera movement by pan, tilt, pedestal, crane or boom, dolly, truck, arc. It also includes the zoom, although only the lens elements, rather than the camera itself, moves during a zoom. However, the zoom represents a motion induced by the camera.

Tertiary motion is *editing motion.* It is the movement (rhythm) induced by shot changes, that is, by switching by cut, dissolve, wipe, or fade from one video source to another, such as from one camera to another, or from one camera take (continuous run) to another, or from camera to video tape, and so forth.

These three motions have one common purpose: to help clarify and intensify the event for the viewer. Specifically, they are the elements that represent control of objective and subjective time and that directly reveal the dynamic structure of an event.

Primary Motion The manipulation of primary motion, the motion in front of the camera, is one of the most important steps in the clarification and intensification process.

If we merely observe an event, such as in news coverage, we have virtually no control over primary motion, the various movements of the event. However, we can still manipulate the primary motion of the event through the cameras for the final screen event. Depending on where we place the cameras, the screen vectors of the primary motion may appear from left to right, right to left, diagonal, up and down, or along the z-axis. Thus, although we cannot influence the event itself, we have still control over primary motion *as it appears on the screen.* The more familiar we are, therefore, with the various movements of the actual event, the easier it will be to manipulate the various motion vectors through proper placement of the cameras. Whenever we analyze the primary motion of an event, we should think how we would like the motion to appear on the screen. This translation process of actual event motion into screen motion vectors will tell us where we must place the camera or cameras and what lenses (or zoom focal length positions) to use.

If we stage the event, we can control primary motion within the event itself and for the camera.

The control of primary motion within the event means that ideally the movements of performers and things should relate naturally. The movements should be *motivated by the context:* the story, the situation, the mood. For example, if we want to intensify and clarify the event of a young couple in love, their movements should primarily be guided by what they feel toward each other and their spontaneous expression of these feelings rather than by where the cameras happen to be. But even then, we must nevertheless guide these spontaneous actions gently so that they are in harmony not only with the event context, but also with the medium requirements (small or large screen, lighting, cameras, timing, sound, and the like).

Blocking, directing the actual movements of performers and objects, or primary motion is, therefore, influenced by the *event context* as well as the *medium context.* If the medium is film, we must block the couple's movements for the large area of the motion picture screen. We might have them running and skipping along the beach, in the park, along the street. We can capitalize on their external actions. When shooting for television, on the other hand, we will probably try to internalize their actions somewhat. We may want to block them in such a way that their motions are *close,* externally and internally, so that they fit the close, yet confined, screen area of television. Their running and skipping can now be expressed by slight changes in posture, with their hands, the movements of their heads. The sea, the wind, and the happy mood of the park can be contained and reflected in their eyes and faces. We move from extensive external to internal action; from motion to emotion.

Since the final product is *screen images,* we are occasionally forced to block primary motion for the specific camera requirements, regardless of whether or not the action feels "natural" to the performer. *Z*-axis staging, for example, frequently feels awkward to the performer or to the person watching the event in the studio. But when shown on the television screen, the movements of the performers and objects seem entirely logical and organic; the vector field seems well integrated and structured.

The ultimate criterion for the use of primary motion is how and how much it contributes to the clarification and intensification of the event.

The ultimate criterion for the *control* of primary motion is how the event motion translates into motion vectors and how well these motion vectors integrate with the total structure of the vector field, that is, how well primary motion contributes to the clarification and intensification of the event *on the screen.*

Secondary Motion Regardless of whether we can command the actual event or not, we always have *full control over secondary motion,* the motion of the camera, at least within its technical limits.

Because secondary motion is actually independent of the event, you might easily be tempted to use camera movement for its own sake and not for the clarification and intensification of the event itself. Try not to fall into this common trap. If the primary motion is sufficient for a clarified and intensified screen event, do not use secondary, or any other, motion you may have available. Most amateur film makers can easily be recognized by their wild and totally unmotivated secondary motions. They weave the camera in front of the event as if they were spraying it with insecticide. Or they zoom in and out at a rate that may cause even the steadiest viewer to become somewhat nauseated.

When and how should you, then, use secondary motion? Without going into specific cases, here are some general guidelines for the use of secondary motion:[6] Secondary motion is a direct medium manipulation in order to clarify and intensify the event. Secondary motion helps to clarify an event by following a specific event action and by pointing to a specific relationship between events or parts of events.

Event Clarification through Secondary Motion: Most often we move the camera to *follow action* or to adjust composition. We should always pan or tilt *ahead* of the action so that the *motion vector* can be properly absorbed within the screen area (Fig. 12·21). Also, the viewer generally wants to see where the object is going, not where it has been.

We use secondary motion to show a relationship of events or objects or to establish an association between them. The secondary motion then either follows or establishes a *graphic vector* or an *index vector.*

Event Intensification through Secondary Motion: The key to the intensification of an event through secondary motion is the manipulation of subjective time. Through secondary motion, a graphic vector or an index vector is *gradually* revealed, explored, or induced, thereby intensifying the energy of the event.

A gradual revelation or creation of a graphic vector through secondary motion can dramatize the dimension of an object or event. The height of a building is greatly intensified through a gradual tilting up.

Dollying through or trucking by a long hallway again intensifies the length of the hallway. The gradual revelation of the graphic vector adds to its magnitude.

The gradual revelation of an index vector also contributes greatly to the intensification of an event. A slow pan from the horrified face of an onlooker to the actual scene of the accident intensifies the scene considerably.

A swish pan from someone pointing to the target point itself often dramatizes the event more than a simple cut from the pointing to the destination.

We can establish an index vector that will literally point to a future happening, thereby heightening the suspense. For example, we pan ahead of a carelessly driven sports car to a hairpin turn of which the driver is unaware. Will he or will he not make the turn?

When we pan, tilt, or zoom on a still photograph, we induce motion into the screen image. For example, when we pan against the index vector of a still picture of a ship and tilt the camera up

12·21

12·22 *Here the index vector is followed by the camera.*

12·23 *In this case, an index vector is induced. A swish pan (very fast pan) between two events induces a strong index vector that points from one event to another, both of which take place at the same time but in different locations.*

and down in a slow, wave-like motion, the ship appears to be moving forward on the screen. In this case, we speak of an *induced motion vector.* As you know, this technique is widely used to animate (and thereby intensify) series of still pictures. The induced motion vector helps to animate a picture (or object in some cases) so that its screen image appears to be actually in motion.

However, if we simply follow an inanimate object, such as a building, with secondary motion, we do not necessarily cause an induced motion vector. Panning up a high building does not cause us to perceive the building as moving. We simply seem to look up at it.

The induced motion vector usually works only on objects that we generally see in motion.

The concept of *induced motion vectors* may cause some confusion. The difference between emphasizing a graphic vector or an index vector through secondary motion and the creation of an induced motion vector is basically that of *context,* that is, the clarification and intensification *intent.* For example, if we pan along an automobile to emphasize its long, sleek lines or its overall length, we merely follow a graphic vector. But if we pan along the picture of an automobile (against the way it is pointed, against its index vector) in order to pretend that it is moving, then we have *induced a motion vector.*

In other words, if the overall context is the *exploration* of a static element by secondary motion, the viewer will perceive the motion subjectively, that is, he will pretend to be scanning the stationary object. If, however, the context spells animation, *event motion,* then the viewer will perceive the screen motion *objectively,* that is, he will see the objects move, while remaining stationary himself.

On a really fast dolly or zoom, the viewer will probably perceive object motion, no matter what the context has been. A fast zoom into an object literally hurls the object into the viewer's lap. A fast dolly in, on the other hand, pushes the viewer into the scene.

Tertiary Motion Tertiary motion, the sequence motion, is such an important phase in structuring the four-dimensional field that we will devote the following chapter (Chapter 13) to its discussion and exploration.

Summary

Timing is the control of time in television and film. The control of both objective and subjective time is an essential element in structuring the four-dimensional field.

There are six types of *objective time* in television and film: (1) *Spot time* depicts the actual spot when an event happens. The log lists spot times—beginning and ending times of shows. (2) *Running time* indicates the overall length of a television show or film. (3) *Story time* shows the objective time span of an actual event as depicted by the screen event. If somebody's life is shown from his birth to his death, the span of his lifetime, rather than the length of the show, is the story time. (4) *Shot time* measures the actual duration of a shot. (5) *Scene time* is the time span necessary to cover a scene. (6) *Sequence time* is a subdivision of the running time and spans several scenes.

Timing is the control of all these times so that they form a dynamic, rhythmically stimulating pattern. In subjective timing, the terms "pace" (perceived duration of the overall show), "tempo" (perceived duration of show segments), and "rate"

(perceived speed of individual performance) are sometimes used.

A more practical terminology uses *pace* (perceived duration) to refer to the overall show, as well as to the sequences, scenes, and performers' actions. The duration of the shot is called "shot time."

Rhythm refers to the *flow* of the show, sequence, scene, accumulation of shots, or the performers' actions.

Four *concepts of motion* are important in structuring the four-dimensional field: (1) the motion paradox, (2) slow and accelerated motion, (3) motion and mass, and (4) types of motion.

The *motion paradox* is that an object can be in motion and at rest at the same time, depending upon motion *context,* that is, against which other body the motion is observed or measured. We usually perceive the figure as moving and the ground as stationary. Therefore, we can reverse this process on the screen (ground moving, figure stationary) without altering our usual figure-ground motion perception.

Slow motion and accelerated motion are more a function of *density* than of speed. In slow motion, the individual television or film units are more dense and in accelerated motion less dense than in the portrayal of regular motion. Because of the increased or decreased density of the individual film or television units within a given time, slow motion (high density) seems to cushion the moving object from gravity, while accelerated motion (low density) seems to make the motion self-propelled, erratic.

Our perception of motion on the screen is influenced by the *perceived mass of the moving object.* The greater the mass of an object, the greater its inertia (tendency of a static body to remain at rest and of a moving body to remain in motion). The motion vector of a large-mass object is more stable than that of a smaller-mass object. The inertia principle can be used as a distortion principle to intensify the motion of an object. This technique is often used in cartoons.

There are three basic *types of motion:* (1) *Primary motion* is *event motion.* It includes everything that moves in front of the camera. (2) *Secondary motion* is *camera motion.* It includes the pan, tilt, pedestal, crane or boom, dolly, truck, arc, and zoom. (3) *Tertiary motion* is *editing motion.* It is the movement induced by shot changes, that is, by switching from one video source to another.

Notes

[1] The Russian theorists in literature call story time "fabla time." Fabla time, like story time, is the total period spanned by the story. See René Wellek and Austin Warren, *Theory of Literature* (New York: Harcourt Brace Jovanovich, Inc., 1949), p. 226.

[2] For more information on Duncker's principles, see Rudolf Arnheim, *Art and Visual Perception* (Berkeley: University of California Press, 1965), pp. 366–367.

[3] *Ibid.,* p. 372.

[4] V. I. Pudovkin, *Film Technique and Film Acting,* trans. and ed. Ivor Montagu (New York: Grove Press, Inc., 1960), pp. 174–182.

[5] László Moholy-Nagy, *Vision in Motion* (Chicago: Paul Theobald & Company, 1947) p. 256.

[6] For a specific breakdown of the types of secondary motion and their specific applications, see Rudy Bretz, *Techniques of Television Production,* 2nd ed. (New York: McGraw-Hill Book Company, 1962); Colby Lewis, *The TV Director/Interpreter* (New York: Hastings House, Publishers, Inc., 1968); and Herbert Zettl, *Television Production Handbook,* 2nd ed. (Belmont, Calif.: Wadsworth Publishing Company, Inc., 1968).

Structuring the Four-Dimensional Field: Picturization

In *visualization* we were concerned with controlling the vector fields of individual, discrete screen images. We worked with the structure of individual shots. In *picturization* we manipulate a *succession of shots, scenes, and sequences.* We are now concerned with the interrelationship of shots so that their individual vector fields form a unified whole. Picturization includes the control of two large areas: (1) *tertiary motion,* which is sequence motion, and (2) *editing,* which means building a screen event.

Tertiary Motion

Tertiary motion is *sequence motion.* Through a change of shots, scenes, and sequences we perceive a movement of progression, a visual development. The important aspect of tertiary motion is not so much the shot itself, the vector field of the shot, but the *moment of change,* the relationship of vector fields from shot to shot. Much like the bars in music, the various transition devices act as an important structural element in the overall development of the film or television show, without drawing too much, if any, attention to themselves. They determine the basic beat and contribute to the sequence or show rhythm.

Like all the other basic aesthetic elements in television and film, the transition devices, such as the cut, dissolve, fade, wipe, and other special transition effects, help to clarify and intensify an event for the viewer. They help the viewer to see better, and make him feel more intensely. They supply the necessary variety and aesthetic tension within an event and contribute at the same time to its structural unity.

13·1 *In a strict sense, the only motion present in film is tertiary motion, the motion created by the succession of individual, static visual images, the frames. However, because the frames follow one another rapidly, we do not perceive this type of tertiary motion, a succession of frames, but rather primary and secondary motions. Only if there is an obvious image change from frame to frame, or if the transition device itself occupies several frames are we aware of sequence motion.*

In television, as in film, the changes from shot to shot determine tertiary motion. Although the changes themselves are usually done electronically, they are quite similar in effect to the transitions in film. Any change from one television video source to another (camera to camera, camera to video tape, video tape to video tape) affects tertiary motion.

Although the transition devices all have the same purpose, namely, to provide the necessary link from shot to shot, they differ somewhat in their specific clarification and intensification functions. We will briefly indicate the major functions of (1) the cut, (2) the dissolve, (3) the fade, and (4) special transitional effects.

The Cut *The cut is an instantaneous change from one image to another.* It is the least obtrusive transition device; it does not call attention to itself. The cut most closely resembles the changing of visual fields by the human eye. Try to scan the things in front of you. Notice how your eyes "jump" from place to place, neglecting the in-between spaces. You are not smoothly panning the scene, but "cutting" from spot to spot. The filmic cut represents similarly a fast, organic change from picture to picture. These are the major clarification and intensification functions of the cut:

1. *To continue action* If one camera can no longer follow the action, we cut to another camera that continues the action. Usually, we cut to either a slightly closer or wider shot than the previous one. A change of field of view from shot to shot gives the shot its necessary aesthetic justification.

2. *To follow or establish a sequence* By cutting, we can follow the natural sequence of an event or sequentially arranged objects. In film, we can eliminate unnecessary steps in the event sequence and concentrate on event highlights. Often, sequentially arranged objects, such as large exhibit items, cannot be covered by a pan. Cutting from object to object will provide smooth transitions while preserving the desired sequence.

If items are not sequentially arranged, we can *establish* a sequence by combining a series of originally disconnected shots.

3. *To change locale* A cut manipulates *screen space,* not actual space. A cut from shot to shot may span instantaneously only the length of a room or several thousand miles.

4. *To reveal detail* We cut to a closer shot to help the viewer see better. A detailed shot isolates the detail from its surroundings and forces the viewer to see in a specific way.

5. *To increase or decrease event density* As we discussed in the previous chapter, we can accelerate the action by cutting out some of the nonessential action detail. This acceleration is especially effective if we cut to another action shot before the first action has been completed. (*Example:* Fight scene: chair falling—before it hits the floor cut to man swinging his fist; before the fist finds its target cut to man falling; before he is down cut to friend coming to his rescue, and so on.) Increasing the event density can prolong an action or moment. For example, we can look at the same moment from different viewpoints or with increasing scrutiny, increasing event detail.

6. *To show simultaneous events* Unless we work with multiscreens or multiple images on a single screen, we must show simultaneous events sequentially. In the context of a screen event, the viewer will accept sequential events as being simultaneous, as long as they are identified as such (meanwhile-back-at-the-ranch).

7. *To interchange past, present, and future events* Through cutting, we can reverse the time arrow and begin with the effect, followed by the cause (flashback). Or we can intercut into the present event flashes of past or future events. Since in film or recorded television the event is actually past, we have, as indicated earlier, great freedom in creating a unique screen time.

8. *To establish an event rhythm* Through cutting, we determine the objective and subjective times of shots, scenes, sequences, entire shows. The cut is one of the principal means of controlling pace and rhythm. The cut establishes a beat and helps to determine the overall event rhythm. Rapid cutting (short shots) usually accelerates the event; slow cutting (shots of longer duration) slows down the rhythm of the event, emphasizing a feeling of calm and tranquility.

9. *To intensify the screen event* The cutting rhythm as mentioned above, the juxtaposition of vector fields, and the change from relatively low-energy long shots to high-energy close-ups through cutting can all contribute to the intensification of a screen event.

The above-mentioned functions of the cut apply to film and *recorded* television only. When working with live television, our usual job is to *interpret* the event in a clarified and intensified way, not to create it. Cutting, therefore, is more event-determined than in film and video tape. In live television, the major functions of the cut are as follows:

1. *To follow and continue action*

2. *To follow or establish a sequence* Since we have a limited number of cameras, the cutting sequence will be limited in number of varied shots within a given time. Usually, rapid cutting from widely dispersed locations is impossible to maintain. A four-camera set-up, for example, allows only three rapid cuts before the first camera must be reset.

3. *To change locale* We can switch from one locale to a widely separated one instantaneously, thereby preserving a continuity of actual event time, although the locations are changed.

4. *To reveal detail* As you know, the inductive use of television calls for a variety of detail shots. When these are shown in sequence, we build the event in an intensified way. The cut from detail to detail is one of the most important functions of the cut.

We cannot increase or decrease event density in live television by stretching or shortening the actual time of the event. What we can do is to show more or less event detail by rapid or slow cutting. Generally, the event density is expressed in an intensification through close-ups or through multiple images rather than a long series of rapid cuts.

We cannot show simultaneous events in live television through cutting. Since we work in real time, a cut cannot arrest the progression of time. We can show simultaneous action only through multiple screen images or two or more receivers, each showing a separate, yet simultaneous, event.

In live television (excluding any recorded inserts), we cannot interchange past, present, and future. We cannot reverse the time arrow but must follow the normal event progression.

The television rhythm of the screen event is basically determined by the rhythm of the actual event itself. However, through cutting we can intensify the prevailing event rhythm. Generally, as mentioned earlier, the overall rhythm, the pace, of a live television event is slower, more organic, more lifelike, than that of edited film or video tape.

The Dissolve *The dissolve is a gradual transition from shot to shot, whereby the two images temporarily overlap.* In contrast to the cut, which itself is an invisible transition, the dissolve is a *clearly visible transition*. The dissolve has its own, though temporary, visual structure. In a slow dissolve, the visual structure of the dissolve becomes more prominent; in a short dissolve, the

 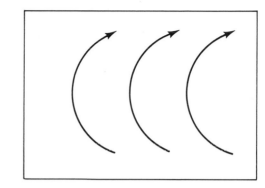

13·2

transition has more of the characteristics of a cut.

The following are clarification and intensification functions of the dissolve:

1. *To provide continuity* A dissolve can provide continuity of action even if the shots would not "cut together" well. In an emergency we can, for example, use a dissolve to bridge the gap between an extreme long shot to an extreme close-up, while keeping the viewer properly oriented. Also, if the vector fields of the preceding and following shots differ widely in screen direction or magnitude, a dissolve can provide the necessary temporary third vector field, which acts as a buffer between the two shots (Fig. 13·2).

Do not rely on dissolves to cover up your picturization mistakes. If you dissolve too often between incompatible shots, you will destroy, rather than enhance, the event continuity.

Assuming that the vector fields of the shots are compatible, a dissolve will assure an extremely *smooth* transition from shot to shot. A dissolve never ends a shot but simply blends it into a new one. A dissolve between shots does not contribute

much to a rhythmic beat, but simply elongates a visual sequence. Because of its rhythmic unobtrusiveness, the dissolve adjusts readily to a variety of beats.

2. *To adjust the rhythm of the screen event to the mood or rhythm of the actual event* A fluid dance sequence, a slow religious service, the mood of a funeral are all properly reflected by a series of dissolves. Dissolves reduce rhythmic accents and interconnect the event into a smooth entity.

3. *To bridge large space and time intervals* Although the cut has by now replaced the dissolve in indicating a change of locale or passage of time, we can still use the dissolve quite effectively to bridge space and time intervals. The dissolve is especially appropriate if we move simultaneously from one place and time period to another place and a later time period. *Example:* Young boy running through hometown fields. Short dissolve to professor in a classroom of a large university speaking on the influence of one's youth on adult behavior.

We can also indicate a passage of time without varying the location. *Example:* Lone survivor of a shipwreck rowing in the ocean. Dissolve to closer shot of the same man still rowing in the ocean.

Again, be warned that the dissolve has become somewhat old-fashioned in this particular function. Within the context of an established story line, a cut can bridge time and space intervals equally well, with the added bonus of keeping the action rhythmically tight.

4. *To show thematic or structural relationships between seemingly unrelated events* A dissolve can thematically connect two separate events. It can also reveal a basic structural relationship between two events. *Example:* Outfielder jumping to catch a ball; dissolve to leaping dancer.

Another warning: Dissolves are readily available in television. This availability may entice you to use dissolves instead of cuts. Don't do it. They may be "safer" than cuts, since they cushion vector discrepancies, but they also destroy your timing. Since dissolves create no rhythmic beat, your presentation will lack accent. Your screen event will lack progression; it will lack intensity and excitement. An overabundance of dissolves is a sure way to bore the viewer.

Some television directors like to use a very fast dissolve, instead of a cut, to soften the transition from shot to shot somewhat. Such fast dissolves are often called "soft cuts," since they function very much like a cut. The soft cut has its problems, however. Although it may help to camouflage an otherwise rough transition, the soft cut lacks crispness and rhythmic clarity. Like too much pedal in piano playing, the indiscriminate use of the soft cut (fast dissolve) muddles the scene.

13·3 *A cut usually generates a staccato rhythm; dissolves generate a legato rhythm. Staccato means the emphasis of each note. Each note appears as a separate, strong entity.*

13·4 *In a legato passage, the notes blend into one another. There are no breaks between them. They appear as a unified passage.*

The Fade In a fade, the picture goes either gradually to black (fade-out) or appears gradually on the screen from black (fade-in).

The function of the fade is to signal a definite beginning (fade-in) or end (fade-out) of a scene or sequence.

The fade is actually not a true transition device; rather, it *defines* the duration of the individual event sequences, or of the total event itself. It functions like the curtain in the theater.

Special Transitional Effects The major special transitional effects are the wipe and the defocus effect.

The Wipe The wipe is such an unabashed transition that it must be classified as a special effect. Its function is clearly expressed by its behavior: to push the old sequence image off the screen, irrespective of vector, thematic, or structural relationships. The old sequence is finished, and the new one comes in loudly and clearly.

In television, where electronic wipes are as easily accomplished as a take (cut), we usually have a great variety of different wipe configurations available.[1] Like the fade, the wipe signals the end of one sequence and the beginning of another. Unlike the fade, the wipe is faster, more transient. It does not put a permanent stop to a sequence, but simply pushes on to the next.

The Defocus Effect The old shot ends out of focus. The new one begins out of focus. The defocus device rates about half-way between the dissolve and the fade in effectiveness and function. Like the fade, it indicates the end of one sequence and the beginning of a new one, and, like the dissolve, it suggests some thematic and structural relationship between the two sequences.

13·5 *In a wipe, the screen image of the new shot seems to push the old one off the screen, either horizontally (horizontal wipe) or vertically (vertical wipe).*

Other special effects such as the flip frame or debeaming transition are all obvious transitions from one space-time environment to another or, more often, from one story segment to another.

In television, *commercial inserts* frequently act as definite transitions from one stage of event development to the next. When writing for television, you should consider commercial breaks as part of your total show development. When skillfully placed, the commercials can function as needed periods of relief, very much like the intermission in a theater performance.

Tertiary motion, the rhythm of the screen event and the varying beat of its sequences, is primarily determined by the choice of transitional devices. The most common device is the cut, which of all transition devices is the only instantaneous one and which does not have a visual existence of its own. All other transitions represent temporary visual elements that either connect, begin, or end event sequences.

Editing

Editing means *building a screen event*. It consists of combining parts of an event or events into a single, unified screen experience. How you build your screen event depends on many contextual factors: what you want to say, why, to whom, and especially how. In other words, your decisions of what to use and what not, what to emphasize and what not, and exactly how to put it together for the screen are influenced by your communications intent, the target audience, your personal style, and the specific medium requirements. Since we have been concerned throughout this book mainly with the last point, the aesthetic medium requirements and techniques, we will discuss editing again within this particular medium context. Specifically, we will discuss (1) continuity editing and (2) complexity editing. *Continuity editing* concerns itself primarily, but not exclusively, with the *clarification* of an event; *complexity editing*

with the *intensification* of an event. When reading and thinking about editing, you should realize that editing procedures are as much audio- as video-dependent. This means that you will have to consider sound (dialogue, sound effects, music) as important an influence on what, when, and where to cut as the pictorial vector field. However, for clarification's sake, we will first discuss the visual editing as part of structuring the four-dimensional field. Then we will examine audio-video combinations in Chapters 14 and 15, which concern themselves with the five-dimensional field and its structure.

Continuity Editing Continuity editing means putting together in a *continuing sequence* bits and pieces of recorded television and film images or a series of event details while the event is in progress. Continuity editing depends on skillful application of the major *picturization principles*. These include: (1) continuing index and motion vectors, (2) converging index and motion vectors, (3) establishing a vector line, (4) ABC cutting, (5) cutting on action, and (6) subject continuity.

One of the most important aspects of continuity editing is to preserve or establish a smooth vector continuity from shot to shot. This vector continuity helps to establish an overall vector field from the various individual shots, scenes, and sequences. It facilitates building a unified screen space and ultimately a unified screen event.

Continuing Index and Motion Vectors Once we have established a strong index vector in normal screening action, we should not reverse this vector in the next shot but should continue it to indicate an uninterrupted action (Fig. 13·6).

13·6

13·7 *When we start with a z-axis vector, any other vectors will appear to be continuing no matter in what direction the follow-up vector points.*

13·9 *We can change the vector direction and still create the illusion of continuing vectors by using a cut-in (or cut-away) of a z-axis vector or any other shot with a neutral vector field.*

13·8 *If we take a series of close-ups of an audience, for example, we must make sure that the index vectors point and continue in the same direction.*

We must be especially careful to continue a *motion vector* in subsequent shots so that the principal direction of the moving object is preserved, as in Figure 13·10. (Remember that we cannot show an actual *motion vector* in a still photograph. A motion vector is created by a moving object.)

Continuing vectors are also important to preserve a principal direction in subsequent scenes or even sequences. For example, if we show someone driving east from San Francisco to Millersburg, Pennsylvania, the car should continue to go east after each stopover during the trip, even if we have changed the direction of the motion vector from time to time during the car's actual travel.

When we show the traditional yellow cab pursuing the black limousine, we must make sure that the cab travels in the same direction as the limousine. If we reverse, rather than continue the motion vectors, the two cars seem to be fleeing from or racing toward, rather than pursuing, each other.

13·10

13·11 *We should always continue the motion vector in the direction it left the screen, that is, at the end of the shot, not necessarily in the direction where it began. Often, the motion vector changes direction within the shot.*

13·12 *As with the z-axis index vector, a z-axis motion vector allows us to move into any direction in subsequent shots without losing motion vector continuity. This car seems to be traveling in the same direction although the motion vectors do not continue in the same screen direction.*

13·13 *If we enter a performer along the z-axis (toward or away from the camera), we can continue his action equally convincingly with a screen right-to-left or left-to-right motion vector.*

13·14 *Even if the z-axis vectors are actually converging in subsequent shots, we will still perceive the motion as continuing in the same direction. Make sure, however, that the background maintains the directional continuity.*

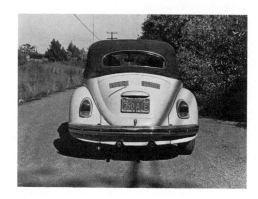

13·15 *In special cases, we can use other converging vectors to indicate continuing motion. If, for example, we have established the travel of a prominent, easily identifiable object, such as a train or an isolated person, we can have the motion vectors converge without destroying their motion continuity. Converging motion vectors often increase the force of the motion (the vectors collide), thereby raising the tension of the event. We should not use converging vectors to indicate continuing motion, however, if the object in motion is not easily recognizable or if the established screen direction is an essential part of the story (running toward a specific place, for instance).*

13·16 *Since the audience members and the speaker are facing each other, their index vectors converge. When we show a close-up of the speaker followed by close-ups of audience members, we must keep the same vector convergence. Otherwise, the audience will appear to look away from, rather than at, the speaker.*

13·17 *When facing the camera directly, we perceive the z-axis vectors as converging, though they actually continue each other. The two people appear to be facing each other.*

Converging Index and Motion Vectors It is not only the continuing vectors that help to preserve vector continuity from shot to shot, but also *converging vectors.* If two elements converge in a single shot, such as two people talking to each other, then they must continue converging in subsequent shots. Two people talking to each other establish converging index vectors. In subsequent close-ups, we must preserve the convergence of the index vectors. If we continue rather than converge the index vectors in the close-ups, the two people seem to be talking away from rather than to each other.

13·18 *Converging motion vectors in subsequent shots indicate that the objects are moving toward each other. For example, the viewer will expect the boy who is running screen-left to screen-right eventually to meet the girl running from screen-right to screen-left.*

13·19 *A sequence of shots showing converging motion vectors between a camper and a fast-moving car on a narrow mountain road warns the viewer of the impending collision.*

13·20 *When moving along the z-axis, the car and the camper will appear as converging although they actually establish continuing vectors.*

Camera 1

Camera 2

13·21 *When two people face each other, their converging index vectors form a vector line. If we want to maintain converging vectors in following close-ups, we must keep the cameras on one or the other side of the vector line. If we shoot from both sides of this vector line, the close-ups will show continuing rather than converging vectors.*

Establishing a Vector Line Establishing a *vector line* whenever possible will help to avoid many awkward picturization mistakes. It will also aid in camera placement. (See Figures 13·21 through 13·25.)

Camera 1

Camera 2

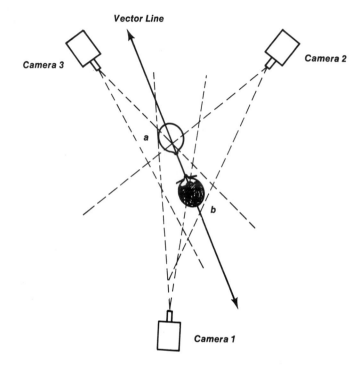

Vector Line

Camera 3

Camera 2

a

b

Camera 1

13·22 *If we cross the vector line in such reverse-angle (over-the-shoulder) shooting, we will have the two conversing people jump from one side of the frame to the other. When cutting from camera to camera, the people will seem to jump into each other's chairs.*

a **Camera 1** *b*

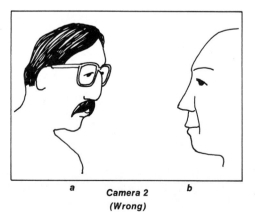

a **Camera 2** *b*
(Wrong)

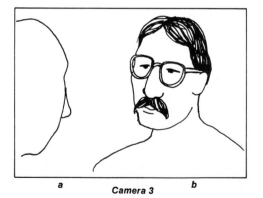

a **Camera 3** *b*

13·23 *A speaker facing his audience also forms a vector line. Again, we should not cross the vector line with the cameras. We must keep the camera that is on the speaker on the same side of the vector line as the audience camera. The index vectors will now properly converge in separate shots. If we cross the vector line, the audience will look away from the speaker. We will create continuing rather than converging vectors.*

Vector Line

Camera 2

Camera 3

Camera 1

Camera 1

Camera 2

Camera 3
(Wrong)

13·24 *A motion vector also describes a vector line. We must not put cameras on opposite sides of the stadium, since every switch to the opposite camera will reverse the motion vector. A cut from a wide shot to a close-up will show the football star running suddenly in the opposite direction.*

13·25 *Reverse angle shooting of two people sitting next to each other and conversing in an automobile presents an especially tricky vector problem. If we take the conversing occupants of the car and the vector line (m–n), the reverse angle shots of the people will clash with the established high-magnitude motion vector of the car, even if the camera stays dutifully on only one side of the (index) vector line.*

Shot 1 continues properly the established direction of the moving automobile, but shot 2 reverses the direction of the car's travel. This vector discrepancy becomes especially apparent when we show the landscape (or street) pass by in the window behind the conversing people. Although we may correctly maintain the screen positions of a and b, we violate the continuity of the motion vector of the traveling car. And, once the motion vector of the car (basic context) has been clearly established, we must continue it in subsequent shots.

One solution to this problem is to switch to a semi-z-axis point of view (diagonal) and then cut to the opposite diagonal shot (d, e). Or we may want to switch to a direct z-axis shot and continue to shoot the close-ups from a z-axis position (f, g, h).

Camera 2

Camera 1

Camera 1 Camera 2

b a c

13·26 *If we put the host (a) in the middle of his guests (b and c), we will not be able to maintain the established screen positions.*

b a

On an a-b two-shot, (a) will be on screen-right; when talking to (c), the a-c two-shot will switch (a) to screen-left.

a c

13·27 *We should always isolate the host on one side and string his guests out on the other. Thus, the converging vectors and the screen positions will not drastically change when we switch to close-ups.*

ABC Cutting Maintaining screen positions is also important when we single out individuals from a group with close-ups (Figs. 13·26 and 13·27).

Cutting on Action To assure maximum continuity of action, we should cut *during* the action, not before or after it. When we cut just before or after the action, we accentuate the beginning or end of the motion vector rather than its continuity —the action itself. For example, if we cut to a close-up of someone getting up from a chair, we should not cut just when he starts to get up or when he is already standing. Let him move partially out of the frame on the first shot, and then have him *complete* the motion in the second shot.

When cutting during a secondary motion (pan, tilt, zoom, or the like), we should continue the secondary motion in the next shot. If we are panning with a moving object, we should have the second camera panning, too, before cutting to it. If we do not have the second camera panning, the motion vector seems oddly disturbed; the object seems to accelerate suddenly and lurch through the frame. Since the first camera is controlling the motion vector of the object through secondary motion (camera movement), the second camera to which we cut must do the same.

If we build a continuous action from prerecorded bits and pieces, we should make sure that the motion vector does not jump from shot to shot.

We can avoid this type of "jump cut" by changing the field of view from shot to shot. Matching the action exactly is very difficult, if not often impossible, even if we keep the camera firmly locked down. Changing the field of view and the angle will make the exact matching of the repeated action unnecessary.

Even in television, where we usually cover the action with a multicamera set-up, a change of angle and field of view is advisable. This will eliminate the problem of having all cameras frame the moving object exactly alike, and thus avoid redundant shots and possible discrepancies in motion vector alignment.

If the motion vectors are too mismatched in the original takes, we may have to insert a neutral cut-in to make combined motion vectors appear continuous. Such "cut-ins" or "cut-aways" are standard procedure in filming. We should always shoot a few close-ups, long shots, or z-axis points of view of a neutral, yet event-related action for cut-away protection.

Subject Continuity If we cut from an extreme long shot to an extreme close-up, it is often hard, if not impossible, to tell which part of the long-shot scene you have isolated for the close-up. (See Figures 13·28 and 13·29.)

Complexity Editing Complexity editing helps to reveal the *complexity and intensity of an event*. In addition to the smooth continuity of the horizontal event (plot) progression, we are now concerned with probing its *depth*. Complexity editing should uncover the inner relationships of an event and stress the complexity and intensity of the event's principal moments. It should facilitate the viewer's psychological closure so that he can perceive a screen gestalt that is made up of event essences and that is larger and more intense than the sum of the actually presented event images. Complexity editing tends to affect subjective, rather than objective, time. It affects levels-of-experience intensity.

13·28 *This change from an XLS of a group of people to the CU of a man does not permit subject continuity. As far as the viewer is able to tell, the CU of the image may or may not be part of the previous XLS group.*

13·29 *In order to preserve subject continuity, we should make sure that the event detail is clearly recognizable before we single it out with a closer shot. The same principle applies to the reverse procedure, when we move from an XCU to an XLS.*

13·30 *A montage generates a "tertium quid," a third something, that is not contained in either of the montage parts. A montage can make explicit a specific message.*

Shot 1 **Shot 2** **Completed Montage**

*Haiku poetry works often on the montage princi-
ple. In its highly economic structure it implies a
larger picture or concept than its lines actually
contain. Here are some examples of Haiku poetry
written by seventh and eighth graders from a
small but very progressive country school in
California.[2]*

My Town

*Fog sleeps on the hills.
Autumn winds blow from the west—
A town suddenly appears.*

—Lee Phillips

The Lake

*Still lake, quiet water
The sun sets, swarms of mayflies.
Fat fish sizzle in pan.*

—Lee Phillips

Hunting

*Shots ring from hills far
All afternoon I watch deer
Eat mother's flowers.*

—Chris Harris

Autumn

*School is in the air
Crackling leaves under your feet
Green is fading out.*

—Tere Banducci

Autumn

*An orange sky of
Monarch butterflies; a field
of flowers, gone, with birds.*

—Ty Wilson

The basic building block of complexity editing is the *montage.* A montage is the juxtaposition of two or more separate event images that, when shown together, combine into a larger and more intense whole.

Types of Montage Although the possible montage combinations are practically endless, they all seem to fall into two large categories: (1) analytical montage and (2) idea-associative montage. In an *analytical montage,* we *analyze* an event as to its thematic and structural essentials and synthesize these essential parts into an *intensified screen event.* In an *idea-associative montage,* we juxtapose two seemingly disassociated images in order to create a third principal idea or concept. Each of these two basic montage categories can be subdivided into two specific types (Fig. 13·31).

Analytical Montage—Sequential: A *sequential* analytical montage juxtaposes the major developmental factors of an event in their *natural sequence,* revealing the cause-effect relationship of an event.

13·31

13·32 First we analyze the actual event as to its major developmental factors.

Actual Event

Developmental Factors

t_1
Beginning

t_2
End

Then we select those factors that proved essential for the development of the event.

DF_1 DF_6 DF_{34} DF_{42}

Then we combine the selected event factors in their original sequence.

New Event Time: t_1

1 6 34 42

t_2

13·33 *As you can see, we have selected only the major cause-and-effect parts of the event. Note that the major part of the event, its major theme "accident," is not even shown but is merely implied. This is exactly one of the main characteristics and strengths of a montage: to imply rather than show the major theme or message of the event.*

13·34 *In this sequential montage, only the major event factors are selected and juxtaposed.*

The sequential montage is timebound; it moves like the original event from t_1 to t_2, from beginning to middle to end—from cause to effect. We *cannot reverse,* or change in any way, the time order of the actual event in the montage. All we do is *condense* the event and thus intensify it. (See two examples of sequential montage in Figures 13·33 and 13·34.)

13·35

To impress upon you the importance of maintaining the natural order of the event in a montage, let's do some switching of the individual montage units. You will probably receive a slightly different message from the montage in Figure 13·35 than from Figure 13·34.

Analytical Montage—Sectional: A sectional analytical montage temporarily arrests the progression of an event and examines the isolated moment from various viewpoints. It shows the various *sections* of an event; it explores the *complexity of the moment.* (See Figures 13·36 through 13·40.)

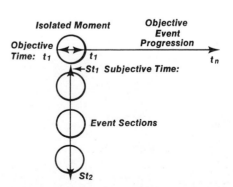

13·36 In a sectional montage, we arrest one specific moment of the event and reveal its complexity. Since we show the complexity rather than the development of parts of the event, we do not move along the horizontal objective time continuum, but rather we move vertically on the subjective (intensity) time line.

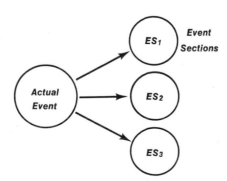

Objectively, we move therefore from event t_1 to event t_1 (one specific moment is shown in a sequence of shots). Subjectively, we progress from st_1 (subjective time) to st_2 (increasing complexity and intensity of the moment).

13·37 *The sectional montage often stresses reaction rather than action. Note how this sectional montage comments on the quality and relative excitement of the lecture by exploring a variety of reactions.*

13·38 *Since we move vertically rather than horizontally in time, the actual sequence of the shots is no longer important. We do not change the basic montage concept by arbitrarily mixing the sequence of the shots.*

13·39 *If we use the sectional montage primarily for emphasizing the complexity of the moment, we may have to go outside the primary event (in which this moment occurs) and show parts of other events that somehow relate to this moment of the primary event.*

13·40 *Through a sectional montage, we can show how past and future events invariably shape the moment of the now.*

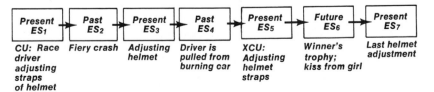

Present ES₁	Past ES₂	Present ES₃	Past ES₄	Present ES₅	Future ES₆	Present ES₇
CU: Race driver adjusting straps of helmet	Fiery crash	Adjusting helmet	Driver is pulled from burning car	XCU: Adjusting helmet straps	Winner's trophy; kiss from girl	Last helmet adjustment

13·41 *Theme: power. A powerful machine is compared to a powerful animal, thus intensifying the basic theme.*

In film and television, the sectional montage is usually presented sequentially, although it explores a single event moment. We show various aspects of one moment in a series of related shots. This sequential presentation of a nonsequential complexity of the moment is quite compatible with the linear structure of film.

The mosaiclike, instantaneous image of television, however, makes a linear representation of the complexity of a single moment less appropriate. As pointed out in previous chapters, the use of multiple screens, each showing one aspect of the complex moment simultaneously, would be much more organic to the medium. The multiple screens would simply extend the mosaic pattern of the single image and reveal the complexity of the moment all at once.

Idea-Associative Montage—Comparison: In the comparison montage, we *compare* seemingly disassociated, yet thematically related, events in order to express or reinforce a basic idea. We compare *similar themes* as expressed in *dissimilar events.* In the comparison montage, we state the

basic theme in the first shot or brief shot series and reinforce this theme in the following shot or shot series. (See Figures 13·41 and 13·42.)

Like most montages, the idea-associative comparison montage is usually presented in a sequence of shots. However, the close thematic relationship makes it possible to compare the two principal montage elements within a single shot. We can, for example, compare the two elements in a superimpose, by panning from one element to another, in a split screen, or simply by having one element succeed the other in a single shot.

Idea-Associative Montage—Collision: In the collison montage, we *collide opposite events* in order to express or reinforce a basic idea (Figs. 13·43 and 13·44). The collision montage generates its *tertium quid* (third something) through *conflict.* In fact, some film theorists have tried to base an entire film syntax on the idea of conflict.[3]

A collision montage usually reminds us of the dualistic existence of man, that is, that we live in the shadow of death and that any process oscillates between the absolutes of beginning and end.

13·42 *Theme: decay. Run-down housing is compared to decaying automobiles.*

You may have noticed that the collision montage represents a *visual dialectic.* The concept of a dialectic in film and television is important, not only to the collision montage, but also to the structuring of the four-dimensional field in general.

What is a visual dialectic? Let's begin by explaining the general concept of dialectic. The ancient Greeks used the dialectical method to search for and, they hoped, to arrive at the truth. Through debate and logical argument, they juxtaposed opposing or contradictory statements and ideas in order to resolve the contradictions in universally true axioms. Much later, the German philosopher Hegel based his whole theory of idealism on a basically simple dialectic: Every being is juxtaposed by a not-being that resolves itself into a becoming. In the spirit of Heraclitus, Hegel considered the ideal as well as the process of life as the result of a continuing "war of opposites."

Specifically, the Hegelian dialectic consists of a *thesis,* which is always opposed by an *antithesis* but which ultimately results in a *synthesis*. This synthesis, then, represents a new thesis. It is opposed by a new antithesis, which again results in a new synthesis. This process repeats itself over and over again, striving, however, closer and closer toward the extremely complex process of the "ideal," an objective spirit, absolute reason. (See Figure 13·45.)

The collision montage is a direct filmic application of the Hegelian dialectic (Fig. 13·46).

Some film makers, such as Sergei Eisenstein, not only used the dialectic as the basic structural and thematic principle of montage, but also as the basic structural system for the whole film. He juxtaposes not only shots in a dialectical manner (colliding basically opposite ideas to create a synthesis, a *tertium quid*), but also scenes and whole sequences. The film itself, then, represents a complex visual dialectic.

Of course, the dialectic is a powerful visual device. Whenever you collide opposites, you deal with high-energy events. You must, therefore, be extremely careful how and when to use the collision montage. If the montage becomes too obvious, you will annoy, rather than enlighten, the sensitive viewer. Collision montage is an aesthetic sledgehammer; use it with great care.

Georg Wilhelm Friedrich Hegel (1770–1831), German idealist and philosopher.

Heraclitus (ca. 540–ca. 480 B.C.), Greek philosopher.

Heraclitus and Hegel were both concerned with finding a philosophy that explains opposites and that unites opposites into a positive process. Heraclitus explained that the inevitable existence of opposites suggests a universal system in which any changes in one direction are ultimately balanced by similar changes in the other. Note the similarity to our vector theory in structuring the two-dimensional field. Hegel, too, sought a system that would synthesize such opposites as ideal and real, general and particular, spirit and nature.

13·43 *Theme: evanescence. A sleek new car is collided with junked cars, thus emphasizing the temporality of man-made things.*

13·44 *Theme: entropy. Here the theme of the impermanence of man is emphasized by colliding young and old in a single shot.*

13·45

13·46

However, you can use the visual dialectic in more subtle ways. Eisenstein, for example, talks about "conflict of graphic directions, conflict of scales, conflict of volumes, conflict of masses, conflict of depths."[4]

The one advantage of the vector theory over the dialectic approach to film and television is that the vectors *need not collide* in order to produce energy. The vector field is more versatile: it *includes* a visual dialectic, but does not depend on it.

Rhythmic Control of Montage One of the most important aspects of a montage is its rhythmic structure. If we simply juxtapose certain shots, we will not necessarily succeed in having the viewer perceive a total structural unit—the montage. He may simply receive the thesis and antithesis elements, but may not be able to perceive the individual montage parts on the all-important synthesis. The control of tertiary motion, the building of a montage rhythm, is therefore one of the most important montage factors. Montage rhythm acts like a rubber band: it holds the individual montage parts together without making them immobile.

How do we structure a montage rhythmically? First, by controlling the length of the individual shots; secondly, by controlling the length of the total montage; and thirdly, by controlling the subjective time, the intensity of the event.

In a montage, we can manipulate tertiary motion in three basic ways: (1) metric control, (2) vectorial control, and (3) thematic control.

Metric Rhythm Control: In controlling a montage *metrically,* we simply induce a tertiary motion beat, regardless of content or existing vector fields within the shots. The basic criterion for manipulating a montage metrically is *shot length* (Fig. 13·47).

Eisenstein eagerly took to the Hegelian dialectic, since it served, not only his aesthetic, but also his political and his own personal aims to have a system that legitimately deals with conflict—that needs conflict for progress. "For art is always conflict," he says, "(1) according to its social mission, (2) according to its nature, (3) according to its methodology."[5] The dialectical theory was, indeed, applied to social conflict quite successfully by Karl Marx, who boldly replaced the Hegelian "idealism" with the more concrete and then-relevant materialism. In his basic theory, he feels that history is nothing but a continuing conflict between economic groups, notably between social classes. He proposed that the thesis, the bourgeoisie (capitalist class), must be opposed by the antithesis, the proletariat (workers), in order to synthesize the two opposing classes into the ideal classless society in which every single member has, theoretically, equal rights.

Karl Heinrich Marx (1818–1883), German writer and social philosopher.

13·47 In a metrically controlled montage, all shots are equally long, or they become progressively shorter. The tertiary motion beat, then, remains even or is accelerated toward the end of the montage.

13·48

Girl running down hill | Girl running on street | Car approaching | CU of girl's face | CU of driver | Driver kneeling near injured girl

The accelerated metrical montage, in which the shots become progressively shorter, is especially effective for the analytical sequential montage (Fig. 13·48).

The beat becomes faster the closer we get to the impending disaster. Just before the accident, we have a series of rapidly pulsating shot flashes.

Vectorial Rhythm Control: In this montage method, the rhythm is dependent upon the vector field in the montage. The criterion for the cut is not the length of the shot (as in the metric method) but the directions and magnitudes of the prevailing vectors (Fig. 13·49).

Thematic Rhythm Control: The cutting rhythm is also determined by the content of the montage, its basic *theme,* the montage story or mood. The line "Look over there!" obviously determines the cut. We show a girl looking "over there" and we follow her action with a shot of the "over-there action."

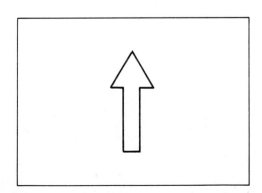

13·49 We cut to the next montage shot when the motion vector within the screen is nearing its completion (object moving out of the screen). We can then cut to a continuing or a converging vector. Often, to amplify the vector magnitude and to energize the whole montage, converging vectors are preferred to continuing vectors. Converging vectors create their visual energy through their opposing directions.

Normally, a combination of all three rhythm controls is used. We may first cut to satisfy the thematic requirements, but then combine the various shots of the montage according to their relative vectors or vector fields, and finally sharpen the rhythm by applying metric control wherever possible.

Metric cutting is, of course, the strongest rhythmic control factor. The viewer will have little trouble identifying and responding to the precise beat of the tertiary montage motion.

The fundamental concept of the montage is *filmic.* This means the montage is a deliberate juxtaposition of fixed event elements, or cells, as Eisenstein calls them, in order to produce a specific effect or energy level. The montage is not organic to the event itself, but represents rather a *synthesized event.* It is a picturization device. This event synthesis is most apparent in the idea-associative montages (comparison and collision) in which generally two disassociated, separate events are juxtaposed to generate a *tertium quid.* The analytical montages (sequential and sectional) are generally based upon the analysis and synthesis of *one event* only. They are, therefore, less of a picturization construct but are more organically event-related than the idea-associative montages.

Live television, on the other hand, generally deals with the progression and change of *one event only.* The precise juxtaposition of several disassociated event elements, as required by the idea-associative montages, is structurally foreign to live television. The only montage that is organic and therefore effective in live television is the analytical sectional montage. For example, we may stretch the duration of the moment by cutting metrically (with an even beat) from action to reaction.

We should realize that the visual montage was extremely important in silent film, where abstract concepts, thoughts, or parts of the event had to be expressed solely by the "tertium quid," the third something that resulted from the montage. There was no dialogue or even scripted music to tell the viewer what exactly was going on, or what the underlying thoughts were in a particular scene. Sergei Eisenstein developed a rather complex theory of film montage, which was designed to show not only the primary theme and action of an event but also its more subtle overtones. Because of their historical importance, we will briefly describe the major types of Eisenstein's filmic montage. You will readily notice that we have borrowed or adapted some of the Eisenstein montage categories for our rhythmic control methods (metric and vectorial, which Eisenstein calls rhythmic). Eisenstein describes five basic methods of montage: (1) metric, (2) rhythmic, (3) tonal, (4) overtonal, and (5) intellectual.

Metric Montage: *The criterion for the metric is the "absolute lengths" of the film pieces.*

Rhythmic Montage: *In the rhythmic montage, the content within the frame is determining the lengths of the pieces. It is the movement within the frame that impels the montage movement from frame to frame. (In other words, graphic, index, and motion vectors lead to the cut and determine the vector field of the total montage.)*

Tonal Montage: *Here montage is based on the characteristic emotional sound of the piece—of its dominant. Tonal montage reflects the degree of emotional intensity. For example, the tilted horizon would be part of a tonal montage, indicating the instability of the scene.*

Overtonal Montage: *The overtonal montage derives from a conflict of the principal tone of the piece (dominant) and the overtones. A comparison or a collision montage would fit into Eisenstein's overtonal montage category. The principal tone of the montage (peace—UN building) is juxtaposed with an overtonal concept (war—A-bomb explosion). An overtonal montage also occurs when the basic montage has more subtle overtones, such as changes in lighting, and the like. For example, the high key lighting of a happy party scene turns into predictive low-key lighting while the party is still going on. Such predictive lighting is one of the aesthetic factors that can turn a tonal into an overtonal montage.*

Intellectual Montage: "*Intellectual montage is montage not of generally physiological overtonal sounds, but of sounds and overtones of an intellectual sort: i.e., conflict-juxtaposition of accompanying intellectual affects.*"[6] *What this means is that intellectual montage is based on the content, the theme, of the scene. The montage is totally controlled intellectually. It requires closure by intellect, not just by emotion or intuition.*

Example: The bases are loaded, and the pitcher is winding up for the all-important pitch. We then may cut rhythmically to the batter, the catcher, the audience, other players, and so on. This type of sectional montage does not violate the natural rhythm of the event, but simply intensifies it. If, however, we build a screen event for television film from several previously recorded events, we can use all types of montages. Again, we must realize that the montage concept is basically *filmic,* that is, a medium-induced, rather than an event-induced aesthetic effect. As such, it does not properly fit the basic requirements of the event-bound live television aesthetics.

So far, we have discussed only the pictorial montage effects, the montage as part of the four-dimensional field. We can, of course, build a montage (especially an idea-associative montage) by juxtaposing specific picture and sound elements. We will discuss the picture-sound montage effects in Chapter 15.

Summary

Structuring the four-dimensional field includes the control of two large areas: *tertiary motion,* which is sequence motion, and *editing,* which means building a screen event. Both processes are part of picturization.

In *visualization,* we are concerned with the control of the vector fields of *individual shots. Picturization* refers to the control of a *succession* of shots, scenes, and sequences.

Tertiary motion, the sequence motion, is determined by the specific use of one or several of these transition devices: the cut, the dissolve, the fade, and special transitional effects.

The *cut* is an instantaneous change from one image to another. The clarification and intensification functions of the cut are (1) to continue action; (2) to follow or establish a sequence; (3) to change locale; (4) to reveal detail; (5) to increase or decrease event density; (6) to show simultaneous events; (7) to interchange past, present, and future events; (8) to establish an event rhythm; and (9) to intensify the screen event.

The *dissolve* is a gradual transition from shot to shot, whereby the two images temporarily overlap. The functions of the dissolve are (1) to provide continuity, (2) to adjust the rhythm of the screen event to the mood or rhythm of the actual event, (3) to bridge large space and time intervals, and (4) to show thematic or structural relationships between seemingly unrelated events.

The *fade* is a gradual appearance or disappearance of a screen image. The fade signals a definite beginning (fade-in) or end (fade-out) of a show, sequence, or scene.

Special transitional effects include the *wipe* and the *defocus effect.* In a *wipe,* the screen image of the new shot seems to push the old one off the screen, either horizontally (horizontal wipe) or vertically (vertical wipe). In a *defocus* effect, the old shot *ends* out of focus, and the new one *begins* out of focus. Its functions are similar to those of a dissolve.

Editing means building a screen event. It consists of combining parts of an event or several events into a single, unified screen experience.

There are two principal ways of editing: (1) *continuity editing,* which concerns itself mostly with the clarification of an event, and (2) *complexity editing,* which deals mostly with the intensification of an event.

In *continuity editing,* these six picturization principles are especially important: (1) continuing index and motion vectors, (2) converging index

and motion vectors, (3) establishing a vector line, (4) ABC cutting, (5) cutting on action, and (6) subject continuity.

In *complexity editing,* a screen gestalt is built from carefully selected event essences. The basic building block of complexity editing is the *montage.* A montage is the juxtaposition of two or more separate event images that, when shown together, combine into a larger and more intense whole.

There are two large montage categories: (1) *analytical montage,* in which an event is analyzed as to its thematic and structural essentials, which are then synthesized again into a larger whole; and (2) the *idea-associative montage,* in which two seemingly disassociated images are juxtaposed in order to create a *tertium quid,* a third something—a third idea or concept. There are two types of analytical montage—sequential and sectional; and two types of idea-associative montage—comparison and collision.

A *sequential analytical montage* juxtaposes the major developmental factors of an event in their natural sequence, revealing the cause-effect relationship of an event. A *sectional analytical montage* temporarily arrests the progression of an event and examines the isolated moment from various viewpoints. It explores the complexity of the event.

The *idea-associative comparison montage* compares seemingly disassociated, yet thematically related, events in order to express or reinforce the event's basic idea. The *idea-associative collision montage* collides opposite events in order to express or reinforce a basic idea. The collision montage represents a visual dialectic, in which an idea is opposed by an opposite idea. Both ideas are ultimately synthesized into a new idea, the *tertium quid.* (This is similar to Hegel's dialectic: thesis-antithesis-synthesis.)

The most important aspect of a montage is its rhythmic structure. The tertiary motion of a mon-tage can be controlled in three principal ways: (1) In *metric rhythm control,* a regular tertiary motion beat is introduced by manipulating the shot length, regardless of shot content. (2) In the *vectorial rhythm control,* the directions and magnitudes of the vectors determine the cut. (3) In the *thematic rhythm control,* the cut is determined by the content of the montage, its basic theme, story, or mood.

Notes

[1] Herbert Zettl, *Television Production Handbook,* 2nd ed. (Belmont, Calif.: Wadsworth Publishing Company, Inc., 1958), pp. 265–267.

[2] From the 1964/65 *Yearbook,* Bolinas School, Bolinas-Stinson School District, Bolinas, California. Mrs. Erika Zettl, teacher.

[3] Sergei Eisenstein, *Film Form and Film Sense,* ed. and trans. by Jack Leyda, in one volume (New York: World Publishing Company, 1957); V. I. Pudovkin, *Film Technique and Film Acting,* ed. and trans. by Ivor Montagu (New York: Grove Press, Inc., 1960).

[4] Eisenstein, *Film Form and Film Sense,* pp. 38–39; and see the section entitled "A Dialectic Approach to Film," pp. 45–63.

[5] *Ibid.,* p. 46.

[6] *Ibid.,* pp. 72–83.

14

The Five-Dimensional Field: Sound

Sound in its various manifestations (dialogue, narration, sound effects, music, and the like) is an integral part of television and film. It represents the all-important fifth dimension in the total structural field of television and film.

In film, sound was considered for some time an *additional* element to an already highly developed, independent aesthetic structure. In television, however, sound has been from the very beginning an *integrated structural* medium element. While today we still speak of silent and sound film, there is no such distinction in television. Unfortunately, the various terms—"film," "motion pictures," "cinema," and "television"—do not incorporate the audio concept. This neglect may have caused some people to believe that sound is either unnecessary or a nonessential adjunct of the visual fields of television and film. Far from it. When dealing with television or film, we must consider sound as essential a structural element as light, space, and time.

In this chapter, we will describe the major aspects of the five-dimensional field: (1) sound and noise, (2) television and film sound and their functions, (3) literal and nonliteral sound, (4) descriptive and abstract sounds, and (5) elements of sound.

Sound and Noise

Before we begin to distinguish the different manifestations and types of sound, we should briefly define what we mean by sound in general. Both sound and noise are audible vibrations (oscillations) of the air.

The distinguishing factor between sound and noise is *communication purpose.* Sound has purpose; it is organized. Noise is random. The identical vibrations can be sound at one time, noise at another. Let's assume, for example, that there is a big crash while you are reading. You run to the window, or outside, to see what is happening. The crash is *noise.* It happened unexpectedly, and it interrupted your activities. It did not fit the pattern of your activities.

Now, let's assume that you have a recording of this crash. You are working on your soundtrack. Your story shows a car running a stoplight and crashing into another car. At the precise moment of impact you use the recording of the crash. The original crash noise has become a *sound.* The crash sound now fulfills an important function within the structure of your film. It has purpose. Similarly, what we usually consider to be beautiful sound, such as a Bach fugue, can become noise if it does not fit into the pattern of your activities. Let's assume that you are trying to think of an appropriate musical theme for your television show. You have all sorts of melodies floating around in your head. When you are just about ready to write one down, your neighbor starts practicing his Bach. Bach has now become noise. Within the present context, it lacks purpose. In its randomness, it works against your planned activities.

Even silence can become noise or sound. When we encounter a close-up of the announcer and we only see, but do not hear, him speak, the resulting silence is actually noise. But if we follow the exclamation "Listen, somebody is coming!" with a period of silence, the silence fulfills its communication purpose; it has become sound.

In the following discussion, we assume the audible vibrations to be *sounds* rather than noise; that is, they are purposeful at all times.

Television and Film Sound

Although television sound and film sound are both used to make the intended communication more effective, they can, and often do, differ in their communication importance and structural application.

Television Sound Sound is essential to television. First, sound is all around us. In the normal course of our activities, we use sound constantly to function properly within our environment and to make our environment function for us. If television is to reflect this reality, or if it is to clarify and intensify reality, we cannot ignore sound but must use it as one of our primary communication factors.

Second, sound is often needed to supply additional information and especially structural unity to the low-definition, inductively arranged visual information. Sound helps the viewer to apply psychological closure to the individual low-definition images, as well as the sequence of images in order to arrive at the intended communication gestalt, the total screen event. Although television has been considered primarily a visual medium, the visual portion of a television program carries generally less information than the audio portion. Just try to follow a television show by watching the pictures alone. It will be very difficult for you to understand what's going on. But you will have little trouble keeping abreast of the screen happening by listening to the audio portion only. Normally, television audio has a higher information density than television video.

Why, then, do we not have better television audio? Because it is difficult to achieve good television sound. (1) In most television shows, the sound is picked up simultaneously with the pictures. In live television, we cannot treat sound separately from the visual portion of the event. Even in television recordings, sound and pictures are usually recorded together. Television production methods normally do not permit postdubbing of sound, as in film. (2) The simultaneous audio-video pickup means that all sound sources must be covered with microphones, whether the sound source is stationary or moving. Additionally, most television events require the microphone to be kept out of the picture. (3) In the construction of television studios, acoustics are usually considered last, if at all. The high ambient noise level during most television productions often cannot be separated from the planned sounds; all sound is amplified equally. (4) The sound reproduction systems in most television receivers are hopelessly inadequate. The small speakers are severely limited in their frequency response and are often ill-placed relative to the usual viewer-listener position.

The major problem of bad television sound, however, is not so much a technical problem as our current failure to demonstrate forcefully the aesthetic necessity for good television sound. Most often, we are satisfied as long as something comes out of the television speaker that is halfway intelligible. And we go right back to worrying about the extremely complex visual processes. Should you, therefore, pay less attention to the pictures, which are low-definition anyway, and concentrate more on television audio? Not necessarily. But be careful to avoid the traditional trap of considering television primarily a *visual* medium. It is an *audio-visual medium*. You should judge the relative importance of video or audio in the context of the total screen event. If the messages are primarily visual, pay more attention to the television pictures; if the messages are primarily aural, concentrate on the sound.[1]

Film Sound In contrast to television, which was born as an audio-visual medium, film learned to talk much later in its development. When sound was finally added to film, its visual aesthetics had **been** firmly established and highly refined. It seems quite natural that for some time respectable film theorists believed that sound was a detriment, rather than an asset, to the art of the film.[2] Film, then, was a *visual* medium, and sound was a foreign element that did not always fit the established visual communication syntax. Pudovkin recognized clearly the basic problem of *adding* sound to a tightly structured visual field: "Usually music in sound films is treated merely as pure accompaniment, advancing in inevitable and monotonous parallelism with the image."[3]

Although film has long since changed from a visual to an audio-visual medium, the visual field still remains for some film makers and theorists in a dominating position. As Kracauer points out, ". . . the medium calls for verbal statements which grow out of the flow of pictorial communications instead of determining their course. Many film makers have accordingly de-emphasized speech."[4]

The high-definition visual film image and the deductive sequential structure (moving from the overall event to its details) are well suited to tell part of the story pictorially. The sound can be casual, the dialogue embedded in visual contexts.[5] There is no need to duplicate with sound what the picture can tell by itself. But when the film is shown on television, the large, high-definition film pictures are reduced to small, low-definition television images. If shot for the wide screen, the camera point of view and the sequential structure of the film images do not entirely fit the new space-time aesthetics of the small television screen. Worse, the film sound, which grew out of the visual context of the film, is no longer adequate to fulfill all the informational and structural sound requirements for television.

Siegfried Kracauer (1889–1966), film theorist and author.

In film, when the dialogue stops, the pictures usually continue with the story-telling. When shown on television, however, the picture often is no longer adequate to carry the story. With no dialogue to help the communication, we become conspicuously and uncomfortably aware of the long pauses between the film speeches. The film dialogue, as natural as it may appear in conjunction with the wide-screen images, appears slow and spotty on television.

Nevertheless, in film, as in television, we must consider sound as an integral aesthetic element, not as an entity separate from the visual. Again, the ultimate criterion for the use of sound is the ultimate communication aims of the total screen event. Pictures and sound must be used in such a way that they modify each other into a balanced, clarified, and intensified total screen event.

Technically, film sound is generally of high quality. In most films, the sound track is recorded separately from the picture. Thus, we have full control over the quality of the soundtrack. We can rerecord and remix any portion of the soundtrack, including parts of the dialogue. Only when sound and pictures are properly manipulated and prepared are the two elements "married," that is, printed together on one film (referred to as answer print).

The sound reproduction equipment in the motion picture theater is also of high quality. High-fidelity amplifiers and speaker systems assure optimum reproduction quality of the sound track.

Functions of Television and Film Sound Specifically, we need television and film sound to fulfill three important functions: (1) to supply essential or additional information, (2) to establish mood and aesthetic energy, and (3) to supplement the rhythmic structure of the screen event.

To Supply or Add Information Generally, we can say things more quickly and accurately than

we can show them. In our verbally oriented society, a word is often worth a thousand pictures. Just try once to communicate with pictures such concepts as justice, freedom, grammar, process, efficiency, learning. Or, try to express nonverbally this simple communication act: telling a friend over the telephone that he should meet you at the library next Wednesday, at 9:30 A.M. It would probably take a considerable effort to communicate such a message solely through pictures. How much simpler it is to show someone telephoning and to deliver the message verbally through the soundtrack.

The relatively precise meaning of words and the established way of using them make the verbal language an extremely flexible and efficient medium of communication. A few words can tell the viewer immediately where the event is taking place, what has happened before, what might happen in the future, and what the situation is all about.

Words can also readily supplement the visual message, provide the appropriate context for it, or comment on it. The more conceptual the messages become and the more we move away from concrete percepts, the more we must rely on verbal language. Any television or film event that probes with some fidelity into the subtle complexities of our thoughts and ideas cannot function with pictures alone; it must resort, at least partially, to verbal communication.

To Establish Mood and Add Aesthetic Energy Sound helps to establish the emotional context, the mood of the event. Happy music can underscore the overall happy context of a screen event; sad or ominous music will do the opposite. Even if the visual part of the scene expresses a neutral or positive atmosphere, the accompanying ominous music will override the visual clues and forewarn the viewer-listener of the impending disaster. (*Example:* Happy cowboy riding innocently through the sun-drenched valley; tympani roll and dis-

sonant staccato chords signaling the upcoming danger.)

Music or other sound effects (such as electronic hisses, whistles, and whines) can supply additional aesthetic energy to the video portion of the event. Cartoons, for example, rely heavily on music and sound effects as an energy source. There is no such thing as the villain simply plunging into the ground. He is literally driven into the ground by the accompanying sound effects.

To Supplement the Rhythmic Structure By itself, the rhythmic structure of the visual vector field is often not precise or conspicuous enough to hold the various picture elements together and to make the viewer perceive the individual shots, scenes, and sequences as a visual whole. (See Figures 14·1 and 14·2.)

14·1 Sound rhythm can act as an important structural element for visual continuity. The sound rhythm acts like a clothesline on which we can "hang" a variety of visuals without losing continuity.

When sound and picture rhythms parallel each other, the total structure becomes unified and stable. We must be careful, however, that the beat does not become too regular for too long a period of time, otherwise the total rhythmic structure will become monotonous and boring. We should then vary the beat by shifting the beat either of the pictures (tertiary motion) or of the accompanying sound.

14·2 By using picture and sound rhythms contrapuntally, we can increase the complexity of the screen event without impairing its clarity.

Music and other sound effects have been used as energizing elements throughout the performing arts. The chanting of the chorus in a classical Greek play was supplemented and energized by the sound of flutes. There is hardly a modern play that does not make heavy use of recorded music and various sound effects. The Moog synthesizer has become an indispensable creative tool for the advertiser who seeks maximum intensification of his commercial message.

Literal and Nonliteral Sound

Literal Sound Literal sound is *referential sound.* The sound itself is less important than what it stands for. Obviously, all types of speech (dialogue, narration, and direct address) belong to the literal sound category. The spoken word stands for a specific referent; it conveys a specific meaning.

Other literal sounds work very much the same way. If we hear the sound of a baby crying, we immediately associate the sound with the actual event: a crying baby. We mentally picture some form of traffic when we hear traffic noises and a car horn. In other words, we immediately associate the literal sound with its referent, the event that contains the sound-originating source.

Literal sounds create a literal imagery only if their symbolism has been learned, that is, if we can immediately associate the sound with its originating source. If someone has never heard the sound of a jet airplane, we cannot communicate the image of a jet plane by sound alone. When using sounds to supply a literal context (such as traffic), we must make sure that the recipient is familiar with their origin; otherwise, the sound will fail to convey literal meaning. We will now discuss two major aspects of literal sound: (1) types of speech and (2) orientation functions.

Types of Speech Three types of literal sound are used most often in television and film speech: (1) dialogue, (2) narration, and (3) direct address.

Dialogue means a conversation between two or more persons. We also speak of dialogue if one person is speaking while the other is listening, or even if one person speaks to himself. Since thinking out loud is actually conversing with oneself, we call it *internal dialogue.* If the conversation is directed toward someone else, we have *external dialogue.*

Dialogue is the chief means of conveying what the event is all about (theme), of developing the story progression (plot), of saying something specific about the people in the story (characterization), and of describing where, when, and under what circumstances the event takes place (context).

Most importantly, we use dialogue to delineate specific characters. The way a person speaks tells a great deal about his general behavior, how he relates and reacts to other persons and specific events. Well-written dialogue gives the viewer some clues as to how the specific character might behave in a specific situation.

Good dialogue seems to come naturally. It often sounds like a tape recording of a randomly observed conversation. As most writers will confirm, however, good dialogue is anything but mirrored reality. On the contrary, good dialogue is usually a carefully *constructed speech pattern* that, in the end, *sounds and feels natural.*

To achieve such a naturally sounding speech pattern, we must see to it that the speech characteristics of the individual characters fit the general event context. In other words, we must make sure that the characters' speech reflects who they are, where they are, what they are doing at what specific time, and how they feel even if all this may not be reflected in the script. Table 14·1 may give some idea of how the context influences the major dialogue variables in the creation of a character.

This table shows only the most basic structural relationships between context and speech patterns. Good dialogue must, besides describing a general personality type, be able to characterize the uniqueness of a *specific individual.*

The important thing to watch in dialogue is that it operates within a fairly consistent pattern. An undereducated laborer who works in a remote Southern farm region cannot suddenly switch to a brand-new vocabulary set, simply because he finds

Table 14.1 Context and Dialogue Variables

Context Variables		Dialogue Variables		
Type	*Examples*	*Word Choice*	*Sentence Structure*	*Rhythm*
Education	High	Wide vocabulary range	Precise syntax	Lucid, fluid
	Low	Limited vocabulary	Double negatives, etc.	Hesitant, uneven
Occupation	Special	Specialized vocabulary depending on occupation	Involved, depending on occupation (lawyer, college professor)	
	General	General vocabulary		
Region	Country	Country-flavor dialect	Simple	Relatively slow
	City	Specific city slang		Fast
	Geographic	Southern, Eastern, etc.		South: legato; East: staccato, etc.
Locale	Office	Formal, businesslike	Precise syntax	Fast
	Bar	Informal	Mixed, relaxed structure	Uneven
	Courtroom	Extremely formal	Highly formal and involved	Precise, even
Time	Period	Vocabulary depending on period (century)	Old language structure	
	Morning		New language, simpler	Faster
	Night			Slower
Partner	Friend	Familiar, less formal	Informal	Relaxed
	Stranger	Formal, general	Formal	Uneven
	Superior	Formal	Formal	
	Inferior	Less formal	Less formal	
Situation	Familiar	Common words	Short, relaxed	Even
	Unfamiliar	Formal	Precise	Uneven
	Emergency	Essential words only	Incomplete	Uneven (staccato)
Attitude	Calm	Large vocabulary	Fairly precise	Even, flowing
	Excited	Limited vocabulary	Less precise	Fast, staccato
	Tense	Limited vocabulary	Short	Staccato
	Hysterical	Often nonsensical	Illogical	Uneven

Samuel L. Clemens comments on such literary pitfalls in constructing dialogue in his delightful essay on Fenimore Cooper's Literary Offenses.[6] He accuses Cooper of having violated in Deerslayer *eighteen of the nineteen rules of literary art. Of the eighteen literary requirements, these three are of special interest to us:*

"They [rules governing literary art] require that when the personages of a tale deal in conversation, the talk shall sound like human talk, and be talk such as human beings would be likely to talk in the given circumstances, and have a discoverable meaning, also a discoverable purpose and a show of relevancy, and remain in the neighborhood of the subject in hand, and be interesting to the reader, and help out the tale, and stop when the people cannot think of anything more to say. . . ."

And:

"They require that when the author describes the character of the personage in his tale, the conduct and conversation of that personage shall justify said description. . . ."

"They require that when a personage talks like an illustrated, gilt-edged, tree-calf, hand-tooled, seven-dollar Friendship's Offering in the beginning of a paragraph, he shall not talk like a Negro minstrel in the end of it. . . ."

Here is how Clemens introduces a dialogue example from Cooper's Deerslayer: "In the Deerslayer story he lets Deerslayer talk the showiest kind of book-talk sometimes, and at other times the basest of base dialects. For instance, when some one asks him if he has a sweetheart, and if so where she abides, this is his majestic answer: 'She's in the forest— hanging from the boughs of the trees, in a soft rain—in the dew on the open grass—the clouds that float about in the blue heavens—the birds that sing in the woods—the sweet springs where I slake my thirst—and in all the other glorious gifts that come from God's Providence!' And he preceded that, little before, with this: 'It consarns me as all things that touches a fri'nd consarns a fri'nd.' "

himself talking to a judge. Although he might now be trying to speak more formally than when in the company of his fellow workers, he simply cannot switch all of a sudden to the involved language of the court. For example, once we have established a character by such lines as: "Can't blame those folks none; they ain't got no money" or "I really don't know nothin' about it," we cannot suddenly have him use sentence structures such as "Everybody went to *his* room," or such vocabulary as "I begged him several times to leave the premises, but he didn't heed my warnings."

Similarly, a person under strong duress will most likely communicate in staccato phrases rather than in long, complex sentences that are made up of choice words.

Generally, dialogue also helps to set the *style* of the performance. The words the characters choose, and the way they use them, often determine their actions. In fact, the structure of the four-dimensional field, that is, the tertiary motion and cutting rhythm, as well as the performance rhythm, speed, tempo, and overall pace, is closely connected to, if not dependent upon, the rhythmic requirements of the dialogue.

Also, the dialogue determines to a great extent just how the scene should look. The dialogue is one of the most important contextual factors that determine visualization as well as picturization.

When using *internal dialogue,* we should make sure that we leave enough pauses for the other, unheard, part of the dialogue. If we run the audible portions of the dialogue too close together, it becomes more of a narration than an internal dialogue. The character has to talk as well as *listen to himself* when engaged in internal dialogue.

Narration can be on- or off-camera. It is basically used to supply additional information. In an on-camera narration, the camera *observes* a narrator who describes a scene. For example, if we re-create a television remote pickup of a football game, we might show the sportscaster on camera, giving a play-by-play description of the game.

Most often, narration is *off-camera.* In some cases, the voice-over-narration advances the plot. The narrator simply tells how the story progresses over a transitional visual scene. In newsfilm or documentaries, the narrator describes the event details that cannot be communicated visually. Beware, however, of having the narrator explain what can plainly be seen. If the screen shows a previously identified official climbing out of his limousine, do not have the narrator parrot: "And now, Chairman Hyde is stepping out of his limousine." Such redundancy does not eliminate communication noise; it causes it. Depending on how informative the pictures are, either much or little narration is needed. Generally, television needs more narration than film. Obviously, the narration must match the style and general mood of the video event. The narration must be integrated into the video portion so that it appears as an *organic* part of the whole screen event, not as an unfortunate adjunct.

As you know, it is not uncommon in television for the performer to *speak directly* to the viewer. The viewer no longer remains a passive observer, but becomes part of the event. He is enticed to participate in, rather than simply witness, a communication process.

Television is ideally suited for such a direct-address method. Most people watch television in the most familiar surroundings possible, their homes. The television performer appears to be a visitor who drops in for a little chat, to tell us what is new, or what is a good bargain in the neighborhood. If he visits often, we get to know him quite well. We get to know his mannerisms, his way of speaking, his style. He becomes part of

our household, our daily routine. And, after a while, he may be so familiar to us that we begin to get tired of him.

Many a performer makes the mistake of addressing his viewers as "the people out there." This is unfortunate. The viewer is anything but "out there." Rather, he is very much *in here,* his home. If anyone is "out there," it is the performer. A skilled performer, therefore, realizes that he is a *guest* in someone's home. He is courteous and low-key in his direct-address communication. There is no need for shouting; the person he addresses (the viewer) is only a few feet away from him. And tuned in on him.

The television viewer is usually alone or in company with somebody he knows quite well. The performer, therefore, is not addressing millions of people but only one or two. (Though he may ultimately *reach* several million people, he should nevertheless *address* only one or two.)

As viewers, we are doing the inviting. If we do not want to have the performer drop in on us, we simply keep the door closed, that is, the set turned off. But once the set is turned on, our predisposition for receiving the performer in our home is already quite favorable. We are ready to listen.

As a performer, you should take advantage of the viewer's readiness to listen and converse with you. Try to involve him in a conversation, even if it is only you, the performer, who is doing the talking. Anticipate the viewer's internal response and react to it. Try to establish a *dialogue* between you (the performer) and the viewer.

If, of course, your job is simply to transmit a fair amount of new information, such as in a newscast, the conversational approach is not the most efficient or even the most effective. Since the viewer is primarily interested in learning what is new, *tell* him. Do not make him work for it.

In *film,* the direct-address method is much less successful than in television, if not aesthetically wrong. In movies, Marshall McLuhan quite rightly observes, "We roll up the real world on a spool in order to unroll it as a magic carpet of fantasy."[7] We go to the movie theater, take our place along with other people in an auditorium, and wait until the opening curtain reveals a construct of high-definition images—a reconstructed world to *dream by.* We want to *look at* or be *engulfed by* the images of film but we have little inclination to participate in the screen event. As spectators, we want to remain anonymous. We become, therefore, quite annoyed if the dream image on the movie screen all of a sudden addresses us directly. We feel discovered—caught in the act of dreaming. We are no longer anonymous, and we are challenged to participate in the communication process. Worse yet, the film hero has become mortal, a psychological equal. We are subjected to the painful experience of hearing the emperor admit that he is, indeed, naked.

Orientation Functions of Literal Sound Literal sounds supply us general information and help us to orient ourselves in space and time and as to specific events. Literal sound often works in accord with the orientation functions of light.

Spatial Orientation: Literal sound can help us to reveal where the event is taking place. If, for example, we accompany the close-up of a girl with literal sounds of the outdoors—birds singing, the rustling of a brook, the crowing of a cock, and the like—we immediately place her somewhere in the country. There is no need for a cumbersome establishing shot; the literal sounds will take over this orientation function. Now think of the same close-up as accompanied with sounds of typical downtown traffic: car horns, automobile engines, trucks, people walking, the policeman's whistle, the patrol car's siren. Obviously, she is no longer in the country but has been transferred to the city merely by the power of literal sound.

The use of literal sound for spatial orientation is especially important in television, where we often work with the visual shorthand of close-ups.

Time Orientation: Through literal sound we can also help to tell the viewer what time it is. There are typical sounds that we associate quite readily with morning, noon, evening, night, winter, summer, and so forth. Morning: alarm clock, shower, coffee maker, and the like. Outdoors: the morning noises may include the newspaper being delivered, somebody having trouble getting his car started in the cold morning air, the bus pulling up, the milkman. An evening or night in the country has the inevitable cricket sounds, the rustling of the evening breeze in the trees, the distant barking of a dog, or the subdued voices and laughter coming from the neighbors. At night, we can add the hooting of an owl for good measure.

Situational Orientation: Dogs barking madly outside will indicate that someone is coming, although the visuals may show an interior only. Even if we stay on a close-up of the stoic face of the chief surgeon, the sound of irregular breathing will indicate that the patient is not doing too well. A baby crying in the next room or the muffled noises of an intense argument filtering through the wall will give precise information about a specific event, even if it is not actually shown.

Sometimes, we can use literal sound to prepare the audience for an upcoming event. For example, we can indicate the imminent danger or the inevitability of a forest fire by sneaking in very gradually the sound of fire sirens while the video still lingers on the carefree campers preparing to cook their freshly caught trout.

When using literal sounds as an orientation device, make sure that they correspond to the other orientation clues, such as light, camera viewpoint, and the like. The sound effect of rush-hour traffic does not fit the occasional automobile that is violating the quiet and emptiness of the midnight main street. And the extreme long shot of a lonely cowboy riding through the empty plains should not produce the close-up clickety-clack of the horse's hoofs. Such video-audio discrepancies are perceived, not as energizing counterpoints, but simply as mistakes.

Nonliteral Sounds Nonliteral sounds have no literal meaning. They do not refer to the sound-emitting source in any way. Rather they *describe* or *evoke* a specific *image* or *feeling*. For example, the howl of a coyote as literal sound denotes the animal itself; as nonliteral sound it suggests loneliness or danger. The most common form of nonliteral sound is, of course, music. We can use nonliteral sound in two basic ways: (1) as *descriptive* nonliteral sound and (2) as *abstract* nonliteral sound.

Descriptive Nonliteral Sound Typical descriptive nonliteral sounds are the "boings," hisses, and whams in a cartoon that accompany the incredible feats of the cartoon characters. When someone bounces along like a giant rubber ball, the "boings" *describe the feeling* of the bounce; they underline the essential visual action. The principal visual vectors are supported by similar audio vectors.

Descriptive nonliteral sounds describe a certain quality or event. They not only give an idea of what a thing or event looks like, but also communicate a *condition* of a thing or an event.

If we used literal sounds to describe a large leak in the ship's engine room, for example, we would probably hear the rushing and gurgling of the water, the engine sounds, the excited voices of the sailors, the clanging of tools against the metal hull. Expressed in nonliteral sounds, we may use some thumping noises that get the more

"squeezed" the higher the water rises. Or we may use music that rhythmically and harmonically reflects the rushing and rising water, the desperate pounding of the engines, the confusion and panic of the crew.

Most often, literal and nonliteral sounds are mixed. Thus, you can describe the *actual event* as well as the *condition* of the event. *Examples:* Footsteps of man running and traffic sounds (literal sounds); fast music to describe the running and excitement of the fleeing person (nonliteral sound). The sound mixture communicates what the event is and how it feels. It "shows" the outside and the inside of the event simultaneously. At least, the literal plus descriptive nonliteral sound combination will increase the magnitude of the screen event's total vector field. The quiet hum of an elevator is often not strong enough to dramatize the speed with which the people are catapulted to the forty-fifth floor, for example. Fast, ascending music will help greatly to evoke in the audience the feeling of a fast elevator ride. The descriptive nonliteral sound lifts the audience to the upper floors more readily than either the quiet hum of the actual literal sound alone or the lighting up of the floor numbers.

Sometimes, you may find it quite effective to use sound effects to describe a particular event and then *segue* (the juxtaposition of two separate audio elements without a noticeable break—similar to a video cut) or *cross-fade* (the simultaneous fading out of one sound element and fading in of another, whereby both elements temporarily overlap—similar to a video dissolve) to similarly descriptive music. Or you may want to switch from descriptive music to sound effects. What comes first depends entirely on the total aesthetic demands of the event and your personal preference, your style.

From the following list, choose some factors and try to "listen" to them. Then pick nonliteral sounds (sound effects or music) that best describe each selected item.

Space	Variable
Distance	far, near, infinite
Size	small, large, inflated, huge, microscopic
Shape	regular, irregular, round, square, jagged, slender, fat, wide, narrow
Height	high, tall, low, short
Volume	large, small

Time	
Seasons	summer, autumn, winter, spring
Clock time	high noon, morning, evening, dusk, dawn, night
Subjective time	boring, fast, exciting, accelerated
Motion	fast, slow, dragging, graceful, clumsy

Light	
Sun	bright, overcast, strong, weak
Moon	soft, brilliant
Searchlight	moving, blinding
Car headlights	passing, approaching, blinding
Color	(see color, Chapter 3)

Quality	Variable
Weight	heavy, light, unbearable, shifting, increasing
Texture	rough, smooth, polished, coarse, even, uneven
Consistency	hard, soft, spongy, solid, fragile, dense, loose
Temperature	hot, cold, warm, cool, heating up, cooling down, freezing, glowing
Personality	stable, unstable, cheerful, dull, alive, sincere, insincere, powerful, rough, effeminate, masculine, weak, strong, pedantic, careless, romantic, moral, amoral
Feeling	funny, tragic, sad, frightened, lonely, panicky, happy, solemn, anxious, loving, desperate, hateful, sympathetic, mean, suspicious, open, guarded

Event

Sports, church service, graduation ceremony, thunderstorm, political campaign, funeral, death, birth, love-making, running, cars in pursuit, and so on

Well-known examples of program music are: Debussy's La Mer (La Mer et Trois Images), *which imitates the restless sounds and movements of the sea; Honegger's* Pacific 231, *which describes the journey of a specific train; Moussorgsky's* Pictures at an Exhibition, *which tells the story of somebody's visit to an art gallery; and Respighi's descriptive orchestral suites,* Fontana di Roma (Fountains of Rome) *and* Pini di Roma (Pines of Rome).

Claude Debussy (1862–1918), French composer of impressionistic music.

Arthur Honegger (1892–1955), Swiss-French composer, closely associated with the movement of modern French music in the first half of the twentieth century.

Modest Petrovich Moussorgsky (1839–1881), Russian composer known for what was then called "realistic" songs, which dealt with the "common people."

Ottorino Respighi (1879–1936), Italian composer, known especially for his operas and ballet music.

The leitmotiv is usually credited to the German composer and poet Richard Wagner (1813–1883), who used the leitmotiv extensively in his operas. But the leitmotiv had been used long before Wagner by many composers, notably by W. A. Mozart in his opera Così fan tutte *and by Carl Maria von Weber in his opera* Der Freischütz.

Wolfgang Amadeus Mozart (1756–1791), German-Austrian composer.

Carl Maria von Weber (1786–1826), German composer, especially noted for his operas.

Music that is used primarily to describe an event or a specific mood is called *program music.* Long before film or television came on the scene, many composers used program music to tell a particular story. These "songs without words" or "tone poems" have now become an almost indispensable communications element in radio, television, and film.

Descriptive, nonliteral sound is often used as a *theme.* A theme describes the basic type of program (crime show, western, situation comedy), the general mood, and the specific style of presentation of a specific show. A good opening theme immediately provides the specific emotional context for the event. It tells the audience whether they are expected to laugh most of the time, to cry, to feel nervous, reassured, or deeply moved. The theme also provides continuity for the individual programs of a series.

Most often, the theme is a short musical composition, or a series of specific sound effects, or a combination of both. Sometimes literal sound effects, such as police sirens or the mooing of cows, are mixed into the musical theme to make sure that the audience will get the basic idea of the show.

The theme introduces the program, and frequently closes it, or indicates the beginning or end of show sequences. A theme can also provide the necessary continuity during commercial breaks.

A very specific application of nonliteral, descriptive sound is the *leitmotiv* (German for "leading motif"). A leitmotiv is a short musical or sound effect phrase that, like a name, denotes a specific person, object, event, or idea. Its basic dramatic function is that of allusion (reference).

Like the bell that caused Pavlov's dog to salivate, the leitmotiv "leads" the audience to perceive readily a specific recurring phenomenon. For example, if we hear a whistle every time somebody is murdered, we will expect the murderer to strike again, even if the story as told by the screen images does not by any means reflect the impending disaster. Like predictive lighting, the leitmotiv often acts as predictive sound.

Expressive Nonliteral Sound Expressive nonliteral sound does not tell a story or describe a thing, idea, or event. Expressive sound, like colors, evokes a specific feeling, a specific mood. We do *not associate* expressive sound with some other event or a specific feeling; expressive sound *creates* a feeling. Expressive nonliteral sounds are pure audio vectors: sound forces with a specific magnitude and direction (progression, rhythm). Any "pure" musical composition, such as a prelude and fugue by Johann Sebastian Bach or an instrumental by a rock group, belongs in the category of abstract nonliteral sound.

The basic function of expressive nonliteral sound in television and film is to evoke directly a specific feeling from the audience or to set a mood, which may or may not be reflected in the video portion, or to act as an aesthetic catalyst or energizer in combination with the visual images (Fig. 14·3). Expressive nonliteral sound is also used to establish or emphasize the basic rhythm of the scene or to mirror aurally the visual complexity of a shot or a sequence of shots.

The ways of producing effective descriptive and expressive sound structures are too numerous and complex to be discussed adequately within the scope of this book. You should consult some of the readily accessible books on musical form and composition.[8] Nevertheless, you must have some idea about the basic sound elements and their fundamental musical structures, especially if you want to use pictures and sound together in creating an effective video/audio (V/A) gestalt.

14·3 We can use the melodic line and/or the rhythmic beat of expressive nonliteral music, like rubber bands, to hold certain shot elements or shot sequences together so that they can be perceived as a flexible, yet unified whole.

Or we can syncopate sound and pictures to create additional tension. We will discuss such contrapuntal video-audio structures more extensively in Chapter 15.

14·4 You can recognize the pitch of a tone by its relative position on the staffs.

Elements of Sound

When we strike a single piano key, or pluck a single guitar string, we can detect five distinct sound elements: (1) pitch, (2) timbre, (3) duration, (4) loudness (dynamics), and (5) attack-decay.

Pitch Pitch indicates the *highness* or *lowness* of a sound measured against an agreed upon scale. The pitch of a tone is perceived and measured by its frequency, that is, vibrations per second. A high-pitched tone vibrates with a higher frequency than a low-pitched tone. The generally accepted pitch standard for voice and instruments is the A above middle C, called A prime (A′), which has a frequency of 440 vibrations per second (Fig. 14·4).

Timbre Timbre (rhymes with amber) describes the *tone quality* or tone color. The timbre of a tone tells you whether it is produced by a clarinet or a violin. Technically, the timbre of a sound is determined by the amount and complexity of overtones. An overtone is a tone that vibrates "over" the fundamental pitch of the tone (Fig. 14·5).

14·5 The fundamental tone and its basic pitch are given by the vibration of a string (or air column) in its full length. The string vibrates as a single unit.

More often, however, the string also vibrates in separate sections. For example, if each half of a string vibrates separately, the overtones produced are an octave higher than the fundamental tone.

The string can also vibrate in three or more equal parts, each division producing a different set of overtones.

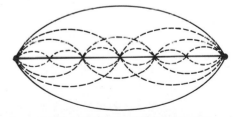

Since overtones vibrate as partial frequencies of the original tone, the overtones act as harmonics (octaves, fifths, and the like) of the basic tone. Sometimes harmonics stand for the combination of the basic tone (fundamental pitch) and its overtones (partial frequencies sounding in combination with the basic tone frequency).

Some instruments, such as the flute or trumpet, produce less complex sounds (fewer overtones) than others, such as the violin or cello (more overtones). A rich, full sound has many overtones. A soft, thin sound usually has few overtones. The human voice has generally more overtones than most instruments.

Duration Duration refers to how long a sound lasts (Fig. 14·6). We may perceive very short bursts of a tone, or a rather long, continuous one. Generally, short bursts of sound, like a series of short shots, produce a fast beat, an up-tempo feeling. A long, continuous tone may become boring to the point of irritation. (See Figure 14·7 and 14·8.)

14·6 *The duration of a tone is precisely determined by a specific notation symbol. You may want to use the customary musical duration symbols to script the duration of your film. For example, you could give the film editor precise instructions of how to cut an accelerating metric montage by translating musical notations into shot times or number of frames.*

14·7 *Metric montage 1.*

14·8 *Metric montage 2.*

Loudness (Dynamics) The loudness of a tone is its apparent strength as we perceive it. You can play a note of a certain pitch and timbre either loud or soft. The variations of perceived strength are the *dynamics* of a sound.

f = forte (loud)

ff = fortissimo (very loud)

p = piano (soft)

pp = pianissimo (very soft)

14·9

14·10 *In a fast attack, the sound gets loud quickly; the rise time is short (a). In a slow attack, the sound takes a while before it reaches the desired loudness; the rise time is long (b).*

14·11 *In a fast decay, the sound dies quickly (a). In a slow decay, the sound fades more gradually (b).*

Attack-Decay The attack or decay of a sound is part of its dynamics and duration (Fig. 14·9). *Attack* means how fast a sound *reaches* a certain level of loudness (Fig. 14·10). The time it takes for the sound to reach the desired maximum loudness is sometimes called "rise time." *Decay* means how fast it fades from a certain level of loudness to where it can no longer be perceived (Fig. 14·11).

The sustaining pedal on the piano, for example, controls the decay of the sound. When you press the pedal, the sound takes more time to fade; the pedal stretches the decay. The damping pedal shortens the decay; the tone dies more quickly. Actually, the decay is also influenced by the acoustics of the room. In a fairly "live" acoustical environment, the decay is slower (more reverberation) than in a rather "dead" environment (few reverberations).

Fast Attack:
High-Magnitude
Motion Vector

Slow Attack:
Low-Magnitude
Motion Vector

Fast Deceleration:
High-Magnitude
Motion Vector

Slow Deceleration:
Low-Magnitude
Motion Vector

14·12 *For example, an object that accelerates to a specific speed quickly produces a fast-attack motion vector; if it accelerates more gradually, it has a slow-attack motion vector. If its motion decelerates relatively quickly or slowly, its motion vector displays a fast or slow magnitude decay.*

The attack and decay factors of a sound are especially important for new electronic instruments, such as the Moog synthesizer, where the attack and decay dynamics of a sound can, and often must, be preset. As soon as the sound is activated, it automatically assumes specific modes of attack, loudness, and decay. In synthesizer terminology, a sound mode including attack and decay is called an "envelope."

The attack and decay dynamics of sound become especially important if we want to parallel the sound vectors with the vectors of the visual field. A visual vector can also reflect a variety of attack and decay modes, depending on how fast the visual vector reaches or loses a specific magnitude.

Each of these basic sound elements can perform a variety of aesthetic functions—either by themselves or in combination with one another. Whether used as sound combinations or as video-audio structures, these various elements yield a virtually endless variety of subtle descriptive and expressive nuances. Yet, there are certain variations to which we respond emotionally with some consistency. Far from being complete or totally reliable, Table 14.2 is meant to demonstrate some of the more common descriptive and expressive variations of the basic sound elements. You should realize that any number of variables, such as harmonic or contrapuntal structures, specific melodic or chordal modes, or the juxtaposition of one or several of these elements with others or with certain visual images, can, and do, readily alter their aesthetic function.

Table 14.2 Basic Descriptive and Expressive Variations of Sound Elements

Sound Element	Variation	Descriptive or Expressive Characteristic
Pitch	High	Thin, high, brittle, exciting, light
	Low	Thick, low, solid, solemn, heavy
Timbre	Thin (pure tones, few overtones, e.g., flute)	Pure, weak, simple, clean, uncomplicated
	Rich (complex tones, many overtones)	Rich, full, complex, vital, strong, bold, grand
	Brassy, metallic	Cold, shrill, bitter, hard, forceful, big
	Reedy (oboe, clarinet)	Sweet, lonely, melancholy
	High-pitched percussion (xylophone)	Exciting, nervous, horrifying
	Low-pitched percussion (tympani)	Dramatic, powerful, important
Duration	Long	Peaceful, calm, stable, monotonous
	Short	Exciting, restless, unstable, nervous
Loudness	Loud	Forceful, important, energetic, close, definite
	Soft	Weak, soothing, peaceful, delicate, subdued, calm
	Crescendo (change from soft to loud)	Increasing power, forceful, intense
	Diminuendo (change from loud to soft)	Decreasing power, intensity loss, becoming more distant
Attack	Fast	Exciting, pointed, sharp
	Slow	Gentle, soft, velvety, casual
Decay	Fast	Intimate, close, confined, compressed, dead, definite
	Slow	Spacious, open, lively, far, alive, smooth, undefined
Key	Major	Positive, vigorous, bright, happy, secure
	Minor	Mysterious, sad, melancholic, lonely

Summary

The five major aspects of the five-dimensional field are (1) sound and noise, (2) television and film sound and their functions, (3) literal and nonliteral sound, (4) descriptive and expressive sounds, and (5) elements of sound.

The basic functions of television and film sound are (1) to supply essential or additional information, (2) to establish mood and add aesthetic energy, and (3) to supplement the rhythmic structure of the visual vector field.

In *television,* sound is especially important since the low-definition visual images are usually inductively presented. It is difficult to achieve good sound in television. The techniques of sound pickup and the inadequate sound reproduction equipment in the home receiver work against high-quality television sound.

In *film,* sound is usually better than in television, since most film sound is added later to the picture under highly controlled conditions. Also, the sound reproduction equipment in film is better than in television.

Sound is distinguished from *noise* in terms of communication purpose. Sound is purposeful communication; noise is random, purposeless.

There are (1) *literal* and (2) *nonliteral* sounds. *Literal sound* is *referential sound.* The sound itself is less important than what it stands for. Literal sound includes the major types of speech: (1) dialogue, (2) narration, and (3) direct address. Besides the obvious informational function of literal sound (through speech), it also helps to orient us in space and time and to the nature of specific events, called situational orientation.

Literal sounds orient us in space if the sounds remind us *where we are,* for example, traffic, birds singing. We are oriented in time if we can readily *associate* the literal sounds with a *time period,* such as morning, evening, night. *Situational orientation* through literal sound means that the sounds tell us more about an event than the pictures show (baby crying, thunderstorm, approaching crowd, and so on).

Nonliteral sound has no literal meaning. It is not symbolic, which means that it does not stand for a particular thing or event. The most common nonliteral sound is music. Nonliteral sound can be *descriptive* and *expressive. Descriptive nonliteral sounds* describe a certain quality or event. They describe what a thing or event looks like, and tell more about the condition of the thing or event. Program music is an example of nonliteral descriptive sound. *Expressive nonliteral sound* evokes a specific feeling, or mood. We do not associate something else with expressive sound; it creates the feeling or mood by itself. A musical fugue or a sonata is an example of expressive nonliteral sound.

There are five basic *elements of sound:* (1) *Pitch* indicates the highness or lowness of a sound measured against an agreed-upon scale. (2) *Timbre* describes the tone quality, or tone color. (3) *Duration* refers to how long we perceive a sound to last. (4) *Loudness* (dynamics) is the apparent strength of a tone as we perceive it. Some sounds are loud; some soft. (5) *Attack-Decay* are especially important for audio-synthesizers, where the attack of a tone as well as its decay can be preset. *Attack* means how fast a tone reaches a certain level of loudness. *Decay* means how fast the sound fades to where it can no longer be perceived.

Notes

[1] Herbert Zettl, *Television Production Handbook,* 2nd ed. (Belmont, Calif.: Wadsworth Publishing Company, Inc., 1968), pp. 73–74, 86–90.

[2] Siegfried Kracauer, *Theory of Film* (New York: Oxford University Press, 1960); Sergei Eisenstein, *Film Form and Film Sense,* ed. and trans. by Jack Leyda (New York: World Publishing Company, 1957); and Rudolf Arnheim, *Film as Art* (Berkeley: University of California Press, 1953).

[3] V. I. Pudovkin, *Film Technique and Film Acting,* ed. and trans. by Ivor Montagu (New York: Grove Press, Inc., 1960), pp. 310–311.

[4] Kracauer, *Theory of Film,* p. 106.

[5] *Ibid.,* pp. 106–107.

[6] Bernard De Voto, ed., *The Portable Mark Twain* (New York: The Viking Press, Inc., 1946), pp. 542–543, 553.

[7] Marshall McLuhan, *Understanding Media: The Extensions of Man* (New York: McGraw-Hill Book Company, 1965), p. 284.

[8] Aaron Copland, *What to Listen for in Music,* rev. ed. (New York: New American Library, Inc., 1963); and Robert Erickson, *The Structure of Music* (New York: The Noonday Press, 1955).

Structuring the Five-Dimensional Field: Sound and Picture Combinations

In structuring the five-dimensional field, we will discuss (1) the basic sound structures and (2) the principal picture-sound combinations. As pointed out before, neither the sound track nor the visual images should be functioning separately in a well-made film or television program. Rather, video and audio should function *together* in order to produce an optimally effective communication experience.

Fortunately, in structuring the five-dimensional field you can apply many of the basic structural principles as developed and used in music. A knowledge of some of the major music structures will help you, not only in clarifying and intensifying the various sound elements, but also in effectively integrating pictures and sound and even in structuring the visual images themselves. In many situations, you will find that you can directly apply musical terminology and structural techniques and principles for the manipulation of the visual fields—for building of screen space.

Basic Sound Structures

With the emphasis on sound structures in the five-dimensional field, we will discuss (1) melody, (2) harmony, and (3) homophonic and polyphonic structures.

Perhaps you may want to try to translate musical terminology and structural principles into an equivalent visual notation—a notation that can be applied directly to the structuring of the visual fields (one- to four-dimensional).

Melody A melody is a series of musical tones arranged in succession. Melody is a tune.

We recognize and remember a melody not so much note for note, but as a sound structure, a sound gestalt. The important structural element of a melody is not so much the scale (the pitch of the

15·1 *Melody moves linearly, horizontally. The melody represents a horizontal sound vector. Each tone leads to another until they appear as an entity: the tune.*

15·2 *Quite generally, a major scale expresses a happy, normal, practical mood.*

The minor scale reflects a sad, mysterious, haunting, less definite mood.

15·3 *The chromatic scale consists entirely of half-tone intervals.*

The whole-tone scale uses whole-tone intervals. It is almost the opposite of the chromatic scale.

Some composers simply arrange a row of notes as their basic scale, regardless of the specific intervals. Since there is a total of twelve notes in a scale before the notes begin to repeat themselves as an octave, the individual row can contain twelve notes. The structuring of such sets of twelve notes has become known as the twelve-tone system.

various tones), but the *relative steps,* the intervals, from tone to tone. Another important structural element of a melody is, of course, its rhythm.

Out of a great variety of possible tone combinations, melodies are usually written in a major or minor scale, or in a combination thereof.

Arnold Schönberg (1874–1951), Austrian-German composer, established the twelve-tone system as a useful compositional device. He taught in Berlin and at the University of California, Los Angeles.

15·4 *The simplest harmonic structure consists of two simultaneous tones.*

The basic unit of the traditional harmonic structure is the triad, a combination of three tones.

While melody consists of horizontal sound vectors, harmony consists of vertical vectors.

As with the scale, the triad can also reflect a major or minor mode.

Vertical, harmonic structures are usually called chords. Generally, they are built from the same scale in which the melody operates (that is, the chords have the tonality of the melody), but the melody and the chords may also operate in different keys or outside of any predetermined scale (as in twelve-tone structures, for example).

The chords can vary considerably in their complexity. We can speak of relative chord density or sound texture. [From "Pentatonic" by P. Peter Sacco, by permission of the composer.]

Harmony While a melody represents a horizontal successive combination of tones, *harmony* consists of a *vertical, simultaneous* combination of various notes (Fig. 15·4).

Melody, then, is a *linear* structure. We can comprehend its total structure only at the point of termination. A melody is only complete when it is over—when it no longer exists. Like the structure of any process, we can remember only its total gestalt; but we cannot perceive its totality all at once.

Harmony is *nonlinear.* Since all elements of the harmonic structure occur simultaneously, we can actually *perceive* a harmonic structure in its totality.

Homophonic and Polyphonic Structures Homophony and *polyphony* stand for two basic ways of combining melodic and harmonic structures. We can use these two basic sound designs not only for structuring single and multitrack audio vector fields, but also single and multiscreen video vector fields, and especially video-audio vector field combinations.

 Homophonic means literally "alike-sounding" (Greek *homo* = the same; *phonos* = sound). In music, homophony refers to the structure in which a single predominating melody is *accompanied* by corresponding chords. Melody and chords do not run independently, but parallel. The chords *support* the melody.

The magnitude of the vertical sound vectors depends on various factors, principally (1) the relative density (texture) of the chord, (2) its perceived sound (how the combined tones sound together—degree of consonance or dissonance), and (3) its tension relative to its own chordal structure (how much or little tension is created among the tones of the chord themselves) or to the melody (total chord sound relative to the tone or tones of the melody). [From "Pavana" and "Pentatonic" by P. Peter Sacco, by permission of the composer.]

15·5 *In this example of homophony, the leading melody is supported by a parallel chord accompaniment. [From Waltz in G Major by Franz Schubert.]*

Translated into vectors, each horizontal vector of the melodic line (horizontal structure) is supported by a vertical, chordal vector (vertical structure).

In a homophonic structure, the melodic, horizontal vectors are independent. The melody can stand by itself.

The chordal, vertical vectors are dependent. They cannot function alone but only in connection with the dominating horizontal melodic vector line. In homophony, melody (horizontal vectors) determines chords (vertical vectors).

15·6 *In a polyphonic structure, each voice is independent of the other. When played separately, each voice forms a self-sufficient entity. Each voice should make sense by itself. When played together, however, the various horizontally independent voices form a vertical, harmonic structure. They become vertically interdependent. [From Inventio I by J. S. Bach, by permission of Edwin F. Kalmus, Publisher of Music.]*

Horizontal

Vectors

15·7 *Vertical vectors are formed incidentally through planned juxtaposition and interaction of the horizontal vectors of the various voices.*

Vertical
Vectors

Polyphonic stands for "many sounds" (Greek *poly* = many; *phonos* = sound). In musical terminology, polyphony refers to two or more *independent* melodic lines which, when played together, form a harmonic whole. Unlike the homophonic structures, where a single dominating melody is accompanied by supporting chords, the polyphonic structures are composed of multiple, equally dominating voices (melodies). No single voice is totally relegated to a supporting role. Each voice runs its own course, sometimes dominating the other voices, and sometimes seemingly assuming a subordinating role (Figs. 15·6 and 15·7).

Most polyphonic music is written in *counterpoint.* Counterpoint is a specific polyphonic technique, which basically means that the notes of one voice are set against the notes of the other voice or voices.

Counterpoint means punctum contra punctum, *Latin for "point against point." In the first half of the fourteenth century, when the term "counterpoint" first appeared,* punctum (point) *was synonymous with* nota (note). Punctum contra punctum *means, therefore,* nota contra notam, *note against note.*

15·8 *To achieve the desired contrapuntal field tension, we can contrast the direction of the horizontal vectors. While one melodic line is going down, the other one is going up or vice versa (forming, in effect, converging or diverging vectors). [From Inventio IV by J. S. Bach, by permission of Edwin F. Kalmus, Publisher of Music.]*

15·9 *Or we can contrast the pitch of the various voices. While one voice operates in a relatively high range (treble), the other voice develops in a lower range (bass). [From Inventio III by J. S. Bach, by permission of Edwin F. Kalmus, Publisher of Music.]*

Counterpoint means vector *contra* vector. While homophonic structures generally require a simple juxtaposition of the horizontal vector fields, that is, the melodic lines of the various voices, contrapuntal structures emphasize an *encounter* among the various voices. We use counterpoint to achieve a certain structural tension—a high-energy vector field.

By contrasting the various horizontal fields of the independent voices in a calculated way, we also create vertical vectors of varying complexity and magnitude. The various voices must make sense not only horizontally (melodic development) but vertically as well (harmonic development).

15·10 *You can also contrast the voices by timbre. One voice may be played by the violin, the other by the flute.*

15·11 *Contrasting dynamics will also help to achieve contrapuntal tension. In effect, we are juxtaposing vectors of varying intensity magnitudes. [From* March in D Major *by J. S. Bach.]*

15·12 *A rhythmic juxtaposition is one of the most effective contrasting devices. While one voice is progressing rather fast, the contrapuntal voice is slow; while one has a sharp staccato beat, the other may proceed as a continuous legato line. [From* The Well-Tempered Clavier *by J. S. Bach.]*

15·13 *One of the most important structural elements of counterpoint is imitation. Imitation means that a short theme, or subject, is stated in one voice and then repeated verbatim or imitated in a slightly changed form in the other voice or voices. [From* The Well-Tempered Clavier *by J. S. Bach.]*

15·14 *The round, or canon, is the purest and most obvious form of imitation. The subject is stated in one voice and then repeated in a second voice, while the first voice continues its melody; then a third voice picks up the same melody. The melodic (horizontal) structure is exactly alike in each voice. The harmonic (vertical) structure is created by a phasic shift of the identical melodies. Of course, simple repetitions of the same subject or theme can become boring rather easily. Whenever we employ the method of imitation (whether in a sound, picture, or picture-sound structure), we must make sure that the vectors (horizontal and vertical) vary enough in direction and magnitude (tension-relaxation) to assure the necessary stimulating variety within its structural unity.*

15·15 The theme (subject) of a fugue is usually introduced all by itself and then repeated in the various voices. [From The Well-Tempered Clavier *by J. S. Bach.]*

In the complex fabric of a contrapuntal vector field, the vertical vectors (harmonic chords as formulated when we read the various independent voices vertically at any given point) act as important structural agents. They hold the horizontal voice lines together and give the independent voices their necessary structural dependence. Essentially, the vertical vectors represent space-time modulators, explicating the spatial (harmonic) as well as the temporal (melodic) relationships and interdependence of the individual voices. Vertical vectors serve as reference points. They tell us where the individual voices have been, where they are going, and how they fit together.

One of the most intricate contrapuntal structures is the *fugue.* In a fugue (the word comes from the Latin *fugere,* to run away, to flee; *fuga,* which means flight), a theme or subject is chased and flees from voice to voice throughout the composition. The theme is imitated and expanded in each of the voices, relating vertically at each point to form a complex, yet unified whole (Fig. 15·15).

After it has been introduced once by all the voices, the exposition is finished. The theme is then imitated, varied, and expanded throughout the voices. This is called episode. When the theme is clearly introduced again in each voice, we have another exposition. There may be several expositions and episodes in a single fugue. The subject "flees" throughout the composition.

Johann Sebastian Bach (1685–1750), probably the greatest German Baroque composer, demonstrated the structural potentials of the fugue in his The Well-Tempered Clavier *and* The Art of the Fugue.

15·16 *Source-connected sound means that we hear a sound and see its originating source at the same time.*

15·17 *Source-disconnected sound means that we hear a sound while the picture shows something other than the sound-producing source.*

Picture-Sound Combinations

The most important aspect in structuring the five-dimensional field is the control of *picture-sound combinations.* Even if we are successful in structuring the picture field and the sound field independently, we cannot expect to arrive at a meaningful video-audio structure by simply adding the two. Rather, we must learn to *combine* the video and audio vector fields. This means that we must learn to structure the pictures and sounds *together* so that they form a synergistic structure, a *video-audio gestalt,* which is the product, rather than the mere sum, of pictures and sound. In order to achieve such a video-audio gestalt, we should always try to *hear* our film or television show while we are visualizing it, and to *see* it while we are structuring its sound. In other words, we should try to conceive and develop the video and audio vector fields *together* as much as possible.

When combining pictures with sound, we can have either (1) source-connected sound or (2) source-disconnected sound.

If we look at somebody while he is talking to us, the sound is source-connected. If we look away at something else during the talk, the sound becomes source-disconnected.

This distinction is important in television and film, since the clarification and intensification of a scene often depends on a careful construct of fluctuating *source-connected* and *source-disconnected* sounds.

The very same sound can change readily from a source-connected to a source-disconnected sound, depending on the accompanying picture. The baby crying sound is source-connected as long as we show the baby that is doing the crying at the same time. If, however, we switch to a close-

up of the concerned mother while continuing the crying, the sound changes from a source-connected to a source-disconnected sound. Similarly, if we continue the video, the close-up of the baby, while replacing the crying sound with the voice of the mother trying to soothe the baby, we switch from source-connected to source-disconnected sound. If we mix the crying sound with the mother's voice, we have a combination of source-connected and source-disconnected sounds. Through proper balancing, we can make one of the two voice tracks the foreground sound, the other one the background sound.

These two fundamental picture-sound combinations apply to all types of sound, whether they fall into the literal or nonliteral sound category. Generally, the literal sounds are more often than not source-connected. We see someone speak and hear simultaneously what he is saying. Nonliteral sounds, such as background music, for example, are often source-disconnected. We usually do not see the orchestra or the electronic gadgets that produce the background music but rather the scene itself, which is intensified by the background music.

Whether the sound is source-connected or source-disconnected, we will find picture and sound combinations in which (1) the picture dominates, the sound supports; (2) the sound dominates, the picture supports; (3) picture and sound alternately dominate and support each other; and (4) picture and sound run fairly independent of each other, yet combine into a *tertium quid,* a third something, a larger picture-sound gestalt.

Video Dominates—Audio Supports (V/a) In many cases, the picture portion of the television show or film tells most of the story, with the sound portion playing a *supporting* role. Here are some examples:

Video	Audio
Chase scene: Man running along deserted road	*Music:* Fast, staccato
Car speeds along in hot pursuit	*Sound:* Car accelerating, brakes squealing, man running and breathing heavily
CU's of man running and expression of driver	
CU of car speeding along z-axis; man falling	

In the preceding example, the literal sounds (car engine, footsteps, breathing) supply additional information; the sounds, however, still remain secondary to the principal communication (storytelling) of the pictures. The music adds no information to the picture story; it merely intensifies it; it makes the scene more exciting.

Video	Audio
MS man and woman walking along beach	*Music:* Peaceful, calm *Crossfade* to: *Sound:* Surf, beach sounds

Again, the music serves merely to intensify the tranquility of the scene. It supports the visuals. Even when we crossfade to the literal sounds of the beach (surf, laughing in the distance, seagulls, foghorns in the distance, and the like), we do not add any new information that is not already contained in the picture. The literal sounds, as with the music, merely *support* the video.

The V/a combination (video dominates, audio supports) happens more often in film than in television, since film has a higher video definition than television. We can *show* more visual detail on the wide motion picture screen than on the television

Pudovkin speaks of synchronized and asynchronized sounds. For Pudovkin,[1] synchronized sound means source-connected; asynchronized means source-disconnected. The terms "synchronism" and "asynchronism" are quite ambiguous, however, since any type of sound should be synchronized with the picture if it is to make any sense at all. "Asynchronized" might imply that the sound is out of step with the picture, regardless of whether the sound is source-connected or source-disconnected.

Karel Reisz[2] and Kracauer[3] were well aware of this ambiguity and suggested two additional types of picture-sound combinations: actual and commentative. Actual sound means any sound that belongs to the world presented on the screen, any war sounds, for example, whether we see the actual explosion or the frightened face of a soldier.

Commentative sound means that the sound does not belong to the pictorial world as presented on the screen. The sound merely comments on the scene. The best example for this commentative sound is a voice-over narration for a documentary.

Karel Reisz (1926–), British film director, producer, and journalist.

screen, and the high linear control (editing) of film lends itself readily to storytelling.

Television's visual mosaic and its mosaiclike approach to storytelling (inductive rather than deductive building of a story), however, should rely much more heavily on the informational (clarification) and emotional (intensification) functions of sound than film. In a great number of television programs, the *audio portion dominates,* while the video supports.

Audio Dominates—Video Supports (A/v) If the major mode of communication is verbal, such as a newscaster reading a news story, the sound obviously dominates the picture.

Video	Audio	
MS announcer	Reads public service announcement	The picture of the announcer certainly gives us much less information than what he says. Here, the audio portion clearly dominates the video.
CU of speaker	Gives address	Whenever speech is the primary means of communication, the picture of the person speaking is merely *supporting* his verbal message. The video images give us the communication context. They give supporting information. But they cannot tell us accurately what the announcer is saying.
MCU of guest	Answers questions	

Video-Audio Alternate (Va/Av) In most television and filmic presentations, video and audio alternate in their dominating and supporting roles. For part of the scene, the audio may dominate, and

then the video may take over; or the pictures may begin to tell the story, with the audio taking over the primary communication role later in the program.

Video	Audio
LS of man and woman walking on beach	*Music:* Romantic, peaceful *Sound:* Natural beach sounds
Zoom in	*Sound:* Segue to actual conversation

In the above scene, we move from V/a to A/v. If we now read the sequence backward (from the CU of the conversing couple to the LS with music), we naturally reverse the A/V domination from A/v to V/a.

Again, if we analyze television programs and films according to A/V dominance, we will probably find more A/v dominance in television and more V/a in film.

Video-Audio Commeasure (V/A) In some instances, neither the video nor the audio portion dominates at any given point, but they are coequal in their informational and emotional functions. They combine synergistically into a larger, unified whole.

For example, opening titles may have a coequal V/A combination. While the words give us specific information about the name of the show and the major participants, the theme music informs us of the type and general style of the show: whether it is a funny country episode or a big-city drama, for example. Pictures and sound combine into an exposition which contains essential context information.

In flashbacks, video and audio often run independently, each providing us with essential information. We may, for example, show someone

walking along a busy downtown street, with the audio portion repeating a conversation the person is recalling. In this case, the video tells the story progressively, while the audio portion provides the necessary flashback. We can easily reverse this procedure, with the audio portion continuing the story and the video flashing back to an earlier happening.

Such a video-audio *phasing* can also be used as an effective transitional device.

Video	*Audio*
Two-shot: Larry and Anne in front of library	*Larry:* Don't you want to go to the concert with me?—Please!
TCU of Anne. Zoom back to reveal concert hall interior; she sits next to Larry	*Anne:* Perhaps.

In this case, the video jumped to the effect phase while the accompanying sound still lingered in the "cause" phase (Fig. 15·18).

Predictive sound works on a similar phasing principle. Predictive sound, like predictive lighting, signals a future happening. For example, the video may show someone driving happily through a beautiful valley. The spirited background music reflects the happy scene. But then, while the pictures continue to show the happy scene, the music changes abruptly into an ominous mood, predicting an impending tragic event (Fig. 15·19).

We can combine simultaneous, yet spatially separated events through commensurate video-audio combinations. We can use the audio portion to communicate an event in location A, while the video shows a simultaneous event in location B. Video and audio portions display similar communicative importance; they neither dominate nor support each other, but they combine into a larger V/A time-space gestalt (Fig. 15·20).

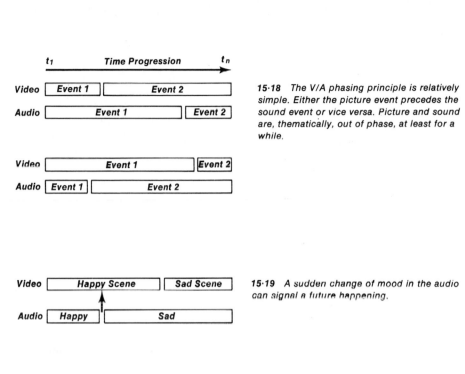

15·18 *The V/A phasing principle is relatively simple. Either the picture event precedes the sound event or vice versa. Picture and sound are, thematically, out of phase, at least for a while.*

15·19 *A sudden change of mood in the audio can signal a future happening.*

15·20 *Independent video and audio tracks can indicate two separate events that occur either at different locations or at different times. Several audio tracks played simultaneously with the picture portion communicate at once several spatially or temporally disassociated events.*

<u>Video</u>

<u>Audio</u>

Screen 1 Screen 2 Screen 3

15·21

Shot 1: *All three tracks (one track for each screen): Running and surf sounds.*

Shot 2: *All three tracks: Running and surf sounds.*

Shot 3: *Tracks 1 and 3: Running and surf sounds Track 2: Fragments of conversation: "Oh, I waited so long — glad to — where have — yes — thanks, and you? —*

Shot 4: *Track 1: Running sounds Track 2: Happy laughter. Conversation fragments: "So happy to — Where were you — really — So, now —* **Track 3:** *Surf*

Video *Audio*

Shot 5: Track 1: Conversation fragments
Track 2: Surf
Track 3: Embracing sounds

Homophonic and Polyphonic Picture-Sound Combinations You will probably have noticed that the above V/A combinations resemble closely the homophonic and polyphonic musical structures.

If the video and audio combinations are *supportive,* that is, if the audio is supporting the video or the video the audio portion, we have a *homophonic* V/A structure. Like the dominating melody that is supported and undergirded by accompanying chords, so the dominating video "melody" can be supported shot by shot, scene by scene, by the audio. Similarly, the melodic dominance of the audio portion can be supported homophonically by video "chords."

When audio and video domination changes frequently or drastically or when audio and video portions run as coequal aesthetic and informational agents, we have a *polyphonic* V/A structure. Similar to the independent voices in the fugue, video and audio portions develop independently as melodic lines, yet they also combine "vertically" into a clarified and intensified V/A gestalt.

The V/A Fugue There are many structural V/A possibilities. For example, we could construct a visual fugue with three screens. Each of the three screens might have its own sound track or we might have a common sound track for all three screens. We could also have a basic single-screen video theme that is counterpointed by two or more simultaneous audio tracks (Figs. 15·21 and 15·22).

Video *Audio*

15·22

Track 1: Running sounds, surf (Time: present)

Track 2: Fragments of conversation, indicating conflict (Time: future)

Track 3: Telephone conversation to arrange this meeting (Time: past)

Track 4: Sounds to increase vector magnitude: music, electronic sounds

Single Screen

In the three-screen example, the video "voices" and the accompanying audio tracks form a rather complex polyphonic space-time structure, in which one characteristic event (such as the opening scene of a man and a woman running toward each other on the beach) is repeated until the end of the exposition.

In the one-screen, multiple-audio-track event, the "outer action" is carried by the video, while the multiple audio tracks reflect the complexity and multilevels (depth) of the "inner" events. Although the audio tracks run parallel with the video, they form, like the voices of the fugue, a vertical complexity.

Video	Audio
Two-shot of couple	*Track 1* She: "How did it go today?" *Track 2* He: "What do you care?" *Track 3* He and She: "Mother." *Track 4* Silence
CU of him	*Track 1* He: "Oh, pretty well." *Track 2* He: "Rotten, awful. Miserable." *Track 3* She: "Liar." *Track 4* Music tension, etc.

Depending on how much of the event complexity we want to communicate, we can emphasize either one, two, or three tracks, or even play them all together. When we play all tracks together, we no longer communicate specific information (the audience will no longer be able to follow exactly what is being said), but we provide a *fabric* of speech sounds that might reflect the complexity of the moment better than any single track.

By emphasizing track 1, while relegating the others to background sounds, we communicate primarily the "outer" event. But if we now bring up track 2, or tracks 2 and 3, we shift the event emphasis from outside to inside. The vector field tends to shift from a horizontal orientation (event progression) to a vertical one (event complexity and depth).

We can increase the magnitude and density of the internal event's vector field by increasing the complexity of the visual images as well. For example, we may want to superimpose and/or key several images on top of one another, or (especially in film) increase the horizontal complexity by rapid shot changes.

Video	Audio
Two-shot of couple	Track 1 emphasized Tracks 2 to 4 background *Event is "outer-oriented"*
CU of him	Track 1 background Track 2 emphasized Tracks 3 and 4 background *Event is "inner-oriented"*
CU of him	Track 1 background Track 2 emphasized Track 3 emphasized Track 4 background *Event is completely "inner-oriented"*
Two-shot of couple Super CU of him Key debeamed image of her	All tracks equally emphasized

Very much as with the fugue, emphasis shifts from voice to voice (track to track), thus fluctuating from an outer event to an inner event orientation. While we are still able to follow the horizontal progression of each voice, the combined voices and images form a complex vector fabric that permits a simultaneous view of outer and inner event. Such a polyphonic V/A treatment is quite similar to the painting of the Cubists (Picasso, Braque; see page 245), who attempted to show the exterior and the interior of an object or event simultaneously.

Selective Sound In a party, while everyone is talking at once, we are still able to listen only to what seems important to us. Or when we walk with someone along a busy downtown street, we do not really perceive the traffic noises but only what the other person is saying to us. Only if the traffic noise becomes so overpowering that it literally drowns out our friend's voice will we become aware of the surrounding noise. Hearing, like vision, is selective. It, too, works on a figure-ground principle. We try to order the audio environment by assigning some sounds the role of the figure (the sounds that are important to us), others that of the ground (background). If the background sounds become too prominent and the figure sounds get swallowed up by the surrounding sounds (as in the above traffic example), we experience a figure-ground reversal. (The ground thus becomes noise—interfering with the intended communication.)

With multitrack recording techniques, however, we can control this figure-ground relationship quite readily. The individual tracks allow us either to sharpen one sound while keeping the others in the background (a technique especially suitable for homophonic structures) or to work two or more tracks contrapuntally against one another (thereby emphasizing the polyphonic structures).

Sound Perspective When selective sound matches selective video, we speak of *sound perspective.* In its most simple application, loudness (sound intensity) and presence (closeness) match the relative closeness of the object on the screen. For example, when we show a speaker close-up, his speech should sound "close," too. His speech sounds should match the magnitude of the visual vectors. If the speaker looks far away (long shot), he should also sound "farther away." In television, where sound and pictures are usually picked up simultaneously (with no or little postdubbing), the sound perspective happens quite naturally. When we are on a close-up, we can lower the boom microphone and get it closer to the sound source. On a long shot, we must raise the boom to keep the microphone out of the picture. Quite naturally, the sound appears to come from farther away.[4]

If a proper sound perspective cannot be maintained, it is better to match close-ups as well as long-shots with close rather than far sounds. Therefore, try to keep the microphone as close to the sound source as possible.

Sound perspective can range from obvious matching of close and far pictures with close and far sounds to more subtle structures. Besides indicating outer, physical distances (close-far), sound perspective can also reveal and intensify inner, psychological distance (inner-outer; genuine-superficial). Here is an example:

Scene: A party. The host is a boisterous, slightly overweight backslapper. He interrupts the various conversations and demands that everyone listen to his puns. The hostess is a good listener. She fills the empty glasses efficiently, but unassumingly.

Audio: Everything the host does is loud. That goes for pictures as well as sound. His sounds are all intensified. His manners and actions are noisy. We have a vector field of high magnitude. The guests' sounds are treated normally. Those in the foreground sound closer than the

ones in the background. Some are loud, some are more quiet. But the sounds of the hostess are purposely kept low. Even if she is shown close-up pouring a drink or talking to someone in passing, we hear very little if anything of her actions. Her manners and actions are silent. The vector field is purposely kept to a low magnitude.

In the host's case, the loud sounds match his loud manners. In the hostess' case, the absence of sound, or low-magnitude sound vectors intensify her temperate, genial, inner calm.

Through a figure-ground shift, that is, by having the host's sounds become progressively less intense while the sounds of the hostess become increasingly prominent, you can change the tenor of the event or the relative position of the major characters of the scene quite readily and dramatically.

V/A Montage A specific polyphonic video-audio combination is the *V/A montage.* Much like the video montage (compare pages 313–323), the V/A montage consists of a juxtaposition of audio and video elements that, when perceived together, produce a highly intensified event, a *tertium quid.*

The V/A montage is usually limited to the idea-associative category. Again, as in the pictorial idea-associative montage, the V/A montage can be of the comparison and collision type.

Idea-Associative V/A Montage Comparison In the V/A comparison montage, we juxtapose pictures and sounds that exhibit *similar* characteristics.

Video	Audio
CU of politician whose speech becomes more and more frenzied and emotional	Actual speech; *crossfade* into sounds of small schoolchildren reciting a patriotic poem in chorus

Video	Audio
MS of new model car speeding along highway	Jet airplane sounds
Shooting gallery in amusement park	Actual war sounds

The above examples of the V/A montage show clearly how literal, source-disconnected sounds are intended to be perceived as source-connected sounds, thus giving the pictorial images highly specific connotations. The politician is spouting shallow slogans, no better than the thoughtless babble of children. The new model car seems to fly along the freeway. And the shooting gallery is nothing but a miniature battlefield catering to the killer instincts of man.

Idea-Associative V/A Montage Collision In the V/A collision montage, we juxtapose pictures and sounds that exhibit *dissimilar* characteristics, which, however, when perceived together produce a specific idea.

Video	Audio
CU's of slum areas	Narrator describing the wealth and significance of the city
LS: Man lost in the desert	Various sounds of water: running faucet, brook, rain
LS: Battle scene	Happy party sounds

In the V/A collision montage, the source-disconnected sounds are not intended to be perceived as source-connected sounds. They are rather designed to *intensify* the basic idea as expressed by the pictorial images through counterpoint.

Like the pictorial idea-associative montages, the V/A montages are usually so obvious a device that, if not handled with kid gloves, they tend to annoy rather than enlighten the sensitive viewer. The average viewer nowadays has enough media sophistication to perceive and correctly interpret even our more subtle aesthetic clues. No need for shouting, provided we have something important to say in the first place.

V/A Matching Criteria When we cover an event live with television, we will encounter few, if any, aesthetic video-audio matching problems. We are mainly concerned with as accurate a pickup of the literal sounds of the event as possible. As soon as we are asked to pick some music for the opening and closing of the remote telecast, however, V/A matching becomes more of a problem. What music should we choose? What are, or at least what should be, the selection criteria?

As pointed out before, ideally we should conceive pictures and sound together. We should see and hear the screen event simultaneously, as an aesthetic whole. In practice, however, such a complete preconception of the whole event is not always possible. Most likely, we find that we think of the pictures first and then try to find the appropriate source-disconnected sounds, such as background music, for example. Or we may have a piece of music available that is especially intriguing and that we then try to match with proper pictures.

Even if the sound portion of the show consists mainly of source-connected, literal sounds of the event, we may find that we still need additional sounds, such as music, for adequate intensification. Or we may want to set the proper mood for a scene with music or use sound to give additional information about an event.

What we need then are some workable criteria by which we can select appropriate sounds and music for the more common video events. There are four general V/A matching criteria: (1) historical-geographical, (2) thematic, (3) tonal, and (4) structural.

Historical-Geographical *Historical matching* means that we match pictures and sound historically. For example, we could match the pictures of a Baroque church with the music of the Baroque period, such as a cantata by J. S. Bach; an eighteenth-century scene in Salzburg, Austria, with a minuet by Mozart; or the Manhattan skyline with a piece by Leonard Bernstein.

You can, of course, narrow the periods considerably. A happening in the early 1960s could be accompanied by the Beatles, an event in the late 1960s by the sounds of "Blood, Sweat, and Tears." In any case, in historical matching we try to select pictures and sound that originated roughly in the same time period.

Geographical matching means that we accompany pictures with sounds that originated in the same geographical area. We could, for example, match a scene of the Bavarian Alps with a typical Bavarian *Laendler* (a favorite local dance music), a scene in the Orient with oriental music, and one in the southern United States with New Orleans jazz.

Thematic When we match video and audio thematically, we select sounds that we are accustomed to hear at specific events or locales. For example, a slow zoom from a long shot of the exterior of a Gothic cathedral to a medium shot of the church entrance could well be matched thematically with an organ prelude. In thematic V/A matching, we should choose *literal* sounds that we expect to originate at the scene that we are depicting pictorially. In thematic matching, we can blend source-connected literal sounds (sounds that actually originate at the place and time of the

filming or telecast) with literal, source-disconnected sounds (sounds that we expect to hear at the scene, which, however, may not actually occur). Here are some examples of thematic V/A matching:

Video	*Audio*
LS: Interior of cathedral	*Music:* Organ prelude (source-disconnected)
	Sound: Congregation praying (source-connected or source-disconnected, depending on whether or not we see the people praying)
CARD: XLS of football stadium from above	*Music:* Typical marching band music
	Sound: Crowd noises

Since the video is from a still photo, both the band music and the crowd noise are source-disconnected but thematically matched.

Video	*Audio*
MS: Funeral scene in cemetery; it is raining	*Music:* Organ or band playing a funeral march (source-disconnected)
	Sound: Rain and crowd noises (source-connected)
CU of couple seated in night club	*Music:* Rather gentle rock music (source-disconnected)
	Sound: People talking softly (source-disconnected); bits of conversations (source-connected)

Thematic V/A matching lends itself readily to V/A montages. In a comparison montage, we simply match pictures and sound that relate *thematically* rather than actually. For example, we might want to match the close-up of a dentist's drill in somebody's mouth with the sound of a chain saw or a jackhammer. The sound of the chain saw exemplifies thematically the way the patient feels during the drilling (comparison montage).

In a collision montage, we simply juxtapose opposite themes. The gay marching band music and the excited crowd noises that we used for the football game may prove a chilling counterpoint when juxtaposed with film or video-tape footage of an actual battle scene.

Tonal In *tonal V/A matching,* we choose sounds that fit the general tone, that is, the *mood and feeling,* of the pictorial scene. If we show a sad scene, the music will be sad, too. Similarly, we match a happy scene with happy sounds. The piercing, ominous staccato sounds that accompany the outlaw waiting for his next victim are a well-known cliché of tonal V/A matching. The romantic music that engulfs the lovers embracing tenderly in the moonlight is another familiar example of tonal V/A matching.

Descriptive nonliteral sounds or combinations of descriptive and expressive music are well suited to tonal matching.

When matching video and audio tonally, we simply "feel out," or sense, the *principal tone* of the visual event or the basic mood we want to communicate. We then select music or other sounds that parallel this principal tone. In combination with the video, the selected sound should then clarify and especially *intensify* the scene. With proper tonal matching, a somber event becomes more somber, a cruel one more cruel, a lovely one more lovely.

Structural *Structural matching* means that pictures and sound are paralleled according to their *internal structure.* Let's try to do some intuitive structural matching. Simply look at the pictures in Figures 15·23 through 15·26 and see whether you can "hear" them.

15·23 *How does this picture sound? Loud? Soft? Fast or slow? Does it have a simple or rather complex beat?*

15·24 *Compare these two pictures. Do they "sound" alike? Which one "sounds" full, brassy, loud? And which one has softer, more peaceful sounds?*

15·25 *Which of these two pictures sounds more polyphonic, which one more homophonic? Which one requires a simple melodic treatment, which a more complex one?*

15·26 *Which of these two pictures is rhythmically comparatively simple? Which one more complex?*

How did you do with "listening" to these pictures? Could you assign each picture a specific type of music? Did they sound different from one another?

Now go back and try to identify some specific pictorial characteristics that prompted you to select a certain type of music. Was it the direction and arrangement of the dominant lines within the pictures? The arrangement of the objects within the frame? The direction and magnitude of the graphic vectors? The texture? The graphic weight? The pictorial balance? The light and shadow distribution? Probably most of these elements and then some more.

In structural matching, a whole series of pictorial elements helps us to conceive a complete vector field—a structural gestalt. This structural gestalt in turn exhibits certain *vector field characteristics:* high or low degree of vector complexity, vector direction, and vector magnitude; high-magnitude or low-magnitude energy as induced by primary, secondary, or tertiary motion; even or uneven beat, and so on. Once we have identified such video vector field characteristics, we must then select a sound structure (a musical composition, for example) with similar audio vector field characteristics. A fast pictorial montage sequence with high-magnitude converging vectors and a fast, definite cutting rhythm obviously demands music that has melodic phrases running against one another (converging vectors in the melody line), whose volume is rather high, and that has a definite beat. Both vector fields (video and audio) suggest tension, drive, conflict.

To isolate the dominant structural element within a picture or picture sequence and to grasp the overall structural gestalt is not always an easy task. Sometimes a picture or picture sequence just does not seem to "sound" right, or it seems to be so indistinct that any number of musical structures seem to fit equally well or equally badly.

In such a situation, we must analyze the picture or picture sequence step by step in terms of the major aesthetic criteria developed throughout this book: light, color, space, time, and motion. We should then be able to establish major connections among these elements. If the visuals have been structured at all, we can reconstruct the underlying structural gestalt and intensify it by adding a sound track with similar structural characteristics. If we find no evidence of visual structure, we at least will not waste time trying to find appropriate music.

Exactly how does such a structural analysis work? And how can we translate the pictorial characteristics into music? There is no single or simple answer. Structural matching, as any other type of V/A matching, depends on many contextual variables, such as the desired overall aesthetic effect, on what immediately preceded the picture sequence to be structurally matched or what follows it, on whether or not we intend any montage effects, and so forth.

Table 15·1 shows how we might approach a structural analysis of the video and its translation into musical terminology for audio matching.

Table 15·1
Video/Audio Structural Analysis

Video

General shape — regular / irregular

Placement within frame — labile (high tension) / stabile (low tension)

Graphic weight — light / heavy

Texture — light / heavy

Field density (number of pictorial elements in frame) — high / low

Field complexity — high / low

Vectors — Graphic — high magnitude / low magnitude; Index — high magnitude / low magnitude

Principal vector orientation — Vertical — high magnitude / Horizontal — low magnitude

Vector change (degree of line continuity) — fast change, low continuity / slow change, high continuity

Light — high-key / low-key

Fall-off — fast / slow

Color — Hue — warm / cold; Saturation — high / low; Brightness — high / low

Show pace (perceived duration of total event) — fast / slow

Audio

Sound shape (timbre, chords) — consonant / dissonant

Chord tension — dissonant (high) / consonant (low)

Chords and beat — light (unaccented) / heavy (accented)

Chords — simple / complex

Horizontal density (melodic density: number of notes within bar) — high / low

Vertical density (harmonic density: chordal or contrapuntal) — high / low

Vectors — melodic progression — definite / indefinite; harmonic certainty — high / low

Principal key and harmonic tendency — exciting (dissonance) / calm (consonance)

Melodic progression and rhythmic continuity — uneven / even

Key — major / minor

Dynamics (loudness) — High contrast (loud-soft) / Low contrast (even)

Pitch — high / low

Timbre — brass, strings / flutes, reeds

Dynamics — loud / soft

Pace of total piece — fast / slow

Video

Audio

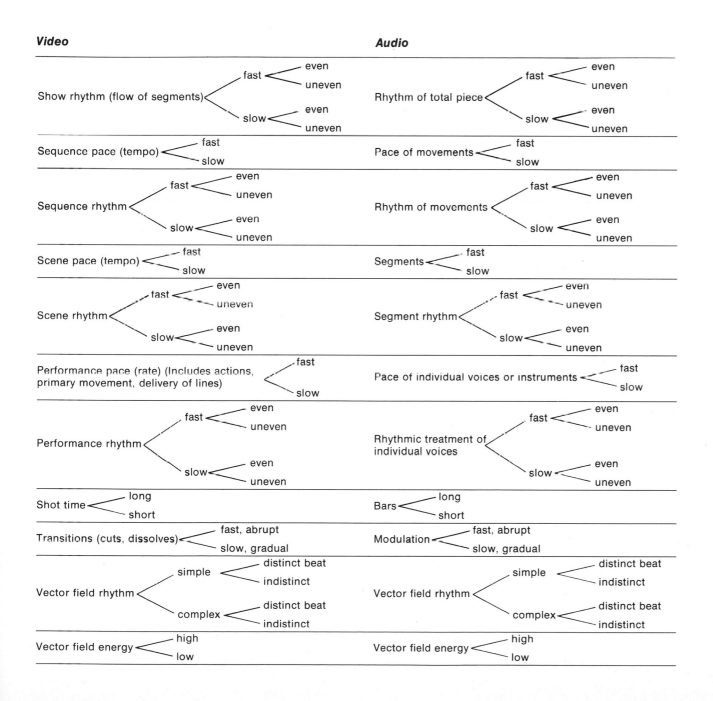

374 Sight · Sound · Motion

To witness the structural power of music, take any film sequence you have at hand and run some arbitrarily selected music with it. You will be amazed how frequently the video and audio seem to match structurally. You simply expect the visual and aural beats to coincide. If they do not, you apply psychological closure and make them fit. Only if the video and audio beats are, or drift, too far apart, do we concede to a structural mismatch—but then only temporarily.

Also, when watching a television show or a film without sound, you will become surprisingly aware of the visual structure, especially of tertiary motion. For example, tertiary motion shows up with undue prominence when watching a drive-in movie from far away without the benefit of the accompanying sound track. When watching the same motion picture with sound, however, the same sequence will appear much smoother. Assuming that the sequence is edited properly, you may not even be conscious of the tertiary motion employed. Again, the organic structural power of music greatly facilitated the pictorial vector flow.

Siegfried Kracauer refers to the "drunken pianist" who accompanied the silent motion pictures. Usually the pianist was so immersed in himself that he completely disregarded the images on the screen. And yet, at least once in a while, the music conformed to the dramatic events on the screen in an amazing accuracy. Even if the music did not fit the film thematically, Kracauer had the impression that "there existed after all a relationship, however elusive, between the drunken pianist's soliloquies and the dramas before my eyes."[5] This relationship, of course, was a structural one.

Quite obviously, we need not go through such a detailed analysis every time we try to match video and audio structurally. Generally, the video sequence will display a *dominant structural feature,* such as a prominent texture, high-magnitude motion vectors, warm colors, high-contrast chiaroscuro lighting, and so on, that we can use for audio selection. At other times, the video might suggest a *clear overall design* (simple pattern with recurring elements and/or continuous lines), a *dominant overall rhythm* (strong, accented, nervous beat or slow, tranquil, continuous rhythmic lines), or a certain *energy level* (extreme close-ups, high-magnitude vectors, bright colors, all of which indicate a high energy level), which we can easily match with sounds of similarly dominant structural characteristics.

The more skilled you become in structural analysis, the quicker you will be able to isolate the dominant structural features. Once you have attained a certain degree of emotional literacy, structural analysis will require so little time and conscious effort from you that you might think the analysis is intuitive.

We will find that in structural V/A matching, the *structure of the sound* tends to dominate the visual structure. Whenever pictures are arbitrarily juxtaposed with music, we try to make the pictures fit the music (at least rhythmically) rather than the other way around. In fact, this tendency to make the video structure conform to the audio structure is so strong that we can, at least up to a point, induce some structure into a totally arbitrary sequence of pictures simply by accompanying it with a well-composed piece of music.

Structural Analysis and Synthesis Structural matching is, of course, not limited to pictures and sound. Structural matching can be extended into a great variety of production tasks, such as the translation of ideas into visual images (visualization, the matching of ideas or words with appropriate pictures), casting (finding the right actor for a specific role), editing dialogue (making sure that the writer has his characters say things that they would most likely say in a given circumstance), building dramatic tension (intensifying outer and inner action), or generating or arbitrating conflict.

As you have noticed, structural matching requires structural analysis and structural synthesis. Through structural analysis, we identify and isolate the basic aesthetic elements; thus we familiarize ourselves with the stuff with which we have to work. Through structural synthesis, we put these elements together so that they form new connections and new relationships—new patterns in which each mutually dependent element feels inevitably right. Indeed, once we have established such a new pattern, the aesthetic elements are usually *consumed* by the new structural field. Thus, the audience may not (and usually should not) be aware of the individual elements but will certainly be aware of the new pattern, of the new aesthetic process.

The new structural field, with its unique relationships and connections among its elements, will help the audience to gain a new perspective, a higher degree of emotional literacy, which, ultimately, can lead to a deeper insight into life. When this happens, we can call our aesthetic communication an unqualified success.

V/A Interference

So far we have talked about how sound can aid the visual communication. But if used improperly, sound can just as easily interfere with the

pictures and inhibit the total communication process. Here are the most common ways in which sound inhibits, rather than facilitates, visual communication: (1) informational interference, (2) volume interference, (3) historical-thematic-tonal mismatching, and (4) structural interference.

Informational Interference Informational interference can occur if there is (1) too little, (2) too much, or (3) the wrong information supplied by the audio.

Too Little Audio Information The misconception that television is primarily a visual medium results frequently in a lack of audio information. As pointed out before, however, the low-definition pictures of television need much more informational supplementing by the audio than the high-definition film images, for example. There are many instances in which the pictures simply cannot give all the necessary information and the announcer has to describe the event, even at the risk of occasionally duplicating with words what the viewer can see. Some people turn down the television audio when watching a football game and listen to the more complete play-by-play description on radio. The highly detailed radio description of the play is often a welcome, if not necessary, informational supplement to the hard-to-follow television images. But we should not go overboard with audio information. If one of the players obviously misses a catch, we need not say that "he missed the catch." What is important for the audience, however, is *who* the player was that missed the catch.

Too Much Audio Information Paradoxically, too much audio information can interfere with picture sequence as much as too little information. If the audio merely parrots the pictures, we tend to protect ourselves from an information overkill by paying less attention to the total communica-

tion. Obvious audio redundancy can easily turn a needed communication facilitation into communication noise. Even on television, there is no need to comment on actions the audience can clearly see. Here is an example:

Video	Audio
Governor walking to the rostrum. He shakes hands with some senators. He mounts the rostrum and waits for the audience to calm down.	*Reporter:* "The Governor is now approaching the rostrum. He shakes hands with some of the people there. Now he is mounting the rostrum. The crowd is buzzing with excitement. The Governor is waiting for them to quiet down."

A few such redundant audio comments will certainly annoy even the most complacent of viewers.

If we can clearly see that somebody is shaking hands with some other people, there is no need for the reporter to tell us this. More important for us would be to know who is shaking hands with whom.

A similar overinformation problem also occurs when the credits are read by the announcer while they appear on the screen. Usually, we read a lot faster than the announcer. So, while we are trying to make out the names on the credit crawl, the announcer is still reading us some names that we have already read. At best, the communication has become difficult. The credits would have been much more direct had they been presented as video or audio information only.

This does not mean, however, that we cannot ever have a complex audio track, in which several things are happening simultaneously. As pointed out earlier in this chapter, we may well run several voice tracks simultaneously, representing various

levels of thought. In a multivoiced track, we are after a total *impression* of the event, a general degree of event complexity. We do not intend to communicate *specific information* any longer. If we want to have the audience understand everything that is being said, we must emphasize one track and keep the others in the background.

Misinformation The most obvious and severe audio interference is misinformation. In a fast play, the sports announcer may get mixed up and identify the wrong player, for example. As long as the player is clearly visible on the screen, the audience will immediately be aware of the mistake. Not much harm is done. But when the picture is not very clear, the audience is heavily relying on audio information. Any audio misinformation, then, becomes a more serious communication problem.

The only way to keep audio misinformation to a minimum is to make sure that you *know* what you are saying. Do not guess. Double check. Triple check. In a live situation, such as in a sportscast, do not hesitate to admit to the audience that you have made a mistake. It is much less professional to keep the audience misinformed than to admit and then correct your error.

Volume Interference Structural interference occurs especially if the audio is too loud or not loud enough (volume interference) or if the audio is rhythmically out of step with the video.

If the sound track is *too loud,* it can become so annoying that the audience simply stops listening. The term "too loud" does not merely mean high volume; it can also mean that the sound energy, the audio vector magnitude, is too high relative to the picture information. Some commercials are guilty of an overabundance of such audio energy. The viewers who complain that the audio is too "loud" are often more sensitive to this excess audio energy than to the actual volume. Even if your VU meter (volume-unit meter—which shows degrees of loudness) indicates that the sound is well within the normal volume range, the viewer may still feel that the audio is "too loud."

If the audio is *too soft,* so that you cannot hear very well what is being said, you obviously experience serious communication interference. Especially in live television or in a video tape recording of a live event, the audio is often quite inferior in quality. In a play, the microphones are often far away from the sound-producing source; in an outdoor event, the ambient noise can interfere quite severely with good audio pickup. Make sure at least that the volume is high enough so that the sounds are clearly audible, regardless of their quality.

But the sound may also be too soft in relation to the video energy. High-energy close-ups or high-energy action on the screen demand equally high-energy sound. If, for example, we show many extremely high-magnitude close-ups of someone playing a cello solo (revealing how the bow makes the strings vibrate or how the fingers press down on the strings), the audio must be of equally high magnitude. What we must do is to use a sound perspective that matches the video not only in terms of relative distance (from the viewer's eyes and ears) but also in terms of perceived energy. A high-energy picture needs a high-energy sound, unless we purposely want to create a V/A disparity for emphasis.

Historical-Thematic-Tonal Mismatching If we strive for historical accuracy, we must select sounds appropriate to the time period depicted in the video portion. A scene that depicts the 1920s can hardly be accompanied by rock-and-roll sound. Nor should the medieval scene that shows

the building of a Gothic cathedral be matched with the organ music of J. S. Bach, who, after all, lived in the Baroque period.

Unless we want to achieve a collision montage, we should not accompany sad scenes with gay music or a happy, light event with ponderous sounds that imply sadness and tragedy.

As easily as we can establish the mood for a scene with proper music, just as quickly we can destroy it with improperly matched sounds or music.

Structural Interference Whenever the vector field of the audio event does not support or parallel the vector field of the video event, we run the risk of structural interference. For example, if we juxtapose an extremely high-density, high-energy visual image with an extremely simple, low-density and low-magnitude sound pattern, the video portion of the screen event will lose, rather than gain, in its aesthetic effectiveness. The same is true of the reverse, when a highly textured, high-magnitude sound is matched with a simple, low-magnitude video event. The high-magnitude music will seduce the viewer into believing that something big is about to happen. When this "something big" fails to occur, the viewer will feel let down, if not cheated.

The video and audio rhythms should complement each other, rather than fight each other. Juxtaposing a fast, driving video sequence with a slow, indistinct audio rhythm makes it very hard for the viewer to conceive any sensible V/A structure. At best, structural V/A interference will leave the viewer confused; usually, he will become irritated and annoyed. One thing pulling in one direction and another in the opposite direction does not make for an energizing structural gestalt. Rather, it will most likely severely inhibit, if not destroy, the energy of the total screen event.

Summary

In structuring the five-dimensional field, we concern ourselves primarily with (1) the basic sound structures and (2) the principal picture-sound combinations.

The *basic sound structures* include (1) melody, (2) harmony, and (3) homophonic and polyphonic audio and video-audio structures. The *melody* represents a horizontal sound vector. *Harmony* consists of a *vertical,* simultaneous combination of various notes. In a *homophonic* structure, the horizontal vector of the melodic line is supported by vertical, chordal vectors. In a *polyphonic* structure, multiple, equally dominating melodies run seemingly independent of, yet parallel to, each other. Several horizontal melodic vectors run independent of each other, yet, when played together, they form a vertical, harmonic vector structure. Most polyphonic music is written in *counterpoint,* which basically means that the notes of one voice are set against the notes of the other voice or voices.

In television and film, the video and audio structure should combine synergistically into a larger *video-audio gestalt.* When combining pictures and sound, the sound can be (1) source-connected or (2) source-disconnected. *Source-connected sound* means that the sound-originating source is seen while the emitted sound is simultaneously heard. *Source-disconnected sound* means that the sound is heard while the picture shows something other than the sound-producing source.

Depending on the specific communication purpose and desired aesthetic impact, pictures and sound can be *combined* so that (1) the picture dominates and the sound supports (V/a); (2) the

sound dominates and the picture supports (A/v); (3) picture and sound alternately dominate and support (Va/Av); and (4) picture and sound run independently, yet combine into a larger V/A gestalt (video-audio commeasure, V/A).

Predictive sound signals a future happening. While the video is leading the viewer in one direction, the audio signals an abrupt change of events.

Like the sound structures, the video-audio structures can also be homophonic or polyphonic. In a *homophonic V/A structure,* the video can be supporting the audio, or the audio the video. The video can resemble the melodic vector, and the audio the supporting chords. Or the audio can take on the melodic lead, with the video becoming the chordal support. When video and audio run parallel as coequals or when the video and audio domination changes frequently, we have a *polyphonic V/A structure.*

One of the V/A structures can be a V/A fugue, in which the individual melodic "voices" (horizontal vectors) can be displayed on separate screens (video) or on multiple sound tracks (audio) or as a combination of both.

Selective sound works on the figure-ground principle. We select the sound that is especially important to us as the dominating sound-figure and relegate all other sounds to the ground (background sounds).

Sound perspective means that the video vectors and the audio vectors should correspond in their respective magnitudes. A close-up picture should be accompanied by a close-up sound (close sound presence), a long shot with a far sound (distant sound).

Much like the video montage, the V/A montage consists of juxtaposing various video and audio elements in such a way that when perceived together they form an intensified *tertium quid.* In a *V/A comparison montage,* we juxtapose pictures and sound that exhibit *similar characteristics.* In a *V/A collision montage,* we juxtapose pictures and sound that exhibit *opposite characteristics.*

When selecting sound for a pre-existing video sequence, such as news footage or in a documentary, for example, these four matching criteria make the job somewhat less haphazard: (1) historical-geographical, (2) thematic, (3) tonal, and (4) structural.

Historical-geographical matching means that the sound matches the pictures historically or geographically. If the pictures show an eighteenth-century scene, it is matched by eighteenth-century music. If the scene plays in the Orient, it is matched with oriental sounds.

Thematic matching means that the video event is matched by sounds that we ordinarily associate with the event. For example, the Gothic cathedral is matched with organ music; the funeral with funeral music; the football game with band music.

Tonal matching means that sounds are chosen that fit the general tone—the mood of the event. For example, lovers are matched with romantic music; a fight with agitated sounds, and so forth.

Structural matching means that the pictures and sound are matched according to their internal structure—their dominant vector fields.

Sometimes, the picture-sound combinations can inhibit, rather than facilitate, communication. In this situation, we speak of *V/A interference.* There are four major types of V/A interference: (1) informational, (2) volume, (3) historical-thematic-tonal mismatching, and (4) structural.

Informational interference can occur if there is too little, too much, or the wrong information supplied by the audio relative to the video.

Volume interference means that the audio is perceived as either too loud or too soft relative to the picture. The principal vectors of video and audio should match in magnitude.

Historical-thematic-tonal mismatching means that within the context of historical, thematic, or tonal matching, the pictures and sounds obviously do not belong to the same historical period or depict the same general theme or mood.

Structural interference means that the video vector field and the audio vector field fight rather than complement each other. A rhythmic discrepancy between video and audio causes an especially obvious and serious structural interference.

Notes

[1] V. I. Pudovkin, *Film Technique and Film Acting,* ed. and trans. by Ivor Montagu (New York: Grove Press, Inc., 1960), pp. 183–193.

[2] Karel Reisz, *The Technique of Film Editing* (London: Focal Press, 1966), pp. 278, 279. In the glossary, p. 278, Reisz defines actual sound as "sound whose source is visible on the screen or whose source is implied to be present by the action of the film . . ." and on p. 279 he defines commentative sound as "sound whose source is neither visible on the screen nor has been implied to be present in the action."

[3] Siegfried Kracauer, *Theory of Film* (New York: Oxford University Press, 1960), pp. 111–124.

[4] Herbert Zettl, *Television Production Handbook,* 2nd ed. (Belmont, Calif.: Wadsworth Publishing Company, Inc., 1968), pp. 110–112.

[5] Kracauer, pp. 137–138.

Glossary

Above-Key Light Position The principal light source (key light) strikes the object from above eye (camera) level.

Accelerated Motion The division of object motion into relatively few motion instances, each one differing considerably from the other. The event density is low. The object appears to be moving more rapidly than ordinarily possible.

Achromatic Containing no saturation. The grayscale is an achromatic scale, ranging from black to white.

Additive Color Mixing The mixing of colored light. Usually the mixing of the light primaries—red, green, and blue.

Aerial Perspective Foreground objects are seen sharp and clear, while background objects become less sharp the farther away they get from the observer (camera).

Aesthetic Energy The energy we perceive from aesthetic phenomena, such as color, sound, motion. Generally, the magnitude of a variety of aesthetic vectors or vector fields.

Analytical Montage–Sectional Arrests temporarily the progression of an event and examines the isolated moment from various viewpoints. It explores the complexity of the event.

Analytical Montage–Sequential The juxtaposition of the major developmental factors of an event in their natural sequence, revealing their cause-effect relationship.

Angles Variety of camera viewpoints.

Area Proportion The harmonious interrelation of various screen areas.

Aspect Ratio The relationship between screen height and width.

At–At Theory Motion consisting of a series of static positions in space; duration consisting of a series of "nows."

A Theory Time theory which holds that there is a clear distinction between past, present, and future.

Attached Shadow Shadow which is on the object itself. The attached shadow is always object connected.

Attack The speed with which a tone reaches a certain level of loudness.

Balance Relative structural stability of objects or events within the screen. Specifically, the distribution of vectors and graphic weight into stabile, neutral, and labile pictorial structures.

Below-Key Light Position The principal light source (key light) strikes the object from below eye (camera) level.

Brightness Sometimes called value, brightness indicates how light or dark a color appears in a black and white photograph (how much light the color reflects).

B Theory Time theory which holds that there is no clear distinction between past, present, and future but that an event is only earlier than, or later than, some other chosen event or events.

Cameo Lighting Foreground figures are lighted with highly directional light, with the background remaining dark.

Cast Shadow The shadow which is produced by the object and thrown on part of the object or onto another object. The cast shadow may or may not be object connected.

Chiaroscuro Lighting Lighting for light-dark contrast to emphasize volume.

Chord The simultaneous combination of two or more tones. A vertical sound vector.

Chroma *See* Saturation.

Chromaticity Diagram A theoretical model in which the interrelationship between hue and saturation is demonstrated mathematically (by wavelengths).

Color Specific electromagnetic waves from the visible light spectrum.

Color Attributes The three color sensations: hue, saturation, and brightness.

Color Constancy The perceiving of a color as uniform, despite variations.

Color Energy The aesthetic energy we perceive from a color; that is, the relative energy a color emits within its contextual field.

Color Harmony Colors that go well together—specifically, the balanced energies of colors.

Color Solid A three-dimensional model in which the interrelationship of hue, saturation, and brightness is graphically demonstrated.

Color Temperature The relative bluishness or reddishness of light, measured in degrees Kelvin.

Complexity Editing The building of a screen gestalt from carefully selected event essences. The basic building block of complexity editing is the montage. Complexity editing intensifies the event.

Context *Experience Context:* The behavioral pattern within which we perceive things—point of view; depends on previous experience, present perceptual sensitivities and predispositions, and expectations. *Event Context:* The peripheral event or events in which the major action takes place.

Contextualism An aesthetic attitude that stresses the relationship between life and art.

Contextualistic Aesthetics *See* Contextualism.

Continuing Vector Vectors that succeed each other in the same direction.

Continuity Editing The assembly of shots that assure vector and vector field continuity. Continuity editing clarifies the event.

Converging Vectors Vectors that oppose each other. They reverse, or at least abruptly change, directions.

Counterpoint A specific polyphonic technique in which the various voices (melodies) encounter each other. Counterpoint means vector contra vector.

Debeaming An internal lighting technique in television. The electron beam is reduced in intensity, in which picture detail is gradually reduced.

Decay The speed with which a sound fades to where it can no longer be perceived.

Deductive Visual Approach Moving from an overview to scenic (pictorial) detail.

Density The relative number of film units (frames) used to depict the motion of an object. The number of events happening within a certain time unit.

Depth of Field Field in which all objects, located at different distances from the camera, appear in focus; depth of field is dependent upon focal length of the lens, *f*-stop, and distance between camera and object.

Descriptive Nonliteral Sound Describes a certain quality or event (such as program music).

Dialectic The juxtaposition of opposing or contradictory statements in order to resolve the contradictions into universally true axioms.

Direct Focus An index vector (or index vectors) pointing directly to a target object.

Duration Refers to how long we perceive a sound to last.

Editing Building screen space. Combining parts of an event, or several events, into a single, unified screen experience. Emphasizing the important event aspects and de-emphasizing the unimportant ones.

Envelope The total duration of a tone, including attack and decay (synthesizer terminology).

Event Density The relative complexity of the event details or facts shown, or the number of film units used for a specific object motion. (*See also* Density).

Expressive Nonliteral Sound Evokes a specific feeling or mood.

External Light The light emitted from an external light source, such as the sun or a lamp.

External Lighting The manipulation of external light sources.

External Vectors Forces with a direction and magnitude operating outside us.

Eye Level The plane parallel to the ground emanating from the eye of the observer. (*See also* Horizon Line.)

Fall-off The "speed" with which the highlight areas turn into shadow areas. Fast fall-off means that the light areas turn abruptly into shadow areas. Slow fall-off means that there is a very gradual change from light to dark or that there is little contrast between light and shadow areas.

Figure-Ground Our tendency to organize a picture field into a stable ground against which less stable figures operate. The figure appears as lying in front of the ground.

Flat Lighting Omnidirectional light. It seems to come from no particular single source. Slow fall-off.

Forced Perspective Forcing parallel lines to converge prematurely at an artificially established vanishing point.

Fugue A musical theme or subject is stated in one voice and then restated at various times in the other voices. The theme is virtually chased from voice to voice throughout the fugue, relating vertically to form a complex yet unified whole.

Gestalt A pattern which we form through the process of psychological closure. The completed pattern, the gestalt, is usually larger and more complex than the mere sum of its parts. In a gestalt, all elements operate in relation to the whole.

Golden Section A classic proportional system in which the smaller section is to the greater as the greater is to the whole.

Graphic Depth Factors Factors that create, on a two-dimensional surface, the illusion of depth graphically (without the use of motion). The major factors are (1) overlapping planes, (2) relative size, (3) height in plane, (4) linear perspective, (5) aerial perspective, and (6) light and shadows.

Graphic Mass A screen area or object that carries a specific graphic weight (which feels relatively light or heavy).

Graphic Vectors A vector created by stationary elements that are arranged in such a way that they lead the eye in a particular direction.

Harmony A number of chords or a vertical sound vector field.

Hegelian Dialectic A thesis which is opposed by an antithesis, ultimately resulting in a synthesis.

High-Key Lighting High overall light level. General (nonspecific) lighting. Background usually light. Predominance of bright picture detail.

Historical-Geographic Matching Sound and pictures are matched historically or geographically. Pictures and sounds originate in the same historical period or geographical area.

Homophonic A/V Structure The audio can be supporting the video or vice versa.

Homophony A structure in which a single predominating melody is accompanied by corresponding chords.

Horizon Line An imaginary line parallel to the ground at eye level. The plane at right angles to the direction of gravity that emanates from the eye of the observer at a given place.

Hue The actual color of the object—red, green, blue, and so on.

Idea-Associative Montage Collision Collides opposite events in order to express or reinforce a basic idea. Operates on the dialectic principle in which one idea is opposed by another (opposite) idea. Both are ultimately synthesized into a new idea, a *tertium quid* (third something).

Idea-Associative Montage Comparison Compares seemingly disassociated, yet thematically related, events in order to reinforce the primary event's basic idea.

Index Vector A vector created by something that points unquestionably in a specific direction.

Indirect Focus An index vector, or vectors, which are redirected by an intermediary object before reaching the target object.

Induced Motion Vector A motion vector induced by secondary (camera) motion on a static event to simulate primary (event) motion.

Inductive Visual Approach Moving from scenic (pictorial) detail to the overview, or presenting a series of event details.

Inertia The tendency of a body at rest to remain at rest and of a body in motion to remain in motion. The greater the mass of an object, the greater its inertia.

Internal Light The energy necessary to make images visible on the television or motion picture screen. Usually applied to television: the electron beam.

Internal Lighting The manipulation of the television electron beam.

Internal Vectors Forces with a direction and magnitude operating inside us.

Keying or Matting One picture is electronically cut into another.

Leitmotiv "Leading motif," a short musical phrase that, like a name, denotes a specific person, object, event, or idea. Its basic dramatic function is that of allusion (reference).

Leveling Eliminating confusing graphic detail in order to produce a clear pattern.

Light Radiant energy, which behaves commonly as electromagnetic waves.

Lighting The deliberate control of light for the purpose of manipulating and articulating the perception of our surroundings.

Linear Perspective Horizontal parallel lines converge toward the distance at the vanishing point, which lies on the eye-level horizon line. A powerful device to create the illusion of depth on a two-dimensional surface.

Literal Sound Referential sound. The sound itself is less important than what it stands for.

Loudness (Dynamics) The apparent strength of a tone as we perceive it (magnitude of a sound vector).

Low-Key Lighting Low overall light level. Selective lighting with fast fall-off. Background is usually dark. Predominance of shadows.

Magnetism of the Frame The pull the frame exerts on objects within the frame.

Mass All the matter a body contains. It is characterized by the object's perceived size, shape, volume, and weight.

Melody A series of musical tones arranged in succession—a tune. Melody is a horizontal sound vector.

Metric Rhythm Control A regular tertiary motion beat created by manipulation of shot length, regardless of shot content.

Montage The juxtaposition of two or more separate event images that, when shown together, combine into a larger, more intense whole.

Motion Paradox An object can be in motion and at rest at the same time, depending on the motion context.

Motion Vector A vector created by an object actually moving in a specific direction, or an object that is perceived as moving on the screen.

Negative Volume Empty space that surrounds, or is described by, positive volumes. A definite, empty space, such as the inside of a room, that is articulated by positive volumes, such as the walls.

Noise Random audible vibrations (oscillations) of the air.

Nonliteral Sound Has no literal meaning. It is not symbolic. The most common nonliteral sound is music.

Notan Lighting Flat lighting. The light is omnidirectional. It seems to come from no particular single source. Slow fall-off.

Objective Color Perception The colors we see are actually present.

Objective Time The time we measure by the clock. Objective, quantitative measure of observable change.

Object Proportions The interrelation of object sizes.

Open Set A set which is not closed in and in which the scenery is not continuous.

Pace Perceived duration of the show or show segment. Part of subjective time.

Performance Pace Refers to the perceived speed of a performer's actions.

Performance Rhythm Refers to the flow of actions and the variety of timing within a scene.

Picturization The control of a succession of shots, scenes, and sequences. The building of sequential screen space.

Pitch Indicates the relative highness or lowness of a sound measured against an agreed-upon scale.

Polyphonic A/V Structure Video and audio run parallel as coequals, or the video or audio domination changes frequently.

Polyphony The combination of two or more independent melodic lines, which, when played together, form a harmonic whole.

Positive Volume Objects that have substance and that can be touched and weighed.

Predictive Lighting Light changes from one mood to another, signaling an impending happening.

Predictive Sound Signals a future happening (a leitmotiv is often used as predictive sound).

Primaries Basic colors with which almost all other colors can be achieved by mixing. Light primaries: red, green, and blue. Paint primaries: magenta (bluish red), yellow, and cyan (greenish blue).

Primary Motion Event motion in front of the camera.

Program Music Music that is primarily used to describe an event or a specific mood.

Psychological Closure The act of taking a minimum of clues and mentally filling in nonexisting information in order to arrive at an easily manageable pattern.

Rack Focus The shift of emphasis from foreground to background object (or vice versa) by changing (racking through) the optical focus from one object to the other in a shallow depth of field.

Rembrandt Lighting A type of chiaroscuro lighting in which only highly selected areas are illuminated while others are kept relatively dark.

Reversed Polarity An internal lighting technique in which the television grayscale is electronically reversed. The dark areas turn light, and the light areas dark.

Running Time Indicates the overall length of a television show or film. It indicates a "from–to" position in the time continuum.

Saturation The color richness; the color strength.

Scene A clearly identifiable, organic part of an event. It is a small structural (action) or thematic (story) unit, usually consisting of several shots.

Scene Pace Refers to the perceived duration of a scene relative to its sequence or other scenes.

Scene Rhythm Depends on the tertiary motion beat as created by the shots and by the primary and secondary motion vectors within the scene.

Scene Time The part of the running time it takes to cover a scene.

Screen Space The space as defined by the borders of the screen, or the cumulative screen space of a shot sequence or multiscreens. (*See also* Sequential Screen Space.)

Secondary Motion Camera motion, including pan, tilt, pedestal, crane or boom, dolly, truck, arc, and zoom.

Selective Sound Works on the figure-ground principle. We select the most relevant sound as the figure and relegate the other sounds to the ground (background).

Sequence The sum of several scenes that compose an organic whole.

Sequence Pace Refers to the perceived duration of a sequence.

Sequence Rhythm Depends on the distribution and pacing of the scenes that make up the sequence.

Sequence Time Is a subdivision of the running time and spans several scenes.

Sequential Screen Space The vector fields as they relate from shot to shot.

Sharpening Adding pictorial information in order to make graphic patterns clearly distinguishable.

Shot The smallest convenient operational unit in film or television. It is the interval between two distinct video transitions, such as cuts, dissolves, wipes.

Shot Rhythm Refers to the beat established through a series of shots that do not as yet compose a scene.

Shot Time Measures the actual duration of a shot.

Show Pace Refers to how fast or slow the overall show is perceived.

Show Rhythm Indicates how well the parts of the show relate to each other sequentially, how well the show flows.

Silhouette Lighting The background is evenly lit, with the foreground figures remaining unlighted. The figures reveal only their contour.

Simultaneous Contrast The simultaneous influence of a background color on the foreground color and vice versa.

Simultaneous Screen Space Various camera angles shown simultaneously on a single screen by matting or superimposition, or on multiscreens.

Size Constancy The perception of the actual size and shape of an object, regardless of distance and angle of view.

Slow Motion The division of object motion into relatively many motion instances, each one differing little from the other. The event density is high. The object appears to be moving more slowly than is ordinarily possible.

Sound Purposeful audible vibrations (oscillations) of the air.

Sound Perspective Video and audio vectors correspond in their respective magnitudes. A close-up picture is accompanied with a close sound, for example.

Sound Texture The relative complexity of a harmonic structure.

Source-Connected Sound Hearing a sound and seeing its originating source at the same time.

Source-Disconnected Sound Hearing a sound while the picture shows something other than the sound-producing source.

Spot Time Depicts the actual spot when an event happens. Beginning and ending times of shows, for example, are spot times.

Story Time Shows the period of a story (event) spanned in the film or television show. Story time usually moves from a specific calendar date to another or from one clock time to another.

Structural Matching Pictures and sound are matched according to their internal structure or their dominant vector fields.

Structural Unit of Film The frame that shows a frozen snapshot of an event.

Structural Unit of Television A continual flow, an image in flux, a process.

Structural Visual Rhythm A beat created by recognizable recurring visual elements.

Subjective Camera The camera assuming the role of an event participant. The camera no longer looks at but participates in an event.

Subjective Color Perception Stimulation of our perception apparatus by means other than colored light, or the mixing of separate and distinct colors in our heads.

Subjective Time The duration we feel. Also called psychological time. A qualitative measure.

Subtractive Mixing The mixing of color pigment (paint), or filters. Usually the mixing of the paint primaries—magenta (bluish red), yellow, and cyan (greenish blue).

Synthesizer Programmed generation of sounds through electronic oscillation.

Tertiary Motion Editing motion induced by shot changes.

Tertium Quid The third something, resulting from a montage.

Thematic Matching The video event is matched by sounds we ordinarily associate with the event, such as cathedral and organ music.

Thematic Rhythm Control Tertiary motion (cut) determined by the content of the montage, its basic theme, story, or mood.

Timbre Describes the tone quality or tone color.

Time Arrow *See* Time Vector.

Time Vector The direction of time as we experience it.

Timing The deliberate control of time. The control of objective and subjective time is an important element in structuring the four-dimensional field in television and film.

Tonal Matching The video event is matched with sounds that express the general tone or the mood of the event, such as lovers and romantic music or fights and agitated sounds.

Two-Point Perspective Linear perspective with two vanishing points. Both vanishing points lie on the same horizon line.

Value *See* Brightness.

Vanishing Point The point at which all parallel lines seem to converge and discontinue (vanish). The vanishing point lies on the horizonline at eye level.

Vector Force with a direction and a magnitude.

Vector Field A combination of various vectors operating within a single picture field (single frame), from picture to picture field (from frame to frame), or from screen to screen (multiscreens).

Vectorial Rhythm Control Tertiary motion (cut), determined by the direction and magnitude of the vectors.

Vector Magnitude The degree of the directional force of the vector; the amount of energy we perceive. A high-magnitude vector is a strong vector; a low-magnitude vector is a weak one.

V/A Collision Montage The juxtaposition of video (pictures) and audio (sound) that exhibit opposite characteristics.

V/A Comparison Montage The juxtaposition of video (pictures) and audio (sound) that exhibit similar characteristics.

V/A Interference Video-audio interference. Video and audio inhibit communication. *Informational Interference:* Too little, too much, or the wrong information is supplied by the audio relative to the video. *Volume Interference:* The audio is perceived as too loud or not loud enough relative to the video. *Structural Interference:* Video and audio vector fields do not match; they fight each other structurally.

V/A Montage Video-audio montage in which various video and audio elements are juxtaposed to produce an intensified *tertium quid* (third something).

Video-Audio Gestalt The product, rather than the mere sum, of picture and sound.

Video Feedback The picture on the television set is photographed again and fed back in the same monitor, producing multiple images.

Visualization The control of the vector field of individual shots that form a visual image of an event.

Volume Duality The interplay between positive volumes (things that have substance and that can be touched or weighed) and negative volumes (empty space that surrounds, or is described by, positive volumes).

Z-Axis The axis in the coordinating system that defines depth. Also the imaginary line that extends from the camera to the horizon.

Z-Axis Blocking Arranging the movement of people and things along the z-axis or in close proximity to it.

Z-Axis Motion Vector Motion along the z-axis (toward or away from the camera).

Z-Axis Space The manipulation of the three-dimensional field, not from a single point of view within the context of a single shot but from several points of view within the context of a shot sequence.

Z-Axis Staging The arrangement of scenery and set pieces along the z-axis.

Bibliography

Albers, Josef. *Interaction of Color.* New Haven: Yale University Press, 1971.

Arnheim, Rudolf. *Art and Visual Perception.* Berkeley: University of California Press, 1965.

_____. *Film as Art.* Berkeley: University of California Press, 1953.

_____. *Toward a Psychology of Art.* Berkeley: University of California Press, 1966.

_____. *Visual Thinking.* Berkeley: University of California Press, 1971.

Augustinus, Aurelius, Saint. *The Confessions of St. Augustine,* trans. E. B. Pusey. New York: E. P. Dutton & Company, Inc., 1951.

Barnett, Lincoln. *The Universe and Doctor Einstein.* New York: William Morrow & Company, Inc., 1957.

Beer, Johannes. *Albrecht Dürer als Maler.* Königstein i.T., Germany: Karl Rebert Langewiesche Verlag, 1953.

Bergson, Henri. *Creative Evolution,* trans. Arthur Mitchell. New York: The Modern Library, 1944.

Birren, Faber. *Color Psychology and Color Therapy,* rev. ed. New Hyde Park, N.Y.: University Books, Inc., 1961.

_____. *Color in Your World.* New York: The Macmillan Company [Collier Books], 1962.

_____. *A Grammar of Color.* New York: Van Nostrand Reinhold Company, 1969.

_____. *Monument to Color.* New York: McFarlane Warde McFarlane, 1938.

Bluestone, George. *Novels into Film.* Baltimore: The Johns Hopkins University Press, 1957.

Bobker, Lee R. *Elements of Film.* New York: Harcourt Brace Jovanovich, Inc., 1969.

Bretz, Rudy. *Techniques of Television Production,* 2nd ed. New York: McGraw-Hill Book Company, 1962.

Burnham, Jack. *Beyond Modern Sculpture.* New York: George Braziller, Inc., 1967.

Campbell, Joseph, ed. *The Portable Jung.* New York: The Viking Press, Inc., 1971.

Churchill, Hugh. *Film Editing Handbook: Technique of 16mm Film Cutting.* Belmont, Calif.: Wadsworth Publishing Company, Inc., 1972.

Copland, Aaron. *What to Listen for in Music,* rev. ed. New York: New American Library, Inc., 1963.

Dean, Alexander, and Lawrence Carra. *Fundamentals of Play Directing,* rev. ed. New York: Holt, Rinehart and Winston, Inc., 1965.

De Sausmarez, Maurice. *Basic Design: The Dynamics of Visual Form.* New York: Van Nostrand Reinhold Company, 1964.

De Voto, Bernard, ed. *The Portable Mark Twain.* New York: The Viking Press, Inc., 1946.

Eastman Kodak Company. *Color as Seen and Photographed,* 2nd ed. Rochester, N.Y.: Eastman Kodak Company, Kodak Publications No. E-47.

Editors of Time-Life Books. *Color.* New York: Time-Life Books [Life Library of Photography], 1970.

_____. *Light and Film.* New York: Time-Life Books [Life Library of Photography], 1970.

_____. *Photojournalism.* New York: Time-Life Books [Life Library of Photography], 1971.

Edman, Irwin. *Arts and the Man.* New York: W. W. Norton & Company, Inc., 1956.

Eisenstein, Sergei. *Film Form and Film Sense,* ed. and trans. Jack Leyda, in one volume. New York: World Publishing Company [Meridian Books], 1957.

_____. *Notes of a Film Director.* London: Lawrence & Wishart, Ltd., 1959.

Erickson, Robert. *The Structure of Music.* New York: The Noonday Press, 1955.

Feldman, Edmund Burke. *Art as Image and Idea.* Englewood Cliffs, N.J.: Prentice-Hall, Inc., 1967.

Fraisse, Paul. *The Psychology of Time.* New York: Harper & Row, Publishers, Inc., 1963.

Fraser, J. T., ed. *The Voices of Time.* New York: George Braziller, Inc., 1966.

Freyberger, Roland. *Licht, Signale, Bilder.* Düsseldorf, Germany: L. Schwann Verlag, 1971.

Gale, Richard M., ed. *The Philosophy of Time.* Garden City, N.Y.: Doubleday & Company, Inc. [Anchor Books], 1967.

Gattegno, Caleb. *Toward a Visual Culture: Educating through Television.* New York: Avon Books, 1969.

Goudsmit, Samuel A., and Robert Claiborne. *Time.* New York: Time-Life Books, 1966.

Hahn, Lewis Edwin. *A Contextualistic Theory of Perception,* University of California Publications in Philosophy, vol. 22. Berkeley: University of California Press, 1942.

Huntley, John, and Roger Manvell. *The Technique of Film Music.* New York: Hastings House, Publishers, Inc., 1968.

Huss, Roy, and Norman Silverstein. *The Film Experience: Elements of Motion Picture Art.* New York: Harper & Row, Publishers, Inc., 1968.

Huxley, Aldous. *The Art of Seeing.* New York: Harper & Brothers, 1942.

Interchem. *The Color Tree,* 2nd ed. New York: Interchemical Corporation, 1965.

Itten, Johannes. *The Art of Color.* New York: Van Nostrand Reinhold Company, 1961.

_____. *Design and Form: The Basic Course at the Bauhaus,* trans. John Maas. New York: Van Nostrand Reinhold Company, 1963.

_____. *The Elements of Color,* ed. Faber Birren and trans. Ernst van Haagen. New York: Von Nostrand Reinhold Company, 1970.

Jacobson, Egbert. *Basic Color.* Chicago: Paul Theobald & Company, 1948.

Josephs, Jess J. *The Physics of Musical Sound.* New York: Van Nostrand Reinhold Company, 1967.

Jung, Carl, ed. *Man and His Symbols.* Garden City, N.Y.: Doubleday & Company, Inc., 1964.

_____. *Psyche and Symbol,* ed. Violet de Laszlo. Garden City, N.Y.: Doubleday & Company, Inc., 1958.

Kandinsky, Wassily. *Point and Line to Plane,* trans. Howard Dearstyne and Hilla Rebay. New York: Solomon R. Guggenheim Foundation, 1947.

Kepes, Gyorgy. *Language of Vision.* Chicago: Paul Theobald & Company, 1944.

_____, ed. *Education of Vision.* New York: George Braziller, Inc., 1965.

_____. *The Man-Made Object.* New York: George Braziller, Inc., 1966.

_____. *Module, Proportion, Symmetry, Rhythm.* New York: George Braziller, Inc., 1966.

_____. *The Nature and Art of Motion.* New York: George Braziller, Inc., 1965.

_____. *Sign, Image, Symbol.* New York: George Braziller, Inc., 1966.

_____. *Structure in Art and Science.* New York: George Braziller, Inc., 1965.

Kinder, Marsha, and Beverle Houston. *Close-Up. A Critical Perspective on Film.* New York: Harcourt Brace Jovanovich, Inc., 1972.

Klee, Paul. *Pedagogical Sketchbook,* trans. Sibyl Moholy-Nagy. New York: Praeger Publishers, Inc., 1953.

_____. *The Thinking Eye: Notebooks of Paul Klee,* ed. Jürgen Spiller and trans. Ralph Manheim. New York: George Wittenborn, Inc., 1961.

Kracauer, Siegfried. *Theory of Film.* New York: Oxford University Press, 1960.

Langer, Susanne. *Feeling and Form.* New York: Charles Scribner's Sons, 1953.

_____. *Philosophy in a New Key,* 3rd ed. Cambridge, Mass.: Harvard University Press, 1957.

Le Corbusier [Charles E. Jeanneret-Gris]. *The Modulor,* 2nd ed., trans. Peter de Francia and Anna Bostock. Cambridge, Mass.: Harvard University Press, 1954.

_____. *Modulor 2.* London: Faber & Faber, Ltd., 1958.

Levin, Richard. *Television by Design.* London: The Bodley Head, Ltd., 1961.

Levitan, Eli L. *An Alphabetical Guide to Motion Picture, Television, and Video Tape Production.* New York: McGraw-Hill Book Company, 1970.

Lewin, Kurt. *A Dynamic Theory of Personality,* trans. Donald Adams and Karl Zener. New York: McGraw-Hill Book Company, 1935.

Lewis, Colby. *The TV Director/Interpreter.* New York: Hastings House, Publishers, Inc., 1968.

Linden, George. *Reflections on the Screen.* Belmont, Calif.: Wadsworth Publishing Company, Inc., 1970.

Lindgren, Ernest. *The Art of the Film,* 2nd ed. New York: The Macmillan Company, 1963.

Luckiesh, Matthew. *Visual Illusions.* New York: Dover Publications, Inc., 1965.

McKim, Robert H. *Experiences in Visual Thinking.* Monterey, Calif.: Brooks/Cole Publishing Company, 1972.

McLuhan, Marshall. *Understanding Media: The Extensions of Man.* New York: McGraw-Hill Book Company, 1965.

Mehrabian, Albert. *Silent Messages.* Belmont, Calif.: Wadsworth Publishing Company, Inc., 1971.

Merleau-Ponty, Maurice. *The Phenomenology of Perception,* trans. Colin Smith. New York: Humanities Press, Inc., 1962.

Millerson, Gerald. *The Technique of Lighting for Television and Motion Pictures.* New York: Hastings House, Publishers, Inc., 1972.

———. *The Technique of Television Production,* rev. ed. New York: Hastings House, Publishers, Inc., 1968.

Moholy-Nagy, László. *Vision in Motion.* Chicago: Paul Theobald & Company, 1947.

Moles, Abraham. *Information Theory and Esthetic Perception,* trans. Joel E. Cohen. Urbana: University of Illinois Press, 1966.

Mueller, Conrad G., and Mae Rudolph. *Light and Vision.* New York: Time-Life Books, 1966.

Nilson, Vladimir. *The Cinema as a Graphic Art,* trans. Stephen Garry. New York: Hill & Wang, Inc., 1959.

Pepper, Stephen C. *Aesthetic Quality: A Contextualistic Theory of Beauty.* New York: Charles Scribner's Sons, 1938.

———. *The Basis of Criticism in the Arts.* Cambridge, Mass.: Harvard University Press, 1945.

Piaget, Jean. *The Construction of Reality in the Child,* trans. Margaret Cook. New York: Basic Books, Inc., 1954.

Popper, Frank. *Origins and Development of Kinetic Art,* trans. Stephen Bann. New York: New York Graphic Society, 1968.

Pudovkin, V. I. *Film Technique and Film Acting,* trans. and ed. Ivor Montagu. New York: Grove Press, Inc., 1960.

Reisz, Karel. *The Technique of Film Editing.* London: Focal Press, 1966.

Reynertson, A. J. *The Work of the Film Director.* New York: Hastings House, Publishers, Inc., 1970.

Rickey, George. *Constructivism.* New York: George Braziller, Inc., 1967.

Smith, Charles N. *Student Handbook of Color.* New York: Van Nostrand Reinhold Company, 1965.

Solomon, Stanley J. *The Film Idea.* New York: Harcourt Brace Jovanovich, Inc., 1972.

Steichen, Edward. *The Family of Man.* New York: The Museum of Modern Art, 1955.

Stephenson, Ralph, and J. R. Debrix. *The Cinema as Art.* Baltimore, Md.: Penguin Books, Inc., 1965.

Stevens, S. S., and Fred Warshofsky. *Sound and Hearing.* New York: Time-Life Books, 1965.

Stuckenschmidt, H. H. *Twentieth Century Music,* trans. Richard Deveson. New York: McGraw-Hill Book Company, 1969.

Teilhard de Chardin, Pierre. *The Phenomenon of Man,* trans. Bernard Wall. New York: Harper & Row, Publishers, Inc., 1961.

Toffler, Alvin. *Future Shock.* New York: Random House, Inc., 1970.

Ushenko, Andrew Paul. *Dynamics of Art.* Bloomington: Indiana University Press, 1953.

Vernon, Magdalen D. *The Psychology of Perception.* Baltimore, Md.: Penguin Books, Inc., 1962.

Weintraub, Daniel J., and Edward L. Walker. *Perception.* Monterey, Calif.: Brooks/Cole Publishing Company, 1966.

Wellek, René, and Austin Warren. *Theory of Literature.* New York: Harcourt Brace Jovanovich, Inc., 1949.

Wilson, John Rowan. *The Mind.* New York: Time-Life Books [Life Science Library], 1964.

Wingler, Hans M. *The Bauhaus,* trans. Wolfgang Jabs and Basil Gilbert. Cambridge, Mass.: The M.I.T. Press, 1969.

Wolfe, Thomas. *The Web and the Rock.* New York: Grosset & Dunlap, Inc., 1938.

Wölfflin, Heinrich. *Gedanken Zur Kunstgeschichte.* Basel: Benno Schwabe & Company Verlag, 1940.

Youngblood, Gene. *Expanded Cinema.* New York: E. P. Dutton & Company, Inc., 1970.

Zettl, Herbert. *Television Production Handbook,* 2nd ed. Belmont, Calif.: Wadsworth Publishing Company, Inc., 1968.

Index

This book was designed by Steve Renick, with Rebecca Hayden as coordinating editor. Technical illustrations were by Carleton Brown and music autography by Eugene Wolf. Composition, printing, and binding were by Kingsport Press, Kingsport, Tennessee. The text type—10 on 12 Helvetica —was set on Linofilm. The text paper is Mountie Offset Enamel. The cover material is Kivar 0, offset. The endpapers are Lindenmeyer Schlosser Multicolor Presidential Blue.